The Best of
The Joy of Painting

with
Bob Ross

America's favorite art instructor

by Annette Kowalski

William Morrow and Company, Inc.
New York

Library of Congress Catalog Card Number: 89-62150
ISBN: 0-688-09246-2

Printed in the United States of America

First Edition

1 2 3 4 5 6 7 8 9 10

To you, Walt, for many years of support, patience, and understanding; for just making it all work—for allowing us the freedom to pursue a dream.

—B. AND A.

ACKNOWLEDGMENTS

Below are just a few of the people whose dedicated efforts culminated in the printing of this book, and without whom there would be no book:

Jane Ross and Walt Kowalski for "running" the show and keeping the home fires burning—thank you! Jim Needham and the entire staff at WIPB-TV, Muncie, Indiana; Joan Kowalski, Joyce Moscato, and Nancy Cox, editorial assistance; Nancy Cox and Steve Ross, "How To" photography assistance; Ron Markum, cover photography; Don Peterson, cartoons; B. K. Wilson; Larry Dyer; Rich Kinkead; family, friends, students, staff, and loyal television viewers who have offered encouragement for many, many years—a very special thank you.

A LETTER TO THE ARTIST

For many years I had the opportunity to travel with Bob as he taught his method of painting. I soon discovered in the classroom that something much larger than learning to paint was happening between Bob and his students; something marvelous, something magic! He seemed to be sharing much more with his students than the desire and ability to paint; he was

bringing to some of them the realization of a lifelong dream. For others, he was instilling a confidence they had never known before—for some, even giving purpose to their lives.

It was the lady who left the classroom with her first masterpiece to proudly present to her grandchild.

It was the somewhat timid man who sent his wife to learn the technique, with the hope that she would somehow relay it to him in the privacy of their own home.

It was the students who mastered the technique to a proficiency that enabled them to teach, thereby opening a whole new world, opening the gates to freedom.

It was the stroke victims who were motivated to regain the use of sluggish arms and hands.

It was people with failing eyesight, encouraged and learning to paint simply from listening and those hard of hearing learning to paint simply by sight.

It was the lady who wanted to lose weight and who dedicated so much of her life to painting that she lost seventy pounds!

Many times I saw Bob hold a person's hand (crippled by arthritis but desperately clutching a brush) and patiently lead it to a canvas where the wonder of wonders happened—a lake was formed or a tree highlighted.

I saw and felt magic happening; was there a way to share this joy with everyone? And so, *The Joy of Painting* television series was born . . . or was it really The Joy of Bob Ross?

And now, through the combined and dedicated efforts of Bill Adler and William Morrow and Company, we shall with this book attempt to share with all of you the best of *The Joy of Painting* and Bob Ross.

This book has been designed to assist you in completing one entire painting at a time. Each set of instructions for a project is self-contained; it will not be necessary for you to refer back and forth through pages and pages to find the help you need. Simply choose the painting you want to work on, read its corresponding instructions thoroughly before you begin, and refer to the "How To" photos as you need them.

Perhaps most important, consider this book a guide for putting your dreams on canvas. Translate its instruction into your very own personalized project. You'll soon see how exciting it is to create unique masterpieces with this fantastic method of painting.

If, through this book, Bob can create in you the desire to paint, what a great gift you will have received, for without desire, without motivation, there will be no accomplishment, and with accomplishment comes confidence and with confidence comes the true feeling of self-worth. I urge you to use this book, this technique of painting, and most of all The Joy of Bob Ross as a vehicle to enrich your life. I know that it's possible, for it has truly enriched mine.

May you always have The Joy of Painting,
Annette Kowalski

INTRODUCTION

There are no great mysteries to painting. You need only the desire, a few basic techniques and a little practice. If you are new to this technique, I strongly suggest that you read the entire Introduction prior to starting your first painting. Devote some time to studying the instructions, looking carefully at the "how-to" pictures and at the finished paintings. Use each painting as a learning experience, add your own ideas, and your confidence as well as your ability will increase at an unbelievable rate. For the more advanced painter, the progressional "how-to" photographs may be sufficient to paint the picture.

PAINTS

This fantastic technique of painting is dependent upon a special firm oil paint for the base colors. Colors that are used primarily for highlights (Yellows) are manufactured to a thinner consistency for easier mixing and application. All of the paintings in this book were painted with the Bob Ross Paint Products. The use of proper equipment helps assure the best possible results.

The Bob Ross technique is a wet-on-wet method, so normally our first step is to make the canvas wet. For this, apply a thin, even coat of one of the special base paints (Liquid White, Liquid Black or Liquid Clear) using the 2" brush. Long horizontal and vertical strokes, assure an even distribution of paint. The Liquid White/Black/Clear allows us to actually blend and mix colors right on the canvas rather than working ourselves to death on the palette.

The Liquid White/Black/Clear can also be used to thin other colors for application over thicker paints much like odorless thinner or Copal Medium. The idea that a thin paint will stick to a thick paint is the basis for this entire technique. This principle is one of our Golden Rules and should be remembered at all times. The best examples of this rule are the beautiful highlights on trees and bushes. Your Liquid White/Black/Clear is a smooth, slow-drying paint which should always be mixed thoroughly before using.

Liquid Clear is a particularly exciting ingredient for wet-on-wet painting. Like Liquid White/Black, it creates the necessary smooth and slippery surface. Additionally, Liquid Clear has the advantage of not diluting the intensity of other colors especially the darks which are so important in painting seascapes. Remember to apply Liquid Clear *very* sparingly! The tendency is to apply larger amounts than necessary because it is so difficult to see.

Should your Liquid White/Black/Clear become thickened, thin it with odorless thinner (not turpentine or other substances).

I have used only 13 colors to paint the pictures in this book. With these 13 colors the number of new colors you can make is almost limitless. By using a limited number of colors, you will quickly learn the characteristics of each color and how to use it more effectively. This also helps keep your initial cost as low as possible. The colors we use are:

*Alizarin Crimson	*Sap Green
Bright Red	*Phthalo (Phthalocyanine) Blue
*Dark Sienna	*Phthalo (Phthalocyanine) Green
Cadmium Yellow	Titanium White
*Indian Yellow	*Van Dyke Brown
*Midnight Black	Yellow Ochre
*Prussian Blue	

(*Indicates transparent or semi-transparent colors, which may be used as underpaints where transparence is required.)

MIXING COLORS

The mixing of colors can be one of the most rewarding and fun parts of painting, but may also be one of the most feared procedures. Devote some time to mixing various color combinations and become familiar with the basic color mixtures. Study the colors in nature and practice duplicating the colors you see around you each day. Within a very short time you will be so comfortable mixing colors that you will look forward to each painting as a new challenge.

Avoid overmixing your paints and strive more for a marbled appearance. This will help keep your colors "alive" and "vibrant." I try to brush-mix a lot of the colors, sometimes loading several layers of color in a single brush. This double and triple loading of brushes creates effects you could never achieve by mixing color on the palette. Pay very close attention to the way colors are loaded into the brushes or onto the knife.

THE PAINTER'S GLOVE

To solve the problem of removing paint from hands after completing a painting project, try using a liquid hand protector called THE PAINTER'S GLOVE, which I developed. This conditioning lotion is applied to the hands *before* you begin painting. Then, simply wash with warm, soapy water. Even oil paints will come off your hands like magic.

THE PAINTER'S GLOVE works equally well with acrylic paints and other stains such as dirt, grease, grime, ink, etc.

This lotion can also be applied to your brushes after cleaning and before storing; this treatment will help preserve your brushes for many years.

PALETTE

To me, my palette is one of the most important pieces of equipment I own. I spent a lot of time designing the palette I use, making it both functional and comfortable. It is large enough to provide ample working space for the large brushes and knives, yet lightweight. I recommend that your palette be made from a smooth, nonporous material such as clear acrylic plastic. Avoid wooden palettes which have not been varnished, or fiberboard or paper palettes. Wood palettes are rarely smooth and, unless well sealed, will absorb the oil from your paint as will fiberboard and paper. These types of palettes can cause your paint to become dry and chalky causing numerous problems. My palette is clear, so it will not distort color, is extremely smooth for easy brush or knife loading, and the plastic will not absorb oil and is easy to clean.

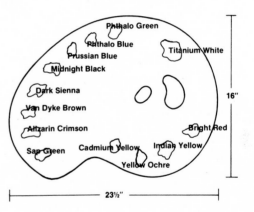

Form the habit of placing your paints in the same location on your palette each time you paint. You can spend an unbelievable amount of time looking for a color on an unorganized palette. The illustration gives the dimensions and color layout of my palette as used on the TV series.

Unused colors may be saved for several days if covered with plastic wrap or foil; for longer periods, cover and freeze. To clean your palette, scrape off excess paint and wipe clean with the thinner. Do not allow paint to dry on your palette. A smooth, clean surface is much easier to work on.

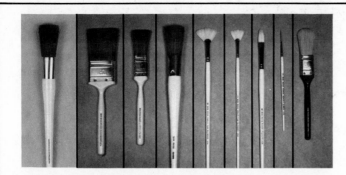

From left to right: 1" Round Brush, 2" Brush, #6 Fan Brush, #3 Fan Brush, Liner Brush, and #6 Filbert Brush, and 1" Oval Brush.

BRUSHES

The brushes you use should be of the finest quality available. Several of the brushes I paint with look very similar to housepainting brushes, but are specifically designed for this method of painting. They are manufactured from all-natural bristles and come in four basic shapes: 2", 1", 1" round and 1" oval. Be careful not to confuse natural bristle with man-made bristles such as nylon, polyester or other synthetic bristles. AVOID WASHING THE BRUSHES IN SOAP AND WATER. Clean your brushes with odorless thinner.

The four large brushes will normally be your most used pieces of equipment. They are used to apply the Liquid White/Black/Clear, paint clouds, skies, water, mountains, trees, bushes and numerous other effects with surprising detail. The 2" brush is small enough that it will create all the effects the 1" brush is used for, yet large enough to cover large areas very rapidly. Another member of the large-brush family is the 1" round brush. This brush will create numerous fantastic effects such as clouds, foothills, trees and bushes. Using several of each brush, one for dark colors and one for light colors, will save you brush-washing time and lessen the amount of paint used.

A #6 Filbert Bristle Brush is used mostly for the seascapes and can also be used for tree trunks and other small detail work.

The 1" Oval Brush is primarily used for making evergreen trees and foothills and for highlighting trees and bushes. This is a brush specially formed by hand with high quality, split-end bristles.

Two other brushes that I use a great deal are the #6 and #3 bristle fan brushes. Your fan brush may be used to make clouds, mountains, tree trunks, foothills, boats, soft grassy areas and many other beautiful effects. Devote some practice time to these brushes and you will not believe the effects you can achieve.

A #2 script liner brush is used for painting fine detail. This brush has long bristles so it holds a large volume of paint. Normally, the paint is thinned to a water consistency with a thin-oil (such as linseed or Copal oil) or odorless thinner. Turn the brush in the thin paint to load it and bring the bristles to a fine point. This brush is also used to complete one of the most important parts of the painting, your signature.

CLEANING THE BRUSHES

Cleaning the brushes can be one of the most fun parts of painting. It's an excellent way to take out your hostilities and frustrations without doing any damage. I use an old coffee can that has a ¼" mesh screen in the bottom. The screen stands about 1" high and the odorless thinner is approximately ¾" above that. To clean your brush, scrub the bristles firmly against the mesh screen to remove the paint. Shake out the excess thinner then beat the bristles firmly against a solid object to dry the brush. Learn to contain this procedure or you will notice your popularity declining at a very rapid rate. One of the simplest and most effective ways of cleaning and drying your brushes is illustrated below:

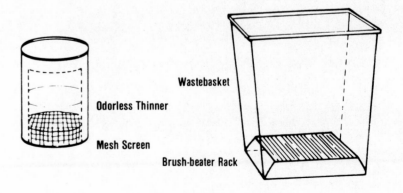

Wastebasket

Odorless Thinner

Mesh Screen

Brush-beater Rack

The brush is shaken inside the wastebasket to remove excess thinner, then the bristles are firmly beaten against the brush-beater rack. (The rack size is 10¾"L x 5¼"W x 5¾"H.)

Odorless thinner never wears out. Allow it to settle for a few days, then reuse. Smaller brushes are cleaned with the thinner and wiped dry on a paper towel or rag.

After cleaning, your brushes can be treated and preserved with THE PAINTER'S GLOVE lotion before storing. Take care of your brushes and they will serve you for many years.

PALETTE KNIFE

The palette knifes I use are very different from traditional painting knives. They are larger and firmer. Practice is required to make these knives into close friends, so spend some time learning to create different effects.

I use two different knives, a large one as well as a smaller knife. The smaller knife is excellent for areas that are difficult to paint with the standard-size knife. The knives have straight edges, so loading is very easy and simple.

The palette knives are used to make mountains, trees, fences, rocks, stones, paths, buildings, etc. Entire paintings can be done by using only knives. The more you use the knives the more your confidence will increase and very soon you will not believe the many effects you can create.

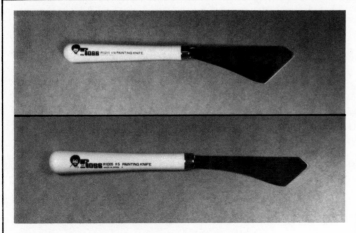

The edge on both knives is straight for easy loading and use.

BLACK GESSO CANVAS PRIMER

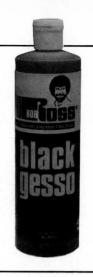

I have recently developed a new product called Black Gesso. This is a flat-Black acrylic liquid primer used in projects requiring a dry pre-coated Black canvas. This water-based paint should be applied very thinly with a foam applicator (not a brush) and allowed to dry completely before starting your painting. Clean the foam applicator with water.

EASEL

A sturdy easel that securely holds the canvas is very important when painting with large brushes. I made the easel I use for mounting on a platform ladder. Any type of step ladder also works well for this type of easel.

CANVAS

The canvas you paint on is also very important. You need a good quality canvas that will not absorb your Liquid White/Black/Clear and leave you with a dry surface.

For this reason, I do not recommend canvas boards or single-primed canvases. I use only very smooth, pre-stretched, double-primed, canvases that are covered with a Grey primer. (The Grey-primed canvas allows you to see at a glance if your Liquid White is properly applied.) You may prefer a canvas with a little tooth, particularly when your painting involves a great deal of work with the knife. Whether the canvas is ultra-smooth or has a little tooth is a matter of individual choice.

All of my original paintings in this book and on the TV series were painted on 18" x 24" canvases. The size of your paintings is totally up to you.

OTHER INSTRUCTIONAL AIDS

In addition to the "Joy of Painting" television series, you will find that workshops, seminars and video tapes are the means of furthering your understanding of the Bob Ross painting technique.

Basic "How To" Photographs: Learn and master these procedures as they are used repeatedly to complete the paintings.

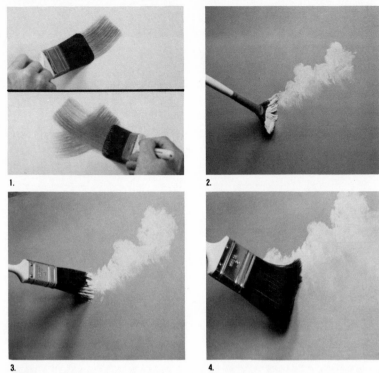

1.

2.

3.

4.

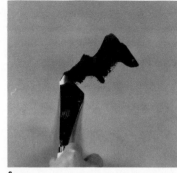

6.

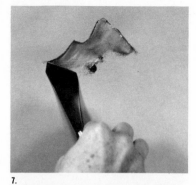

7.

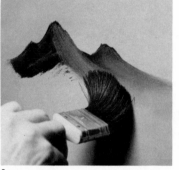

8.

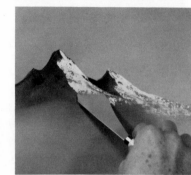

9.

SKIES

Load the 2" brush with a very small amount of paint, tapping the bristles firmly against the palette to ensure an even distribution of paint throughout the bristles. Use criss-cross strokes to begin painting the sky, starting at the top of the canvas and working down towards the horizon. (Photo 1.) Add cloud shapes by making tiny, circular strokes with the fan brush (Photo 2) the 1" brush (Photo 3) or you can use the 2" brush, the 1" round brush or the oval brush. Blend the base of the clouds with circular strokes using just the top corner of a clean, dry 2" brush. (Photo 4.)

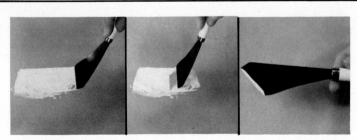

5. Pull the paint out flat on your palette—then cut across to load the long edge of the knife with a small roll of paint.

MOUNTAINS

Load the long edge of the knife with a small roll of paint and use firm pressure to shape just the top edge of the mountain. (Photo 6.) Remove the excess paint with a clean knife (Photo 7) and then use the 2" brush to pull the paint down, completing the entire mountain shape. (Photo 8.) With a small roll of paint on the long edge of the knife, apply highlights and shadows (paying close attention to angles) using so little pressure that the paint "breaks." (Photo 9.) Use a clean, very dry 2" brush to tap and diffuse the base of the mountain, creating the illusion of mist. (Photo 10.)

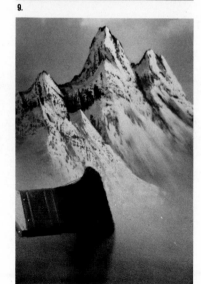

10.

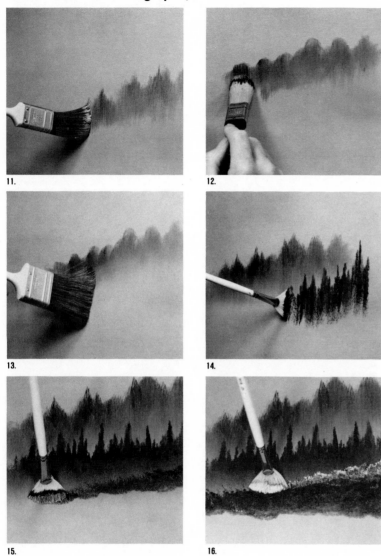

11.

12.

13.

14.

15.

16.

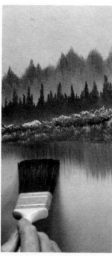

17.

18.

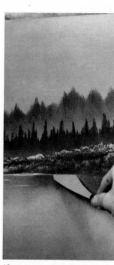

19.

FOOTHILLS

Foothills are made by holding the 1" brush vertically (Photo 11) or the oval brush (Photo 12) and tapping downward. Use just the top corner of the 2" brush to firmly tap the base of the hills, to create the illusion of mist. (Photo 13.) Indicate tiny evergreens by tapping downward with the fan brush. (Photo 14.) The grassy area at the base of the hills is added with the fan brush (Photo 15) and then highlighted, forcing the bristles to bend upward. (Photo 16.)

REFLECTIONS

Use the 2" brush to pull the color straight down (Photo 17) and then lightly brush across to give the reflections a watery appearance. Load the long edge of the knife with a small roll of Liquid White (Photo 18) and then use firm pressure to cut-in the water lines. (Photo 19.) Make sure the lines are perfectly straight, you don't want the water to run off the canvas.

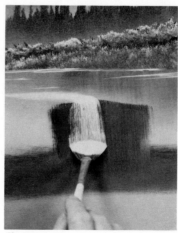

20.

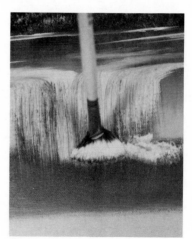

21.

WATERFALLS

Use single, uninterrupted strokes with the fan brush to pull the water over the falls (Photo 20) then use push-up strokes to "bubble" the water at the base of the falls. (Photo 21.)

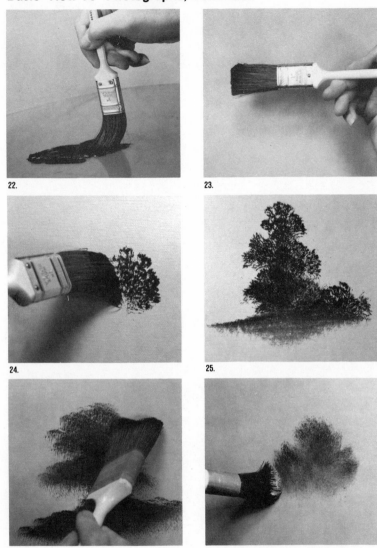

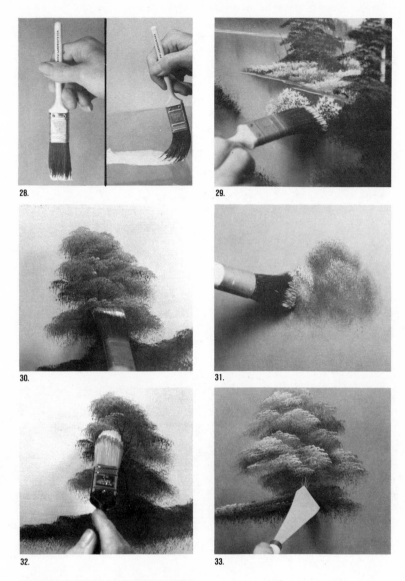

LEAF TREES AND BUSHES
Pull the 1" brush in one direction through the paint mixture (Photo 22) to round one corner. (Photo 23.) With the rounded corner up, force the bristles to bend upward (Photo 24) to shape small trees and bushes. (Photo 25.) You can also just tap downward with the 2" brush (Photo 26) or the round brush. (Photo 27.)

HIGHLIGHTING LEAF TREES AND BUSHES
Load the 1" brush to round one corner. (Photo 28.) With the rounded corner up, lightly touch the canvas, forcing the bristles to bend upward. (Photo 29.) You can also tap to highlight using the corner of the 1" brush or 2" brush (Photo 30) the round brush (Photo 31) or the oval brush. (Photo 32.) Use just the point of the knife to scratch in tiny trunks, sticks and twigs. (Photo 33.)

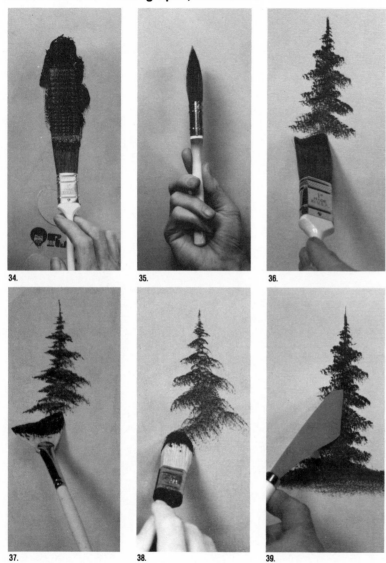

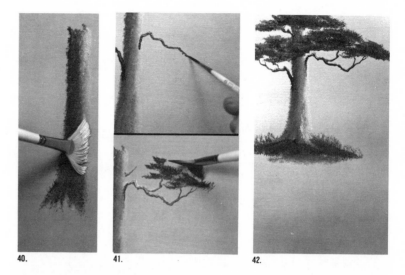

LARGE EVERGREEN TREES

Hold the fan brush vertically and tap downward to create the "fuzzy" bark (Photo 40.) Use thinned paint on the liner brush to add the limbs and branches then push up with just the corner of the fan brush (Photo 41) to add the foliage (Photo 42.)

EVERGREENS

"Wiggle" both sides of the 1" brush through the paint mixture (Photo 34) to bring the bristles to a chiseled edge. (Photo 35.) Starting at the top of the tree, use more pressure as you near the base, allowing the branches to become larger. (Photo 36.) You can also make evergreens using just one corner of the fan brush (Photo 37) or the oval brush (Photo 38.) The trunk is added with the knife. (Photo 39.)

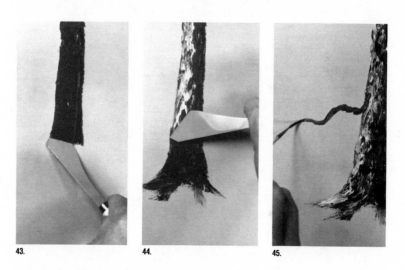

LARGE TREE TRUNKS

Load the long edge of the knife with paint and starting at the top of the tree, just pull down. (Photo 43.) Apply highlights, using so little pressure that the paint "breaks." (Photo 44.) With a very thin paint on the liner brush, add the limbs and branches. (Photo 45.)

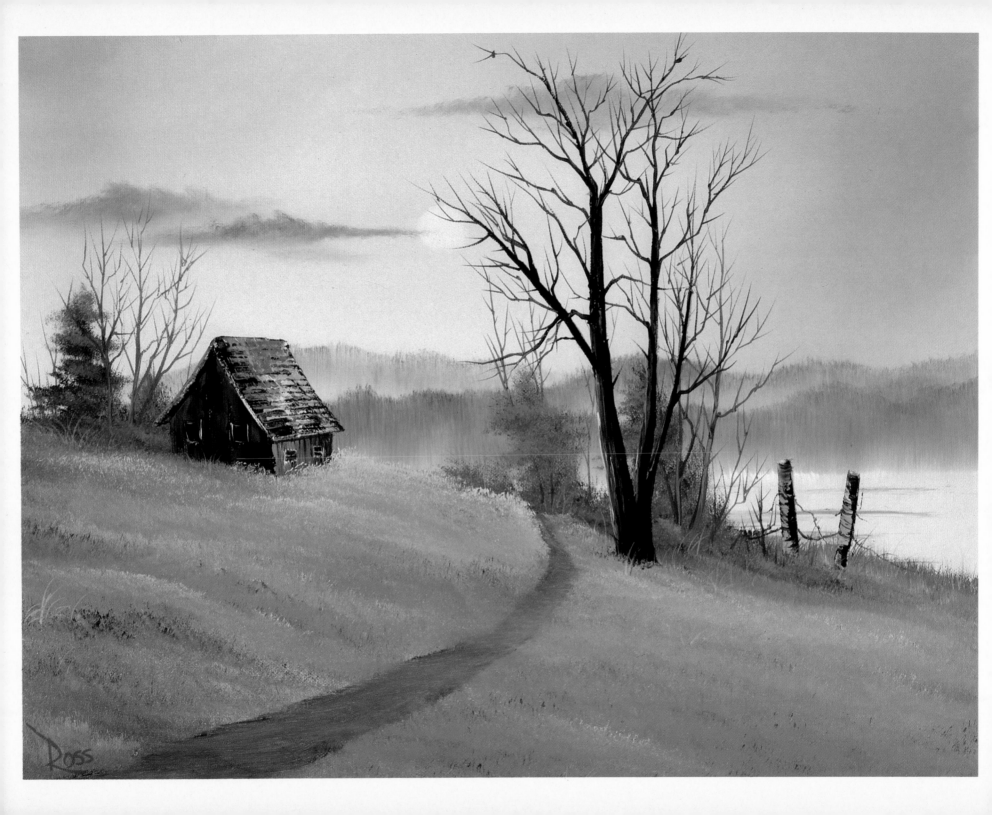

MATERIALS

2" Brush
#6 Fan Brush
#2 Script Liner Brush
Large Knife
Small Knife
Liquid White
Titanium White

Midnight Black
Dark Sienna
Van Dyke Brown
Cadmium Yellow
Yellow Ochre
Indian Yellow

Start by covering the entire canvas with a thin, even coat of Liquid White using the 2" brush. Work long horizontal and vertical strokes, work back and forth to ensure an even distribution of paint on the canvas. Do NOT allow the Liquid White to dry before you begin.

SKY

Load the 2" brush with Dark Sienna, tapping the bristles firmly against the palette to ensure an even distribution of paint throughout the bristles. Starting at the top of the canvas, begin painting the sky using small criss-cross strokes. The color will mix with the Liquid White and automatically get lighter as you near the horizon. With Cadmium Yellow on the brush, use the same small criss-cross strokes to add the golden aura around the sun and then use Titanium White on your fingertip to add the sun. Very, very lightly blend the entire sky.

With Dark Sienna on the fan brush and tight circular strokes, add the cloud shapes. Use just the top corner of a clean, dry 2" brush and circular strokes to blend out the base of the clouds and then again, lightly blend the entire sky.

BACKGROUND

Load the 2" brush with Dark Sienna, then use just one corner and short, downward strokes to begin indicating the most distant hills. Working in layers, allow each range of hills to become darker as you move forward in the painting.

With Titanium White on a clean 2" brush, pull straight down to add the water to the base of the distant hills and then lightly brush across. Use Dark Sienna on the long edge of the knife and firm pressure to add water lines and ripples.

MIDDLEGROUND

Start by underpainting the entire lower portion of the canvas (the foreground) by just tapping downward with a mixture of Dark Sienna and Van Dyke Brown on the 2" brush. Pay close attention to angles, this is where you will begin forming the lay-of-the-land.

The small leafy trees and bushes are made with the fan brush and a mixture of Van Dyke Brown and Dark Sienna. Use small upward pushes with just one corner of the brush to form the trees. Add paint thinner to the same Brown mixture to load the liner brush (twirling the bristles to bring them to a sharp point) and add the small leafless trees.

Highlight the leaf trees and bushes with Yellow Ochre on the fan brush, still using small upward pushes. Working in layers, move forward in the painting and add larger tree trunks with the script liner brush and the thinned Brown mixture.

Load the 2" brush by tapping the bristles into various mixtures of Yellow Ochre, Cadmium Yellow, Indian Yellow and Titanium White. Still paying close attention to the lay-of-the-land, tap downward with the brush to apply highlights to the grassy ground area beneath the trees. If you have trouble making this paint stick to the dark undercoat, try adding a little paint thinner or Liquid White to the mixture. (A thin paint will stick to a thick paint.)

CABIN

Load the long edge of the knife with a small roll of Van Dyke Brown by pulling the paint out very flat on your palette and just cutting across. Study the angles of the cabin and add the front of the roof. Touch the knife to the canvas to add the back of the roof and then pull down to add the side and front of the cabin.

For the highlights, again load the long edge of the knife with a small roll of a mixture of Dark Sienna, Van Dyke Brown and Titanium White. Using so little pressure that the

paint "breaks," highlight the front and side of the cabin and then "bounce" some of the highlight mixture down the front of the roof. "Sparkle" the very edges of the roof by just touching them with a little Titanium White on the knife.

Add the windows with Midnight Black on the short edge of the small knife. Form the proper angle at the base of the cabin by using the knife to scrape away any excess paint. Tap in the grassy area at the base of the cabin still using the 2" brush and the grassy highlight mixtures.

FOREGROUND

Continuing to follow the lay-of-the-land (and working forward in layers) use both the fan brush and the 2" brush to add grass to the underpainted foreground. Use various mixtures of Liquid White, Titanium White, all the Yellows and Dark Sienna.

Add the path using short, horizontal strokes with Van Dyke Brown on the fan brush. Watch the perspective, allowing the path to become wider as it nears the foreground. Use Titanium White on the fan brush to highlight the path, and the 2" brush to extend the grassy areas over the edges of the path.

Continue using various mixtures of all the Yellows, Titanium White and Dark Sienna on the 2" brush, the fan brush or the 1" brush to tap on the remainder of the grassy highlights.

LARGE TREES

Load the long edge of the knife with a small roll of Van Dyke Brown to add the larger tree trunks. Hold the knife vertically, touch the canvas lightly and just give a little sideways pull to shape the trunks and large branches. Highlight the left sides of the trunks (where the light would strike) by just lightly touching with a mixture of Titanium White and Van Dyke Brown on the knife.

The small limbs and branches are made with a mixture of paint thinner, Midnight Black and Van Dyke Brown. Dip the liner brush into the thinner and twirl the brush as you pull it through the mixture, bringing the bristles to a sharp point. As you shape the tiny limbs and branches, add more thinner if the paint refuses to flow easily.

The fence is made with Van Dyke Brown on the knife and again highlighted with a mixture of Titanium White and Dark Sienna. Use thinned Midnight Black on the liner brush to add the fence wire.

FINISHING TOUCHES

With just the point of the knife, scratch in small sticks and twigs. You can also use thinned mixtures of paint on the liner brush to add other small details and long grasses.

Again load the liner brush with very thin paint, bring the bristles to a sharp point and use very little pressure to sign your painting. What a masterpiece!

If you have enjoyed working with this monochromatic color scheme, try this painting using other color schemes.

Golden Knoll

1. Use criss-cross strokes to paint the sky.

2. Add the sun with your finger.

3. Use circular strokes with the fan brush to shape the clouds . . .

4. . . . then blend the clouds with one corner of the 2" brush . . .

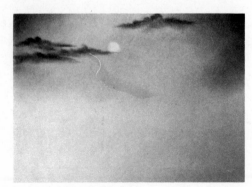

5. . . . and the sky is complete.

Golden Knoll

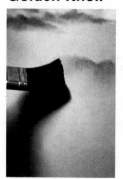

6. With the 2" brush, use short downward strokes to paint the distant hills.

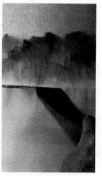

7. Use the knife and firm pressure to add the water lines.

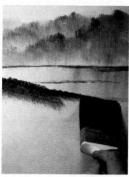

8. Tap downward with the 2" brush . . .

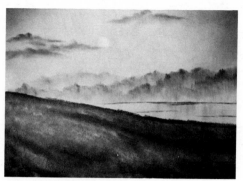

9. . . . to underpaint the foreground.

10. The small leafy trees are made with the fan brush.

11. Use thinned paint on the liner brush to add small tree trunks.

12. Tap downward with the 2" brush to highlight the grassy areas.

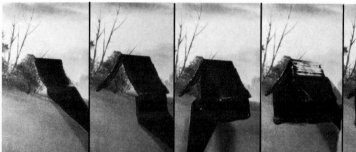

13. Progressional steps used to paint the cabin.

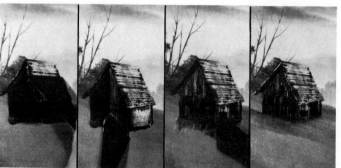

14. Use horizontal strokes with the fan brush . . .

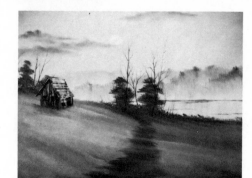

15. . . . to add the path.

16. Tree trunks are made . . .

17. . . . and then highlighted with the knife.

18. Use the liner brush to add limbs and branches.

19. Paint the fence with the knife.

20. Add the fence wire with the liner brush.

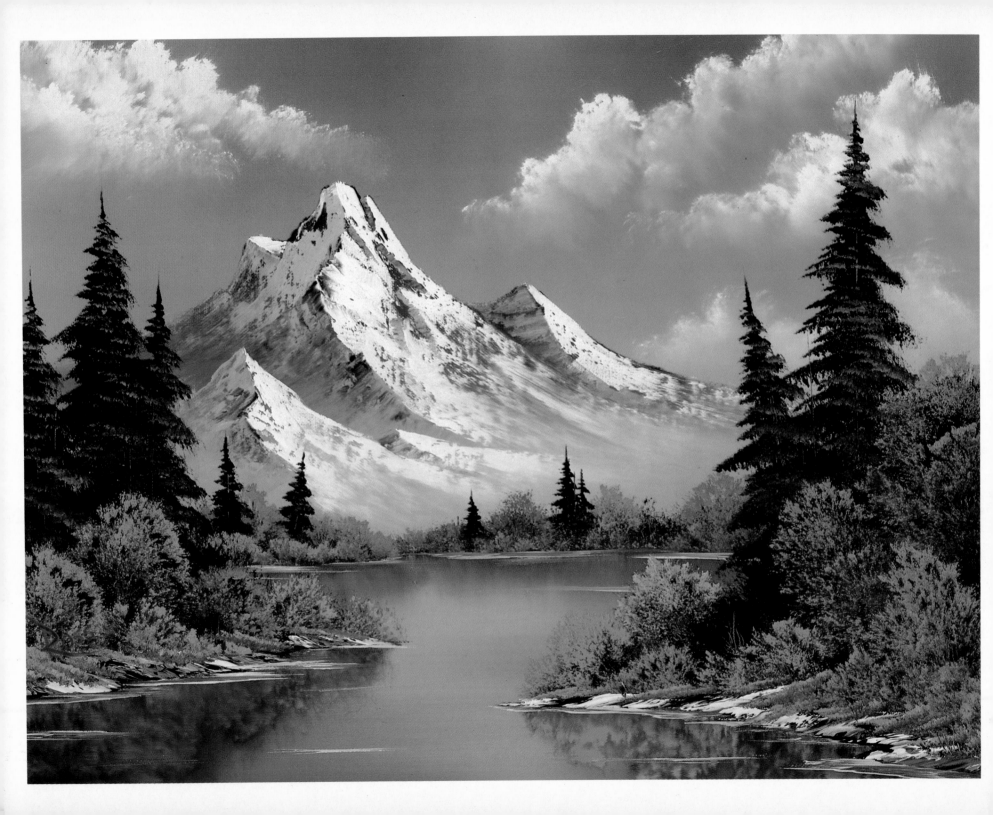

MATERIALS

2" Brush	Dark Sienna
1" Brush	Van Dyke Brown
#2 Script Liner Brush	Alizarin Crimson
Large Knife	Sap Green
Liquid White	Cadmium Yellow
Titanium White	Yellow Ochre
Phthalo Blue	Indian Yellow
Prussian Blue	Bright Red
Midnight Black	

Start by covering the entire canvas with a thin, even coat of Liquid White using the 2" brush. With long horizontal and vertical strokes, work back and forth to ensure an even distribution of paint on the canvas. Do NOT allow the Liquid White to dry before you begin.

SKY AND WATER

Load the 2" brush with a mixture of Phthalo Blue and Midnight Black by tapping the bristles firmly into the paint on your palette to ensure an even distribution of paint throughout the bristles. Starting at the top of the canvas, use criss-cross strokes to begin painting the sky. The sky will automatically get lighter as you work towards the horizon and the color mixes with the Liquid White already on the canvas.

Starting at the bottom of the canvas, use long horizontal strokes to add the water, still using the Blue-Black mixture on the 2" brush. Pulling from the outside edges of the canvas, leave the center area unpainted to create the illusion of light shimmering across the water. Again, notice how the color becomes lighter as you work up towards the horizon.

With a clean, dry 2" brush, use long horizontal strokes to blend the entire canvas.

Load the 1" brush with Titanium White and just a touch of the Bright Red. Use tiny, circular strokes to form the cloud shapes. With just the top corner of a clean, dry 2" brush, use the same circular strokes to blend out just the base of the clouds and then a sweeping upward motion to lightly blend and "fluff" the clouds.

MOUNTAIN

Use a mixture of Midnight Black, Prussian Blue, Van Dyke Brown and Alizarin Crimson to paint the mountain. Pull the mixture out very flat on your palette and just cut across to load the long edge of the knife with a small roll of paint. Using firm pressure on the canvas, shape just the top edge of the mountain and then use the blade of the knife to remove any excess paint.

With a clean, dry 2" brush, pull the paint down towards the base to complete the shape of the entire mountain.

Use a mixture of Titanium White with a VERY small amount of Bright Red to add the snow to the mountain. Again, load the long edge of the knife with a small roll of paint. Holding the knife vertically, touch the top of each peak and use so little pressure that the paint "breaks." Paying close attention to angles, glide the knife down the RIGHT side of each peak (where the light would strike).

The snow on the shadow sides of the peaks is a mixture of Titanium White and Prussian Blue. Again, load the knife with a small roll of paint and apply it by pulling in the opposing direction.

With a clean, dry 2" brush (being careful to follow the angles you have created) tap the base of the mountain to diffuse and then gently lift upward to create the illusion of mist.

BACKGROUND

Underpaint the small background trees at the base of the mountain by adding a small amount of Sap Green to the mountain mixture of Midnight Black, Prussian Blue, Van Dyke Brown and Alizarin Crimson. Load the 1" brush by pulling it in one direction through the mixture, to round one corner. With the rounded corner UP, touch the canvas and force the bristles to spread and bend upward as you shape

the tiny trees and bushes. Reverse the brush and reflect some of this dark mixture into the water. Use a clean, dry 2″ brush to pull the reflections straight down and then gently brush across.

To highlight the small trees and bushes, dip the 1″ brush into Liquid White and pull it in one direction through various mixtures of all the Yellows and Sap Green. Again, with the rounded corner up, force the bristles to bend upward as you apply the highlights. (Be very careful not to "kill" all of the dark base color, use it to separate the individual trees and bushes.) Reverse the brush and reflect the highlights into the water. Use a clean, dry 2″ brush to VERY LIGHTLY pull down and brush across, giving your reflections a watery appearance.

Mix a little Liquid White with Dark Sienna on your palette, pull it out flat and cut across to load the long edge of the knife with a small roll of paint. Use the knife and firm pressure on the canvas to cut in the water lines and ripples. Water always lies flat, so make sure your lines are perfectly straight and parallel to the bottom edge of the canvas.

FOREGROUND

The evergreen trees are made with the 1″ brush and the same dark mixture of Midnight Black, Prussian Blue, Van Dyke Brown, Alizarin Crimson and Sap Green. Load the brush to a chiseled edge by "wiggling" the bristles as you pull both sides of them through the paint mixture on your palette.

Holding the brush vertically, touch the canvas to create the center line of the tree. Starting at the top of the tree, use one corner of the brush to just touch the canvas to form the top branches. Working back and forth (forcing the bristles to bend downward) use more pressure as you move down the tree, allowing the branches to become larger as you near the base of the tree. With the same dark mixture, load the 1″ brush to round one corner. Again, with the rounded corner up, underpaint the trees, bushes and ground area at the base of the large evergreen trees. Reverse the brush and reflect this dark color into the foreground water.

Use a mixture of Titanium White and Dark Sienna on the very edge of the knife to add the evergreen tree trunks. You can also use just the point of the knife to scratch in just the indication of tree trunks and branches.

Load the 1″ brush to a chiseled edge with a mixture of Midnight Black and Yellow Ochre and lightly touch highlights to the right sides of the evergreens. (If you have trouble making the paint stick, add a little paint thinner or Liquid White to the mixture.)

Highlight the foreground trees and bushes with various mixtures of Liquid White, all the Yellows, Sap Green and Bright Red. Again, working in layers, create individual trees and bushes; be very careful not to destroy all of your dark underpaint. Reverse the brush and reflect these highlight colors into the foreground water. With a clean, dry 2″ brush, use a VERY light touch to pull down the reflections and gently brush across.

Use Van Dyke Brown on the knife to add the banks along the foreground water's edge. Be very careful of the angles here and then use a mixture of Titanium White, Dark Sienna and Van Dyke Brown on the knife to highlight. Use so little pressure that this paint "breaks," creating the impression of small rocks and stones.

Use a small roll of Liquid White on the long edge of the knife to cut-in the foreground water lines.

FINISHING TOUCHES

Use the point of the knife or thinned paint on the liner brush to add small sticks and twigs or other small details.

Use the liner brush and very thin paint to sign your painting with pride!

Mountain Reflections

1. Use criss-cross strokes to paint the sky.

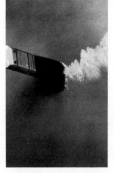

2. Use the 1" brush and circular strokes to paint the clouds . . .

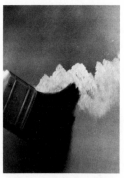

3. . . . the top corner of the 2" brush to diffuse the base of the clouds.

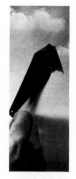

4. Shape the top edge of the mountain with the knife . . .

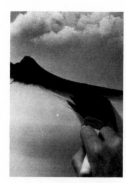

5. . . . pull down with the 2" brush to complete the entire shape.

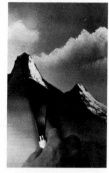

6. The knife is used to add highlights.

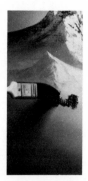

7. Use the 1" brush to add small background trees . . .

8. . . . then pull down with 2" brush for reflections.

9. Use the knife to cut-in water lines . . .

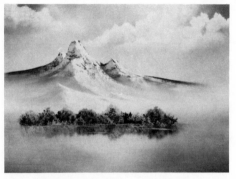

10. . . . and ripples to complete the background.

11. Load the 1" brush for evergreens . . .

12. . . . round one corner for the bushes.

13. Add tree trunks with the knife.

14. Use the 1" brush to highlight small trees and bushes . . .

15. . . . and then reflect them by pulling down with the 2" brush.

16. Land areas are made . . .

17. . . . and then highlighted with the knife.

18. Use the knife to cut-in water lines . . .

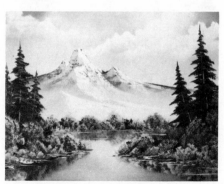

19. . . . and other small, final details.

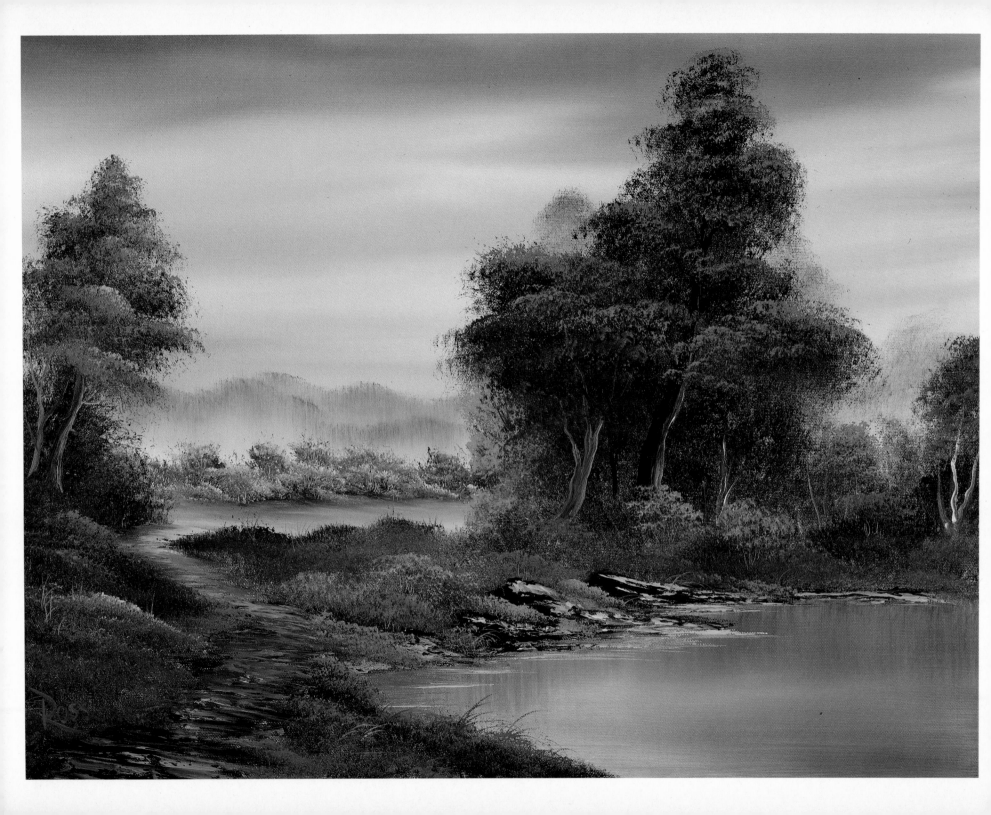

MATERIALS

2" Brush	Phthalo Blue
1" Brush	Midnight Black
1" Round Brush	Dark Sienna
#6 Fan Brush	Van Dyke Brown
#2 Script Liner Brush	Alizarin Crimson
Large Knife	Sap Green
Liquid White	Cadmium Yellow
Liquid Black	Yellow Ochre
Titanium White	Indian Yellow
Phthalo Green	Bright Red

Start by covering the entire canvas with a thin, even coat of Liquid White, using the 2" brush. Use long horizontal and vertical strokes, working back and forth to ensure an even distribution of paint on the canvas. Do not allow the Liquid White to dry before you begin.

SKY

Use a clean, dry 2" brush and some Midnight Black and Phthalo Blue to make diagonal strokes in the sky area, allowing the color to become lighter as it mixes with the Liquid White near the horizon.

Without cleaning the brush, add a very small amount of Phthalo Green and pull in some water at the bottom of the canvas using very straight horizontal strokes.

Mix a little Phthalo Blue with some Alizarin Crimson and load a clean, dry 2" brush. With this Lavender color, again make diagonal strokes in the sky. Without cleaning the brush, repeat with a very small amount of Bright Red. Add some Indian Yellow to the brush and lay in some bright sunny areas in the sky. Now, blend the entire sky with a clean, dry 2" brush.

BACKGROUND

Pull the round brush through some Midnight Black, Phthalo Blue and Titanium White, forming a chiseled edge with the bristles of the brush. With this Blue-Grey color, gently touch the canvas and pull downward to form the foothills. Use a clean, dry 2" brush and firmly tap the bottoms of the trees to create a misty area at the base of the foothills.

Using the round brush loaded with Midnight Black, Sap Green and Van Dyke Brown, tap in some distant tree shapes at the base of the foothills. Without cleaning the brush, pick up some Yellows and very gently tap some highlight color onto these tree shapes.

Load the 2" brush with the Lavender (Blue and Crimson) sky color, some Sap Green and Titanium White to lay in a little meadow area at the base of the distant trees. Use the fan brush to pull some of the tree colors into the meadow, creating the lay-of-the-land.

The larger, closer trees are made with the round brush loaded with Midnight Black and Phthalo Blue. Starting at the bottoms, just tap in basic tree and bush shapes. Be sure to extend some of this dark color into the water area for reflections. Dip the liner brush into thinner and then Van Dyke Brown to paint in small trunk indications. You can also add some tree trunks using the Liquid White on the liner brush.

The large tree trunk is applied with a small roll of paint on the long edge of the knife, using a mixture of Van Dyke Brown and Dark Sienna. Just touch the canvas and gently pull to the side—making sure the tree trunk is wider at the base than at the top. Highlights are made in the same way using a mixture of Titanium White, Yellow Ochre and Bright Red and gently touching the right side of the tree trunk.

With Liquid Black on the liner brush, add limbs and branches to the tree, highlighting with Liquid White.

Dip the round brush into Liquid White and various mixtures of the Yellows, Bright Red and Sap Green. Starting at the top of the trees, gently tap in some leaf indications.

Using the 1" brush and the same color mixtures, create bush shapes at the base of the trees. Grassy areas are made by holding the brush horizontally and bending the bristles upward. You can reverse this entire procedure to create reflections in the water area.

WATER

Using a clean, dry 2″ brush, use vertical strokes to pull down the reflections. Gently brush across to create the illusion of water.

Use a mixture of Van Dyke Brown and Dark Sienna on the edge of the knife to lay in some little stones and to add a path beside the pond. Highlight the stones and the path with a mixture of Van Dyke Brown and Titanium White.

With a mixture of Liquid White and Phthalo Blue on the edge of the knife, cut in the water lines around the edges and under the stones.

FINISHING TOUCHES

Use the point of the knife to cut in long grasses, sticks and twigs.

You are now ready to sign this beautiful painting and enjoy your creation.

Secluded Lake

1. Use the large brush to paint in the basic sky pattern.

2. Pull downward with the top corner of the round brush to make distant trees.

3. Tap the bottom of the distant trees with the 2″ brush.

4. Tap with the round brush to make and highlight the next layer of trees.

5. Use the large brush to pull a touch of the color out . . .

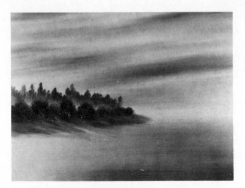 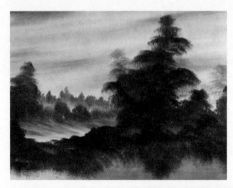

6. . . . to create the distant meadow.

7. Larger bushes . . .

8. . . . trees . . .

9. . . . and reflections are made with the round brush.

10. Tree limbs are made with the liner brush.

Secluded Lake

11. Tree trunks are made . . .

12. . . . and highlighted with the knife.

13. Use the round brush to highlight large trees.

14. Bushes highlighted with the 1" brush pushed upwards.

15. Pull downward with the large brush to create reflections.

16. Small sticks and twigs are "cut-in" with the point of the knife.

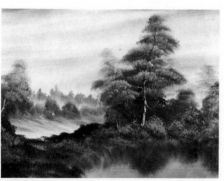

17. Work in layers completing the most distant areas first.

18. Use the knife to make . . .

19. . . . and highlight . . .

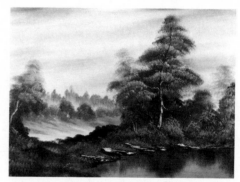

20. . . . the land area around the lake.

21. Use back and forth horizontal strokes to lay in the path.

22. Water lines are "cut-in" . . .

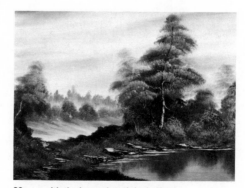

23. . . . with the long edge of the knife.

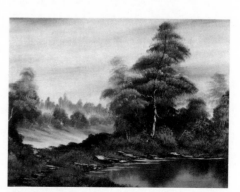

24. The remaining foreground is painted in and highlighted with the 1" brush.

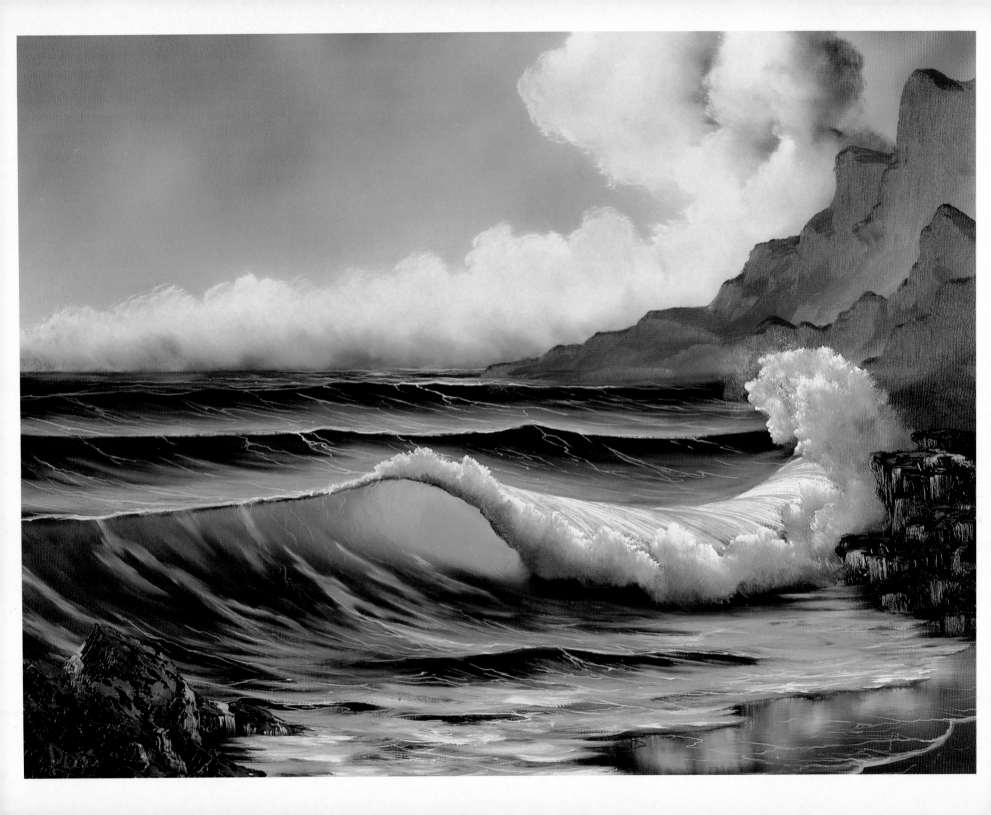

MATERIALS

2″ Brush	Prussian Blue
#6 Fan Brush	Midnight Black
#6 Filbert Brush	Dark Sienna
#2 Script Liner Brush	Van Dyke Brown
Large Knife	Alizarin Crimson
Black Gesso	Cadmium Yellow
Liquid White	Yellow Ochre
Titanium White	Bright Red
Phthalo Blue	

Cover the entire canvas with a thin, even coat of Black Gesso and allow to dry completely before you begin.

Cover the top half of the dry Black canvas with a thin even coat of Liquid White using the 2″ brush. Use long horizontal and vertical strokes, working back and forth to ensure an even distribution of paint on the canvas. Do not allow the Liquid White to dry before you begin. Now, clean and dry your 2″ brush.

To the dry Black area just below the horizon, use the 2″ brush and a mixture of Prussian Blue and Yellow Ochre to add a large band of color. Without cleaning the brush, add Phthalo Blue to the lower portion of the canvas and Van Dyke Brown to the lower right hand corner. Your entire canvas should now be wet: Liquid White above the horizon, then the Prussian Blue, Yellow Ochre mixture, Phthalo Blue and Van Dyke Brown in the corner.

SKY

The sky is Phthalo Blue with a touch of Bright Red loaded on a clean, dry 2″ brush. Use criss-cross strokes to paint the sky, allowing the cloud areas to remain unpainted.

With the same brush, pick up a mixture of Midnight Black and Bright Red. Use just the corner of the brush and small circular strokes to underpaint the cloud shapes. Highlight the tops of the clouds with a clean, dry 2″ brush and Titanium White, again use one corner and circular strokes. Be careful not to destroy all of the dark shadow color. With a clean, dry 2″ brush, gently blend the two colors together and lift upward to fluff.

BACKGROUND

At this point, use the filbert brush and Titanium White to loosely sketch the basic shape of the large wave in the foreground.

Load the fan brush full of Titanium White, hold the brush horizontally, barely grazing the canvas, begin laying in the water along the horizon. (In this painting the horizon is about eight inches down from the top of the canvas.) Paint the swell behind the large wave with a long horizontal line of Titanium White. Still using the fan brush, grab the top of the line of paint, using small sweeping strokes to pull it back, blending into the dark base color. Also apply a long line of Titanium White across the top of the large wave, pull back and blend.

HEADLANDS

With the fan brush, make a Lavender mixture of Alizarin Crimson, Phthalo Blue and Titanium White and begin shaping just the top edge of the most distant headland. Without touching this top edge, use a clean, dry 2″ brush to pull the paint down towards the horizon, tapping to blend and mist. Use less Titanium White in the mixture allowing the closer headlands to become darker in value. Be sure to complete each one before moving forward with the next. Use Titanium White and short horizontal strokes with the fan brush to add water to the base of the headlands.

LARGE WAVE

Paying very close attention to the angle of the water, use Titanium White on the fan brush (hold it horizontally) and pull the water over the top of the large, crashing breaker.

Underpaint the foam using the filbert brush and a Lavender mixture of Phthalo Blue, Alizarin Crimson and Titanium White using very small circular strokes.

The transparent "eye" of the wave is a mixture of Titanium White and a very little Cadmium Yellow. Use the filbert brush to scrub the color into the canvas, several times if necessary, to achieve the desired degree of lightness. Allow this very light color to extend out across the top of the wave. Use the top corner of a clean, dry 2" brush to gently blend the "eye." Working out across the top of the wave, pull the light color down into the dark to blend and shape the wave.

Still using the Titanium White and Cadmium Yellow mixture, with a little paint thinner on the liner brush, add thin lines of highlights to the back water and across the very top of the large wave. Also use paint thinner, Phthalo Blue and Titanium White on the liner brush to add small details to the water.

Highlight the foam with the filbert brush and the Titanium White and Cadmium Yellow mixture. Use small circular strokes on just the outside edges of the foam where the light would strike. Use the top corner of the 2" brush to lightly blend the highlights into the darker base color.

FOREGROUND

The basic shape of the large rock in the foreground is made using Van Dyke Brown and the knife. Add a little Dark Sienna to the Van Dyke Brown as you shape and form the rock.

Use a thin mixture of Liquid White, Titanium White and Phthalo Blue on the fan brush to create the dripping water over the rock with downward strokes.

Swirl in water and foam to the base of the rock and on the beach area with a mixture of Titanium White and Phthalo Blue on the fan brush. Allow this color to mix and blend with the dark base colors already on the canvas. Don't destroy all of the dark, allow small patches to show through the lighter foam and water color. Be careful not to overmix.

To make the wet sand, add a little Dark Sienna and then Titanium White to the lower right corner of the canvas. With a clean, dry 2" brush, pull down and gently brush across to create the illusion of reflections.

The ripples on the beach are thin lines made with paint thinner and the light Blue mixture loaded on the liner brush. Use the Lavender color on the liner brush to add a thin shadow line under the water on the beach and to add small foam patterns to the wave.

Use Van Dyke Brown to add the smaller rocks to the left side of the canvas. Highlight with a mixture of Yellow Ochre, Van Dyke Brown and Dark Sienna, using so little pressure that the paint "breaks." Use Titanium White on the fan brush to add water to the base of the stones and the same thin, light Blue mixture to add water dripping over the stones.

FINISHING TOUCHES

Use thinned paint on the liner brush to add final details and foam patterns to the painting.

With the completion of this seascape, you have truly experienced the "JOY OF PAINTING"!

Secluded Beach

1. The top portion of a black canvas is covered with Liquid White.

2. Use criss-cross strokes to paint the sky.

3. The shadows for the clouds are painted with the corner of the 2" brush.

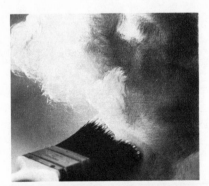

4. Paint the highlights on the clouds with the corner of the brush using small circular strokes.

Secluded Beach

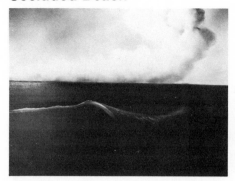

5. A sketch of the major wave is made with the filbert brush.

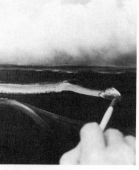

6. With the fan brush, paint in the basic shapes for the major waves.

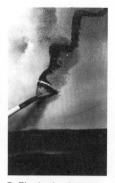

7. The basic shapes for the headlands are painted with the fan brush . . .

8. . . . then blended downward with the 2" brush.

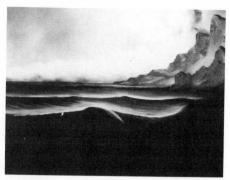

9. Complete the most distant headland first, then work forward.

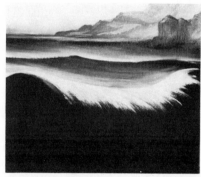

10. Paint the highlights on the crashing wave.

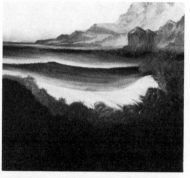

11. Paint the shadow area of the foam on the wave.

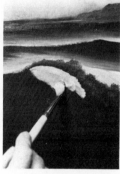

12. The eye of the wave is painted with the filbert brush.

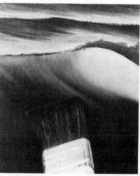

13. Blend with the large brush.

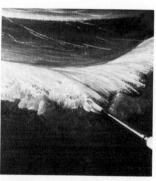

14. Use small circular strokes of the filbert brush to highlight the foam on the wave.

15. Foreground rocks are made and highlighted with the painting knife.

16. The indication of dripping water is made with the fan brush.

17. The fan brush is used to add foam patterns.

18. Pull down, then across, to give the sand a wet look.

19. Water lines are painted with the liner brush loaded with a thin paint.

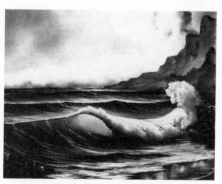

20. Your seascape is finished and ready for a signature.

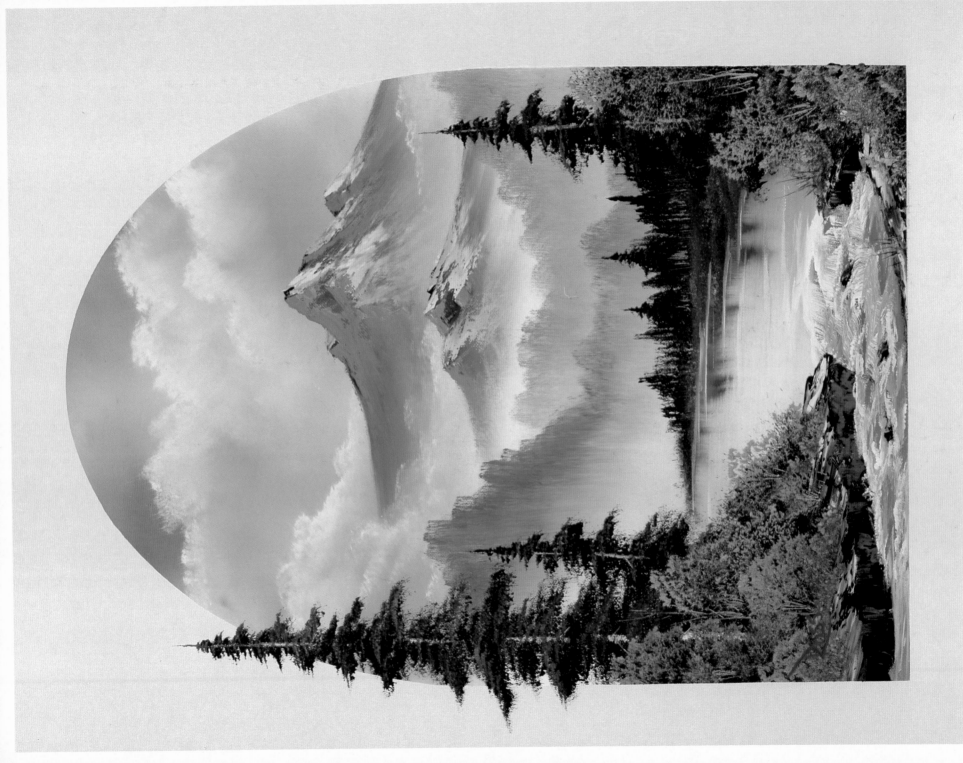

MATERIALS

2" Brush	Prussian Blue
1" Brush	Midnight Black
#6 Fan Brush	Dark Sienna
#2 Script Liner Brush	Van Dyke Brown
Large Knife	Alizarin Crimson
Small Knife	Sap Green
Adhesive-Backed Plastic	Cadmium Yellow
Liquid White	Yellow Ochre
Titanium White	Indian Yellow
Phthalo Green	Bright Red
Phthalo Blue	

Start by covering the vertical canvas with adhesive-backed plastic (Con-Tact Paper) from which a center design has been removed.

Cover the exposed area of the canvas with a thin, even coat of Liquid White using the 2" brush. Do NOT allow the Liquid White to dry before you begin.

SKY

Load the 2" brush with a very small amount of Prussian Blue. Starting at the top of the canvas, use small criss-cross strokes allowing the sky to become lighter as you near the horizon. Add small amounts of Phthalo Blue and Phthalo Green to the same brush.

Use horizontal strokes and the Blue-Green mixture to underpaint the water on the bottom portion of the canvas. With a clean, dry 2" brush, blend the entire canvas.

Use a mixture of Titanium White with a VERY small amount of Bright Red on the fan brush to make the clouds. With one corner of the brush, make tiny circular strokes to form the cloud shapes. Blend the base of the clouds with just the top corner of a clean, dry 2" brush and then gently lift upward to "fluff."

MOUNTAINS

The larger, more distant mountain is painted with a mixture of Midnight Black, Van Dyke Brown and Prussian Blue loaded on the long edge of the knife. Use firm pressure to shape the top of the mountain and then with a clean, dry 2" brush, pull the color down to the base of the mountain.

Highlight the mountain with various mixtures of Titanium White and Dark Sienna. Starting at the top of the mountain, glide the knife down the right side of each peak, using so little pressure that the paint "breaks."

The shadows are applied to the left sides of the peaks using mixtures of Van Dyke Brown, Prussian Blue and Titanium White. (Use the small knife for small crevices and other hard-to-reach areas of the mountain.) Use a clean, dry 2" brush and gently tap to diffuse the base of the mountain, carefully following the angles.

Finally, lift upward with the brush to create a misty appearance. To float the clouds around the base of the distant mountain, use the fan brush and Titanium White (which has been thinned with a small amount of Liquid White). Make tiny circular strokes with one corner of the brush and then use one corner of the 2" brush to blend the base of the clouds, and upward sweeping strokes to "fluff."

Add the second smaller, range of mountains using the same mountain-color mixtures. Again, tap the base of the mountain to diffuse and mist.

BACKGROUND

With a mixture of Phthalo Green, Prussian Blue, Van Dyke Brown and Titanium White, form the foothills at the base of the mountains using just the corner of the 1" brush and short, downward strokes. With a clean, dry 2" brush, tap the base of the hills firmly, to mist.

Form another, closer range of hills using the same mixture, plus a small amount of Alizarin Crimson and Prussian Blue, to darken. Create the misty illusion at the base of these foothills by tapping with a clean, dry 2" brush.

Load the fan brush with a mixture of Prussian Blue, Van Dyke Brown, Midnight Black and Sap Green. To indicate the

small evergreens at the base of the foothills, hold the brush vertically and just tap downward.

Use the 2" brush to pull the dark color down into the water for reflections and then gently brush across to give the reflections a watery appearance.

The large evergreen in the background is made by holding the fan brush vertically and touching the canvas to form the center line of the tree. Turn the brush horizontally and starting at the top, lightly touch the canvas to begin adding small branches. Working from side to side, as you move down the tree, use more pressure on the brush and automatically the branches will become larger as you near the base of the tree.

To make the little grassy areas that live along the edge of the water, use the fan brush with a Yellow-Green mixture. With this mixture still on the fan brush, lightly touch highlights to the right side of the large evergreen tree in the background.

Use a mixture of Titanium White and Dark Sienna on the knife to add the tree trunks and a small roll of Liquid White to cut in the water lines.

FOREGROUND

With Midnight Black and Prussian Blue on the 2" brush, darken the lower portion of the canvas, where the waterfall will be.

Add the large evergreen trees in the foreground with the Prussian Blue, Van Dyke Brown, Midnight Black and Sap Green mixture on the fan brush. Use Dark Sienna and Titanium White on the knife for tree trunks, then add all the Yellows to the dark fan brush to highlight the branches.

The large bushes are underpainted using the 2" brush and the same dark mixture of Midnight Black, Van Dyke Brown, Sap Green and Prussian Blue.

WATERFALL

Load your fan brush with a mixture of Liquid White and Titanium White. Holding the brush horizontally, make a short horizontal stroke and then pull straight down to create the falling water. The bubbling action at the base is made by touching the canvas, forcing the bristles to bend upward. Continue the water action with wandering horizontal strokes.

Highlight the small leaf trees and bushes on either side of the falls with various mixtures of Liquid White and all the Yellows, Sap Green and Bright Red on the 1" brush.

Load the knife with Van Dyke Brown and "build" rock and land masses on either side of the falls and along the water's edge. Highlight with Titanium White and Dark Sienna on the knife, using so little pressure that the paint "breaks."

FINISHING TOUCHES

Remove the adhesive-backed plastic from the canvas! You can extend the large evergreen tree beyond the border for an interesting effect. Don't forget to sign your painting!

Mountain River

1. Cover the canvas with Con-Tact Paper with a center design removed.

2. Use criss-cross strokes to paint the sky . . .

3. . . . and horizontal strokes for the water.

4. Paint the clouds with the fan brush.

5. Use the knife to shape the top of the mountain . . .

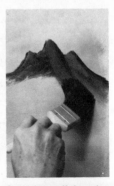

6. . . . then pull the paint down to the base.

Mountain River

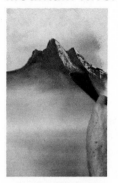 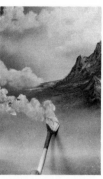 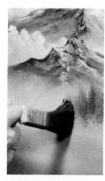 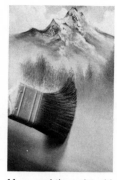 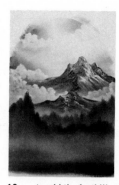 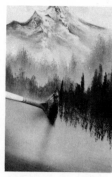

7. Highlight the mountain with the knife.

8. Use the fan brush to float clouds around the base of the mountain.

9. Add the second mountain range.

10. Tap down with the 1" brush . . .

11. . . . and then mist with the 2" brush . . .

12. . . . to add the foothills to the base of the mountains.

13. Use the fan brush to add the small evergreens . . .

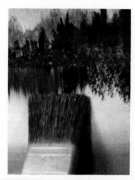 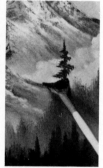 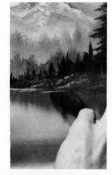 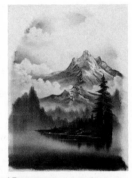

14. . . . then use the 2" brush to reflect them into the water.

15. More distinct evergreens are made with the fan brush.

16. Cut in water lines with the knife . . .

17. . . . to complete the background.

18. Use the fan brush for the large evergreens . . .

19. . . . and the 2" brush to underpaint the trees and bushes.

20. Downward strokes with the fan brush start the waterfall.

 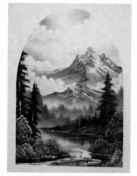 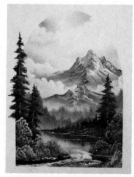

21. Highlight the trees and bushes with the 1" brush.

22. Use the knife to add the rocks and land areas . . .

23. . . . and then swirl water around the base of the rocks.

24. Remove the Con-Tact Paper . . .

25. . . . from the canvas.

26. Extend the evergreen to complete the painting.

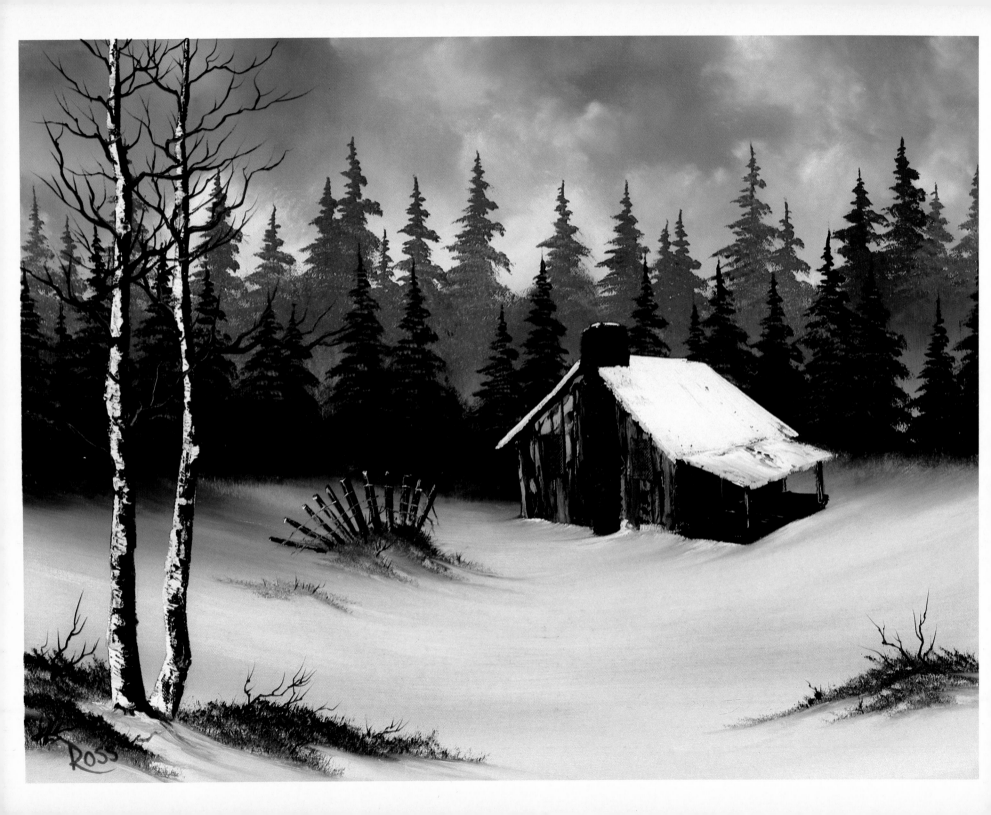

MATERIALS

2" Brush	Titanium White
#6 Fan Brush	Prussian Blue
#2 Script Liner Brush	Midnight Black
Large Knife	Dark Sienna
Small Knife	Van Dyke Brown
Liquid White	Alizarin Crimson
Liquid Clear	Bright Red

Start by covering the entire canvas with a thin, even coat of Liquid White using the 2" brush. Work back and forth with long horizontal and vertical strokes to ensure an even distribution of paint on the canvas. Do NOT allow the Liquid White to dry before you begin.

SKY

Load the 2" brush with a small amount of Alizarin Crimson by tapping firmly against the palette to distribute the paint evenly throughout the bristles. Use criss-cross strokes to create a Pink glow in the center of the sky, near the horizon. Use long horizontal strokes to add a little Pink to the ground area.

Without cleaning the brush, pick up some Prussian Blue and use small criss-cross strokes to "dance-in" the remainder of the sky, being very careful not to cover all the Pink glow. Leave small openings in the sky (where the clouds will be added) and then add a little of this Blue color to the ground area. With a clean, dry 2" brush, blend the entire sky area of your painting.

The clouds are made by loading a clean, dry 2" brush with Titanium White. "Twirl-in" the cloud shapes using circular strokes in the unpainted areas of the sky. Use just the top corner of a clean, dry 2" brush, and gently blend out the base of the cloud shapes. Lightly lift upward to blend and fluff. You can now blend the entire canvas with very gentle, long, horizontal strokes.

BACKGROUND

The evergreens in the background are made by loading the 2" brush with a mixture of Prussian Blue, Midnight Black, Van Dyke Brown, Alizarin Crimson and a little Titanium White. Hold the brush horizontally and just tap down to add the basic shape of the trees. The more distinct tree tops are made with the same mixture on the fan brush. Holding the brush vertically, touch the canvas to create the center of the tree. Turn the brush horizontally and use just one corner to add the branches. Use a clean, dry 2" brush to tap and diffuse the base of the trees, creating the illusion of mist.

Being very careful not to "kill" the misty area, add the closer row of evergreens using the 2" brush, and the same mixture without the addition of Titanium White. Again, use the fan brush to add the tree tops. With just the point of the knife, scratch in the tree trunks.

Use long horizontal strokes with Titanium White on the 2" brush to add the snow-covered ground area. Allow the brush to pick up some of the dark base color of the trees for a shadow effect; this is where you begin creating the lay-of-the-land. Try not to completely cover all of the Pink and Blue which you have already reflected into the snow-covered ground area.

CABIN

Use the knife to remove excess paint from the canvas to form the basic shape of the cabin. Load the long edge of the knife with a small roll of Titanium White by pulling the paint out flat on your palette and just cutting across. Add the snow-covered roof to the cabin shape, remembering that angles are very important. With a small roll of Van Dyke Brown, add the back edge of the roof and then use a mixture of Dark Sienna and Van Dyke Brown for the front and side of the cabin. With a mixture of Titanium White, Dark Sienna and Bright Red, highlight the front of the cabin; add Van Dyke Brown to the mixture to highlight the dark side of the cabin. The chimney is made with Van Dyke Brown using the small knife; highlights are Van

Dyke Brown and Bright Red. Use Titanium White to add snow to the top of the chimney and the back edge of the roof.

With Van Dyke Brown, add the porch roof and floor to the cabin. Highlights are a mixture of Dark Sienna and Van Dyke Brown. Add the porch railings and then just use the point of the knife to cut-in the indication of boards. Use the small edge of the small knife to scrape in the windows.

FOREGROUND

Add snow to the base of the cabin by dipping the fan brush into Liquid Clear and then pulling it through Titanium White to load. Hold the brush horizontally and just graze the canvas to begin forming the lay-of-the-land. Allow some of the dark cabin color to mix with the paint, creating a shadow effect.

You can make little grassy areas by using mixtures of Prussian Blue, Van Dyke Brown and Dark Sienna on the fan brush. Hold the brush horizontally and force the bristles to bend upward as you push it into the canvas. Use the fan brush to blend out the base of these grassy areas and create the contours in the snow.

Load the long edge of the knife with a small roll of Van Dyke Brown to add the fence. Cut-in the wire on the fence with

Titanium White on the heel of the knife. Again, pull out the base of the fence with the fan brush to blend and create shadows.

TREES

The large trees in the foreground are made with Van Dyke Brown and the fan brush. Hold the brush vertically. Starting at the top of each tree, pull down. By using more pressure as you near the base, automatically your tree will become wider. Use Titanium White on the long edge of the knife for the highlights on the right sides of the trees. Hold the knife vertically, touch the edge of the tree and just give a little sideways pull.

Add the limbs and branches with thinned Van Dyke Brown on the liner brush. Dip the brush into thinner and turn the handle as you pull the bristles through the paint bringing them to a sharp point.

FINISHING TOUCHES

You can add small sticks and twigs with thinned Van Dyke Brown and Dark Sienna using the liner brush. Using the same brush and thinned paint, sign your painting. Stand back and admire your masterpiece.

Country Cabin

1. Criss-cross strokes are used to paint the sky.

2. The 2" brush is used to paint and blend the clouds.

3. Tap downward with the 2" brush . . .

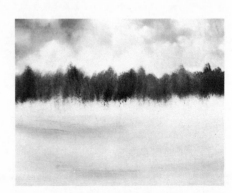

4. . . . to paint the base shapes for distant evergreen trees.

Country Cabin

5. The fan brush is used to paint the individual tree tops.

6. Tap the base of the trees with the 2" brush to create mist.

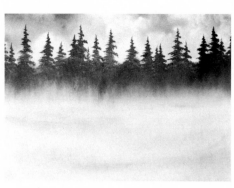

7. Use the mist at the base of the trees to separate the layers of trees.

8. With the 2" brush . . .

9. . . . paint in the snow. Pay particular attention to the lay-of-the-land.

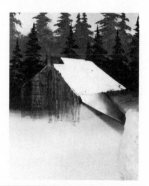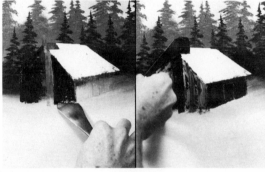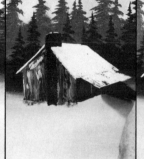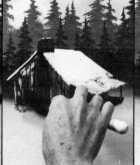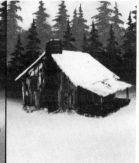

10. Progressional steps used to paint the cabin.

11. Use the knife, loaded with a roll of paint, to make the fence.

12. Push upward with the fan brush . . .

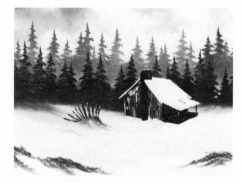

13. . . . to paint the grassy areas in the foreground.

14. Pull downward with the fan brush to paint the initial tree shapes . . .

15. . . . then highlight with the knife.

16. The script liner brush is used to paint individual tree limbs and branches.

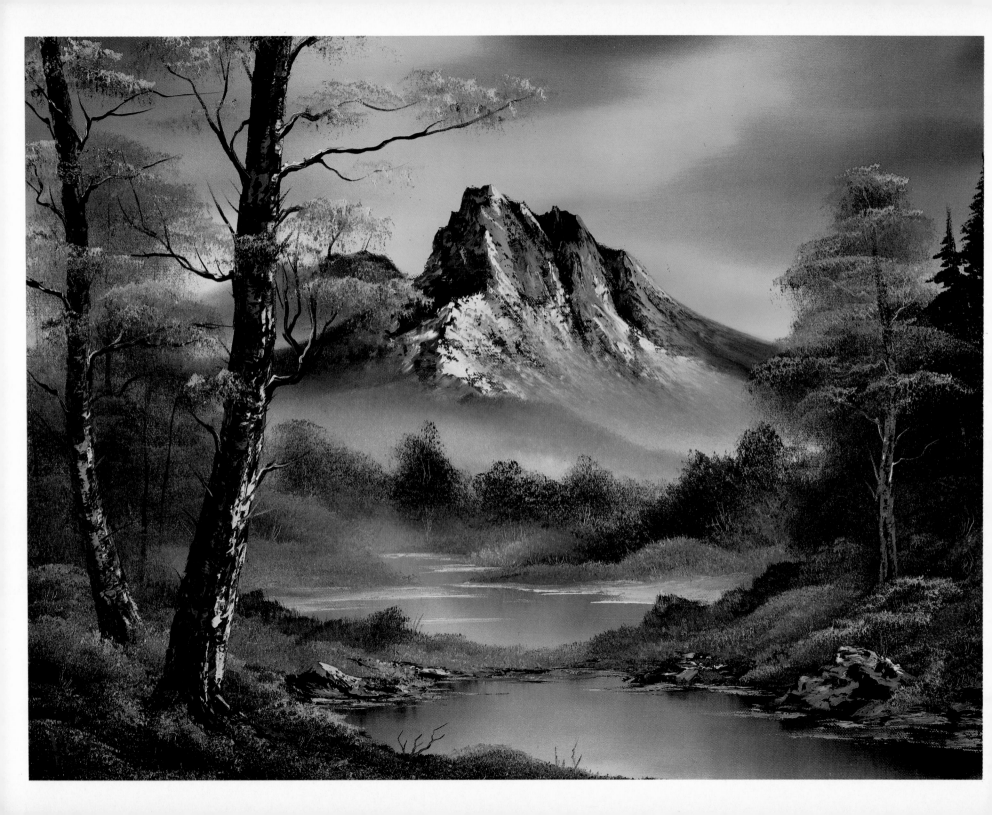

MATERIALS

2″ Brush	Prussian Blue
1″ Brush	Midnight Black
1″ Round Brush	Dark Sienna
#6 Fan Brush	Van Dyke Brown
#2 Script Liner Brush	Alizarin Crimson
Large Knife	Sap Green
Small Knife	Cadmium Yellow
Liquid White	Yellow Ochre
Liquid Black	Indian Yellow
Titanium White	Bright Red

Start by covering the entire canvas with a thin, even coat of Liquid White, using the 2″ brush. Use long horizontal and vertical strokes, working back and forth to ensure an even distribution of paint on the canvas. Do not allow the Liquid White to dry before you begin.

SKY

Load the 2″ brush with Indian Yellow and Bright Red. Using horizontal strokes, add a little of this color into the sky area of the painting—also brush some color into the center of the water area. Without cleaning the brush, pick up a mixture of Alizarin Crimson and Prussian Blue and add to the sky, still using horizontal strokes. Again not cleaning the brush, pick up some Midnight Black and Blue and fill in the sky area continuing to use horizontal strokes. Blend the entire sky with a clean, dry 2″ brush.

MOUNTAINS

The small, distant mountain is made with a mixture of Prussian Blue and Midnight Black. Load the long edge of the knife with a small roll of paint. Using very firm pressure, lay in a small mountain shape. Use the knife to remove any excess paint and then pull down and blend the entire mountain with a clean, dry 2″ brush.

With a mixture of Midnight Black, Prussian Blue, Alizarin Crimson and Van Dyke Brown, again with a small roll of paint on the long edge of the knife, begin forming the large mountain shape. Use very firm pressure, really pushing the paint into the canvas. Use the knife to remove any excess paint, then with the 2″ brush, pull down the color and blend out the bottom of the mountain.

The shadows on this mountain are made with a mixture of Titanium White, Prussian Blue, and Alizarin Crimson. Load the long edge of the small knife with a small roll of paint and begin laying the shadow color on the left side of your mountain peaks. Use very little pressure—allow the paint to "break."

With a mixture of Bright Red, Prussian Blue, Alizarin Crimson, Yellow Ochre, Dark Sienna and Titanium White, gently lay color on the right side of the peaks; again, so little pressure that the paint "breaks." Use the 2″ brush to tap out the base of the mountain, carefully following the angles. Finally, load the long edge of the knife with a small roll of Titanium White and very lightly apply highlights to the right sides of the peaks—where the sun would strike. With the large brush, again tap out the base and gently pull upward.

WATER

Load the 2″ brush with Prussian Blue, firmly tapping the brush against the palette to ensure an even distribution of paint throughout the bristles. The water is made by holding the brush flat and pulling the color from the outside in on the lower half of the canvas. Leave an area in the center of the canvas unpainted. This will later be a sheen across the water. Blend the entire water area with a clean, dry 2″ brush.

BACKGROUND

"Drop" in some little background tree indications by loading the round brush with the Lavender mixture and just tapping in basic tree shapes at the base of the mountain. Allow some of this dark color to extend into the water area for reflections. Highlight these trees using the same round brush and various mixtures of Yellows and Sap Green. These colors too, should extend into the water. With a clean,

dry 2″ brush, gently pull down the reflections and brush across—giving the appearance of water. With a mixture of Liquid White and Prussian Blue on the long edge of the knife, "cut" in water lines at the base of the trees.

Load the round brush with a mixture of Van Dyke Brown, Sap Green and Dark Sienna, moving forward in your painting, tap in some larger tree and bush shapes along either side of the water. Begin painting these trees at the base, allowing the color to get lighter as you near the top of the trees. Extend this dark color into the water.

For tree trunks, load the fan brush with Van Dyke Brown. Holding the brush vertically, touch the canvas and just pull down. Highlight the tree trunks by loading the long edge of the knife with a mixture of Bright Red, Van Dyke Brown and Titanium White. Hold the knife vertically and just touch this color to the right side of the trunks. Use the liner brush with thinned Liquid Black to make limbs and branches. Highlight with a little Liquid White. Highlight the trees with the round brush using a mixture of Yellows and Bright Red. Load the brush and just touch the canvas forming leaf shapes. To highlight small trees and bushes, use the 1″ brush and various mixtures of Sap Green, the Yellows and Bright Red. Pull the brush through the paint in one direction to round one corner. With the rounded corner up, touch the canvas forcing the bristles to bend upward. Use this stroke to form tree and bush shapes. The evergreen trees are made by loading the fan brush with Sap Green, Van Dyke Brown and Midnight Black. Hold the brush vertically and just touch the canvas to create a center line. Turn the brush horizontally and begin making branches using just one corner. As you near the bottom of the tree, use more of the brush and more pressure causing the lower branches to get larger. Highlight these trees with the fan brush using Yellow and Sap Green.

FOREGROUND

The stones along the water's edge are made by loading the knife with Van Dyke Brown and just touching the shapes to the canvas. Highlights are a mixture of Bright Red, Titanium White and Van Dyke Brown, applied so slightly that the paint "breaks." Cut in water lines with a little Liquid White on the long edge of the knife.

The large tree trunks are made with Van Dyke Brown on the fan brush. Starting at the top of the canvas, pull in the trunks allowing them to get wider as you near the base of the tree. Highlights are applied by loading the long edge of the knife with a small roll of Titanium White, Bright Red and Van Dyke Brown mixture. Holding the knife vertically, gently touch the right side of the tree trunk and give a little pull.

Prussian Blue can be applied to the left side of the trunk using the same method. Limbs and branches are made using the liner brush with Liquid Black. Highlights are Liquid White.

For the leaves, load the 2″ brush with various mixtures of Sap Green, Yellow and Bright Red and just tap in leaf shapes.

FINISHING TOUCHES

Sticks and twigs can be scratched in with the point of the knife. Your painting is ready for a signature.

Mountain Splendor

1. With horizontal strokes of the 2" brush, lay in the basic sky.

2. Lay in the initial mountain shape with a firm pressure.

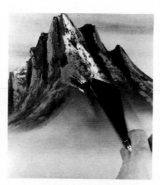

3. Highlights are applied using almost no pressure on the knife.

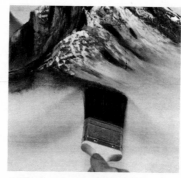

4. With the 2" brush, tap in foothills at the base of the mountain.

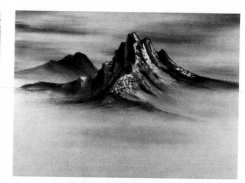

5. Angles are most important when painting mountains.

6. The round brush is used . . .

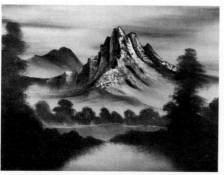

7. . . . to tap in the base shapes for trees and bushes.

8. Pull downward, then across, to create foreground reflections.

9. Pull downward with the fan brush to make tree trunks . . .

10. . . . with Liquid Black on liner brush, add branches . . .

11. . . . then add indication of leaves with round brush.

12. Tap downward with corner of fan brush . . .

13. . . . to paint the evergreens.

14. The knife is used to make . . .

15. . . . and highlight land areas, rocks and stones.

16. Liquid White, on the long edge of the knife, is used to "cut-in" water lines.

17. Tap with corner of 2" brush for indication of leaves on trees.

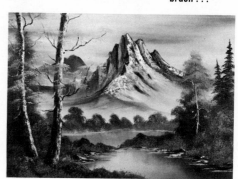

18. Complete the fine detail, sign and admire.

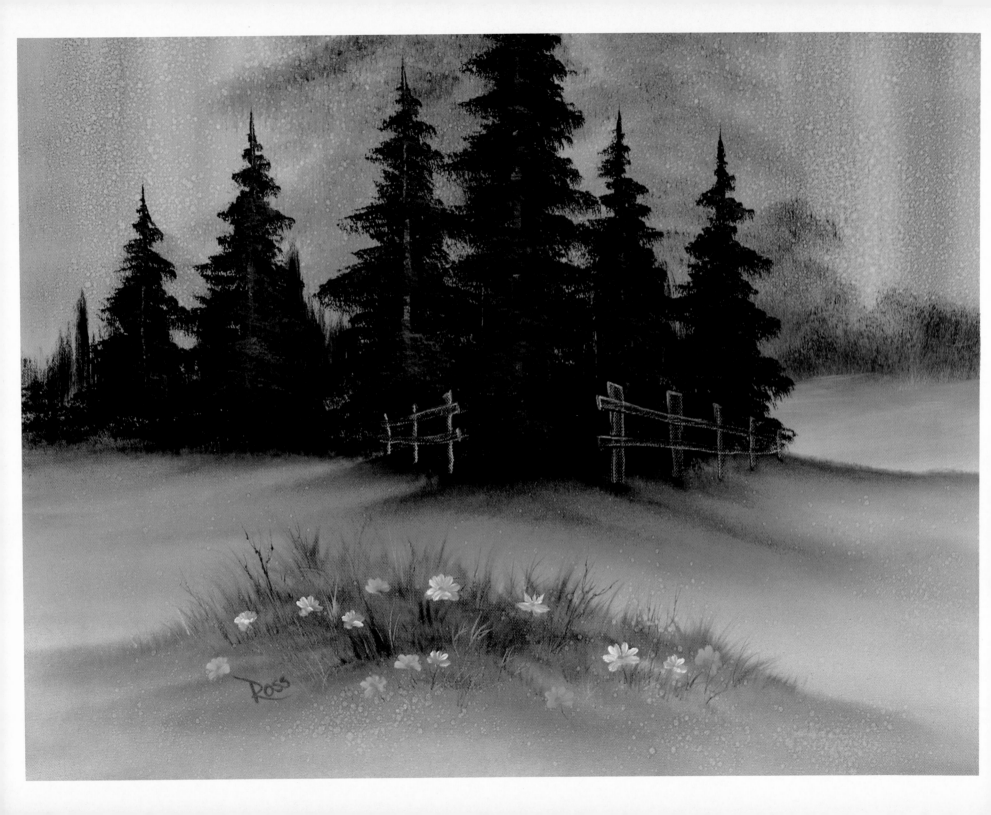

MATERIALS

2" Brush
#6 Fan Brush
#6 Filbert Brush
#2 Script Liner Brush
Small Knife
Liquid Clear
Titanium White
Phthalo Blue

Midnight Black
Dark Sienna
Van Dyke Brown
Alizarin Crimson
Sap Green
Cadmium Yellow
Yellow Ochre

Start by covering the entire canvas with a VERY THIN, even coat of Liquid Clear using the 2" brush. Work back and forth with long horizontal and vertical strokes to ensure an even distribution of paint on the canvas. Do NOT allow the Liquid Clear to dry before you begin.

SKY

Using very little paint on the 2" brush, make vertical streaks of color in the sky starting with Dark Sienna. Without cleaning the brush, add Alizarin Crimson, Van Dyke Brown and finally Phthalo Blue. Blend lightly.

BACKGROUND

Tap downward to just indicate the distant tree shapes using a mixture of Dark Sienna and Alizarin Crimson on the 2" brush. Lightly lift upward to blend.

Dip the fan brush into paint thinner and then lightly rub the bristles against the knife blade, spraying the canvas with tiny droplets of the thinner. The thinner will react with the Liquid Clear and create the impression of tiny, distant leaf shapes.

With the 1" round brush and Dark Sienna, add the small bushes at the base of the distant tree shapes. Using the same brush, pull a little of this color onto the ground area to begin creating the lay-of-the-land. Use thinned paint on the liner brush to add small branches, sticks and twigs to the bushes in the background.

LARGE EVERGREENS

With the knife, make a dark mixture on your palette of Phthalo Blue, Midnight Black, Van Dyke Brown, Sap Green and Alizarin Crimson. Pull both sides of the 2" brush through the mixture, "wiggling" the bristles to bring them to a chiseled edge. Holding the brush vertically, touch the canvas to create the center of the tree. Turn the brush horizontally and use just one corner to begin forming the branches. As you work down the tree, use more pressure on the brush allowing the branches to become larger as you near the base.

You can also indicate tree shapes by holding the brush vertically and tapping downward.

The evergreen trunks are made by loading the long edge of the knife with a mixture of Titanium White and Dark Sienna. With a small roll of paint, just touch the trunk indications to the canvas.

Highlight the evergreens by adding Cadmium Yellow to the same dark 2" brush. Bring the bristles to a chiseled edge and lightly apply the highlights using just one corner of the brush.

Use Dark Sienna on the 2" brush to scrub in the ground color under the large trees. Paying close attention to the lay-of-the-land, pull down a little of the dark color from the base of the trees to create a shadowy effect.

The fence is made by just scraping away the paint, using the small edge of the small knife. Watch your perspective! Highlight the fence with a thinned mixture of Titanium White and Dark Sienna on the liner brush. Use the 2" brush to tap and blend the base of the fence.

FOREGROUND

Load the fan brush with various mixtures of Liquid Clear, Van Dyke Brown, Dark Sienna and Yellow Ochre. "Punch-in" the grassy area in the foreground by pushing the bristles of the brush straight into the canvas, forcing them to bend upward. Use just the corner of the fan brush to pull up the long grasses.

The daisies are made with the filbert brush. Load the brush with various mixtures of Liquid Clear, Titanium White and Phthalo Blue to paint the tiny petals. Use Liquid Clear and Yellow Ochre to touch the centers of the daisies.

FINISHING TOUCHES

With the liner brush and various mixtures of Liquid Clear, Dark Sienna and Van Dyke Brown, add long stems and grasses to the daisy patch. Don't forget to sign your painting!

Daisy Delight

1. Use vertical strokes, with the 2" brush . . .

2. . . . loaded with a small amount of transparent paint, to make the background.

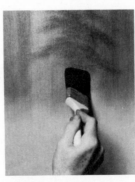

3. Use the 2" brush . . .

4. . . . to tap in basic background tree shapes.

5. The fan brush and knife . . .

6. . . . are used to "flick" paint thinner onto the background. Very little thinner is required.

7. Tap downward with the round brush . . .

8. . . . to paint the indication of distant trees and bushes.

Daisy Delight

9. Large evergreens are painted by tapping downward with the 2" brush.

10. The indication of distant trees are made by pulling downward with a large brush.

11. With the edge of the knife . . .

12. . . . paint tree trunks in the large evergreen trees. Highlights are then applied to the trees using a 2" brush.

13. Using a tapping stroke . . .

14. . . . pick up a touch of the tree color and work it outward to create the lay-of-the-land.

15. Scrape firmly with the small edge of the knife to make the fence.

16. Use the script liner brush . . .

17. . . . to add detail to the fence.

18. Push upward with the fan brush to paint the grassy area in the foreground.

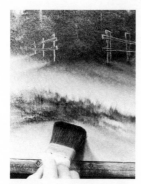

19. With a 2" brush, tap the edge of the color to blend the grassy areas into the picture.

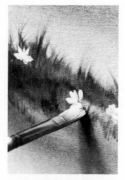

20. Individual daisies are painted with the filbert brush.

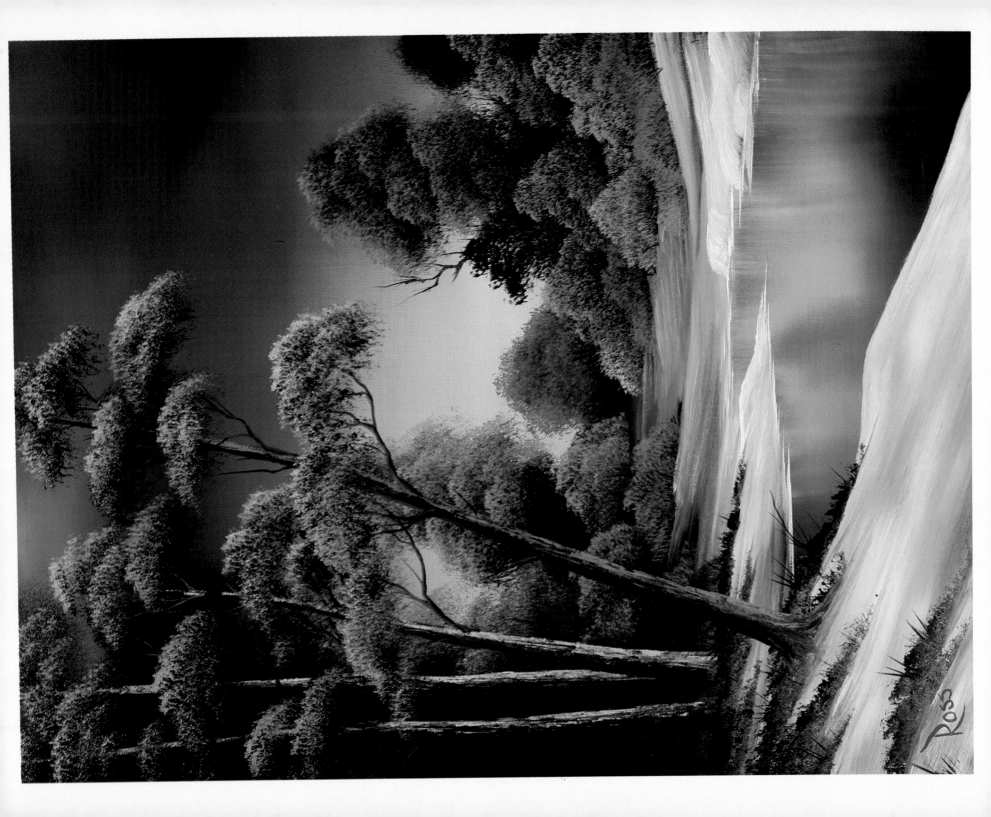

MATERIALS

2″ Brush	Phthalo Blue
1″ Brush	Dark Sienna
#6 Fan Brush	Van Dyke Brown
#2 Script Liner Brush	Alizarin Crimson
Large Knife	Cadmium Yellow
Liquid White	Yellow Ochre
Black Gesso	Indian Yellow
Titanium White	Bright Red

Start with a canvas that has been covered with a thin, even coat of Black Gesso and allowed to dry completely.

In the center of the vertical, dry Black canvas, use the 2″ brush to apply a large area of Indian Yellow. Above the Indian Yellow, add some Alizarin Crimson and across the top of the canvas, Phthalo Blue. Below the Indian Yellow, cover the canvas with a thin, even coat of Van Dyke Brown. Do not allow these colors to dry before you begin.

SKY

Load a clean, dry 2″ brush with Titanium White. Starting just above the horizon and working up towards the top of the canvas, begin making criss-cross strokes in the sky. Notice how the White paint works with the under colors; your sky should be Yellow at the horizon, then Pink and finally Blue at the top. If your sky is not light enough you can add more Titanium White, but be sure your brush is clean and dry. Now, softly blend the entire sky with a clean, dry 2″ brush.

BACKGROUND

Load the round brush by tapping it into a mixture of Van Dyke Brown and Dark Sienna. Underpaint the small trees and bushes along the horizon by just tapping in the basic shapes.

Dip the liner brush into paint thinner and turn the handle as you pull the brush through Van Dyke Brown, forcing the bristles to come to a sharp point. Use the loaded brush to just indicate the distant tree trunks.

Highlight the trees with various mixtures of all the Yellows and Bright Red on the round brush. Use the top corner of the brush to just touch the highlights to the basic shapes. This is where you begin forming individual trees and bushes, try not to just hit at random. Work in layers and be careful not to "kill" all the dark base color.

Begin adding the snow-covered ground area under the distant trees with Titanium White on the fan brush. Use horizontal, sweeping strokes, paying close attention to the lay-of-the-land, allowing the White to pick up the wet color already on the canvas.

WATER

Add the water with Titanium White on the 2″ brush. Hold the brush flat against the canvas and pull straight down to create the reflections. (Notice how the White paint mixes with the color already on the canvas.) Gently brush across to give your reflections a watery appearance.

Continue adding snow around the edges of the water using Titanium White on the fan brush. "Cut-in" the water lines using a small roll of Liquid White on the long edge of the knife. As you extend the snow-covered ground area to the bottom of the canvas, you can emphasize the shadow areas by adding a little Phthalo Blue or Alizarin Crimson.

LARGE TREES

With Van Dyke Brown and Dark Sienna on the round brush, underpaint the cluster of large trees using a tapping motion. The tree trunks are Van Dyke Brown and Dark Sienna on the fan brush. Hold the brush vertically and, starting at the top of the canvas, pull down. Allow the trunks to become wider near the base by applying more pressure on the brush. Load the long edge of the knife with a mixture of Titanium White, Dark Sienna and Bright Red. Hold the knife vertically and just touch highlights to the right sides of the trunks.

Use thinned Van Dyke Brown on the liner brush to add the limbs and branches. Underpaint the leaf clusters on the

trees with Van Dyke Brown on the round brush by just tapping. With a clean round brush, gently highlight the leaves still using the mixtures of Yellows and Bright Red.

Use Titanium White on the fan brush to add snow to the base of the trees. With Van Dyke Brown and Dark Sienna on the fan brush, you can add small grassy areas in the snow. Holding the brush horizontally, push it straight into the canvas and force the bristles to bend upward. Pull a little of this color into the snow to create shadow areas.

FINISHING TOUCHES

Use thinned Van Dyke Brown on the liner brush to add long grasses, small sticks and twigs. Add a signature and you will have had THE JOY OF PAINTING!

Golden Sunset

1. Use criss-cross strokes . . .

2. . . . to paint the sky.

3. Initial tree shapes are tapped in with the round brush.

4. A thin paint on the liner brush . . .

5. . . . is used to paint the tree trunks in the background.

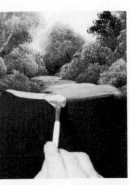

6. Snow is painted with the fan brush. Angles are very important.

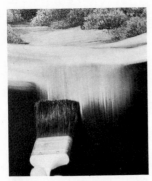

7. Pull straight down, then across, to make reflections.

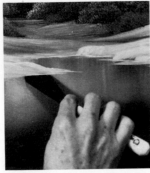

8. Use the edge of the knife, loaded with Liquid White, to "cut-in" water lines.

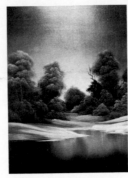

9. Work in layers . . .

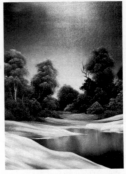

10. . . . completing the most distant areas first.

11. Tree trunks are made by pulling downward with the fan brush . . .

12. . . . then highlighting with the edge of the knife.

Golden Sunset

13. Tree limbs are painted with the liner brush loaded with a thin paint.

14. The round brush is used . . .

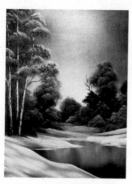

15. . . . to tap leaves on the trees. Pay close attention to individual shapes.

16. Push upward with the fan brush . . .

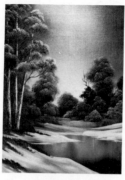

17. . . . to paint grassy areas on the snow.

18. Pull downward with the fan brush to paint tree trunks, . . .

19. . . . highlight with the edge of the knife . . .

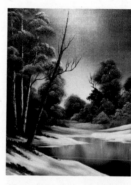

20. . . . then add branches with the liner brush and a thin paint.

21. Add leaves to the branches by tapping with the top corner of the round brush.

22. Sticks and twigs are painted with the liner brush.

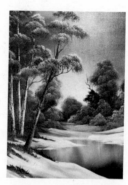

23. Your painting should now be finished. View this painting under several different light sources.

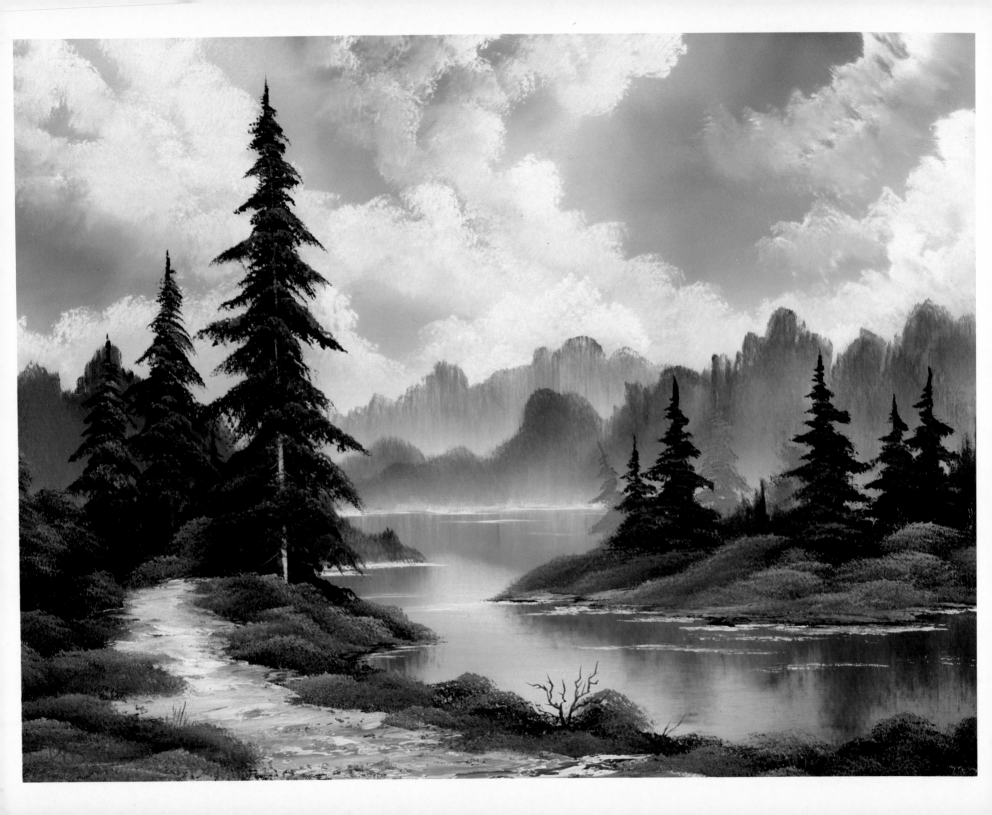

MATERIALS

2" Brush
1" Brush
1" Oval Brush
#6 Fan Brush
#2 Script Liner Brush
Large Knife
Liquid White
Titanium White
Phthalo Green
Phthalo Blue

Prussian Blue
Midnight Black
Dark Sienna
Van Dyke Brown
Alizarin Crimson
Sap Green
Cadmium Yellow
Yellow Ochre
Indian Yellow
Bright Red

Start by covering the entire canvas with a thin, even coat of Liquid White using the 2" brush. With long, horizontal and vertical strokes, work back and forth to ensure an even distribution of paint on the canvas. Do NOT allow the Liquid White to dry before you begin.

SKY

Load the 2" brush by tapping the bristles into a mixture of Phthalo Blue with a very small amount of Phthalo Green. Use criss-cross strokes to add the color randomly throughout the sky.

Use horizontal strokes with the same brush and mixture to underpaint the water on the lower portion of the canvas. Starting from the outside edges of the canvas and pulling in, leave the center area of the water unpainted to create the illusion of shimmering light. Very lightly blend the entire canvas with a clean, dry 2" brush.

Use Titanium White on the 2" brush and tiny circular strokes to form the cloud shapes. Lightly blend the bottoms of the clouds, again using circular strokes, with just one corner of a clean, dry 2" brush. Use gentle, sweeping upward strokes to "fluff."

FOOTHILLS

Load the oval brush with a very light mixture of Phthalo Blue, Titanium White, Midnight Black, Phthalo Green and Alizarin Crimson. Touch the brush to the canvas and pull down to shape the first range of foothills. With a clean, dry 2" brush, tap the base of the hills to create the illusion of mist.

Use the same mixture with less Titanium White for the second range of darker hills. This time, hold the oval brush vertically and pull down. Again, mist by tapping to diffuse with the 2" brush. Highlight the second range by adding the Yellows to the oval brush and using tiny downward pulls. Tap to soften the base of the hills with a clean, dry 2" brush.

Use the oval brush to reflect the foothill color into the water for reflections. With a clean, dry 2" brush, pull the color down and lightly brush across. Load the long edge of the knife with a small roll of Titanium White. Touch the White paint to the water's edge (at the base of the hills) and slightly push up with the knife.

The third range of hills (on the left side of the painting) is even darker. Again, highlight the hills with the oval brush and mist the base with the 2" brush. Reflect the color of the hills into the water and then use the 2" brush to pull down and lightly brush across. Use tiny push-up strokes along the water's edge using a small roll of Titanium White on the long edge of the knife.

MIDDLEGROUND

Some of the small trees and bushes are made using a mixture of Yellow Ochre and Dark Sienna; the dark trees are a mixture of Prussian Blue, Midnight Black, Van Dyke Brown, Alizarin Crimson and Sap Green. To make the small evergreens on the right side of the painting, load the fan brush full of paint and then holding the brush vertically, touch the canvas to form the center line of the tree. Turn the brush horizontally and with one corner of the brush, lightly touch the canvas to begin adding the top branches. Working from side to side, as you move down the tree, use more pressure on the brush (forcing the bristles to bend downward) and automatically the branches will become larger as you near the base of each tree. Use just one corner to add the

small bushes at the base of the trees.

Reverse the brush to reflect the small evergreens into the water, pull down again with a clean, dry 2″ brush and lightly brush across to give the reflections a watery appearance. Use a bit of Cadmium Yellow on the fan brush to add a few highlights to the evergreen branches.

Use the dark tree-mixture on the 2″ brush to underpaint the ground area at the base of the trees. Hold the brush horizontally and tap downward; pull the color straight down for the reflections and then lightly brush across. Highlight the grassy area by tapping downward with the 1″ brush using Liquid White and various mixtures of all the Yellows and Bright Red.

Rub-in the banks along the water's edge with Van Dyke Brown on the long edge of the knife. Use a small roll of Titanium White on the knife to add the water lines and ripples.

FOREGROUND

The large evergreens are made by loading the oval brush with the same dark mixture of Prussian Blue, Midnight Black, Van Dyke Brown, Alizarin Crimson and Sap Green.

Hold the brush vertically and touch the canvas to form the center line of the tree. Turn the brush horizontally and starting at the top of the tree, lightly touch the canvas to begin adding the top branches. Working from side to side, as you move down the tree, use more pressure on the brush (forcing the bristles to bend downward) and automatically the branches will become larger as you near the base of each tree.

Use the dark base color on the oval brush to add the small trees and bushes at the base of the large evergreens. Load the 2″ brush with the same dark mixture to underpaint the entire foreground, leaving the path area unpainted.

The large tree trunks are made with a mixture of Dark Sienna and Titanium White using the knife. Add Cadmium Yellow to the dark mixture already on the oval brush and lightly touch highlights to the branches of the evergreens. Use various mixtures of all the Yellows, Sap Green and Bright Red on the 1″ brush to form the trees and bushes in the foreground, along the edges of the path. Working in layers, just tap downward to create the individual shapes, being very careful not to "kill" all of the dark undercolor.

The path is made with a small roll of Titanium White on the long edge of the knife. Make short, horizontal strokes using so little pressure that the paint "breaks." Pay close attention to your perspective, the path should get wider as it nears the foreground. Use a very small amount of Dark Sienna on the knife for the shadow areas and then use the Yellow highlight mixtures on the 1″ brush to paint additional bushes along the edges of the path.

FINISHING TOUCHES

Use a mixture of paint thinner and Van Dyke Brown on the liner brush to add sticks, twigs and other small details. Also use a very thin paint to add your signature.

Peaceful Haven

1. With the 2″ brush, use criss-cross strokes to paint the sky . . .

2. . . . and long, horizontal strokes to paint the water.

3. The clouds are made and blended with the 2″ brush.

4. Pull down with the oval brush to paint the first range of foothills . . .

5. . . . and then tap to mist with the 2″ brush.

Peaceful Haven

6. Hold the oval brush vertically to add more hills.

7. Pull down reflections with the 2" brush.

8. Use the knife . . .

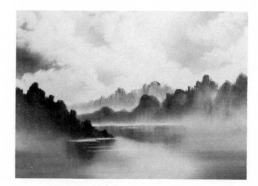

9. . . . to add the water lines and ripples.

10. Paint the evergreens with the fan brush.

11. Use the 2" brush to underpaint the grassy areas . . .

12. . . . and pull down reflections.

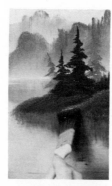

13. Highlight the grassy areas with the 1" brush.

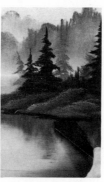

14. Use the knife to add the banks . . .

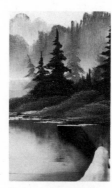

15. . . . and water lines.

16. Large evergreens are made with the oval brush.

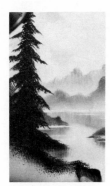

17. Tap down with the 2" brush to underpaint the foreground.

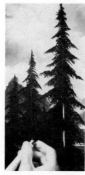

18. Add the tree trunks with the knife . . .

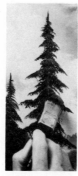

19. . . . and highlights with the oval brush.

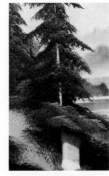

20. Highlight small bushes with the 1" brush.

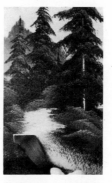

21. Add the path with the knife . . .

22. . . . and small details with the liner brush.

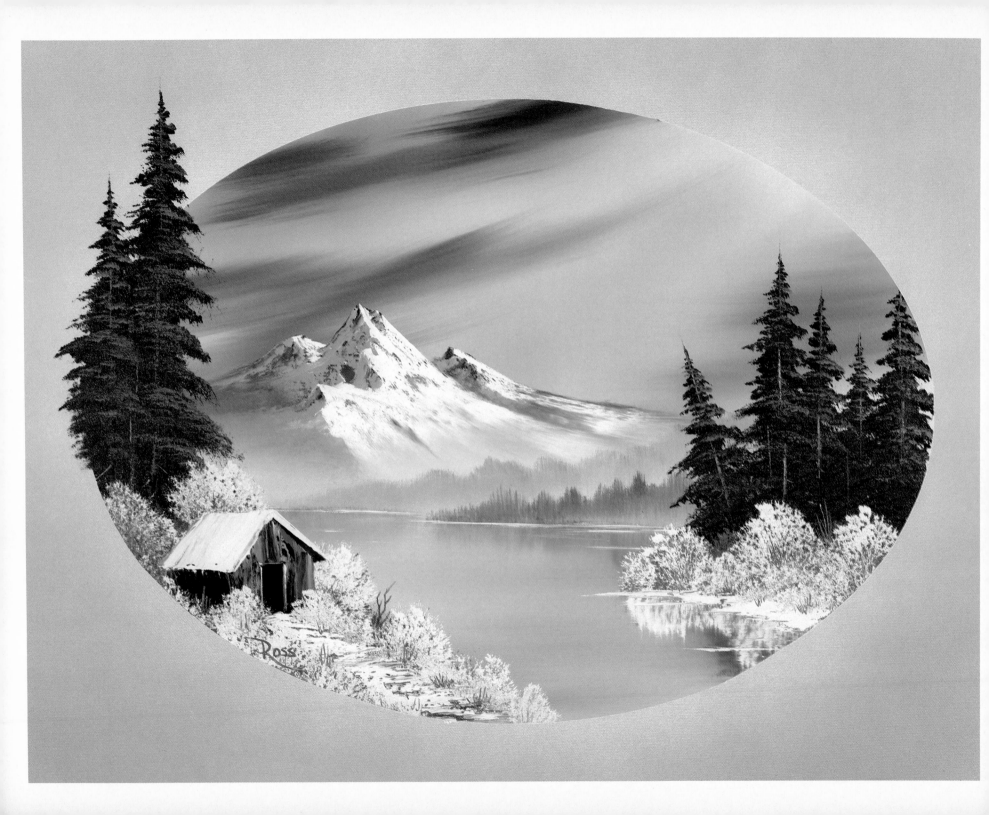

MATERIALS

2" Brush	Titanium White
1" Brush	Phthalo Blue
#6 Fan Brush	Midnight Black
#2 Script Liner Brush	Dark Sienna
Large Knife	Van Dyke Brown
Adhesive-Backed Plastic	Alizarin Crimson
Flat Blue Acrylic Paint	Bright Red
Liquid White	

Cover the entire canvas with a thin, even coat of Blue acrylic paint (available in Paint or Hardware Stores) and allow to dry. Cover the dry canvas with adhesive-backed plastic (I use Con-Tact paper) from which a large oval has been removed from the center.

Cover the entire exposed area of the canvas with a thin, even coat of Liquid White using the 2" brush. Use long horizontal and vertical strokes, working back and forth to ensure an even distribution of paint on the canvas. Do not allow the Liquid White to dry before you begin. Now, clean and dry your 2" brush.

SKY

Load the 2" brush with a small amount of Alizarin Crimson. Make a diagonal Pink area across the sky using criss-cross strokes. Without cleaning the brush, add a little Phthalo Blue to some Alizarin Crimson on your palette and use this Lavender mixture to cover the remainder of the sky, again using criss-cross strokes. Still not cleaning the brush, use Alizarin Crimson and horizontal strokes to add the water to the lower half of the painting. With a clean, dry 2" brush, blend the entire sky and water areas.

Using the same brush and Midnight Black, form diagonal clouds across the sky with small sweeping strokes. Add a small amount of Black to the sides of the water area. Blend the entire sky and water.

MOUNTAIN

The mountain color is Midnight Black, Phthalo Blue and Alizarin Crimson. Use the knife and very firm pressure to shape just the very top edge of your mountain. With a clean, dry 2" brush, pull the color down to the base of the mountain to shape and diffuse.

The snow is a mixture of Titanium White with just a touch of Bright Red. Just touch the top of each peak and, as the knife "slides" down the side, use so little pressure that the paint "breaks." The shadow sides of the peaks are made the same way, using a mixture of Titanium White with a touch of Phthalo Blue and Midnight Black, pulling the paint in the opposite direction. With a clean, dry 2" brush held vertically, tap the base of the mountain, following the angles, and then gently lift upward to create the illusion of mist.

BACKGROUND

Add some Titanium White to the mountain mixture and shape the foothills using just the corner of the 2" brush and short downward strokes. Tap the base of the hills to mist. Add another layer of darker hills using the same mountain mixture but this time with less Titanium White. Allow a little of this color to extend into the water. With a clean, dry 2" brush, pull the color downward and then brush across to create the reflections. Load the long edge of the knife with a very small roll of Liquid White, then go straight into the canvas to "cut-in" the water lines.

FOREGROUND

The large evergreen trees on the right side of the canvas are made with the fan brush and a mixture of Midnight Black, Van Dyke Brown, Phthalo Blue and Alizarin Crimson. Load the brush full of paint then, holding it vertically, just touch the canvas to form the center of the tree. Turn the brush horizontally and use just one corner to add the small top branches. As you move down the tree, working from side to side, begin using more pressure. Forcing the bristles to bend downward, allow the branches to become larger as you near the base of the tree. Trunk indications are Dark Sienna and

Titanium White on the long edge of the knife and just touched to the canvas.

Highlight the evergreens with a mixture of Liquid White and Phthalo Blue.

The small bushes under the trees are made with a mixture of Phthalo Blue, Midnight Black and a little Titanium White. Pull the 1" brush through the paint in one direction to round one corner. With the rounded corner up, touch the canvas and force the bristles to bend upward to form the small trees and bushes. Extend this dark base color into the water, pulling down and then lightly brushing across with the 2" brush to create the reflections.

Highlight the bushes by dipping the 1" brush into Liquid White and pulling it in one direction through a mixture of Titanium White with a touch of Bright Red. With the rounded corner up, very gently touch the canvas forcing the bristles to bend upward as you form individual bush shapes. Reverse the brush to add highlights to the reflections. With a clean, dry 2" brush, very gently (three hairs and some air) pull down the reflections and brush across to give them a watery appearance.

Paying close attention to angles, add a snow bank under the bushes and trees with Titanium White on the long edge of the knife. Use Liquid White on the knife to cut-in water lines and the point of the knife to scratch in small sticks and twigs.

Working in layers, complete the right side of the canvas before moving forward to the left side.

CABIN

Use a clean knife to remove the paint from the basic shape of the cabin. With Van Dyke Brown on the long edge of the knife, lay in the back edge of the roof then use a mixture of Van Dyke Brown and Dark Sienna for the front and side of the building. Highlight the front of the cabin with a mixture of Dark Sienna and Titanium White using so little pressure that the paint is allowed to "break." Use Van Dyke Brown for the door and the point of the knife to scratch in the planks. Lay in the snow-covered roof with Titanium White and then just touch a little "snow" to the back edge of the roof.

The path is Titanium White on the long edge of the knife and applied with horizontal strokes. Add a few more snow covered bushes to the cabin and the path.

At this point remove the Con-Tact Paper from the painting.

Extend the large evergreens on the left out of the oval and onto the unpainted area of the canvas, using the same dark tree mixture on the fan brush. Again, use a mixture of Dark Sienna and Titanium White for the trunks and highlight with a mixture of Liquid White and Phthalo Blue on the fan brush.

FINISHING TOUCHES

Add additional sticks and twigs and dead branches to the evergreens with the point of the knife. Sign your painting with a paint that has been thinned with paint thinner, using the liner brush. This painting should excite your imagination; try it again using other colors to base-coat the canvas and cutting different shapes from the Con-Tact paper.

Winter Oval

1. Cover the canvas with an oval made from Con-Tact paper.

2. Use criss-cross strokes to paint the sky.

3. Basic cloud shapes are made and blended wtih the 2" brush.

4. Initial mountain shapes are made with the knife . . .

5. . . . then blended downward with the 2" brush.

6. The knife is used to paint highlights and shadows.

Winter Oval

7. Foothills are made by pulling downward with the corner of the 2" brush.

8. Tap downward with the top corner of the 2" brush to create mist.

9. Pull downward, then across, to create reflections.

10. Use the knife to "cut-in" water lines.

11. Use the corner of the fan brush for evergreens.

12. Tree trunks painted with the knife.

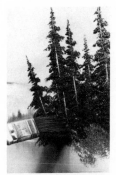

13. Push upward with the 1" brush to make and highlight bushes.

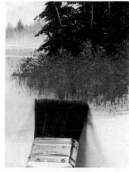

14. With the 2" brush, pull straight down for reflections.

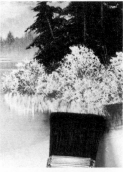

15. Highlights are reflected in the same manner using a very delicate touch.

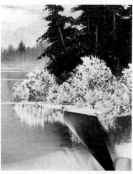

16. Snow is layed in with the knife, paying close attention to angles.

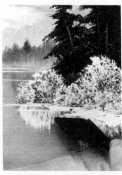

17. Cut-in water lines with the edge of the knife and Liquid White.

18. Highlights are applied to the evergreens with the fan brush.

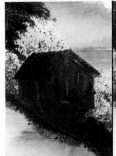

19. Progressional steps used to paint the cabin.

20. Use the knife to paint a snow covered path.

21. Carefully remove the Con-Tact paper.

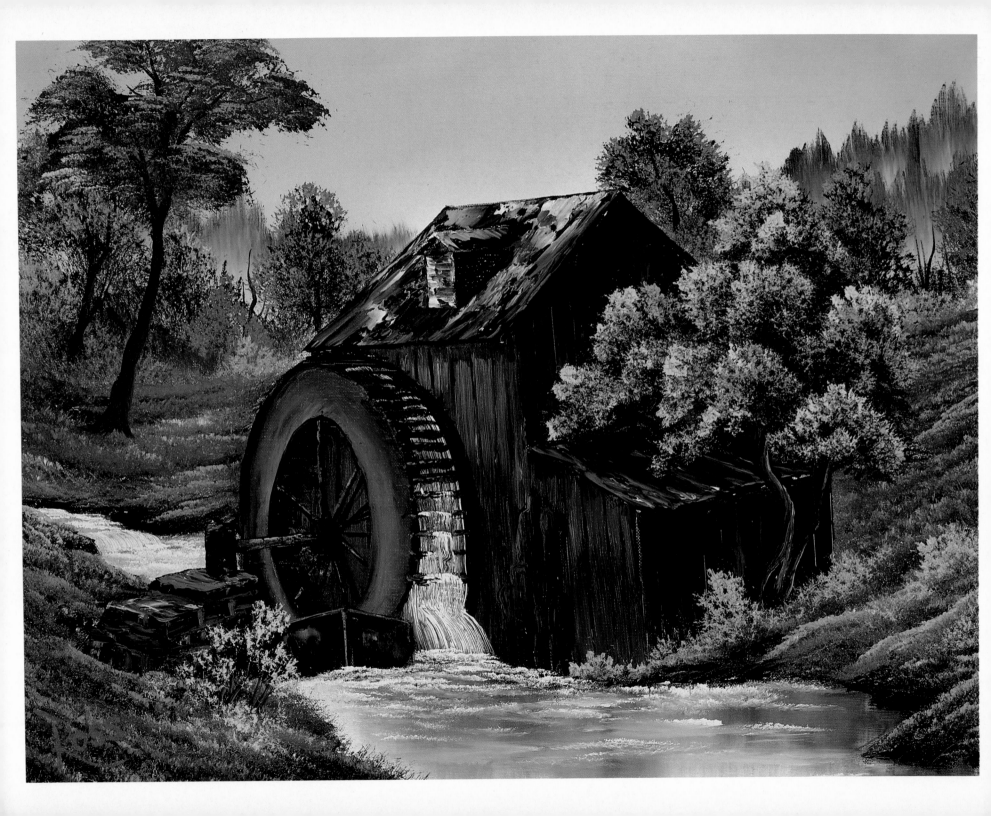

MATERIALS

2" Brush	Indian Yellow
1" Brush	Bright Red
Large Knife	Prussian Blue
Liquid White	Phthalo Blue
#6 Fan Brush	Sap Green
#2 Script Liner Brush	Titanium White
Alizarin Crimson	Van Dyke Brown
Dark Sienna	Yellow Ochre
Cadmium Yellow	

Cover the entire canvas with a thin, even coat of Liquid White using the 2" brush. Apply the Liquid White in long horizontal and vertical strokes. Do not allow the Liquid White to dry before you begin.

SKY

With the 2" brush, loaded with a small amount of Alizarin Crimson, use criss-cross strokes to put a Pink area in the sky. Without cleaning the brush, add Phthalo Blue and use the criss-cross strokes to complete the sky. With a clean, dry brush blend the entire sky together.

BACKGROUND

The distant tree indications are made with the 2" brush, loaded with Alizarin Crimson and Prussian Blue (use very little Blue). Hold the brush vertically, touch the top corner to the canvas and pull down. Basic tree and bush shapes are Van Dyke Brown, Alizarin Crimson, and Sap Green applied with the large brush. Pull the brush through the paint in one direction to round one corner. With the rounded corner up, push in your basic tree and bush shapes. Turn the brush from side to side to give your tree shape. The brush may also be held horizontally, pushed slightly upward, bending the bristles to create grassy areas. Tree trunks are made with the fan brush. Load the brush full of Van Dyke Brown, then pull one side through Titanium White. Start at the top of the tree, hold the brush vertically, touch the canvas and pull down-ward. Trees and bushes are highlighed with the 1" brush loaded with Liquid White, Cadmium Yellow, Sap Green and Yellow Ochre, in varying amounts. You may also like to add Indian Yellow and Bright Red. Load the brush to round one corner. With the rounded corner up, push in your highlights with a slight upward motion. Decide where your stream will be, then use the large brush to pull some of the background color straight down. A small amount of Prussian Blue may be added to the background color. Use the palette knife loaded with Van Dyke Brown to create the land areas. Pay close attention to angles. The highlights on the land are a mixture of Van Dyke Brown, Titanium White and a touch of Prussian Blue, applied with the knife. The highlights on the stream are made with the fan brush loaded with Liquid White and Titanium White. Hold the brush horizontally, touch the canvas and push slightly upward. The soft grassy areas in the background are made with the fan brush and Liquid White, Cadmium Yellow, Sap Green and Yellow Ochre. Load the brush full of paint, touch the canvas and push upward. Work in layers, completing the most distant layers first, following the general lay-of-the-land.

WATERWHEEL

Use the knife and scrape out a basic shape for your structure. With the knife, fill in the entire building with Van Dyke Brown. Use a small roll of Van Dyke Brown, Dark Sienna and Titanium White to highlight the roof of your building. Pay attention to angles, use very little pressure on the knife and allow the paint to "break." The dark side of the building is highlighted with a mixture of Van Dyke Brown, Dark Sienna and Titanium White. Apply with the knife using long vertical strokes. Use very little pressure and allow the paint to "break" so it looks like old wood. Add a little more Titanium White to your color and highlight the front of your building. You can use the point of the knife to cut in boards on the building. When the building is complete, decide where you

want the waterwheel and scrape out a basic shape with the knife. Fill in this area with Van Dyke Brown. Highlight the outside of the wheel with a touch of Yellow Ochre on the fan brush. The water on the wheel is made with the fan brush loaded with Liquid White and Titanium White. Now, use a small roll of Van Dyke Brown on the knife to put the paddles on the wheel. Use a roll of Van Dyke Brown on the knife to make the spokes for the wheel. Highlight your spokes with a little Brown and White on the knife.

FOREGROUND

When your waterwheel is complete, lay in your land areas for the foreground. With the large brush, pull some of the dark color down into the water for reflections. Use the fan brush with Liquid White and Titanium White to highlight the water and create movements. Highlight your land areas with the knife, then lay in the grassy areas with your fan brush as before. The trunk of the tree is made with the knife and Van Dyke Brown. Highlights are Van Dyke Brown and Bright Red applied with the knife. The leaves are made and highlighted the same as the background trees.

FINISHING TOUCHES

Use the point of the knife to scrape in sticks and twigs. You are now ready to sign this beauty using the liner brush with a color which has been thinned.

The Old Mill

1. Pull down with the 2" brush to make distant trees.

2. The 1" brush is used to highlight trees and bushes.

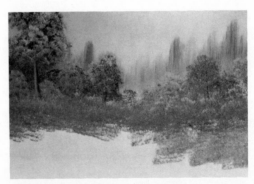
3. Background trees and bushes completed.

4. Pull down with the large brush to create reflections.

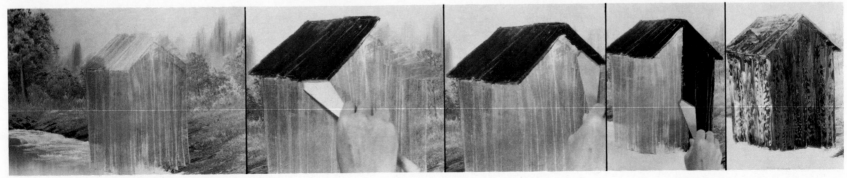
5. Steps used to complete the building.

The Old Mill

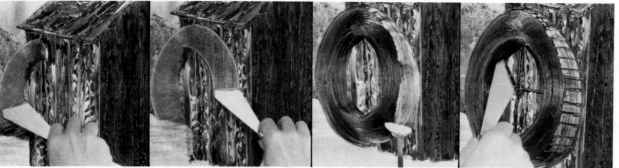

6. Steps used to complete the waterwheel.

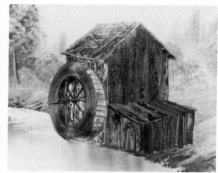

7. Background completed.

8. Foreground land areas laid in with the knife.

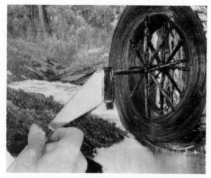

9. The support post is made with the knife.

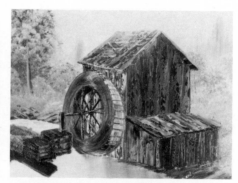

10. Foreground partially completed.

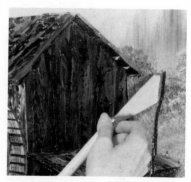

11. The tree is made with the knife.

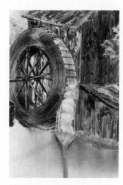

12. Completing the water with the fan brush.

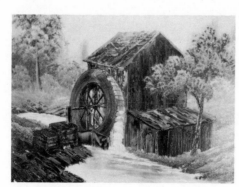

13. Foreground completed.

14. Finishing touches applied with the 1" brush.

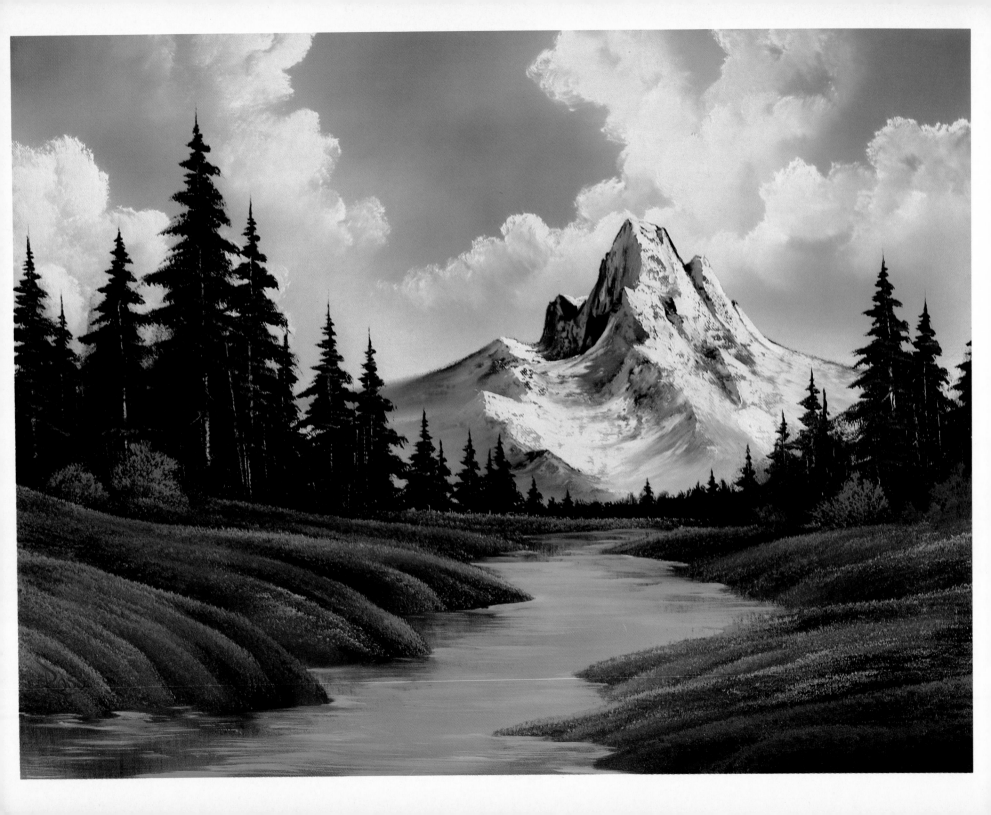

MATERIALS

2″ Brush	Midnight Black
1″ Brush	Dark Sienna
#6 Fan Brush	Van Dyke Brown
#2 Script Liner Brush	Alizarin Crimson
Large Knife	Sap Green
Small Knife	Cadmium Yellow
Liquid White	Yellow Ochre
Titanium White	Indian Yellow
Phthalo Blue	Bright Red
Prussian Blue	

Start by covering the entire canvas with a thin, even coat of Liquid White using the 2″ brush. Work back and forth with long horizontal and vertical strokes to ensure an even distribution of paint on the canvas. Do NOT allow the Liquid White to dry before you begin.

SKY

Load the 2″ brush with a mixture of Phthalo Blue and Midnight Black by tapping the bristles firmly against the palette to ensure an even distribution of paint throughout the bristles. Starting at the top of the canvas, use criss-cross strokes to "dance-in" your sky. Be sure to leave open, unpainted areas for the clouds. With the same mixture, add long, horizontal strokes to the bottom half of the canvas for the water. Use a clean, dry 2″ brush to blend the entire canvas.

To add the clouds to the unpainted areas in the sky, load a 1″ brush with a mixture of Titanium White and a small amount of Bright Red. Use circular strokes to just "float-in" the cloud shapes. Remember clouds are free, they just float around. With just the top corner of a clean, dry 2″ brush, blend the bottoms of the clouds and then gently lift upward to fluff.

MOUNTAIN

Use the knife to make a mixture of Midnight Black, Van Dyke Brown, Prussian Blue and a small amount of Alizarin Crimson. Pull the paint out very flat on your palette and just "cut" across to load the long edge of the knife with a small roll of paint. With firm pressure, shape just the top edge of the mountain. Complete the mountain shape by blending downward with a clean, dry 2″ brush.

The snow on the mountain is Titanium White. Again, load the long edge of the knife with a small roll of paint and paying close attention to angles, apply the highlights with so little pressure that the paint "breaks." The shadow sides of the peaks are made with a mixture of Titanium White and Phthalo Blue using the small knife.

Still following the angles, use a clean, dry 2″ brush and gently tap to diffuse the base of the mountain. Very lightly lift upward with the brush to create the illusion of mist.

BACKGROUND

Add some Sap Green to the mountain mixture of Midnight Black, Van Dyke Brown, Prussian Blue and Alizarin Crimson. With the 2″ brush held vertically, apply this color to the base of the mountain for the distant trees. You can use the same mixture on the fan brush to indicate just a few distinct tree tops. Hold the brush vertically and touch the canvas to create the center of the tree. Turn the brush, and use just one corner to add the branches.

Still using the same color on the 2″ brush, underpaint the entire ground area, paying close attention to the lay-of-the-land. With a 1″ brush, pull down just a little of this dark base color into the water area for reflections.

Use the point of the knife to scratch in tree trunks or they can be made by just touching the canvas with a mixture of Dark Sienna, Titanium White and Phthalo Blue on the knife. Highlight the evergreens by adding Cadmium Yellow to the dark mixture already on the fan brush and gently touch to the branches of the trees. Be very careful not to "kill" all the dark base color of the trees.

The small bushes at the base of the evergreens are made by loading the 1″ brush with various mixtures of all the Yellows and Sap Green. Pull the brush in one direction

through the paint to round one corner. With the rounded corner up, touch the canvas and gently force the bristles to bend upward as you shape each bush.

FOREGROUND

The entire ground area is highlighted by loading the 2″ brush with various mixtures of all the Yellows, Sap Green and Bright Red. Hold the brush horizontally and, working forward in your painting, tap in these highlight colors to create the grassy areas paying close attention to the lay-of-the-land.

WATER

With a mixture of Titanium White, Liquid White and Phthalo Blue on the fan brush, use short, gentle horizontal strokes to add the water to the center of the painting.

FINISHING TOUCHES

Your masterpiece is ready for a signature. Dip the liner brush into the paint thinner and twirl the bristles to bring them to a sharp point as you pull the brush through the thinned paint.

Sign, stand back and admire!

Mountain Stream

1. Use criss-cross strokes . . .

2. . . . to paint the initial sky patterns. Horizontal strokes are used to paint the water.

3. The 1″ brush is used to paint the basic cloud shape.

4. Blend the base of each cloud with the top corner of the large brush . . .

5. . . . then soften the entire sky, using long horizontal strokes.

6. Lay in the basic mountain shape with the knife . . .

7. . . . then pull downward with the 2″ brush to blend and remove excess paint.

8. With the knife, applying very little pressure, . . .

Mountain Stream

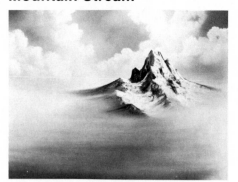

9. . . . paint the highlights and shadows on the mountain.

10. Loosely paint the base of the evergreens.

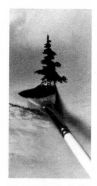

11. Create the individual tree tops with the fan brush . . .

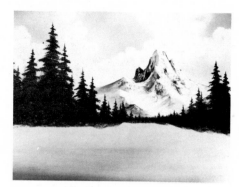

12. . . . to complete the background trees.

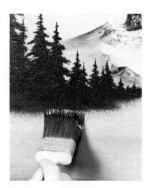

13. Use the 2" brush . . .

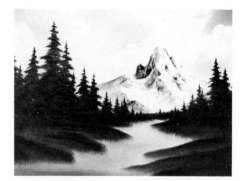

14. . . . to tap in the base color for the land areas.

15. The edge of the knife is used to paint tree trunks.

16. Tap downward with the large brush to paint the soft grassy areas. Angles are very important.

17. Push upward with the 1" brush to make individual bushes.

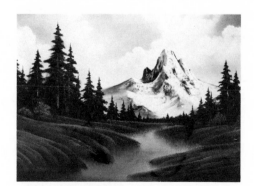

18. Land areas completed.

19. Use the fan brush . . .

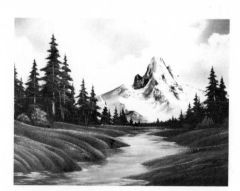

20. . . . to paint highlights on the water. Add your finishing touches, then sign.

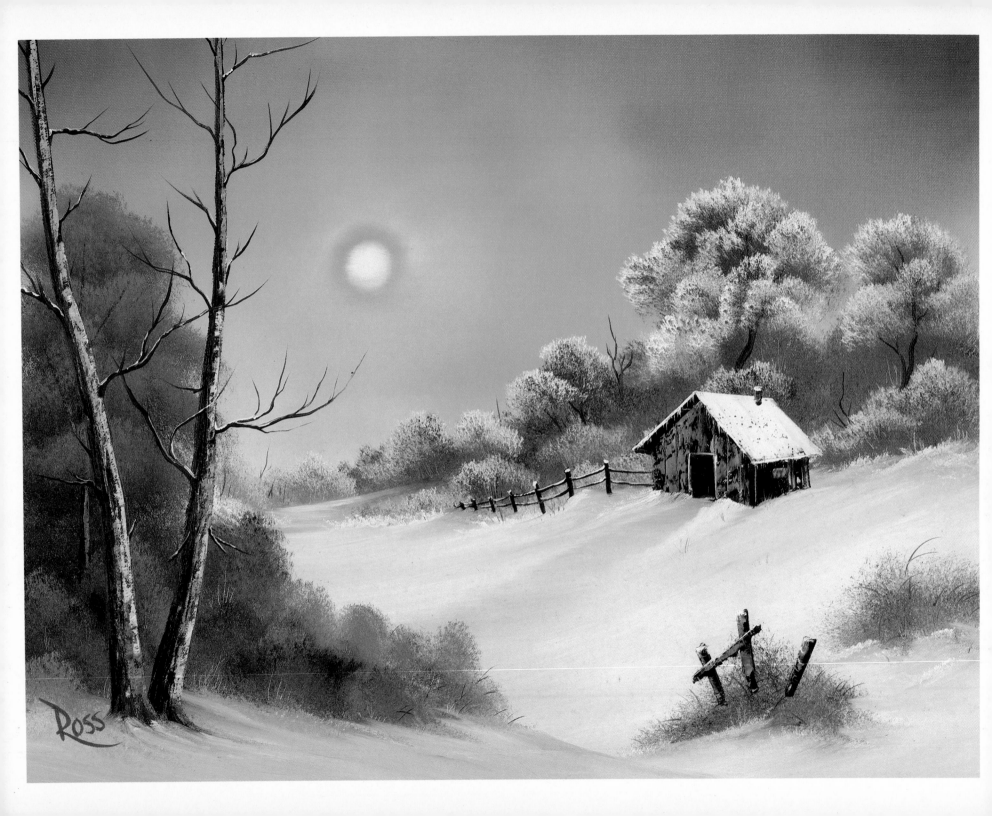

MATERIALS

2″ Brush	Phthalo Blue
1″ Brush	Midnight Black
1″ Round Brush	Dark Sienna
#6 Fan Brush	Van Dyke Brown
#2 Script Liner Brush	Alizarin Crimson
Large Knife	Cadmium Yellow
Small Knife	Yellow Ochre
Liquid White	Indian Yellow
Liquid Black	Bright Red
Titanium White	

Start by covering the entire canvas with a thin, even coat of Liquid White, using the 2″ brush. Use long horizontal and vertical strokes, working back and forth to ensure an even distribution of paint on the canvas. Do not allow the Liquid White to dry before you begin. Clean and dry the 2″ brush.

SKY

Load the 1″ brush with a mixture of Cadmium Yellow and a very little Bright Red. Begin the sky by making a small Orange circle in the area where the sun will be. With a clean, dry 1″ brush, pick up a brush-mixture of Titanium White and Alizarin Crimson. Make a Pink circle around the sun using criss-cross strokes, allowing the color to extend out a little along the horizon. Load a 2″ brush with a mixture of Alizarin Crimson and Dark Sienna, using criss-cross strokes, make a circle of color above the Pink in the sky. Without cleaning the large brush, load it with Van Dyke Brown and cover the remainder of the sky, again using criss-cross strokes. Before cleaning your 2″ brush, add a little Van Dyke Brown, Phthalo Blue, and Alizarin Crimson to the ground area (or lower half) of the painting. With a clean, dry 2″ brush, blend the entire sky. The sun is a White circle in the center of the Orange area of the sky. You can make this circle using your finger and Titanium White. Remove any excess White paint with your knife and blend this area very lightly with a clean, dry 2″ brush.

BACKGROUND

The background trees are made using Van Dyke Brown and Dark Sienna, just brush-mixed on the 1″ round brush. Tap in the basic tree shapes along the horizon, making a little hill, to begin creating the lay-of-the-land. By starting at at the base of the trees, the color will automatically get lighter as the paint mixes with the Liquid White near the top of the trees. Pull the dark color down to create shadows under the trees. (Watch the lay-of-the-land.) The tree trunks are made using the liner brush. Put a little Liquid Black on your palette and twist the bristles as you pull the brush through the paint, to create a sharp point. Using just the point of the brush, paint trunks and branches in the background tree shapes. To highlight the trees, dip your 1″ brush into the Liquid White and load it with a mixture of Titanium White and a VERY small amount of Bright Red. Use just the top corner of the brush to gently tap the Pink color on the trees, creating individual tree shapes and working in layers; careful not to cover all of your dark base color. While the paint is still on the brush, add a little of the color to the ground under the background trees. Continue adding snow to this ground area by loading the fan brush with Titanium White and shaping the contour of the land. Add just a touch of Phthalo Blue for the shadows.

CABIN AND FENCE

Load the long edge of the knife with a small roll of Van Dyke Brown. Lay in the back eave of the cabin, then the front and side. Highlight the front with a mixture of Van Dyke Brown and Titanium White, loaded on the knife, using very little pressure; allow the paint to break. With a roll of Titanium White, pull on the roof and add just a touch of snow to the back eave. Use the small knife and Van Dyke Brown to make the door in the front of the cabin; a touch of Phthalo Blue and Titanium White for the window. Outline the door and window with Titanium White. The chimney is Bright Red with a touch of White snow on top.

The fence is made with Liquid Black on the liner brush, highlighted with Liquid White. Use Titanium White on the fan brush to add snow to the base of the fence and the cabin. Just a touch of Phthalo Blue will create shadows and a path to the cabin. Again, pay close attention to the "lay-of-the-land."

FOREGROUND

Load the 1" brush with Van Dyke Brown and Dark Sienna by tapping the bristles firmly into the paint on your palette. Tap in the large tree mass on the left by starting at the base and allowing the color to become lighter as you near the top. With the dark color still in the brush, you can add some patches of grass in the snow by just touching the brush to the canvas and gently pushing upward. With Titanium White and a little Phthalo Blue on the fan brush, begin forming the contour of the land at the base of the trees and grasses. Also pull in some of the dark base color to create shadows. Use a very small roll of Van Dyke Brown on the edge of the knife to make the tree trunk. Highlight the trunk with a mixture of Van Dyke Brown and Titanium White on the knife and just touch the right side of the tree trunk where the light would strike. Use the 1" round brush to apply highlights to the large tree with mixtures of all the Yellows and the Bright Red. Use just the top corner of the brush. Be careful not to completely cover the dark base color. You can also form some little bush shapes at the base of the tree.

Use Van Dyke Brown on the knife to "build" some old fence posts in one of the grassy areas. Use a mixture of Van Dyke Brown and Titanium White to just touch highlights to the posts.

The large tree in the foreground is made by loading the fanbrush with Van Dyke Brown, holding the brush vertically and just pulling, in the tree trunk shapes. The branches are made with Liquid Black and the liner brush. Apply highlights to the tree trunk with a mixture of Van Dyke Brown and Titanium White on the knife and just touch the right side of the trunk, where the light would strike. Use Liquid White on the liner brush to highlight the branches.

FINISHING TOUCHES

Use the fan brush and Titanium White to add a little snow to the foot of the tree and pull in the dark base color to create shadows. Scratch in sticks and twigs using the point of the knife, then sign your painting. Stand back and admire! Not all winter paintings need be cold.

Warm Winter Day

1. Paint a circle with the 1" brush . . .

2. . . . then use criss-cross strokes to lay in the layers around the sun. Blend the entire sky with a 2" brush.

3. A finger is used to paint the sun.

4. Blend with the large brush.

5. Background tree shape is tapped in with the round brush.

Warm Winter Day

6. Pull some of the tree color down to help create shadows in the snow.

7. Tree trunks are painted with the liner brush loaded with a thin paint.

8. Highlights are tapped on the distant tree shapes with the round brush.

9. The fan brush is used to paint the snow, paying careful attention to angles.

10. Progressional steps used to paint the cabin.

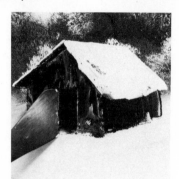

11. Liquid Black/White and the liner brush are used to paint the fence.

12. Use the round brush . . .

13. . . . to make trees and bushes in the foreground.

14. Tree trunks made with the knife.

15. Sticks and twigs may be scratched in with the point of the knife.

16. Grassy areas made by pushing upward with the fan brush.

17. Fence posts are made with the knife.

18. Pull downward with the fan brush to paint the large tree shape . . .

19. . . . then highlight with the painting knife. Sign and admire!

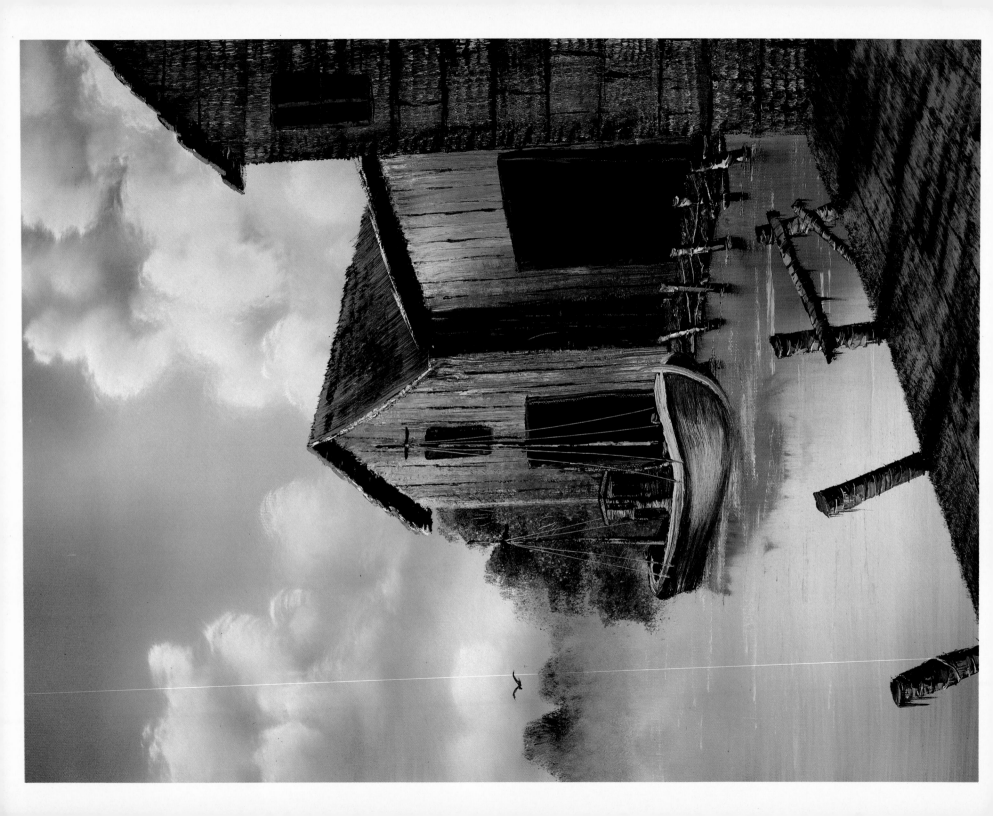

MATERIALS

2″ Brush	Midnight Black
#3 Fan Brush	Dark Sienna
#2 Script Liner Brush	Van Dyke Brown
Large Knife	Sap Green
Small Knife	Cadmium Yellow
Liquid White	Yellow Ochre
Titanium White	Indian Yellow
Phthalo Blue	Bright Red

Start by covering the entire canvas with a thin, even coat of Liquid White, using the 2″ brush. Use long horizontal and vertical strokes, working back and forth to ensure an even distribution of paint on the canvas. Do not allow the Liquid White to dry before you begin.

SKY AND WATER

Load the 2″ brush with a mixture of Van Dyke Brown and Phthalo Blue. Cover the sky area with criss-cross strokes beginning at the top of the sky. Blend.

Add more paint to the brush; starting at the bottom of the canvas, pull in the water with flat horizontal strokes. Working from the edge of the canvas, leave an area in the center unpainted to create a sheen of light across the water.

Load the 2″ brush with Titanium White to paint the clouds. Use just the top corner of the brush and small circular strokes. With a clean, dry brush, blend out the bottoms of the clouds and gently lift upward to fluff.

BACKGROUND

Use the 2″ brush and a mixture of Phthalo Blue and Van Dyke Brown to tap in some very small trees in the background. Extend some of this dark color into the water. With a clean, dry 2″ brush gently pull down and brush across to create reflections. Larger trees are made the same way, but highlighted with a mixture of Yellows and Sap Green on the brush.

BUILDINGS

Start with the most distant building. Load the 2″ brush to a chiseled edge by pulling both sides through a large amount of Van Dyke Brown. Begin by outlining just the top and laying in the back roof overhang. Pull down the front and then the side of the building. Continue by adding the front of the second building and the front roof overhang of that building. Allow this dark Brown paint to extend into the water area to create reflections.

Without cleaning the brush, pick up a little Dark Sienna and some Titanium White—again forming a chiseled edge. Gently graze the front of these buildings, allowing the brush to shake and tremble to create highlights. Load the edge of the knife with a roll of Van Dyke Brown to "cut" in boards. With a clean, very dry 2″ brush, blend these highlights by gently brushing downward. Use Van Dyke Brown on the long edge of the small knife to lay in the shadow side of the building and to add the doors and windows.

Use a mixture of Midnight Black, Phthalo Blue and Titanium White to lay highlights on the roof of the first building. Use a gentle touch, allowing the paint to break.

"Drop in" a little walkway at the base of these buildings by using Van Dyke Brown and horizontal strokes with the knife. Highlights are a mixture of Midnight Black, Phthalo Blue and Titanium White. Again, allow this paint to break. With a clean, dry 2″ brush, just grab some of this dark color and pull down. Gently brush across to create reflections.

Use Midnight Black and the knife to add the posts to the walkway. Highlight with a little Van Dyke Brown and Titanium White. Reflect into the water by pulling down just the bottoms and gently brushing across with the 2″ brush. Cut in water lines with Liquid White on the edge of the knife.

Using the same procedure, add the large building in the foreground.

Brush in the large walkway using Van Dyke Brown on the 2″ brush. Highlights are Midnight Black, Phthalo Blue and

Titanium White, loaded on the knife and gently grazed across the dark color. Cut in vertical planks with a roll of Midnight Black paint on the long edge of the knife. Blend by pulling across with a clean, dry 2" brush.

BOAT

Use Van Dyke Brown on the fan brush and carefully lay in a basic boat shape. With Titanium White paint on the brush, define the edges and add highlights. With a clean, dry 2" brush, grab just the bottom of the boat and pull down to create the reflection and then gently brush across. With Van Dyke Brown on the small knife, "build" a little house on the boat and highlight with a mixture of Van Dyke Brown and Titanium White. Add a touch of Bright Red to the roof. Masts are made with Van Dyke Brown on the knife, highlighted with Titanium White. Use the point of the knife to just cut in wires and riggings. Cut in water lines around the boat with a mixture of Phthalo Blue and Liquid White on the knife.

FINISHING TOUCHES

Add posts to the walkway with Van Dyke Brown on the long edge of the knife. Highlight the left sides with Phthalo Blue, Van Dyke Brown and Titanium White. A tiny touch of Bright Red on the top of each post will complete your painting.

What an accomplishment! Sign, stand back and admire.

Dock Scene

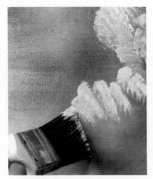

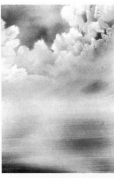

1. Use criss-cross strokes to paint the sky.

2. With the top corner of the 2" brush lay in the basic cloud shape.

3. Blend the bottom of each layer of clouds with the top corner of the 2" brush . . .

4. . . . then use long horizontal strokes to complete the sky.

5. Pull downward with the 2" brush to create distant tree shapes.

6. Pull down with large brush for reflections.

7. Larger trees are made and highlighted with the top corner of the 2" brush.

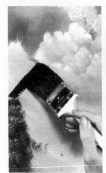

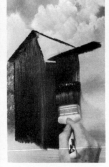

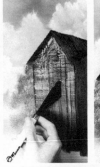
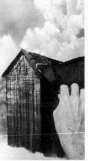
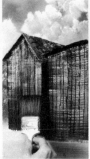
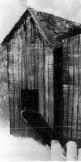

8. With the large brush . . .

9. . . . fully loaded with paint . . .

10. . . . lay in the initial building shapes.

11. Highlight by "bouncing" the 2" brush down the side.

12. The indication of boards is made with the knife.

13. With very little pressure, paint the roof on the building.

14. Pull downward to smooth the wood.

15. Doors and windows . . .

16. . . . are painted in with the knife.

Dock Scene

17. The indication of a walkway is painted in with the knife.

18. Pull straight down with the large brush to create reflections.

19. Posts are made and highlighted by pulling sideways with the knife.

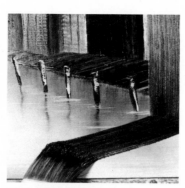

20. The basic shape for the front walkway . . .

21. . . . is applied with a 2" brush.

22. Allowing the brush to "bounce" as it is pulled downward will create a weathered wood effect.

23. Window made by pulling sideways with the knife.

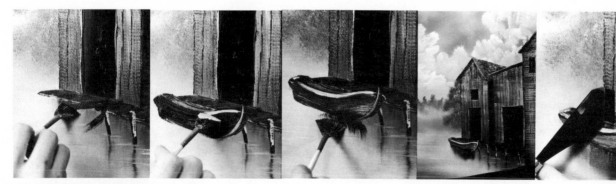

24. Progressional steps used to paint the boat.

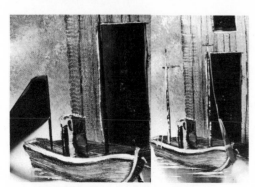

24. Progressional steps used to paint the boat.

25. Add posts to the walkway in the foreground using the knife.

26. Bounce the brush along the walkway to create an old wood effect. . . .

27. . . . lay in the indication of individual boards . . .

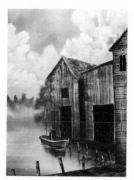

28. . . . then blend lightly with a large brush to complete.

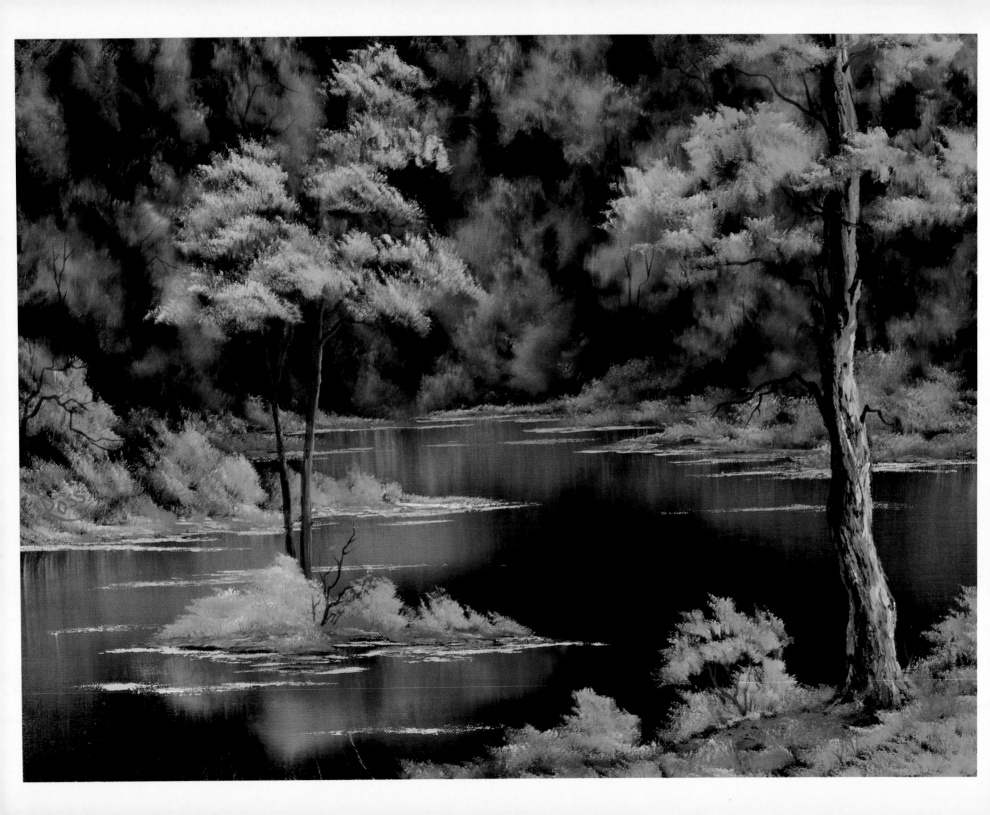

MATERIALS

2" Brush	Phthalo Blue
1" Brush	Dark Sienna
#6 Fan Brush	Van Dyke Brown
#2 Script Liner Brush	Sap Green
Large Knife	Cadmium Yellow
Black Gesso	Yellow Ochre
Titanium White	

Start this painting with a canvas that has been covered with a thin, even coat of Black Gesso and allowed to dry completely.

Use the 2" brush to cover the dry, Black canvas with a thin, even coat of Sap Green, adding a small amount of Van Dyke Brown to the corners. Do NOT allow the canvas to dry before you begin.

BACKGROUND

To create the suggestion of very distant trees, load the fan brush with Cadmium Yellow. With one corner of the brush and small push-up strokes, indicate the tree shapes on the upper portion of the canvas. Use vertical strokes with a clean, dry 2" brush to lightly blend. Add a few tiny tree trunks with a mixture of paint thinner and Van Dyke Brown on the liner brush.

Load the 2" brush with Cadmium Yellow, hold the brush horizontally and pull straight down to add reflections to the water. (For extra "sparkle", add a small amount of Titanium White to the brush.) Very lightly brush across.

Use Van Dyke Brown, Dark Sienna and Titanium White for the land area. Pull the mixture out very flat on your palette and just cut across to load the long edge of the knife with a small roll of paint. Add the banks along the water's edge and then highlight by adding more Titanium White to the mixture. The water lines and ripples are made by just touching the canvas with a small amount of Cadmium Yellow on the knife. Finish the background by using one corner of the fan brush and Cadmium Yellow to "pop-in" tiny bushes and grassy areas along the banks.

MIDDLEGROUND

The land projection or island on the left side of the painting is made with a mixture of Van Dyke Brown, Dark Sienna and Titanium White, using the knife. After shaping the island, highlight with a mixture of Titanium White and Van Dyke Brown, using so little pressure that the paint "breaks".

Use one corner of the fan brush with a mixture of Cadmium Yellow and Yellow Ochre to push in the small bushes and grassy areas on the island. With Cadmium Yellow on the 2" brush, pull straight down to add the reflections and then lightly brush across. Again, add the water lines and ripples with a very small roll of Cadmium Yellow on the long edge of the knife.

The tree trunks are made with a mixture of Van Dyke Brown and Dark Sienna on the fan brush. Hold the brush vertically and pull down to shape each trunk. Highlight the right sides of the trunks with a mixture of Titanium White and Dark Sienna on the knife.

Use a mixture of paint thinner and Van Dyke Brown on the liner brush to add the small limbs and branches. The leaf clusters are Cadmium Yellow on the fan brush; again use just one corner to push in the shapes.

FOREGROUND

With the same mixture of Van Dyke Brown, Dark Sienna and Titanium White on the knife, add the foreground at the lower right corner of the canvas. Paying close attention to angles, highlight the ground with a mixture of Titanium White and Van Dyke Brown using very little pressure on the knife.

Load the fan brush with a mixture of Sap Green and Cadmium Yellow and use just one corner of the brush to again shape the bushes and ground cover in the foreground. Be very careful not to "kill" all of the dark undercolor; use it to separate the individual shapes.

The large tree trunk in the foreground is made with Van Dyke Brown on the knife. Starting at the very top of the

canvas, pull down allowing the trunk to become wider as you near the base. Highlight the right side with Titanium White and Dark Sienna on the knife, using very little pressure so that the paint "breaks." Touch the shadow side of the trunk with a mixture of Prussian Blue and Titanium White, for reflected light. Holding the knife blade vertically, use a series of touching strokes to work the colors together.

The limbs and branches are made with a very thin mixture of thinner and Van Dyke Brown on the liner brush. Use a mixture of Cadmium Yellow and Yellow Ochre and one corner of the fan brush to shape the leaf clusters. Try not to just hit at random; take the time to shape the individual limbs and branches. You can also use the same mixture on the corner of the brush to add small growth to the base of the tree.

FINAL TOUCHES

Additional sticks and twigs can be added with a thin paint on the liner brush, or just scratch in final details with the point of the knife. Don't forget to sign your masterpiece!

Emerald Waters

1. Paint distant trees with one corner of the fan brush . . .

2. . . . then blend with the 2" brush.

3. Add tiny trunks with the liner brush . . .

4. . . . to complete the faraway trees.

5. Use the knife to add the water's edge.

6. Pull down reflections with the 2" brush.

7. Add water lines with the knife . . .

8. . . . to complete the background.

9. Paint the land areas with the knife.

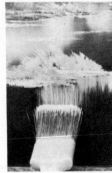
10. Pull down reflections with the 2" brush . . .

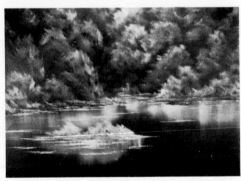
11. . . . to create the small island.

Emerald Waters

12. Use the knife to add the foreground.

13. Use one corner of the fan brush . . .

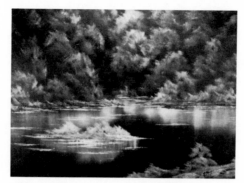

14. . . . to add the bushes to the foreground.

15. Fan brush tree trunks . . .

16. . . . are high-lighted with the knife.

17. Add limbs and branches with the liner brush . . .

18. . . . and leaves with the fan brush.

19. Large tree trunks are made . . .

20. . . . and high-lighted with the knife.

21. Use the liner brush to add limbs, branches . . .

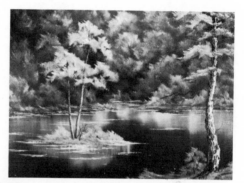

22. . . . and other small details to the finished painting.

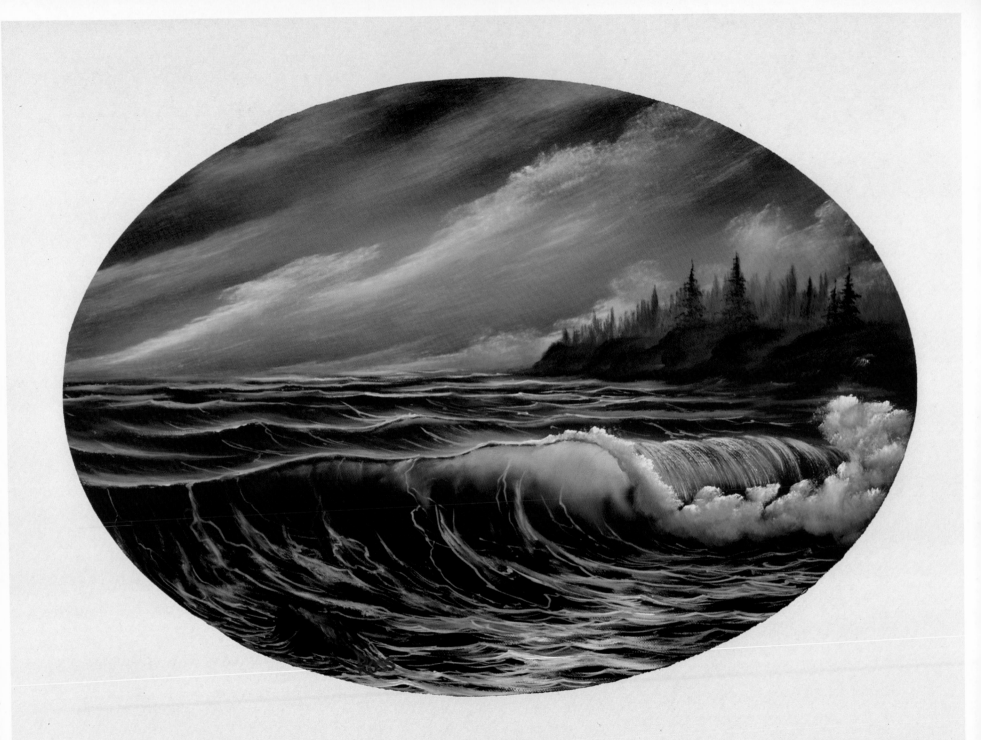

MATERIALS

2″ Brush
#6 Filbert Brush
#6 Fan Brush
#2 Script Liner Brush
Small Knife
Adhesive-Backed Plastic
Masking Tape
Black Gesso
Liquid White

Titanium White
Phthalo Green
Phthalo Blue
Midnight Black
Dark Sienna
Van Dyke Brown
Alizarin Crimson
Cadmium Yellow

Start by covering the entire canvas with adhesive-backed plastic (such as Con-Tact Paper) from which you have removed a 14 x 20 center oval. Then, cover the entire canvas with a thin, even coat of Black Gesso and allow it to dry completely before you begin painting. Apply masking tape (just above center) across the horizontal canvas, to mark the horizon.

Use the 2″ brush to cover the top portion of the canvas with a thin, even coat of various mixtures of Alizarin Crimson, Midnight Black and Phthalo Blue. Cover the lower portion of the canvas with various mixtures of Phthalo Green, Phthalo Blue and Midnight Black. Do NOT allow the canvas to dry before you begin!

SKY

Load the 1″ brush with Titanium White and tap the cloud shapes in the sky. Use a clean, dry 2″ brush to blend the base of the clouds, being very careful not to destroy the top edges of your cloud shapes. You can use Titanium White on the fan brush to add additional clouds and then use sweeping, upward strokes to blend the entire sky. When you are satisfied with your sky, remove the masking tape from the canvas.

BACKGROUND

Use the 2″ brush to add a mixture of Phthalo Blue and Midnight Black along the horizon, to the small area left dry by the masking tape. To determine just where the background water will be, use Titanium White on the filbert brush to lightly sketch the large foreground wave.

Load the fan brush with a mixture of Midnight Black, Phthalo Blue, Phthalo Green and Van Dyke Brown. Hold the brush vertically and tap downward to indicate the tiny trees in the background, just above the horizon. You can use the corner of the brush to add a few branches to the more distinct trees. Use the same dark mixture on the fan brush to shape the rocky land projection under the trees and then highlight with a very small amount of Titanium White on the brush.

BACKGROUND WATER

With Titanium White on a clean fan brush, use short, rocking strokes to add the water along the horizon and at the base of the land projection. Use long, horizontal strokes to paint the tops of the background swells. With short, sweeping strokes, pull back to blend the tops of the swells.

LARGE WAVE

Load the filbert brush with a mixture of Titanium White and a very small amount of Cadmium Yellow. Use circular strokes to scrub the color into the "eye" of the wave. Allow the color to extend out across the top of the wave.

Use the top corner of a very clean, dry 2″ brush and small circular strokes to lightly blend the "eye" of the wave.

With a clean fan brush and Titanium White, use single downward strokes to highlight the water rolling over the top of the wave.

Underpaint the foam with a Lavender mixture of Titanium White, Phthalo Blue and Alizarin Crimson. Use the filbert brush and small, circular strokes.

Highlight the foam with Titanium White on a clean, dry filbert brush. Use tiny, circular, push-up strokes to light just the top edges of the foam. Use the top corner of a clean, dry 2″ brush and small circular strokes to lightly blend just the base of the highlights. Use a thinned, dark Blue mixture on

the liner brush to add a tiny shadow under the foam along the edge of the wave.

FOREGROUND WATER

Load a clean fan brush with Titanium White. Paying close attention to the angle of the water, use short, horizontal and vertical scrubbing strokes to create the foam patterns in the wave and to highlight the water in front of the large wave. Be very careful not to "kill" all of the dark base color. You can very lightly blend these highlights with a clean, dry 2" brush.

Use paint thinner and various mixtures of Titanium White, Phthalo Blue and Cadmium Yellow on the liner brush to add final "sparkles" to the water, paying close attention to where the light would strike.

The stone in the foreground is made with the small knife using a mixture of Van Dyke Brown and Dark Sienna. Highlight the top of the stone with a mixture of Dark Sienna and Titanium White, using so little pressure on the knife that the paint "breaks."

FINAL TOUCHES

The final touch in this painting is to remove the Con-Tact Paper from the canvas, and VOILA!, you have created a masterpiece. One you should not forget to sign!

Oval Essence

1. Use masking tape to keep the horizon straight.

2. Use the 1" brush to tap in the cloud shapes . . .

3. . . . and then blend with the 2" brush.

4. Add additional clouds with the fan brush.

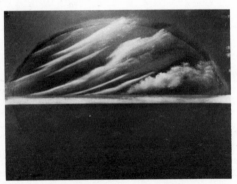
5. Remove the masking tape from the horizon.

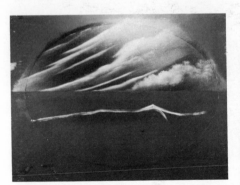
6. Loosely sketch the large wave.

7. The fan brush is used to paint the evergreens . . .

8. . . . and the headlands in the background.

9. Add the background water . . .

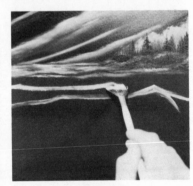
10. . . . and the swells behind the large wave . . .

Oval Essence

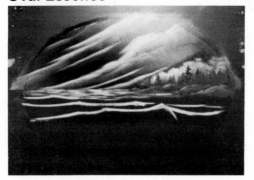

11. . . . with the fan brush.

12. Also use the fan brush to blend the area between the swells.

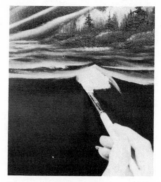

13. Use the filbert brush to scrub in the "eye" of the wave . . .

14. . . . and then blend with the 2" brush.

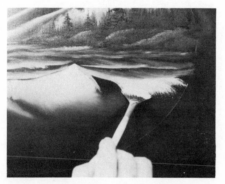

15. Use the fan brush to pull the water over the breaker.

16. Underpaint the foam . . .

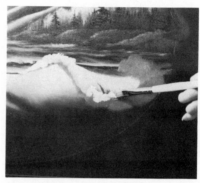

17. . . . and then add the highlights with the filbert brush.

18. Lightly blend the foam with the 2" brush.

19. Add foam patterns to the wave with the fan brush.

20. "Sparkle" the water with the liner brush.

21. Use the small knife to add the stone in the foreground.

22. Remove the Con-Tact Paper and your painting is complete.

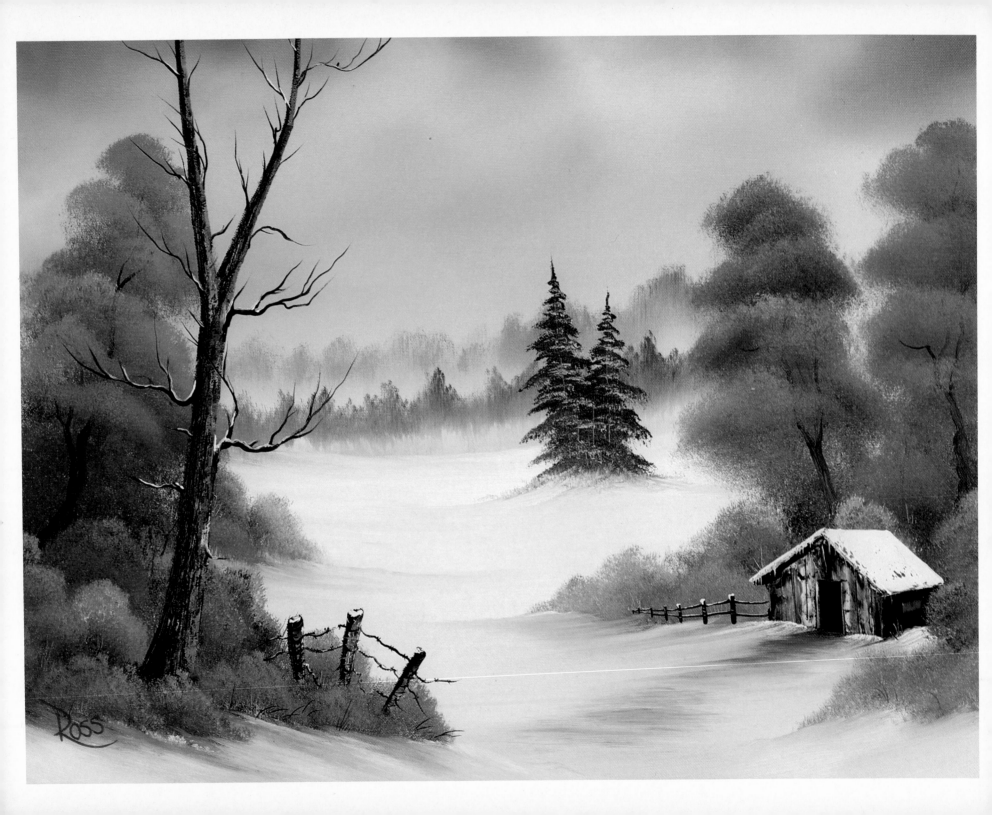

MATERIALS

2" Brush	Midnight Black
1" Round Brush	Dark Sienna
#6 Fan Brush	Van Dyke Brown
#2 Script Liner Brush	Alizarin Crimson
Large Knife	Cadmium Yellow
Liquid White	Yellow Ochre
Liquid Black	Indian Yellow
Titanium White	Bright Red
Phthalo Blue	

Start by covering the entire canvas with a thin, even coat of Liquid White, using the 2" brush. Use long horizontal and vertical strokes, working back and forth to ensure an even distribution of paint on the canvas. Do not allow the Liquid White to dry before you begin. Now, clean and dry your 2" brush.

SKY

Load the 2" brush by tapping the bristles firmly into Indian Yellow. Using criss-cross strokes, add this color to the sky just along the horizon. Then, with horizontal strokes, add a little of the color to the ground area of the painting. Without cleaning the brush, add some Alizarin Crimson to the bristles. Still using criss-cross strokes, add a Pink area to the sky above the Yellow, and again add a little Pink to the ground. Without cleaning the brush, pick up some Midnight Black and Phthalo Blue, add this color in the sky, to the top of the canvas and also to the ground area. With a clean, dry brush blend the entire canvas.

BACKGROUND

Make the foothills by loading the 2" brush with Midnight Black, Phthalo Blue and a little Titanium White. Hold the brush horizontally, and use just one corner to form the foothills by touching and pulling downward. To create the mist at the base of the hills, hold a clean, dry 2" brush vertically and use just the top corner to firmly tap the bottoms of the hills and then gently lift upward. The second layer of hills is made in the same way, using a darker mixture by adding less Titanium White. Again, diffuse the base to create the illusion of mist. With a mixture of Liquid White and Phthalo Blue on the fan brush, hold the brush horizontally and just lift upward to add small bushes to the base of the hills.

Begin creating the lay-of-the-land by loading the fan brush with Titanium White. Hold the brush horizontally and pull in the snow-covered ground area at the base of the foothills. You can add a very little Bright Red and Indian Yellow to reflect the sky into the snow. The small evergreens in the background are made by loading the fan brush with a mixture of Midnight Black, Phthalo Blue, Alizarin Crimson and Titanium White. Hold the brush vertically and just touch the canvas to create a center line. To paint the branches, hold the brush horizontally, using just one corner, work back and forth causing the bristles to bend downward. Apply more pressure as you near the base, allowing the tree to become larger. Highlights are applied the same way using a mixture of Titanium White and Phthalo Blue. Just add this color where the light would strike, careful not to cover all the dark base color. Bend the bristles upward to make little grasses growing at the base of the trees. Pull some of the dark color into the snow to create shadows under the trees, again paying close attention to the "lay-of-the-land".

FOREGROUND

The large leaf trees are made by loading the 1" round brush with a mixture of Van Dyke Brown and Dark Sienna, tapping the bristles firmly against the palette to ensure an even distribution of paint. Tap the tree and bush shapes onto the canvas, beginning at the base of the trees and working upward, allowing the color to become lighter as you near the top. Use Van Dyke Brown, thinned with paint thinner, on the liner brush to add a few trunk indications. Highlights are made by loading the 1" round brush with various mixtures of

all the Yellows and Bright Red. Form the trees by making individual branch and bush shapes, working in layers and being careful not to completely cover all the dark base color. With Titanium White on the fan brush, lay snow under the trees, pulling in some of the dark tree color to create shadows. (Watch the "lay-of-the-land"!)

CABIN

Start by loading the long edge of the knife with a small roll of Van Dyke Brown. Touch the canvas to form the back eave of the roof, then pull in the front of the cabin, then the side. With Titanium White on the knife, lay on the snow-covered roof; also add a little snow to the back eave. With a mixture of Dark Sienna and Titanium White on the knife, gently highlight the front of the cabin, using so little pressure, the paint is allowed to break. With Van Dyke Brown, add a door; with a mixture of Titanium White and Phthalo Blue loaded on the small edge of the knife, just touch a window to the side of your cabin. Use the point of the knife to "cut" around the door and also scratch in slab indications on the front and side.

Use the fan brush with Titanium White to add snow at the base of the cabin, a little Alizarin Crimson and Phthalo Blue to indicate a path. Back to the 1" round brush, continue with a few bushes around the building using the same mixtures as before. The little fence is Liquid Black on the liner brush, add snow with Liquid White on the liner brush.

FOREGROUND TREES

The large tree in the foreground is made by loading the fan brush with a mixture of Midnight Black and Van Dyke Brown. Hold the brush vertically and pull in the basic trunk shape. (Remember, no telephone poles.) Highlight the trunk with a mixture of Titanium White and Dark Sienna loaded on the long edge of the knife. Hold the knife vertically and just touch the right side of the trunk, where the light would strike. Add limbs and branches using Liquid Black on the liner brush. Liquid White on the brush to add snow to the branches. The large fence posts are Van Dyke Brown, made with the knife, Titanium White to add the snow. The wire on the fence is Liquid Black on the liner brush, Liquid White for the snow. Add some bushes and long grasses to the base of the tree using the same mixtures as before, also using Phthalo Blue and Titanium White for highlights. Continue using the fan brush to lay in the snow, creating shadows and the "lay-of-the-land".

FINISHING TOUCHES

Use Liquid Black or Liquid White on the liner brush to add small sticks and twigs to your painting. Sign and admire! You have just created a masterpiece.

Winter Hideaway

1. Use criss-cross strokes to paint the sky.

2. Pull downward with the corner of the 2" brush to make foothills.

3. Tap the base of the foothills with the top corner of the 2" brush . . .

4. . . . to create a soft, misty effect. The mist is used to separate the layers of foothills.

Winter Hideaway

5. Lift upward with the fan brush to create a grassy effect under the foothills.

6. Snow is painted with the fan brush.

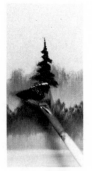

7. Use the corner of the fan brush to paint the evergreen trees.

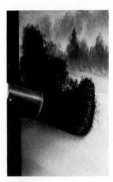

8. Paint the basic tree and bush shapes.

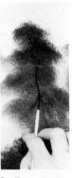

9. Tree trunks painted with the liner brush and a thin paint.

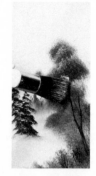

10. Tap downward to highlight trees and bushes.

11. Pull some of the bush color into the snow to help create shadows.

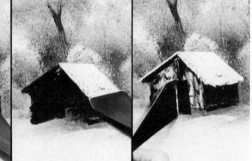

12. Progressional steps used to paint the cabin.

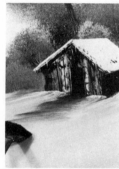

13. Use the fan brush to paint the path.

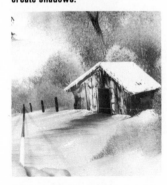

14. Liquid Black, on the liner brush, is used to paint the fence.

15. Complete the snow, paying close attention to angles.

16. Pull downward with the fan brush to paint the tree trunk.

17. Use the painting knife to highlight.

18. Liquid Black is used to paint individual tree limbs.

19. Fence posts are made and highlighted with the knife.

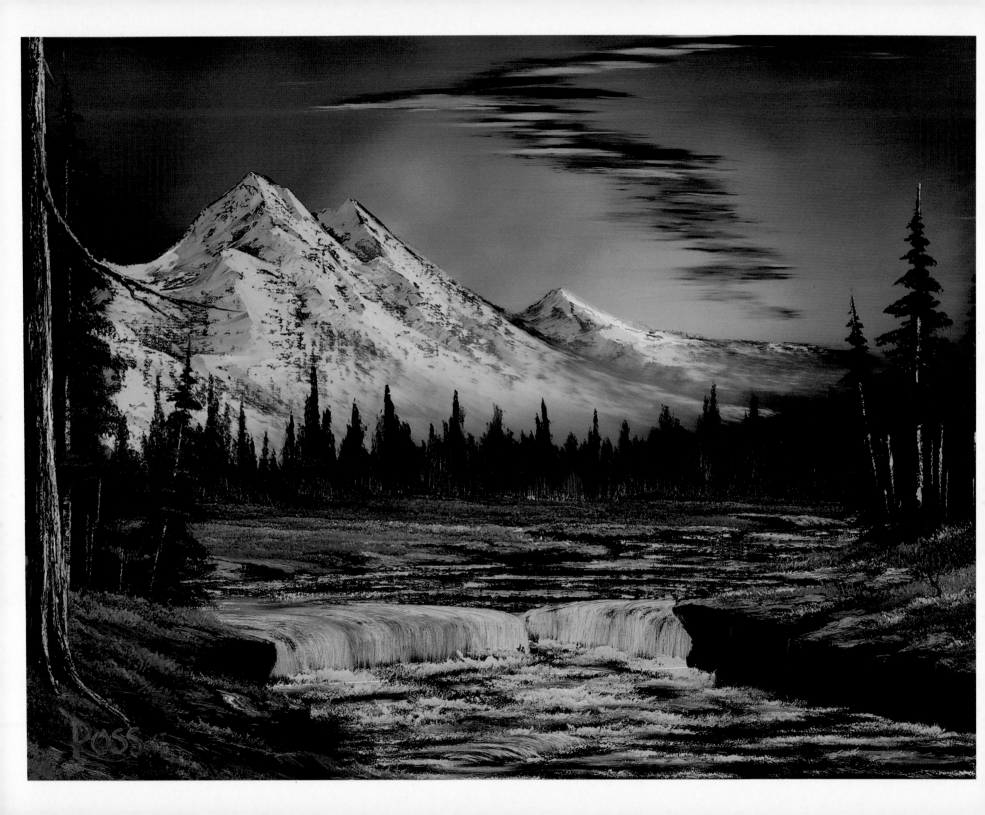

MATERIALS

2″ Brush
Large Knife
Liquid White
Black Gesso
#6 Fan Brush
#2 Script Liner Brush
Alizarin Crimson
Dark Sienna
Cadmium Yellow

Indian Yellow
Bright Red
Phthalo Blue
Phthalo Green
Sap Green
Titanium White
Van Dyke Brown
Yellow Ochre

Start with a canvas that has been painted with Black Gesso and allowed to dry completely. With the 2″ brush, cover the entire canvas with a mixture of Alizarin Crimson and a small amount of Phthalo Blue (to make a Purple color). Use long horizontal and vertical strokes to blend the entire canvas. Do not allow the paint to dry before you begin.

SKY

Load a 2″ brush with Titanium White. Start in the lightest part of the sky, using criss-cross strokes and blend outward.

The clouds are made with a Purple color made by mixing Alizarin Crimson and Phthalo Blue. Load a small roll of paint on the knife and use short horizontal strokes to lay in the basic cloud shapes. With the 2″ brush use long horizontal strokes to blend the clouds. The clouds are highlighted in the same manner using Titanium White and Phthalo Blue.

MOUNTAIN

The mountain is made with the knife loaded with the same Purple color. Blend downward with the 2″ brush. The highlights are Titanium White and Phthalo Blue applied with no pressure, paying very close attention to angles. The shadows are the same Purple color with a touch of Titanium White added. The mist at the base of the mountain is made with the 2″ brush, held vertically, and tapped into the canvas. Hold the brush flat and lift upward, following the angles in the mountain, to blend and remove the tap marks.

BACKGROUND

The same Purple color is used to make the small trees in the distance. Load the fan brush full of color, touch the canvas with the brush held verically and tap downward. The indication of tree trunks is made with a small amount of Titanium White on the fan brush. Touch the canvas at the base of the trees and lift upward, with the brush held horizontally.

Grassy areas under the distant trees are made with the 2″ brush loaded with varying mixtures of Cadmium Yellow, Sap Green, Indian Yellow and Yellow Ochre. Hold the brush horizontally and tap downward to create the soft grassy areas. The land areas are Van Dyke Brown and Dark Sienna, applied with the fan brush. Hold the brush horizontally and use short back and forth strokes to scrub in the basic shapes. Highlights are applied the same way using Yellow Ochre.

WATER

Start your water directly under the background area using a mixture of Titanium White and Phthalo Blue on the knife. Load a small roll of color on the long edge and, holding the knife horizontally, just touch the canvas. Be careful not to cover all the dark areas. Your water should remain horizontal or it will not look correct. The waterfall is made with the fan brush loaded with Titanium White and Phthalo Blue. Hold the brush horizontally, make a short horizontal stroke, then go downward. Foam is created by pushing the brush into the canvas, forcing the bristles to bend upward.

FOREGROUND

The large evergreen trees are made with the same Purple color on the fan brush. Hold the brush vertically and touch the canvas to make a center line. Turn the brush horizontally and use just the corner to make branches, forcing the bristles to bend downward. Tree trunks are made with the edge of the knife loaded with Titanium White and Phthalo Blue,

touched to the canvas. Highlights are Sap Green, Cadmium Yellow, and a touch of Van Dyke Brown applied with the fan brush.

Rocks, stones and cliffs are made with the knife and Van Dyke Brown. Highlights are Yellow Ochre and Dark Sienna applied the same way.

The grassy areas in the foreground are made with the fan brush and varying mixtures of Cadmium Yellow, Sap Green, Yellow Ochre, Indian Yellow and a touch of Bright Red. Hold the brush horizontally, forcing the bristles to bend upward.

The large tree on the left is made with the fan brush loaded with Van Dyke Brown. Hold the brush vertically, touch the canvas and pull downward. Highlights are Titanium White, Bright Red and Dark Sienna. Load a small roll of paint on the edge of the knife, hold the knife vertically and touch the canvas. Shadows are Phthalo Blue and a touch of Titanium White applied in the same manner. Limbs may be painted on using either the fan brush or the script liner brush.

FINISHING TOUCHES

Sticks and twigs may be painted in with the liner brush and a thin paint. This is a painting that will look different under various light sources and will bring you a lot of joy.

Arctic Beauty

1. Use the 2" brush and criss-cross strokes to paint the sky.

2. Use the knife to lay in basic cloud shapes . . .

3. . . . blend with the 2" brush . . .

4. . . . and then highlight with a small roll of paint on the knife.

5. With firm pressure, use the knife to lay in basic mountain shape.

6. The 2" brush is used to pull down and blend the base of the mountain.

7. Paying close attention to angles, use the knife to highlight the mountain . . .

8. . . . tap the base with the 2" brush to create the illusion of mist.

9. Tapping downward with the fan brush . . .

Arctic Beauty

10. . . . will create small trees in the distance.

11. Indicate tree trunks by lifting upward with the fan brush.

12. Use the 2" brush horizontally to tap in grassy areas under distant trees.

13. Land areas are scrubbed in using the fan brush.

14. Use a small roll of paint on the knife to begin laying in the background water.

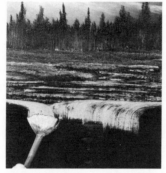

15. The fan brush is used to pull in the waterfall . . .

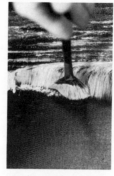

16. . . . and to create the foamy areas of the water.

17. Use the fan brush to make the larger evergreen trees.

18. Tree trunks with the knife will complete the background trees.

19. Use the fan brush to continue making evergreen trees . . .

20. . . . and to add rocks, stones and cliffs . . .

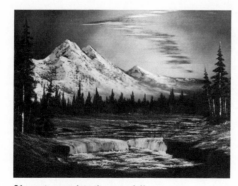

21. . . . to complete the waterfall.

22. The large pine tree in the foreground is made with the fan brush . . .

23. . . . highlighted with the knife . . .

24. . . . and completed by adding limbs with the fan brush. Your painting is ready to sign.

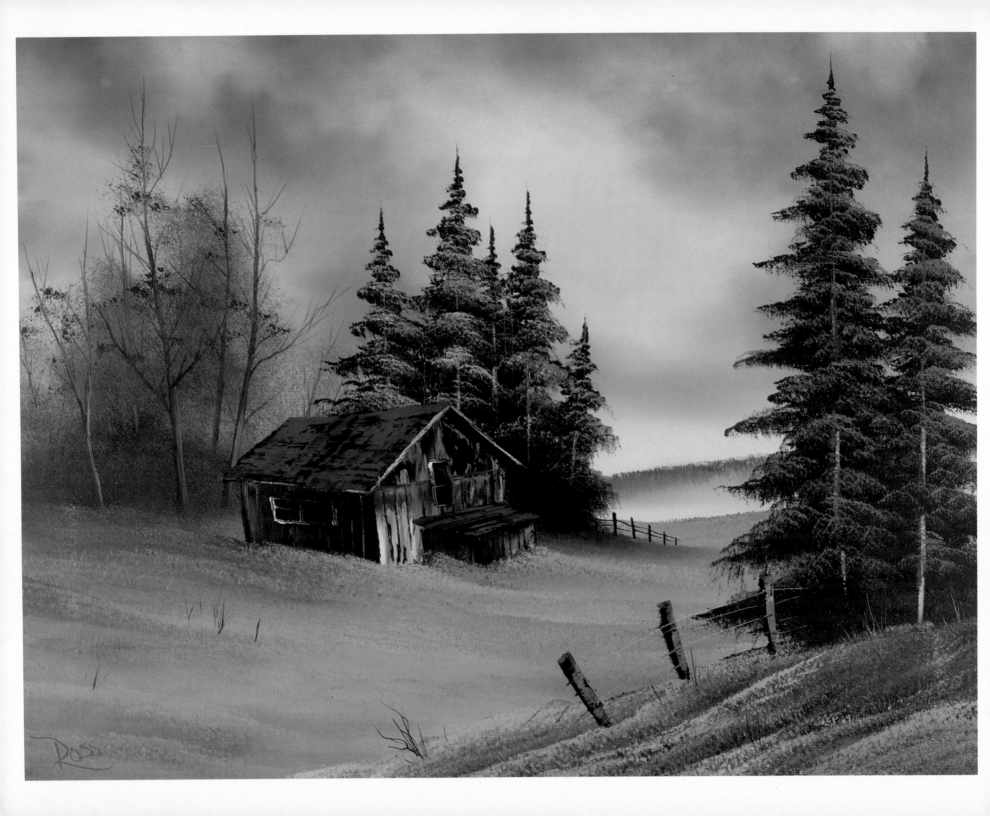

20. CABIN AT SUNSET

MATERIALS

2" Brush
1" Brush
1" Round Brush
1" Oval Brush
#6 Fan Brush
#2 Script Liner Brush
Large Knife
Small Knife
Liquid White
Titanium White
Phthalo Blue

Prussian Blue
Midnight Black
Dark Sienna
Van Dyke Brown
Alizarin Crimson
Sap Green
Cadmium Yellow
Yellow Ochre
Indian Yellow
Bright Red

Start by covering the entire canvas with a thin, even coat of Liquid White, using the 2" brush. Use long horizontal and vertical strokes, working back and forth to ensure an even distribution of paint on the canvas. Do not allow the Liquid White to dry before you begin.

SKY

Load a clean, dry 2" brush with a very small amount of Cadmium Yellow. Use criss-cross strokes to make a Yellow area in the center of the sky just above the horizon. Without cleaning the brush, tap the bristles into some Yellow Ochre and add this color above the Cadmium Yellow. Still using criss-cross strokes, and without cleaning the brush, add Bright Red above the Yellow Ochre. Lightly blend these three colors. With Titanium White on the same brush, use criss-cross strokes to create a small light area in the center of the sky.

With a mixture of Alizarin Crimson and Phthalo Blue on the 2" brush, use circular strokes to add clouds around the bands of color and then just Phthalo Blue on the brush to extend the entire sky area to the top of the canvas. With a clean, dry 2" brush, very lightly blend the entire sky.

FOOTHILL

Load the 1" oval brush with a mixture of Alizarin Crimson, Midnight Black, Van Dyke Brown, Dark Sienna and Titanium

White. Just tap in the tree tops allowing the Yellow in the sky to extend a little below the foothill. With a clean, dry 2" brush, tap the base of the foothill to diffuse and then gently lift upward to create a Yellow misty area.

BACKGROUND

Load the same 2" brush by tapping the bristles into a mixture of Alizarin Crimson, Midnight Black, Van Dyke Brown and Dark Sienna. Hold the brush horizontally and tap in this dark base color to the ground area on the right beneath the foothill. At this point, begin determining the lay-of-the-land and be careful not to "kill" the Yellow misty area that separates the foothill from the ground area. Tap the bristles of the same brush into a mixture of Cadmium Yellow, Sap Green and Yellow Ochre and gently tap this highlight color over the dark base color of the ground area.

Again, load the 2" brush with the same dark base mixture plus a little Sap Green and begin tapping in the ground area on the left side of the painting, continuing to move forward until the entire lower portion of the canvas is covered with this dark base color.

The clump of leaf trees in the background is made by loading the 1" round brush with a dark base mixture of Van Dyke Brown and Dark Sienna. Starting at the base of the trees, just tap in the basic shape. Add tree trunks using thinned Van Dyke Brown on the liner brush. Still using the dark mixture and the 1" round brush, complete the clump of trees by adding a little foliage to the front of the tree trunks.

The evergreens in the background are made by loading the fan brush with a mixture of Midnight Black, Prussian Blue and Sap Green. Hold the brush vertically and just touch the canvas to create the center of the tree. Turn the brush horizontally and begin adding the small branches at the top of the tree by using just one corner of the brush. Working from side to side and forcing the bristles to bend downward, use more pressure as you near the base of the tree allowing the branches to become larger.

The evergreen trunks are a mixture of Dark Sienna and Titanium White loaded on the long edge of the knife and just touched to the canvas. Load the 1" oval brush with a mixture of Sap Green and Cadmium Yellow. Just touch this highlight color to the branches of the evergreens where the light would strike.

CABIN

Load the knife with a small roll of Van Dyke Brown. Lay in the back edge of the roof. Paying close attention to angles, pull down the front of the roof and then add the front and the side of the cabin. With a mixture of Bright Red and Dark Sienna on the knife, "bounce" a little color on the front of the roof. With a mixture of Titanium White, Dark Sienna and Yellow Ochre, highlight the front of the cabin, using so little pressure that the paint "breaks". Use the same mixture with less White to highlight the side of the cabin.

Use Van Dyke Brown to add the little shed to the side of the cabin. Start with the roof, then the front and side. Again, add the Bright Red and Dark Sienna mixture to the roof, then highlight the front of the shed. Use the small knife to highlight the side of the shed. Still using the small knife and Van Dyke Brown, add the windows.

FOREGROUND

Load the 2" brush to a chiseled edge with a mixture of Midnight Black, Prussian Blue and Sap Green. Form the large evergreens in the foreground by holding the brush vertically and just touching the canvas to create the center line of each tree. Turn the brush horizontally and begin adding the small branches at the top of the tree by using just one corner of the brush. Working from side to side and forcing the bristles to bend downward, use more pressure as you near the base of the tree allowing the branches to become larger. Continue using this dark color to add the land mass at the base of the foreground trees. Use a mixture of Van Dyke Brown and Titanium White on the knife to just indicate the tree trunks. Highlight the branches of the trees with Sap Green and Cadmium Yellow on the 1" oval brush.

FINISHING TOUCHES

Use thinner and Van Dyke Brown on the liner brush to add the tiny fence in the background. The large foreground fence is made with Van Dyke Brown on the long edge of the large knife. Highlight the right side of the fence posts with a mixture of Van Dyke Brown and Titanium White on the knife. Use Liquid White and the heel of the knife to "cut-in" the fence wires.

With thinned paint on the liner brush, sign your painting.

Cabin at Sunset

 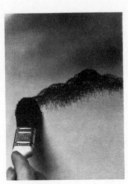 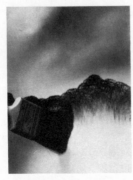 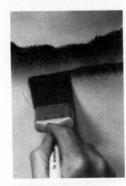 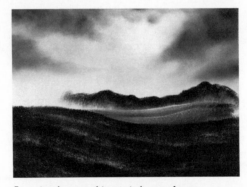

1. Use criss-cross strokes to paint the sky.

2. Tap downward with the 1" oval brush to create foothills . . .

3. . . . then tap firmly with the top corner of the 2" brush to create mist at the base.

4. With the 2" brush . . .

5. . . . tap downward to create layers of grass.

Cabin at Sunset

6. Tree indications are tapped in with the round brush.

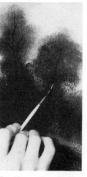

7. Use the liner brush to paint trunks.

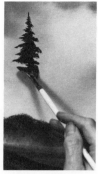

8. The fan brush is used to paint evergreens.

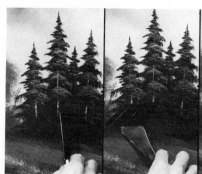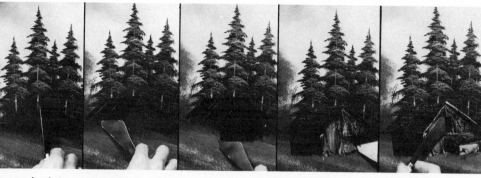

9. Progressional steps used to paint the cabin.

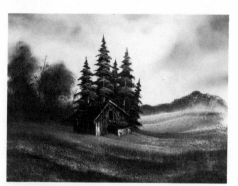

10. Have the background completely finished before starting the foreground.

11. Large evergreens are made with the 2" brush.

12. Tree trunks are added with the knife.

13. Foreground areas are layed in with the 2" brush . . .

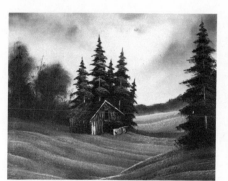

14. . . . then highlighted. Pay particular attention to the lay of the land.

15. Distant fence post made with the liner brush.

16. Fence posts in the foreground are made with the knife.

17. Use the heel of the knife, loaded with Liquid White, to "cut-in" wire on the fence.

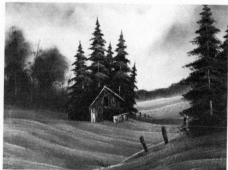

18. Your painting should need only a signature to be complete.

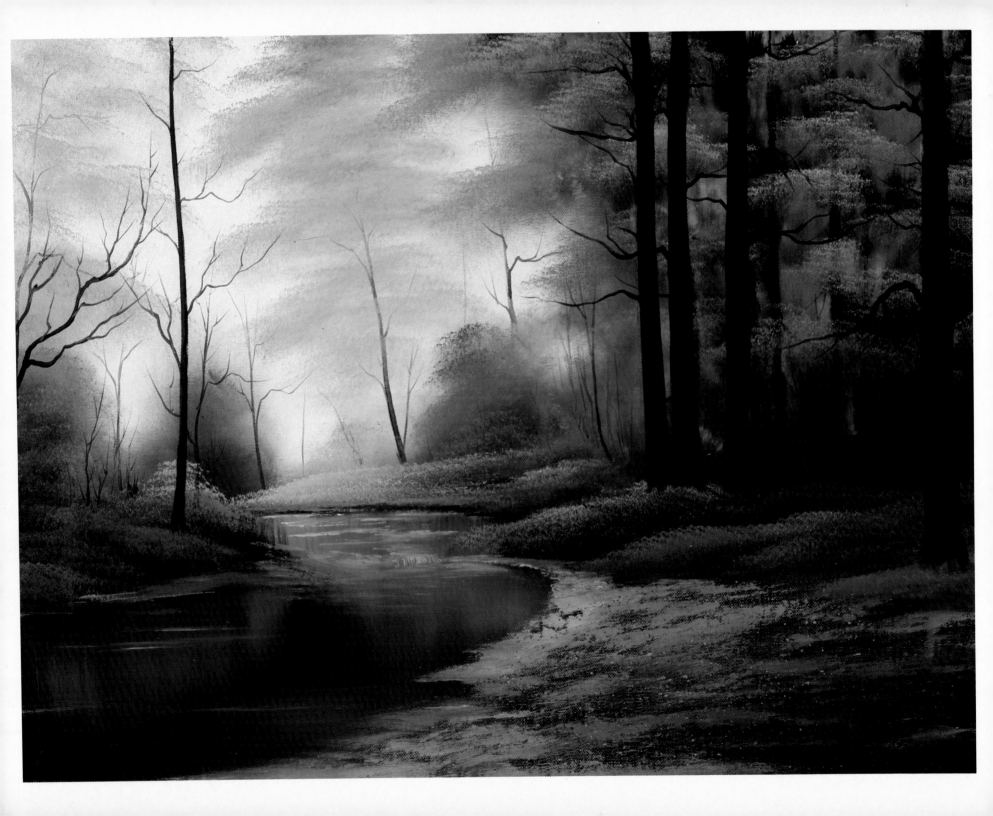

MATERIALS

2″ Brush	Midnight Black
1″ Brush	Dark Sienna
#6 Fan Brush	Van Dyke Brown
#2 Script Liner Brush	Sap Green
Large Knife	Cadmium Yellow
Black Gesso	Yellow Ochre
Liquid White	Indian Yellow
Titanium White	Bright Red
Phthalo Blue	

Decide where the basic dark shapes in your painting are going to be and cover those areas with Black Gesso and allow to dry completely.

When the canvas is dry, cover the unpainted area with a thin coat of Liquid White. Use the 2″ brush to cover the dry Black Gesso with a thin, even coat of a mixture of Phthalo Blue, Sap Green and Van Dyke Brown. With the same dark mixture on the brush, lightly underpaint the basic tree shapes in the Liquid White area.

SKY

Use various mixtures of Cadmium Yellow, Yellow Ochre and Titanium White to indicate the light shining through the background trees (on the right side of the painting). Load the fan brush with the mixtures and firmly twirl the bristles as you push the paint into the dark area above the horizon. Keep the brush moving as you spin the bristles and be very careful not to "kill" all of the dark. Remember, you need dark in order to show light. Use a clean, dry 2″ brush and vertical strokes to lightly blend this area.

BACKGROUND

With Midnight Black on the fan brush, hold the brush vertically and use downward tapping strokes to add the small, distant tree trunks to the right side of the background. Use a mixture of paint thinner and Midnight Black on the liner brush to add limbs and branches to the trunks. Add Van

Dyke Brown to the mixture on the liner brush to paint the small tree trunks in the light area of the background.

Load the 1″ brush with the dark base color (Phthalo Blue, Sap Green and Van Dyke Brown) and then tap the bristles into various mixtures of all the Yellows. Highlight the background trees and bushes by tapping downward with the brush to form the individual tree and bush shapes. Try not to just hit at random.

Load the 2″ brush by tapping the bristles into various mixtures of all the Yellows and Titanium White to add the grassy area at the base of the background trees. Hold the brush horizontally and just tap downward, creating the lay-of-the-land as you apply the highlights.

The water in the background is made using Titanium White on the 2″ brush. Hold the brush horizontally against the canvas and just pull straight down. Because the canvas is still wet, notice how the brush picks up the dark base color already on the canvas and the color automatically mixes with the White. Lightly brush across with a clean brush to "shimmer" the water.

FOREGROUND

Moving forward in the painting, underpaint the small land projection on the left with the same dark mixture of Phthalo Blue, Sap Green and Van Dyke Brown on the 1″ brush. Still concentrating on the lay-of-the-land, highlight this grassy area using all the Yellows and Titanium White on the brush. Add water to the base of this projection by pulling down with Titanium White on the 2″ brush and then again, lightly brush across to "shimmer" the water.

The land areas are made with a mixture of Van Dyke Brown, Dark Sienna and Titanium White. Load the long edge of the knife with a small roll of this mixture to add the banks along the water's edge. Pull in the large land mass in the foreground using so little pressure on the knife that the paint "breaks," allowing some of the dark undercolor to show through the mixture.

Use Titanium White on the fan brush and short, horizontal strokes to add the water ripples and movements. You can even pull in a small waterfall.

TREES

Load the fan brush with Midnight Black. Holding the brush vertically and starting at the top of the canvas, pull down to add the large tree trunks on the right side of the painting. Increase the pressure on the brush as you near the base of the tree to thicken the trunk.

The limbs and branches are made by dipping the liner brush into paint thinner and then turning the brush as you pull the bristles through Midnight Black to load (bringing the bristles to a sharp point). Use little pressure on the brush to add the limbs and branches to the large tree trunks.

With the Midnight Black-paint thinner mixture on the liner brush, add the tree trunks on the left side of the painting. Use Cadmium Yellow on the 1" brush to add additional leaf clusters to the trees. Again, just tap downward.

FINISHING TOUCHES

Use the thinned Midnight Black on the liner brush to add additional sticks and twigs and small tree trunks to your painting.

Hidden Creek

1. Paint the basic dark shapes with Black Gesso.

2. Use the 2" brush to underpaint . . .

3. . . . the background tree shapes.

4. "Twirl-in" the background light areas with the fan brush . . .

5. . . . and then blend with the 2" brush.

6. Using the fan brush for the trunks . . .

7. . . . and the liner brush for the limbs and branches . . .

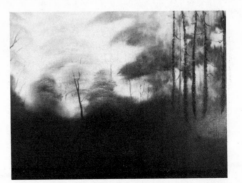

8. . . . add the background trees.

9. Highlight the trees with the 1" brush . . .

Hidden Creek

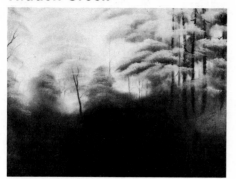

10. . . . to complete the background.

11. Tap downward with the 2" brush . . .

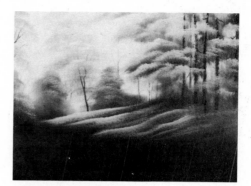

12. . . . to paint the grassy areas.

13. Pull down with the 2" brush for reflections.

14. Use the knife to add banks along the water's edge.

15. With Titanium White on the fan brush . . .

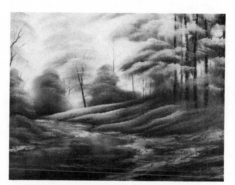

16. . . . add water movements to the painting.

17. Make the large tree trunks with the fan brush . . .

18. . . . the limbs and branches with the liner brush . . .

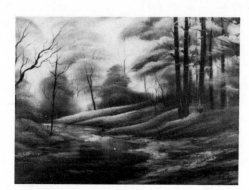

19. . . . to complete the painting.

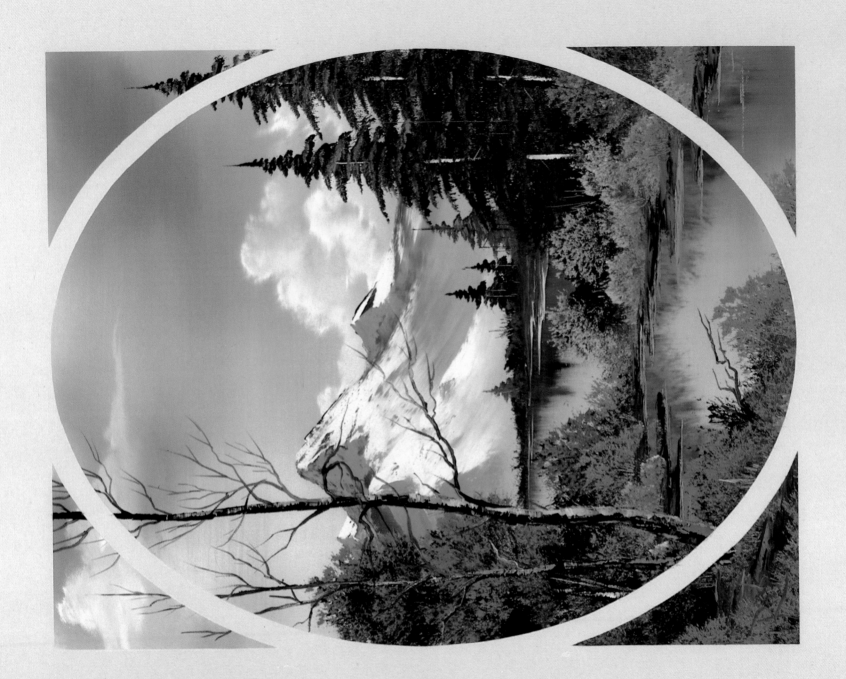

MATERIALS

2" Brush	Midnight Black
1" Brush	Dark Sienna
#6 Fan Brush	Van Dyke Brown
#2 Script Liner Brush	Alizarin Crimson
Large Knife	Sap Green
Adhesive-Backed Plastic	Cadmium Yellow
Liquid White	Yellow Ochre
Titanium White	Indian Yellow
Phthalo Blue	Bright Red

Start by covering the vertical canvas with adhesive-backed plastic (Con-Tact Paper), from which the corners and a center oval have been removed (refer to the first How-To Photo).

Cover the exposed area of the canvas with a thin, even coat of Liquid White using the 2" brush. Work back and forth with long horizontal and vertical strokes to ensure an even distribution of paint on the canvas. Do NOT allow the Liquid White to dry before you begin.

SKY AND WATER

With the 2" brush, add Indian Yellow to the center of the sky using criss-cross strokes. Starting just above the horizon, extend the color up to the left corner of the canvas and then reflect the same color into the water on the lower portion of the canvas. Without cleaning the brush, add Yellow Ochre to both sides of the Indian Yellow (in both the sky and water) and then add Alizarin Crimson. Still not cleaning the brush, complete the sky and water with a mixture of Phthalo Blue and Alizarin Crimson (Lavender). Now, with a clean, dry 2" brush, blend the entire canvas.

Load the 1" brush with Titanium White by pulling the brush in one direction through the paint to round one corner. With the rounded corner up, add the clouds using small circular strokes. Use a clean, dry 2" brush to blend and diffuse the base of the clouds and then gently lift upward to fluff. Lightly blend the entire sky.

MOUNTAIN

The mountain is quite Purple, made with a mixture of Phthalo Blue, Alizarin Crimson and Midnight Black. (You can test the color by adding a small amount to some White paint; it should look Lavender.) Load the long edge of the knife with a small roll of paint by pulling the mountain mixture out flat on your palette and just cutting across. Use firm pressure to shape just the top edge of the mountain. With the 2" brush, pull the paint down to the base to complete the entire mountain shape.

Highlight the mountain with a mixture of Titanium White and a small amount of Bright Red. Again, load the long edge of the knife with a small roll of paint. Holding the knife vertically, pull the paint down the right side of the peaks using so little pressure that the paint "breaks." Use a mixture of Titanium White and Phthalo Blue to add the snow to the left sides of the peaks, pulling in the opposite direction.

Using a clean, dry 2" brush and, following the angles, tap to diffuse the base of the mountain (creating the illusion of mist).

BACKGROUND

The small evergreens are made by adding Sap Green and Van Dyke Brown to the mountain mixture of Phthalo Blue, Alizarin Crimson and Midnight Black. Load the fan brush quite full of paint and, holding it vertically, just touch the canvas to create the center of each tree. Starting at the top of the tree, use one corner of the brush to add the branches. Working from side to side, use more pressure as you near the base of the tree causing the branches to become larger.

Using the same mixture, hold the fan brush horizontally, touch the canvas and force the bristles to bend upward as you add the ground area beneath the small evergreens. Reverse the brush and reflect the trees into the water. With a clean, dry 2" brush, pull the reflections straight down and then lightly brush across to create a watery appearance.

Use a small roll of Liquid White on the knife and firm pressure to cut in the water lines. With the point of the knife, scratch in trunk indications.

FOREGROUND

Working forward in the painting, use the same dark tree mixture on the fan brush to add the large evergreens.

Underpaint the leaf trees and bushes by pulling the 1" brush through a mixture of Van Dyke Brown and Dark Sienna, to round one corner. With the rounded corner up, touch the canvas forcing the bristles to bend upward. Reverse the brush to reflect these trees and bushes into the water and again use a clean, dry 2" brush to pull down and lightly brush across.

Working in layers, extend the trees and bushes on the left side of the painting to the bottom of the canvas, then add tree trunks with the knife and Dark Sienna. Highlight the right sides of the trunks with a mixture of Dark Sienna, Titanium White and Phthalo Blue on the knife.

Highlight the leaf trees and bushes by dipping the 1" brush into Liquid White and then pulling it through various mixtures of all the Yellows, Dark Sienna and Bright Red. With the rounded corner of the brush up, touch the canvas and force the bristles to bend upward as you shape the individual trees and bushes; try not to just hit at random. Be very careful not to "kill" all of your dark base color. Remember, you need dark in order to show light. Reverse the brush to reflect the highlights into the water. Once again, use a clean, dry 2" brush to very lightly pull down and brush across the reflections.

Lightly touch highlights to the right sides of the large evergreens using Yellow Ochre on the fan brush.

Add the banks along the water's edge with Van Dyke Brown and the knife. Highlights are Van Dyke Brown, Bright Red and Titanium White, applied so lightly that the paint "breaks." Use Liquid White on the knife to cut-in the water lines and ripples. You can add little grassy areas to the banks with the highlight colors on the fan brush.

The path is also made with Van Dyke Brown on the knife using short horizontal strokes and then highlighted with Van Dyke Brown and Titanium White.

LARGE TREES

The large trees in the foreground are made by loading the fan brush with Van Dyke Brown. Starting at the top of the canvas, hold the brush vertically and pull down. Use more pressure as you near the base of the trees causing the trunks to become wider.

Highlight the right sides of the tree trunks with a mixture of Titanium White and Bright Red using the knife. The branches are added with thinned Van Dyke Brown on the liner brush.

FINISHING TOUCHES

You can use the point of the knife to just indicate small sticks and twigs or use thinned paint on the liner brush to add final details.

Remove the adhesive-backed plastic from the canvas, and VOILA! a masterpiece. Don't forget to add your signature.

Sunset Oval

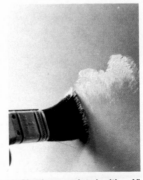
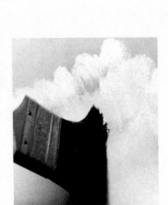
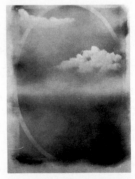

1. Start with a canvas covered with Con-Tact Paper which has a design cut out of the center.

2. Use criss-cross strokes . . .

3. . . . to paint the initial sky colors. Blend with a 2" brush to remove all harsh edges.

4. Clouds are painted with a 1" brush using small circular strokes.

5. Use the top corner of the 2" brush . . .

6. . . . to blend the base of each cloud. Long horizontal strokes are then used to soften and blend the entire sky.

Sunset Oval

7. Use the knife to paint the basic mountain shape . . .

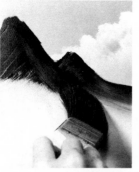

8. . . . then blend downward with a 2" brush to remove excess paint and soften toward the base.

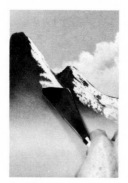

9. Apply highlights and shadows to the mountain with the knife.

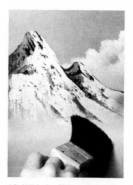

10. With the 2" brush, tap the base of the mountain . . .

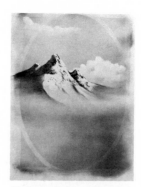

11. then lift upward to create the illusion of mist at the base.

12. Use the corner of the fan brush to paint evergreens.

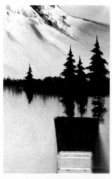

13. Reflections are made by pulling straight down, then across.

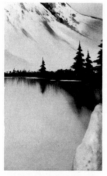

14. Waterlines are "cut-in" with the edge of the knife and Liquid White.

15. Use the fan brush to paint the large evergreens.

16. Push upward to create the initial tree and bush shapes.

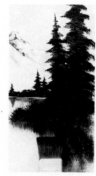

17. Pull straight down, then across, . . .

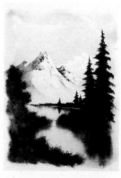

18. . . . to create reflections under the trees and bushes in the foreground area.

19. Tree trunks are painted with the edge of the knife.

20. Push gently upward to paint highlights on individual bushes.

21. The knife is used to make and highlight the path.

22. Land areas in the foreground are painted with the knife.

23. Push upward with the fan brush to make grassy areas.

24. Carefully remove the Con-Tact Paper . . .

25. . . . to expose your beautiful painting.

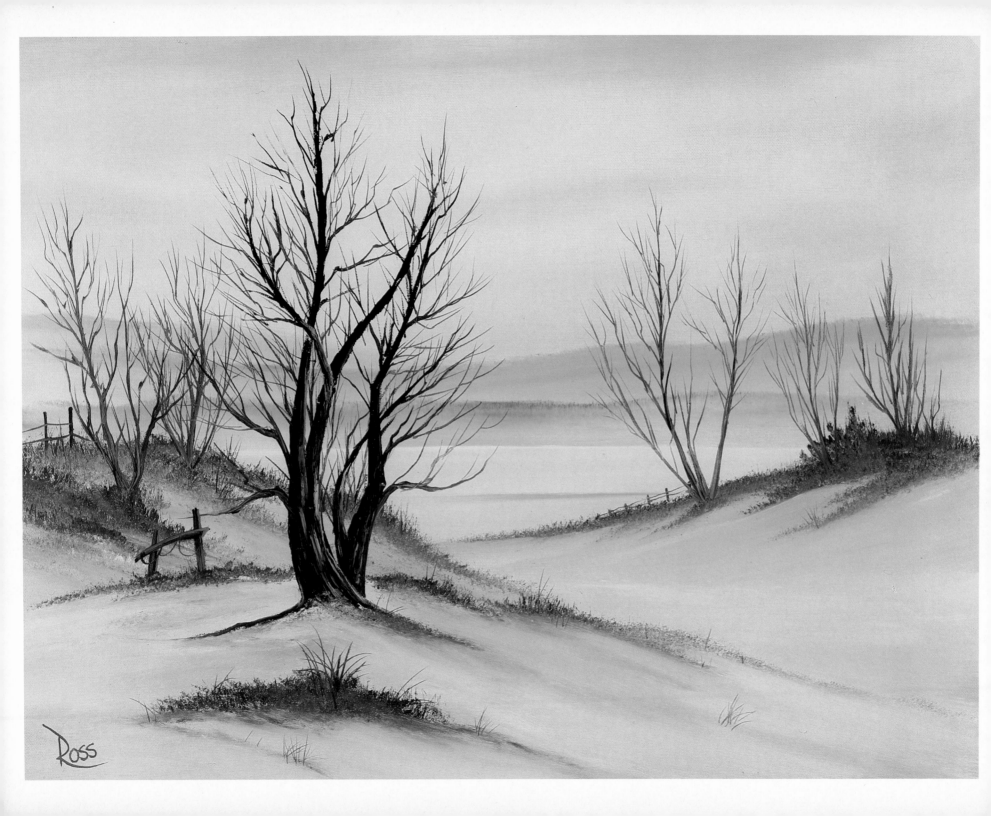

MATERIALS

2″ Brush	Phthalo Blue
#6 Fan Brush	Midnight Black
#2 Script Liner Brush	Dark Sienna
Large Knife	Van Dyke Brown
Liquid White	Alizarin Crimson
Titanium White	Bright Red

Start by covering the entire canvas with a thin, even coat of Liquid White, using the 2″ brush. Use long horizontal and vertical strokes, working back and forth to ensure an even distribution of paint on the canvas. Do not allow the Liquid White to dry before you begin.

SKY

Load the 2″ brush with Alizarin Crimson, tapping firmly against the palette to ensure an even distribution of paint throughout the bristles. Holding the brush horizontally and leaving some areas unpainted, make long, sweeping horizontal strokes of Pink in the sky. Also use horizontal strokes to add a little Pink to the bottom half of the canvas where the snow and water will be. Without cleaning the brush, pick up a little Midnight Black with just a touch of Phthalo Blue. Again using sweeping, horizontal strokes, add this color to the unpainted areas in the sky and also add a little to the ground area of the painting. Use a clean, dry 2″ brush to blend the entire canvas.

BACKGROUND HILLS

Without cleaning your 2″ brush, pick up a very small amount of Midnight Black and Phthalo Blue. To shape the most distant hill, use just one corner of the brush to touch the canvas and pull down. This hill should be very light in value but darker at the top than at the bottom. Use a clean, dry 2″ brush to tap and diffuse the base of the hill, creating the illusion of mist. By adding more paint to your brush, each range of hills can be made darker as you work forward. Work in layers, tapping and misting as you go.

BACKGROUND WATER

To make the frozen lake at the base of the hills, use the 2″ brush with Titanium White. Decide where you would like your lake to be; hold the brush flat against the canvas and pull down with short strokes. Then, use horizontal strokes with more Titanium White. Use the knife to add a little of the Phthalo Blue-Midnight Black mixture and continue to brush across to soften.

BACKGROUND TREES

Load the 2″ brush with a Lavender mixture of Titanium White, Alizarin Crimson and Phthalo Blue. Moving forward in the painting and paying close attention to the lay-of-the-land, add the small hill in front of the frozen lake.

Use Van Dyke Brown and Dark Sienna on the fan brush to make the grassy areas. Hold the brush horizontally and push it into the canvas, forcing the bristles to bend upward. You can create all sorts of little "happenings" but, pay close attention to angles. Use Titanium White with a touch of Bright Red on the fan brush to apply snow and highlights to your little hill. Carefully follow the shape of the hill and don't be concerned if you pull in a little of the Brown color, it will create shadow effects. Try not to completely cover the Lavender base color.

Use the liner brush and Van Dyke Brown to make the small leafless trees. Dip the brush into paint thinner and turn the handle as you pull through the paint, forcing the bristles to a sharp point. Be sure to load a lot of paint into the bristles. Use very little pressure as you form the tree trunks and branches. You can start from the top of the trunks and branches working towards the base, or start from the base and work out towards the tips. Experiment, find out which method works best for you. You can also use this same technique to add the tiny fence under the trees.

FOREGROUND

Use the same Lavender mixture on the 2″ brush to shape the small hill in the foreground. With Van Dyke Brown and

Dark Sienna on the fan brush, add the most distant grassy area to this hill. Again, use Titanium White with a little Bright Red on the fan brush to pull in the snow at the base of the grass. Add the small trees and fence and tiny sticks and twigs with the liner brush and thinned Van Dyke Brown. Complete this hill in stages, finishing the most distant areas before moving forward.

The large tree in the foreground is made with Van Dyke Brown and the knife. Pull the paint out flat on the palette and just "cut" across to load the long edge of the knife with a small roll of paint. Start at the base of the tree and allow the trunk and branches to become smaller as you near the tips.

Use a thinned mixture of Dark Sienna and Titanium White on the liner brush to highlight the trunk and create the appearance of bark. Use thinned Van Dyke Brown on the same brush to add the small limbs and branches. With Van Dyke Brown on the fan brush, you can form the bottom of the trunk, then add some snow to the base of the tree with Titanium White.

FINISHING TOUCHES

Additional sticks and twigs and long grasses can be added using the liner brush and Van Dyke Brown. Now, all you need is a signature!

Winter Solitude

1. Use the 2" brush . . .

2. . . . to paint the initial sky and land patterns.

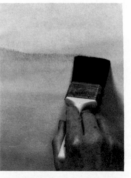
3. Tap downward with the 2" brush to make distant foothills.

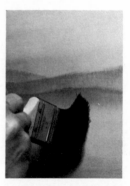
4. Use the top corner of the 2" brush . . .

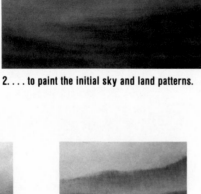
5. . . . to firmly tap the base of each foothill to create a misty effect.

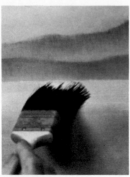
6. The 2" brush is used . . .

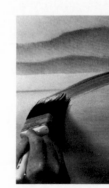
7. . . . to pull color across the area which indicates a frozen lake or pond.

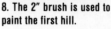
8. The 2" brush is used to paint the first hill.

Winter Solitude

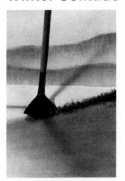

9. Push upward with the fan brush . . .

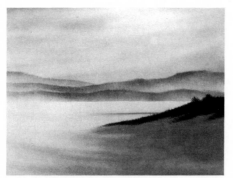

10. . . . to paint grass on the hills.

11. Use the fan brush to clean up the bottom of the grassy areas.

12. Trees painted with the liner brush loaded with a thin paint.

13. Fence post made with the liner brush and a thin paint.

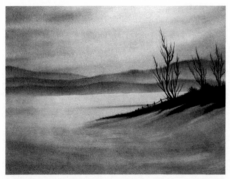

14. Work in layers, completing the most distant hill first.

15. Use the 2″ brush to apply color for the next hill.

16. Pushing upward with the fan brush . . .

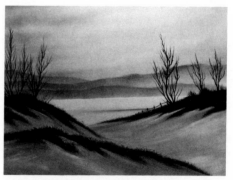

17. . . . to add grass to the foreground hills. Pay close attention to angles.

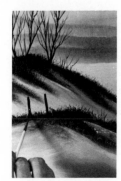

18. Use the liner brush to paint fence post, sticks and twigs.

19. The knife is used . . .

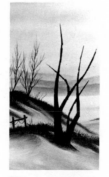

20. . . . to paint the main trunk of the large tree.

21. Small tree limbs are added with the liner brush.

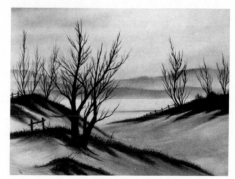

22. Add a few finishing touches and your masterpiece is completed.

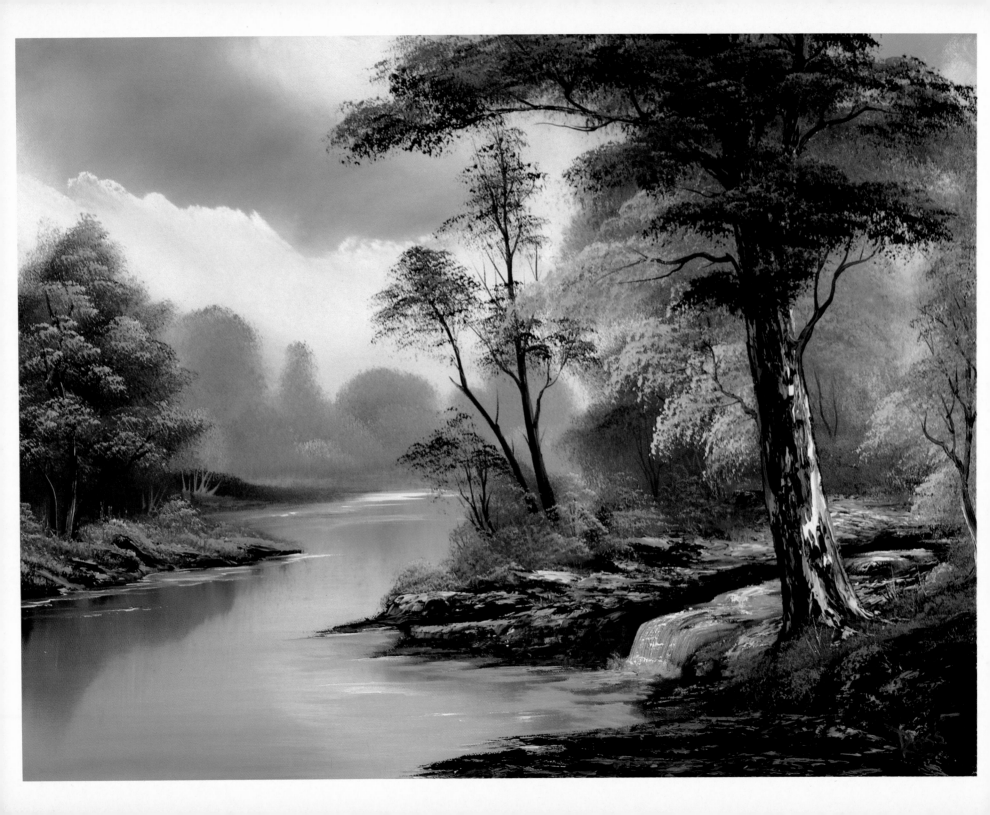

MATERIALS

2" Brush	Midnight Black
1" Round Brush	Dark Sienna
#6 Fan Brush	Van Dyke Brown
#2 Script Liner Brush	Alizarin Crimson
Large Knife	Sap Green
Small Knife	Cadmium Yellow
Liquid White	Yellow Ochre
Titanium White	Indian Yellow
Phthalo Blue	Bright Red
Prussian Blue	

Start by covering the entire canvas with a thin, even coat of Liquid White using the 2" brush. Work back and forth with long horizontal and vertical strokes to ensure an even distribution of paint on the canvas. Do NOT allow the Liquid White to dry before you begin.

SKY

Load the 2" brush with a mixture of Prussian Blue, Midnight Black and a small amount of Yellow Ochre. Use small twirling motions to add this color to the sky, leaving open areas for clouds. With long horizontal strokes use the same color to add the water to the lower portion of the canvas.

Use a clean, dry 2" brush and circular strokes to blend the entire sky.

With Titanium White on the 2" brush, use circular strokes to add the clouds to the open areas in the sky. With a clean, dry 2" brush, blend out the bottoms of the clouds and then gently lift upward to fluff.

BACKGROUND

Add more Midnight Black to the sky mixture, load the 1" round brush and tap in the basic background tree shapes. Allow some of this dark base color to extend into the water area for reflections. Add various mixtures of Yellow Ochre, Indian Yellow and Bright Red to the same brush for the highlights. Tap downward with just the top bristles of the brush to create individual tree and bush shapes. With a clean, dry 2" brush, gently pull down the reflections and lightly brush across to give them a watery appearance.

Add Van Dyke Brown to the tree mixture and use the 2" brush to tap in the ground area at the base of the distant trees. Pull a little of this dark mixture into the water and again, gently brush across, to create reflections. Use a small roll of Liquid White on the knife to cut-in the water lines.

MIDDLEGROUND

Underpaint the larger trees and bushes with a mixture of Van Dyke Brown, Midnight Black, Phthalo Blue and Alizarin Crimson using the 1" round brush. Just tap in the basic tree and bush shapes. Add this dark base color to the water for the reflections. Use a clean, dry 2" brush to pull down the reflections and then gently brush across to create a watery appearance.

Use thinned Van Dyke Brown on the liner brush to add the tree trunks and branches to the basic shapes.

Highlight the trees and bushes using various mixtures of Dark Sienna, all the Yellows, Sap Green, Bright Red and Alizarin Crimson on the 2" brush. With just one corner of the brush, tap in the leaf patterns to form individual tree and bush shapes. Be very careful not to " kill" all of your dark base color.

The land at the base of the trees and bushes on the left side of the painting is made with Van Dyke Brown using the knife. Highlight the land area with a mixture of Dark Sienna, Van Dyke Brown and Titanium White on the knife. Use mixtures of all the Yellows and Sap Green on the fan brush; push the bristles straight into the canvas and force them to bend upward as you add little grassy areas to the land. Use firm pressure with Liquid White on the knife to cut-in the water lines.

WATERFALL

On the right side of the painting, underpaint the banks of the waterfall with Van Dyke Brown and Dark Sienna on the

knife. Extend this dark mixture to the bottom of the canvas (leaving an open area for the waterfall) and then add the highlights with a mixture of Titanium White, Dark Sienna, Van Dyke Brown and Phthalo Blue.

To paint the waterfall, use the fan brush and a mixture of Liquid White, Titanium White and Phthalo Blue. With Titanium White on the small knife, "skip" some highlights across the waterfall. Use the fan brush and Liquid White and Titanium White to add little water actions to the base of the falls and along the water's edge at the base of the banks.

FOREGROUND

Use Van Dyke Brown and the knife to add the large tree trunk in the foreground and then highlight with a mixture of Dark Sienna, Titanium White and Phthalo Blue. Use the corner of the 2″ brush to add leaves to the tree with a mixture of Sap Green and Dark Sienna. Highlight the leaves with a mixture of Yellow Ochre and Sap Green.

FINISHING TOUCHES

Use the point of the knife to scratch in small sticks and twigs or you can use thinned paint on the liner brush to add final details.

Hidden Stream

1. Use small circular strokes . . .

2. . . . to paint the initial sky shapes.

3. Use the 2″ brush to make . . .

4. . . . and blend the individual cloud formations.

5. Tap downward with the round brush to paint the basic tree and bush shapes.

6. Pull straight down, then across, with the 2″ brush to create reflections.

7. The indication of land areas is made by tapping downward with the 2″ brush.

8. Use the knife, applying a firm pressure, . . .

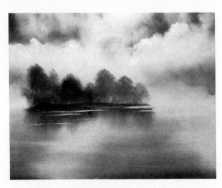

9. . . . to cut in water lines.

Hidden Stream

10. A thin paint, on the liner brush, . . .

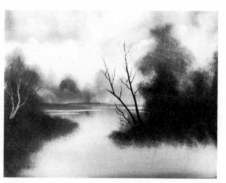

11. . . . is used to paint tree trunks.

12. Pull straight down, then across, . . .

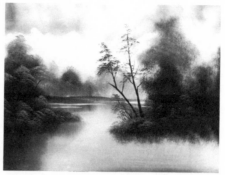

13. . . . to make reflections under the foreground bushes and trees.

14. Land areas are made with the knife.

15. Push upward with the fan brush to paint grassy areas.

16. The knife is used to "cut-in" water lines.

17. Use the knife . . .

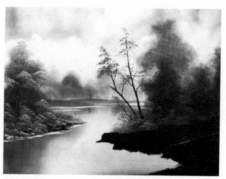

18. . . . to lay in the large land areas.

19. Using very little pressure, apply highlights with the knife.

20. Use the fan brush to paint the waterfall . . .

21. . . . then add highlights with the knife.

22. With the knife . . .

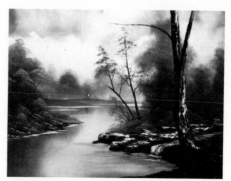

23. . . . paint and highlight the large tree trunk.

24. Use the corner of the 2" brush to make foliage.

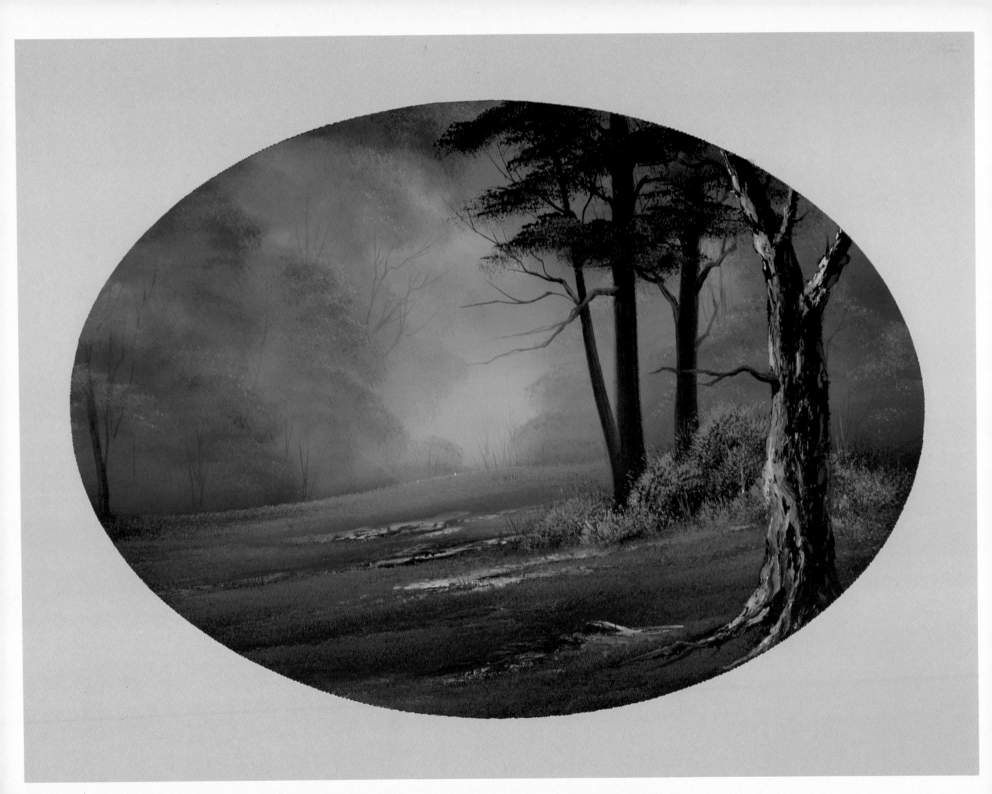

MATERIALS

2″ Brush	Midnight Black
1″ Brush	Dark Sienna
#6 Fan Brush	Van Dyke Brown
#2 Script Liner Brush	Alizarin Crimson
Large Knife	Sap Green
Adhesive-Backed Plastic	Cadmium Yellow
Black Gesso	Yellow Ochre
Liquid White	Indian Yellow
Titanium White	Bright Red
Phthalo Blue	

Start by covering the entire canvas with adhesive-backed plastic (such as Con-Tact Paper) from which you have removed a 14x20 center oval. Then, cover the entire canvas with a thin, even coat of Black Gesso and allow it to dry completely before you begin painting.

Use the 2″ brush to cover the exposed area of the canvas with a mixture of Alizarin Crimson and Phthalo Blue; allowing the center to be quite light by using less Phthalo Blue in that area. Because this mixture is made with transparent colors, the canvas should still look quite dark. Do NOT allow the canvas to dry before you begin!

SKY

Using the 2″ brush with Liquid White, decide where the lightest area of your sky is and begin with criss-cross strokes, blending from the lightest area outward. Notice how the sky "comes alive" as the Liquid White picks up the transparent colors already on the canvas. This step can be repeated as many times as necessary to achieve a desired lightness in the sky, but be sure to clean and dry the brush before each application! Gently blend the entire sky with long, horizontal strokes.

BACKGROUND

Use the 2″ brush and the same Alizarin Crimson-Phthalo Blue mixture to block in the general background tree and bush shapes. Hold the brush horizontally and tap downward with just the corner of the brush, paying close attention to form and shape. These shapes should be very soft and quiet, this will help create the illusion of distance in your painting. Be careful not to "kill" the bright center area of the sky. Add more Phthalo Blue to darken the paint mixture as you move further away from the light area.

Use the liner brush and the Alizarin Crimson-Phthalo Blue mixture, which has been thinned with paint thinner, to add the tree trunks, twigs and branches.

For leaf clusters and foliage on the background tree and bush shapes, use the 1″ brush and various dark mixtures of Alizarin Crimson and Phthalo Blue with a small amount of Titanium White. Hold the brush horizontally and, using just one corner, tap in the individual shapes. Don't just hit at random, this is where you give shape and form to your trees and bushes. Work in layers keeping the most distant trees and bushes quite dark; add a small amount of Titanium White to the mixture as you move forward.

MIDDLEGROUND

The soft grassy highlights are made with the 2″ brush and various mixtures of Alizarin Crimson, Phthalo Blue, all the Yellows and a small amount of Bright Red. Load the brush by holding it at a 45-degree angle and tapping the bristles into the various paint mixtures. Allow the brush to "slide" slightly forward in the paint each time you tap (this ensures that the very tips of the bristles are fully loaded with paint).

Begin at the base of the most distant trees and work forward in layers, carefully following the lay-of-the-land. By holding the brush horizontally and gently tapping downward, you can create grassy highlights that look almost like velvet. Add a small amount of Titanium White to the brush for the brightest areas in the grass.

Use Van Dyke Brown on the knife for the exposed land areas, rocks and stones and then highlight with a mixture of Titanium White and Dark Sienna, using so little pressure that

the paint "breaks." Use the 2" brush with the Yellow-Green mixtures to add the grassy areas around the rocks and stones.

For the larger tree trunks on the right, use the fan brush and Midnight Black. Holding the brush vertically, and starting at the top of each tree, just pull down. Use more pressure on the brush as you near the base of the tree and automatically the trunk will become wider.

The limbs and branches are made with a mixture of Midnight Black and paint thinner on the liner brush. Bring the bristles to a sharp point and use very little pressure on the brush. Continuing to work in layers, extend the grassy areas into the foreground.

Add foliage to the trees with the 1" brush and a mixture of Alizarin Crimson and Phthalo Blue. Use one corner of the brush and tap downward. Use the same brush to just block in some small bush shapes at the base of the trees.

Highlight the bushes by dipping the 1" brush into Liquid White, then pulling it in one direction (to round one corner) through various mixtures of all of the Yellows and Sap Green. With the rounded corner up, shape each bush using gentle pressure, allowing the bristles to bend upward.

Use the point of the knife to scratch in small sticks and twigs and then highlight the left sides of the trunks with Titanium White, Dark Sienna and a touch of Bright Red on the knife. With a clean knife, gently "touch and tap" the highlights for a muted effect.

FOREGROUND

The large tree trunk in the foreground is made with Van Dyke Brown on the long edge of the knife. Starting at the top of the canvas, pull down, allowing the trunk to become wider near the base.

Load the long edge of the knife with a mixture of Titanium White, Dark Sienna and Bright Red. Hold the knife vertically and gently touch highlights to the left side of the trunk, allowing the paint to break, creating a bark texture. Use a mixture of Titanium White and Phthalo Blue on the right side of the trunk for shadows. Use Van Dyke Brown in the middle of the trunk to pull the highlight color and shadow color together, giving the trunk a rounded effect. Use thinned Van Dyke Brown on the liner brush to add the limbs and branches.

FINISHING TOUCHES

Remove the adhesive-backed plastic from the canvas to expose another beautiful masterpiece! Don't forget to add your signature!

Misty Forest Oval

1. Cover the entire canvas with Black Gesso.

2. Use criss-cross strokes . . .

3. . . . to paint the sky.

4. Use the 2" brush to tap in basic tree shapes . . .

5. . . . and the liner brush to add the tree trunks . . .

Misty Forest Oval

6. . . . to the background.

7. Tap in the grassy highlights . . .

8. . . . then add land areas . . .

9. . . . to the background.

10. Pull down trunks . . .

11. . . . then add limbs and branches . . .

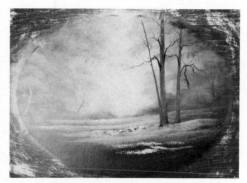

12. . . . to the large middleground trees.

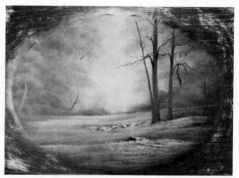

13. Extend the land and grassy areas into the foreground.

14. Add leaf clusters to the trees.

15. Use the 1" brush to highlight the small bushes . . .

16. . . . and then scratch in sticks and twigs.

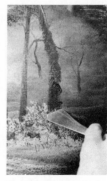

17. Pull down the large tree trunk . . .

18. . . . and highlight with the knife . . .

19. Remove the adhesive-backed plastic . . .

20. . . . to expose your finished masterpiece!

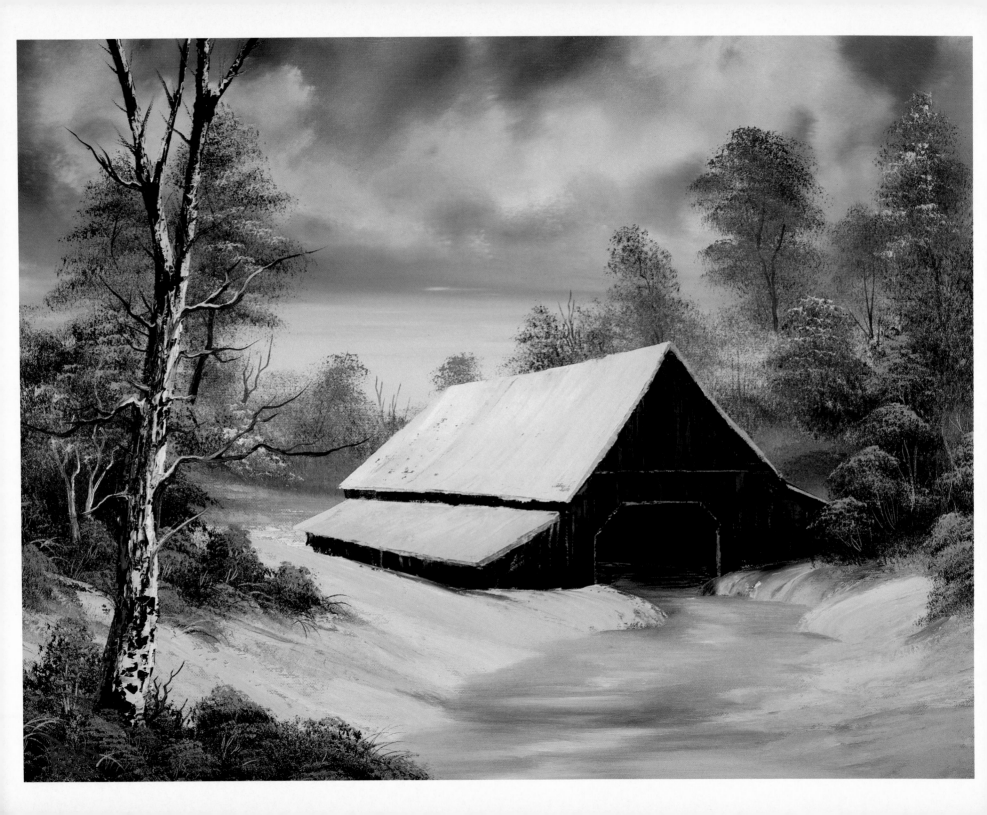

MATERIALS

2" Brush	Phthalo Blue
1" Brush	Midnight Black
1" Round Brush	Dark Sienna
#6 Fan Brush	Van Dyke Brown
#2 Script Liner Brush	Alizarin Crimson
Large Knife	Cadmium Yellow
Small Knife	Yellow Ochre
Liquid White	Indian Yellow
Liquid Black	Bright Red
Titanium White	

Start by covering the entire canvas with a thin, even coat of Liquid White, using the 2" brush. Use long horizontal and vertical strokes, working back and forth to ensure an even distribution of paint on the canvas. Do not allow the Liquid White to dry before you begin.

SKY

Load the 2" brush with a little Indian Yellow. Using horizontal strokes, lay in a band of this color in the sky area just above the horizon. Without cleaning the brush, add a band of Yellow Ochre and then, still not cleaning the brush, add a band of Bright Red. Blend these colors together very slightly. Now, clean and dry your brush. Still with the 2" brush, pick up a little Midnight Black and begin making little x-patterns across the top of your canvas. Leave an area unpainted between the colors and the Black. With a clean 2" brush, using Dark Sienna, make small circular cloud shapes into the unpainted area of the sky. Highlight these clouds using the 1" brush, loaded with a mixture of Titanium White and a little Bright Red. Make small circular movements where the Dark Sienna meets the Black. Use the top corner of a clean, dry 2" brush and just blend out the bottoms of the Pink clouds. Gently fluff the clouds by lifting upward. Finish the sky by loading the long edge of the knife with a small roll of Cadmium Yellow. Holding the knife horizontally, go straight into the canvas and add some tiny cloud streaks into the Yellow area of the sky. Blend gently with a clean, dry 2" brush.

BACKGROUND

Load the 1" round brush with a mixture of Midnight Black, Phthalo Blue and Alizarin Crimson. Tap in some basic tree shapes across the horizon. Make trunk indications using the liner brush and thinned Van Dyke Brown. Highlight these trees with various mixtures of Yellow, Alizarin Crimson, Bright Red and Titanium White and Phthalo Blue, Alizarin Crimson and Titanium White.

Use the 2" brush and Titanium White to lay in snow at the base of the background trees. Use the fan brush to create the lay-of-the land by pulling in some of the dark tree colors— creating shadows in the snow. Lift upward, making a misty effect at the base of the trees.

BARN

Use the knife to remove the paint and scrape in your basic barn shape. Load the 2" brush with Van Dyke Brown, pulling through the paint to form a chiseled edge. Use the brush flat to pull in the back overhang. Then, pull straight down to form the front of the barn. Next lay in the sides of the barn. Without cleaning the brush, load it with a mixture of Titanium White and Dark Sienna. Pull this highlight color very gently over the dark barn, allowing the paint to "break" and "wiggle." This should give the impression of old wood. Use Van Dyke Brown on the long edge of the knife to cut in boards. Very, very gently blend using the 2" brush and vertical strokes. With Van Dyke Brown and the small knife, lay in the barn door. Using the large knife and Titanium White, lay snow on the roof and along the edges.

FOREGROUND

With the 2" brush and Titanium White (with Phthalo Blue for shadows), pull in the snow-covered ground area around the barn and in the foreground.

Load the round brush with a mixture of Midnight Black, Van Dyke Brown, Phthalo Blue and Dark Sienna and tap in the foreground tree and bush shapes. Use the liner brush and Liquid White to add tree trunks. Highlight the tree and bush shapes by tapping with the round brush, using various mixtures of White, Red, Yellows and Blue. Use a clean, dry fan brush to form the lay-of-the-land by pulling the dark colors into the snow-covered ground areas, creating shadows.

LARGE TREE

Load the fan brush with Van Dyke Brown. Hold the brush vertically, touch the top of the canvas and pull straight down. Increasing pressure will cause the tree trunk to get wider near the bottom. Use Liquid Black on the liner brush to indicate limbs and branches. Highlight the tree trunk by loading the long edge of the knife with a small roll of Van Dyke Brown and Titanium White. Hold the knife vertically, touch the right edge of the tree trunk and gently pull towards the left. The left side of the trunk is highlighted in the same way using a little Phthalo Blue and Titanium White. Add snow to the branches using Liquid White on the liner brush.

FINISHING TOUCHES

Use the liner brush to pull up long grasses, sticks and twigs and also to sign your name. Your masterpiece is complete.

Barn at Sunset

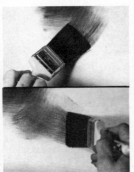
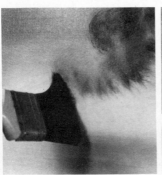
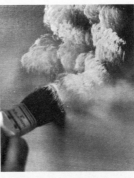
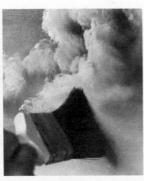
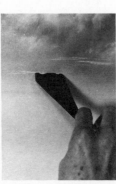

1. With horizontal strokes, lay in the light colors at the horizon.

2. Use criss-cross strokes to complete the dark areas of the sky.

3. Use corner of the 2" brush to lay in the basic cloud shapes.

4. Highlights are applied to the clouds with the 1" brush . . .

5. . . . then blended with the top corner of the 2" brush.

6. Individual streaks of color are added with the knife . . .

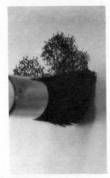

7. . . . then blended with horizontal strokes of the large brush.

8. Basic tree and bush shapes made with the round brush.

9. Highlights are applied to trees and bushes with the round brush. Work in layers, . . .

10. Initial snow shapes are layered in with the 2" brush . . .

11. . . . then shadows and fine detail are added with a fan brush.

Barn at Sunset

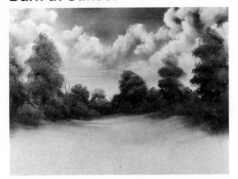

12. When the background is complete . . .

13. . . . scrape out the basic barn shape.

14. Underpaint the barn.

15. Add boards and door . . .

16. . . . then snow on the roof . . .

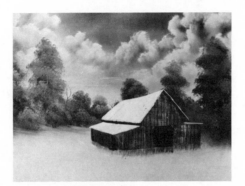

17. . . . to complete the barn.

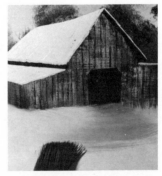

18. The indication of a path is made with horizontal strokes.

19. Pull a small amount of color into the snow to create shadows.

20. Use the liner brush to paint in trunks . . .

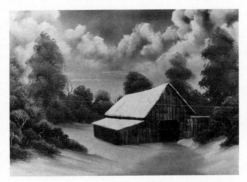

21. . . . then highlight the bushes and trees with the round brush.

22. Lay in the basic tree shape with a fan brush . . .

23. . . . then highlight with the knife.

24. Tree limbs are made and highlighted with the liner brush.

25. Add fine details and sign.

MATERIALS

2" Brush
1" Oval Brush
#6 Fan Brush
#2 Script Liner Brush
Large Knife
Small Knife
Masking Tape
Black Gesso
Liquid White
Titanium White

Phthalo Blue
Midnight Black
Dark Sienna
Van Dyke Brown
Sap Green
Cadmium Yellow
Yellow Ochre
Indian Yellow
Bright Red

Cover the entire canvas with a thin, even coat of Black Gesso and allow to dry completely before you begin. When the canvas is dry, cover a 2" border at the top and bottom of a vertical canvas with masking tape. Cover 3" on each side of the canvas with the tape. Using the 2" brush, cover the entire dry canvas with a mixture of Sap Green and Phthalo Blue. Do not allow your canvas to dry before you begin the painting.

BACKGROUND

Create the misty effect in the background by using the fan brush to "twirl-in" Titanium White on the upper portion of the canvas. By using quite a bit of pressure on the brush, the Titanium White will pick up the dark mixture already on the canvas giving the background a Blue-Green color. With a clean, dry 2" brush use long, vertical strokes to blend the background.

Add the indication of distant tree trunks by loading the fan brush with Midnight Black. Hold the brush vertically and use a downward tapping motion as you work from the top of the canvas down towards the horizon. Use more pressure on the brush, allowing the trunks to become wider as you near their base.

To add the tiny limbs and branches to the tree trunks, use a mixture of Midnight Black and paint thinner on the liner brush. Turn the brush as you pull it through the mixture, forcing the bristles to a sharp point and then use very little pressure to paint the limbs and branches.

Because the canvas is already wet with the dark underpaint, you need only highlight colors to create the grassy areas to the painting. Load the 2" brush with various mixtures of all the Yellows and Bright Red. Hold the brush horizontally and tap downward; working in layers, pay close attention to the lay-of-the-land. Be sure not to extend the highlight colors into the area where the water will be added.

WATER

Load the fan brush with Titanium White. Starting in the background, add the water by holding the brush horizontally and using short, horizontal strokes. The Titanium White should mix with the wet, dark underpaint, adding a Blue-Green color to the area. As you work forward in the painting, use downward strokes and swirls to create tiny waterfalls and other details of moving water. Watch your perspective and allow the stream to become wider as you near the foreground.

Use a mixture of Van Dyke Brown and Dark Sienna on the knife to add the rocks and stones to the water's edge and then highlight with a mixture of Titanium White and Dark Sienna.

You can add grass to the base of the individual rocks with a mixture of all the Yellows on the fan brush.

WATERFALL

Underpaint the large rocks beside the waterfall with Van Dyke Brown on the knife and again highlight with a mixture of Titanium White and Dark Sienna. Use the small knife to add the smaller rocks and stones to the center of the water.

Use a mixture of Liquid White and Titanium White on a clean fan brush for the waterfall. Holding the brush horizontally, start with a short, horizontal stroke and then pull the brush straight down with a long continuous stroke to add the falling water. Be sure to clean and reload the brush between each stroke. Use the corner of the brush and push-up strokes to add the foaming action to the base of the falls at the bottom of your painting.

Still using the grassy-highlight mixtures of all the Yellows, Sap Green and Bright Red on the 2" brush, use push-down strokes to add the grass to the large waterfall stones and rocks. Be sure to follow the contour of the rocks and stones and try not to completely cover them with this growth.

LARGE TREES

Add the large evergreen tree trunks in the painting with a mixture of Van Dyke Brown and Midnight Black on the fan brush. Again, hold the brush vertically and pull down. Make sure your trunks are wider at the base than at the top. With a small roll of Titanium White and Bright Red loaded on the long edge of the knife, vertically touch the right sides of the trunks for highlights. Apply shadows to the left sides of the trunks with a mixture of Titanium White and Phthalo Blue.

Use a thinned mixture of Midnight Black and Van Dyke Brown on the liner brush to add the limbs and branches to the trees. Underpaint the leaves by tapping with a mixture of Midnight Black and Sap Green on the oval brush. Carefully form individual leaf clusters, try not to just hit at random. Highlight the leaves with a Green mixture made by loading the oval brush with Midnight Black and Cadmium Yellow. Just tap to highlight being very careful not to "kill" all of your dark base color.

FINISHING TOUCHES

At this point, you can remove the masking tape from your painting. Use Titanium White on the fan brush to extend the water into the borders created by the tape and then use the 2" brush with all of the Yellow highlight mixtures to add the grassy areas to the edges of the stream.

Use a very thinned mixture of color on the liner brush to sign your painting. You have truly created a masterpiece!

Evening Waterfall

1. Tape the borders of the canvas.

2. The background is painted with the fan brush . . .

3. . . . and blended with the 2" brush.

4. Pull down the trunks with the fan brush . . .

5. . . . then add branches with the liner brush . . .

6. . . . to complete distant trees.

7. Use the 2" brush . . .

8. . . . to tap in soft grassy areas.

Evening Waterfall

9. The stream is painted with the fan brush.

10. Shape rocks and stones with the knife.

11. The water fall . . .

12. . . . and foam are added with the fan brush.

13. Push down with the 2" brush to add grass to the rocks.

14. Paint large tree trunks with the fan brush . . .

15. . . . and then highlight with the knife.

16. Tap downward to paint . . .

17. . . . and highlight leaves with the oval brush.

18. Remove the tape . . .

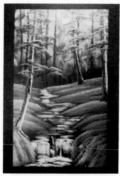

19. . . . from the borders of the painting.

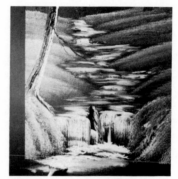

20. Use the fan brush to extend the waterfall . . .

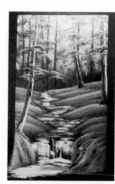

21. . . . outside the borders of the painting.

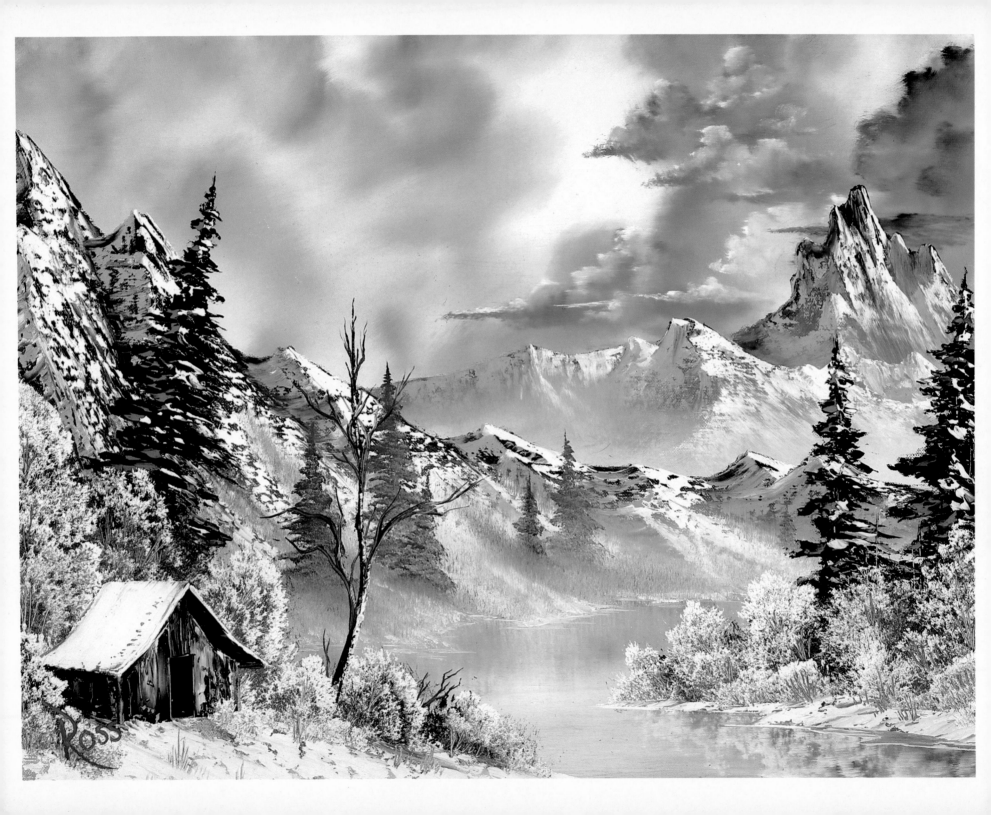

MATERIALS

2″ Brush	#2 Script Liner Brush
1″ Brush	Prussian Blue
Liquid White	Titanium White
Large Knife	Van Dyke Brown
#6 Fan Brush	

Cover the entire canvas with a thin, even coat of Liquid White using the 2″ brush. Work the paint back and forth, up and down, in long horizontal and vertical strokes to cover the canvas evenly. Do not allow the Liquid White to dry before you begin.

SKY

Mix a large batch of Grey by blending together 1/3 part Prussian Blue to 2/3 parts of Van Dyke Brown. This color, along with White, will be used to paint the entire painting. Load a small amount of Grey into the 2″ brush. Tapping it firmly on the palette will insure equal distribution throughout the bristles. Using one corner of the brush, in small circular strokes, lay in your basic cloud shapes. With a clean, dry 2″ brush, using the same circular strokes, blend the sky together. The indication of light rays is made with long strokes, at the desired angle, using a clean 2″ brush. To create distance in the sky, make some of the clouds more distinct. This is done with Grey and White, applied with the corner of the fan brush in small, circular strokes. Gently blend with the 2″ brush.

MOUNTAINS

Load a roll of dark Grey on the long edge of the knife. Using a very firm pressure, draw in your basic shape for the most distant mountains. Remove all excess paint and use the large brush to pull the remaining color down, following the angles in the basic mountain shapes. The highlights on the mountains are made with a small roll of Titanium White loaded on the long edge of the knife. Using almost no pressure, pull the knife down the side of the mountain where light would strike, allowing the paint to "break." The shadow side of the mountain is made the same way using a mixture of Grey and White pulled in the opposite direction. The shadow color should be lighter than the base color and darker than the highlights. When you have the highlights and shadows completed, tap the bottom of the mountain with the large brush held vertically, following the angles of the highlights and shadows, to create the mist. Use the brush flat, pulling upward, to remove the tap marks and to soften the mist. The mountains in the foreground are made the same way except the base color is darker to help create distance. Leave a misty area between your mountains for separation. With a clean 1″ brush, lift upward in short vertical strokes to make the indication of distant trees at the base of the mountain. Larger, more detailed trees are made with the fan brush loaded with a color just dark enough to show up well. Touch the brush to the canvas to make the center of the tree. Turn the brush sideways and use just the corner to make the limbs. Blend the trees and land area together, pulling upward in short strokes with a clean 1″ brush.

WATER

Lay in your basic water area using the 2″ brush with a little Grey and White. Use the brush flat, pulling from the outside in from both sides leaving an area in the center unpainted to create a sheen of light across the water. The reflections are made with the distant tree color on the 2″ brush. Holding the brush horizontally, touch just the very bottom of the land areas and pull straight downward. Gentle horizontal strokes with the large brush will give your reflections a watery appearance. Water lines are cut in with the palette knife at the point where the land and water meet. Pull the long edge of the knife through Liquid White laid on your palette and with a firm pressure cut in water lines.

TREES AND BUSHES

The large evergreen trees in the foreground are made with

your darkest Grey and the palette knife. Pull the long edge of the knife through the paint and touch the canvas, with the knife held vertically, to make the center of the tree. To start the tree, load a small amount of paint on the very point of the knife. Holding the knife flat, touch the canvas and move the blade from side to side to create branches. As you work down the tree, use larger amounts of paint on the knife and use more of the blade. When you have your basic tree shape completed, use the point of the knife to cut in a trunk indication. The highlights and shadows on the trees are made with the palette knife. Load a small roll of paint on the long edge and, with no pressure, pull outward from the center in horizontal strokes. The bushes under the evergreens are made with the 1" brush loaded with a dark Grey color. Load the brush by pulling it through the paint, in one direction, to round one corner. With the rounded corner up, lay in your basic shapes with a slight upward push of the brush. The bushes are highlighted with a mixture of Liquid White and Titanium White applied in the same manner. The land areas under the bushes are Titanium White applied with the knife. With a small roll of paint, using very little pressure, lay in these areas. Pay particular attention to the angles of each stroke and try to follow the lay-of-the-land.

CABIN

The cabin is made with the palette knife. I would suggest that you use the knife to scrape in a basic shape to follow; the removal of the paint will also make the next step easier. Start with the back eave or overhang, using a very dark Grey. The other side of the roof is Titanium White. Angles are very important to give your cabin the right appearance. The front and side are then put in using a very dark Grey applied in downward strokes. Small amounts of White may be added to the front of the cabin to create an aged appearance. Make the door with dark Grey, pulling the paint sideways and then highlighting the edges with White. You can now lay the land areas under the cabin with the knife and Titanium White. The tree near the cabin is made with a dark Grey color. Load a small roll of paint on the long edge of the knife. Wide parts of the trunk are made by pulling the knife sideways and thin parts by just touching the canvas. The limbs are made with the script liner brush loaded with dark Grey which has been thinned with a light oil. Highlights are Titanium White applied in the same manner.

FINISHING TOUCHES

With the point of the knife, scratch in sticks and twigs. Use a paint which has been thinned with oil on the script liner brush to sign your painting. Try your hand at painting scenes using only one other color and White. You will be amazed at some of the striking and beautiful results.

Shades of Grey

1. Clouds are made with the corner of the large brush.

2. Completed sky and mountain shape.

3. Completed mountains, showing angles of highlights and shadows.

4. Large evergreen tree...

Shades of Grey

...made with the knife.

5. Highlighting evergreens made with the knife.

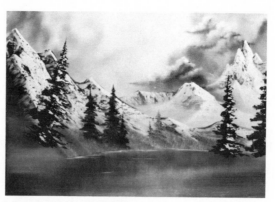

6. Evergreen trees completed.

7. Loading the 1" brush to make foreground bushes.

8. Highlighting foreground bushes.

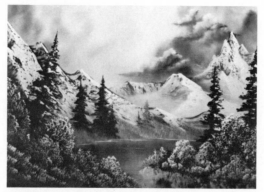

9. Structure of foreground trees and bushes.

10. A small roll of paint...

...is used to lay in land areas.

11. Progressional steps used to make the cabin.

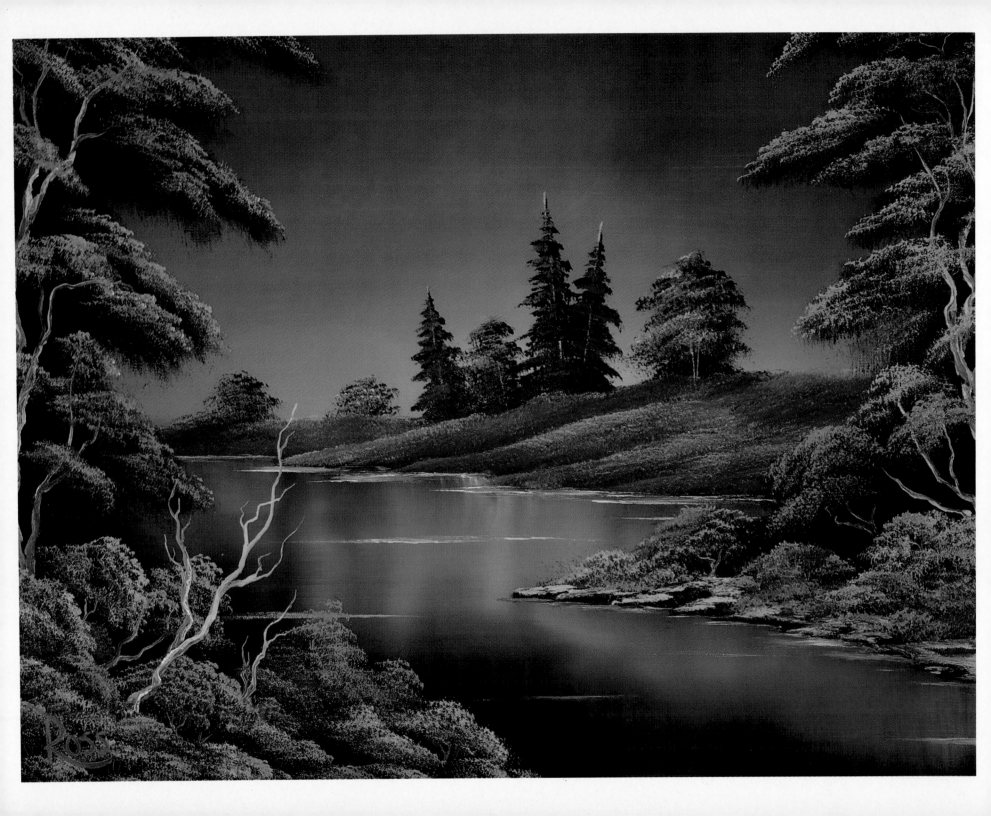

MATERIALS

2" Brush	Cadmium Yellow
1" Brush	Indian Yellow
Large Knife	Bright Red
Liquid White	Prussian Blue
Black Gesso	Phthalo Blue
#6 Fan Brush	Sap Green
#2 Script Liner Brush	Titanium White
Alizarin Crimson	Van Dyke Brown
Dark Sienna	Yellow Ochre

Start with a canvas that has been painted with Black Gesso and allowed to dry completely. Begin in the center of the canvas and paint an oval shaped area with Alizarin Crimson on the 2" brush. Another oval is painted around the first one using Phthalo Blue, then the remainder of the canvas is covered with Prussian Blue. With a clean, dry 2" brush, blend the entire canvas with long horizontal and vertical strokes. Do not allow the color to dry before you begin.

SKY

Use the 2" brush loaded with a very small amount of Liquid White to create your sky. Decide where you want your horizon and work all the way across the canvas using criss-cross strokes. Work upward from the horizon in layers, allowing the Liquid White to blend with the undercolors. This procedure may be repeated to achieve a desired lightness. Use long horizontal strokes to remove brush strokes and clean up your sky.

BACKGROUND

Start with a very dark color made from mixing Van Dyke Brown, Bright Red and Prussian Blue. Load the 2" brush by tapping it into this very dark Brown color. Hold the brush horizontally and tap downward to make the distant hills, allowing a little of the sky color to blend with the Brown. While you have this color on your brush, use the corner to tap in the basic leaf tree shapes. The distant evergreens are made with the fan brush, fully loaded with the same Brown color. Hold the brush vertically and touch the canvas to make the center of the tree. Turn the brush horizontally and use just the corner to make the branches. As you work down the tree, apply more pressure and force the bristles to bend downward. Highlights are varying mixtures of Cadmium Yellow, Sap Green, and Indian Yellow. The highlight colors are applied to the grassy areas and leaf trees with the 2" brush, tapped downward. Work in layers, completing the most distant areas first. The indication of tree trunks are made with a small roll of paint on the long edge of the knife, touched to the canvas. The evergreens are highlighted with Sap Green and Cadmium Yellow, applied with the fan brush.

WATER

To create reflections, load a small amount of Titanium White on the 2" brush. With the brush held horizontally, touch the canvas under the background land areas and pull straight down. Allow the Titanium White to mix and blend with the colors on the canvas. A few horizontal strokes, with the brush held flat, will give your reflections a watery appearance. Water lines are made with a mixture of Liquid White and Phthalo Blue loaded on the long edge of the knife. Hold the knife horizontally and cut into the canvas with a firm pressure.

FOREGROUND

Using the original Brown color, load the 2" brush by tapping into the color. The basic shapes for the bushes and trees are laid in using the corner of the brush, tapped firmly against the canvas in a downward direction. Tree trunks are made with the liner brush fully loaded with Titanium White which has been thinned to a watery consistency with paint thinner. Start at the top of the trunk and work downward applying more pressure as the trunk gets thicker toward the bottom. To create beautiful and interesting effects, turn the brush as you are working downward. Highlights are applied

to the trees and bushes with the 1″ brush loaded with varying mixtures of Cadmium Yellow, Sap Green, Yellow Ochre, Indian Yellow and Bright Red. Load the brush by tapping the bristles firmly into the color. Apply the highlights by tapping downward on the canvas. Do not allow the brush to slide. If your paint does not want to stick, thin your color with either Liquid White or paint thinner. Continue to complete each part of your painting in layers, finishing the most distant areas first. Land areas are a mixture of Van Dyke Brown and Dark Sienna applied with the fan brush. Use short back and forth strokes with the brush held horizontally to scrub in your land areas. Highlights are Yellow Ochre, Titanium White and a touch of Bright Red applied in the same manner. Be careful not to cover all the dark areas.

FINISHING TOUCHES

Additional sticks and twigs may be painted in with the liner brush or scraped in with the point of the knife. The signature is painted on with the liner brush loaded with a color thinned with a light oil. This is a painting that should be viewed under several different light sources.

Blue River

1. Use Liquid White and criss-cross strokes . . .

2. . . . to create the sky, then blend.

3. Tap downward with the 2″ brush . . .

4. . . . to make distant hills.

5. Using the 2″ brush for basic leaf tree shapes . . .

6. . . . and the fan brush for evergreens . . .

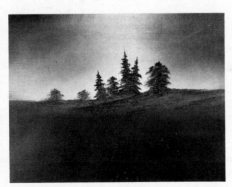

7. . . . complete background trees.

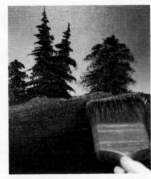

8. With the large brush, apply highlights to grassy areas . . .

9. . . . and tree trunk indications with the knife . . .

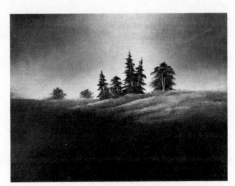

10. . . . to complete the distant hills and trees.

Blue River

11. With the 2" brush, pull straight down . . .

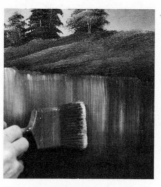

12. . . . and gently brush across to create water.

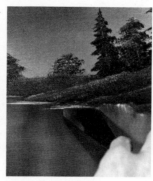

13. Use the long edge of the knife to cut in water lines.

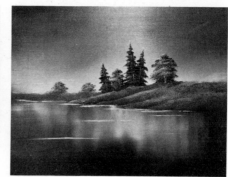

14. The background is complete.

15. Use just the corner of the 2" brush . . .

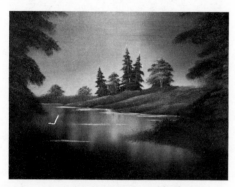

16. . . . to lay in foreground trees and bushes.

17. Use the liner brush . . .

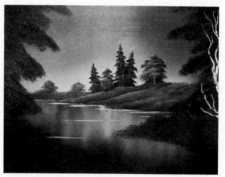

18. . . . to make tree trunks.

19. With the 1" brush, apply highlights . . .

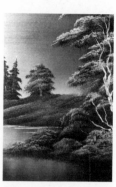

20. . . . to the foreground trees and bushes.

21. Pull in foreground reflections with the large brush.

22. Scrub in . . .

23. . . . and highlight land areas, using the fan brush.

24. Cut in water lines using the long edge of the knife. And the painting is ready to sign.

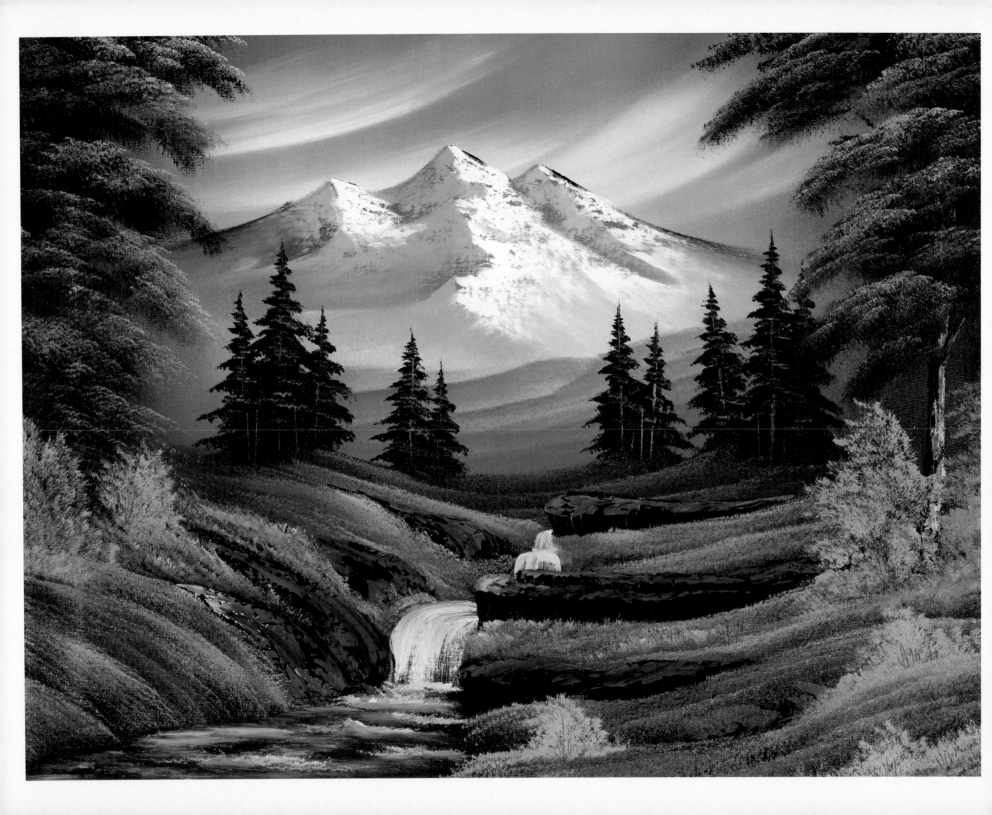

MATERIALS

2" Brush	Midnight Black
1" Brush	Dark Sienna
#6 Fan Brush	Van Dyke Brown
#2 Script Liner Brush	Alizarin Crimson
Large Knife	Sap Green
Liquid White	Cadmium Yellow
Liquid Black	Yellow Ochre
Titanium White	Indian Yellow
Phthalo Blue	Bright Red

With the 2" brush, cover the center top area of the canvas with a thin, even coat of Liquid White. Cover the bottom and sides of the canvas with a thin, even coat of Liquid Black. With a clean, dry 2" brush carefully blend the two colors together where they join. Do not allow the Liquid White and Liquid Black to dry before you begin.

SKY

Load the 2" brush with a little Phthalo Blue and Midnight Black. Starting at the top of the canvas, make criss-cross strokes in the White area of the sky. Gently blend using long horizontal strokes. For the clouds, load a clean, dry 2" brush with Titanium White. Use long, diagonal, sweeping strokes to put just the indication of whispy clouds in the sky.

MOUNTAIN

Load the knife with a mixture of Phthalo Blue, Alizarin Crimson, Midnight Black and Van Dyke Brown. Pull the paint out flat on your palette and just cut across to load a small roll of paint on the long edge of the knife. Use firm pressure to shape just the top edge of the mountain. Remove any excess paint with the knife, then use the large brush to pull the paint down to the base of the mountain to complete the shape. Highlight the mountain by loading the long edge of the knife with a small roll of Titanium White. Use the knife to pull the paint down the right sides of the peaks using so little pressure that the paint "breaks." The shadow sides are made with a mixture of Titanium White, Phthalo Blue and a touch of Van Dyke Brown. Apply this color to the left sides of the peaks, pulling in the opposite direction, again using very little pressure.

With a clean, dry 2" brush, tap the base of the mountain to diffuse and then gently brush upward to create the illusion of mist.

BACKGROUND

To the mountain mixture add more Phthalo Blue and Titanium White. Load the 2" brush and gently tap in the foothill shapes at the base of the mountain.

The small evergreen trees in the background are made with the fan brush and a mixture of Midnight Black, Van Dyke Brown, Sap Green and Phthalo Blue. Load the brush full of paint then, holding it vertically, just touch the canvas to form the center of the tree. Turn the brush horizontally and use just one corner to add the small top branches. As you move down the tree, working from side to side, use more pressure, forcing the bristles to bend downward, allowing the branches to become larger as you near the base of the tree. Trunk indications are Dark Sienna and Titanium White on the long edge of the knife and just touched to the canvas.

Still using the dark tree mixture, load a 2" brush and tap in the ground area under the background trees. Highlights are various mixtures of all the Yellows and Sap Green loaded on a clean 2" brush. Begin creating the lay-of-the-land as you tap the highlights over the dark base color.

Rocks and stones are shaped with the knife using a mixture of Van Dyke Brown and Dark Sienna. Highlight by adding Titanium White to the mixture and just grazing the bright surfaces of the rocks.

STREAM

Load the fan brush by dipping it into Liquid White and pulling it through Titanium White. Holding the brush horizontally, use just one corner and downward strokes to start

the tiny background stream. As you move forward, let the stream disappear behind some of the rocks and then reappear.

Continue working in stages, adding the grassy highlights, the rocks and stones and then the little stream, completing the most distant areas first before moving forward. Watch your perspective; as you work forward in the painting allow the rocks and stones to become larger and the stream to become wider.

FOREGROUND

Underpaint the pool of water in the foreground using Phthalo Blue on the large brush. After painting and highlighting the largest rocks and stones in the foreground, you can add additional little bushes and grassy areas with the fan brush. Load the brush with various mixtures of all the Yellows and Sap Green. Hold the brush horizontally and force the bristles to bend upward as you add the additional growth.

Continue highlighting the grassy areas with the 2" brush. Concentrate on the lay-of-the-land, we need to contain the pool of water in the foreground with small grassy hills.

Use Titanium White and Phthalo Blue on the fan brush to add the pool of water in the foreground. Use swirling, horizontal strokes to bring the water to the edge of the grassy areas. The little water splashes are made by bending the fan brush bristles upward.

TREES AND BUSHES

The large tree trunk on the right is made with the knife and a mixture of Van Dyke Brown and Dark Sienna. Add the tree over the dark, Liquid Black edge of the canvas. Highlight the trunk by adding Titanium White to the Brown mixture. Load the knife with a small roll of paint and, holding it vertically just touch the right side of the trunk and give a little sideways pull. Use a mixture of Sap Green, Phthalo Blue, Van Dyke Brown and Midnight Black on the 2" brush to add the leaves to the tree. You can also use this dark base color to add leaves to the left side of the canvas. Highlight the leaves by loading a 2" brush with mixtures of all the Yellows and Sap Green. Use just the corner of the brush to tap in basic leaf shapes and clusters. Don't just hit at random. If you have trouble making the highlight colors stick to the canvas, add Liquid White or paint thinner to the mixtures.

Add small bushes to the base of the trees with the 1" brush. Pull the brush in one direction through various mixtures of Sap Green and all the Yellows to round one corner. With the rounded corner up, gently touch the canvas forcing the bristles to bend upward. Create individual bushes by shaping them one at a time and being very careful not to "kill" all the dark Liquid Black base color that was already on the canvas.

FINISHING TOUCHES

Use the point of the knife to scratch in small sticks and twigs. Sign your painting with a thinned paint on the liner brush. Once again, you have truly experienced THE JOY OF PAINTING!

Mountain Hide-Away

1. The canvas is covered with both Liquid White and Liquid Black.

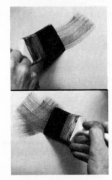

2. Use criss-cross strokes to paint the sky.

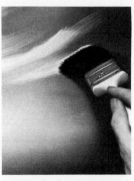

3. The indication of clouds made with an upward stroke of the 2" brush.

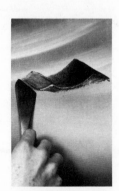

4. Lay in the basic mountain shape with the painting knife . . .

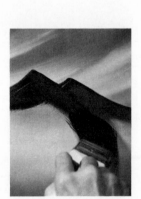

5. . . . then blend downward with the 2" brush.

Mountain Hide-Away

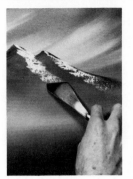

6. The knife is used . . .

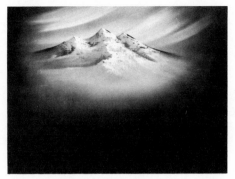

7. . . . to paint highlights and shadows on the mountain, paying careful attention to angles.

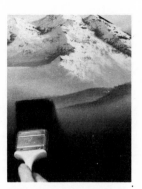

8. Tap downward with the 2" brush to paint distant hills.

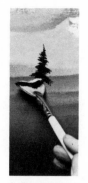

9. The fan brush is used to paint the evergreen trees.

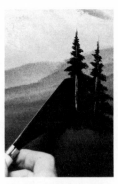

10. The knife is used to paint tree trunks.

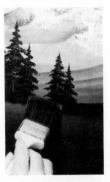

11. Tap in a dark base color using the 2" brush.

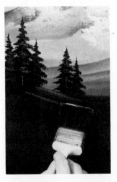

12. Highlights are tapped on in layers.

13. Use the knife to paint rocks.

14. The 2" brush is used to tap grass.

15. The stream is painted with a fan brush.

16. Push upward with the fan brush to make large grassy areas.

17. Soft grassy areas on the bank are tapped in with the 2" brush.

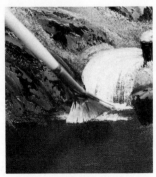

18. Push upward with the fan brush to create foam.

19. Use the knife to make tree trunks.

20. The corner of the 2" brush is used to paint leaves on the trees.

21. Individual bushes are made by pushing upward with 1" brush.

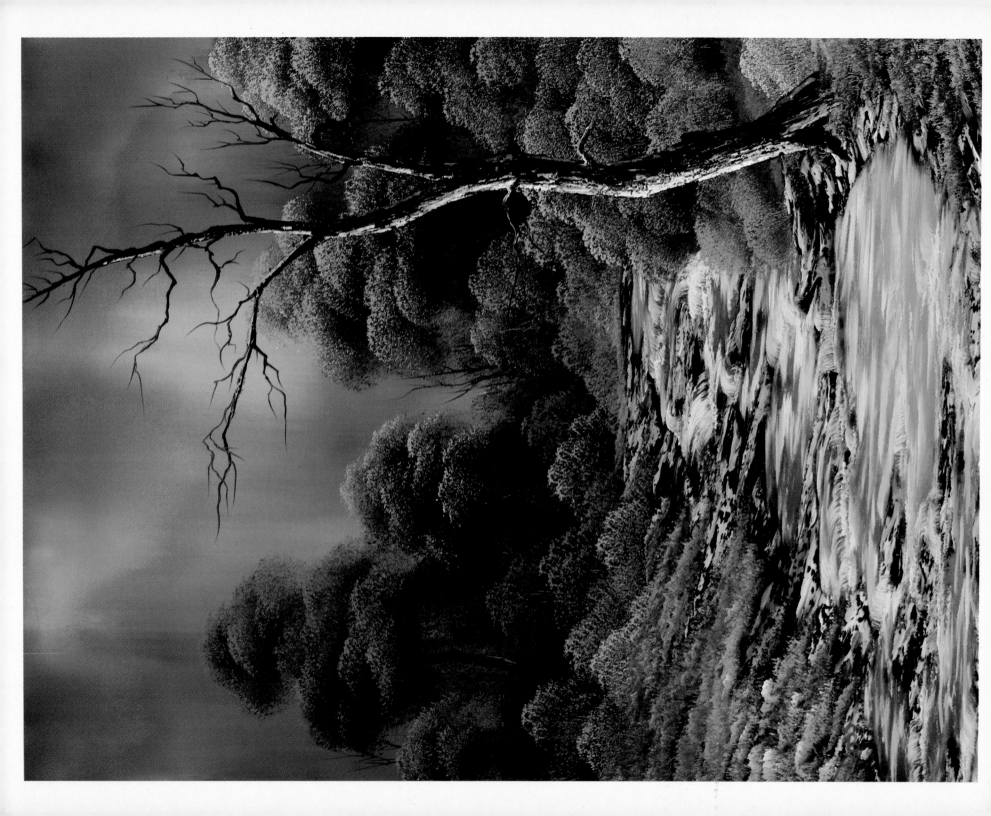

MATERIALS

2″ Brush	Midnight Black
1″ Brush	Dark Sienna
1″ Round Brush	Van Dyke Brown
#6 Fan Brush	Alizarin Crimson
#2 Script Liner Brush	Sap Green
Large Knife	Cadmium Yellow
Liquid White	Yellow Ochre
Titanium White	Indian Yellow
Prussian Blue	Bright Red

This painting was designed to help you deal with some of the mistakes that can happen on canvas, or simply a painting with which you are unhappy. The painting was started with a canvas which had been covered with Liquid White, to which had been added a Blue sky and water and background trees in various shades of all the Yellows, Browns, Sap Green and Alizarin Crimson.

The paint on your canvas must be wet; if necessary, you can recreate the conditions to accomplish this Happy Accident.

BACKGROUND

The first step is to use the knife to firmly scrape all the paint from the previously painted canvas. Notice how some of the color or pigment has remained in the weave of the fabric. Use firm, vertical strokes with the 2″ brush to blend and diffuse the images still remaining on the canvas, creating the illusion of misty trees in the distance.

Load the 1″ round brush with a mixture of Dark Sienna, Van Dyke Brown, Alizarin Crimson and Sap Green. Use a downward tapping motion to add the closer, more distinct tree and bush shapes along the horizon. By starting at the base of the trees, automatically the color will get lighter as you near the tree tops. Use the liner brush and thinned Van Dyke Brown to add the tree trunks to the basic shapes.

Dip the round brush into Liquid White (to thin the paint) and then use various mixtures of all the Yellows, Sap Green and Bright Red to highlight the trees and bushes. With just the top bristles of the brush, tap downward as you create individual tree and bush shapes. Don't just hit at random; work in layers completing the most distant shapes before moving forward and be very careful not to "kill" the dark base color.

WATER

Begin shaping the water, at the same time creating reflections, by using the 2″ brush to pull down some of the paint from the base of the trees and bushes.

Use a mixture of Dark Sienna and Van Dyke Brown on the knife to shape the land areas, rocks and stones in the water. Pull the paint out very flat on your palette and just cut across to load the long edge of the knife with a small roll of paint. The highlights are a mixture of Titanium White, Dark Sienna and Prussian Blue on the knife and applied with so little pressure that the paint "breaks."

Reflections are made by using the 1″ brush to grab the paint at the base of the rocks and stones, pull straight down and then gently brush across.

Add little grassy areas over the land at the water's edge by using various mixtures of all the Yellows, Sap Green and Bright Red on the fan brush. Push the bristles of the brush into the canvas forcing them to bend upward. If you find that the paint won't stick, add a little paint thinner to the mixtures.

Use the point of the knife to just scratch in tiny indications of sticks and twigs in the trees and bushes.

The stream is made by loading a clean fan brush with a mixture of Liquid White, Titanium White and Prussian Blue. Starting at the most distant point and working forward, use short horizontal strokes to "swirl-in" the water around the base of the rocks and land. Use tiny downward strokes to pull the water over some of the rocks; little push-up strokes to add the splashes and foamy actions to the water.

FOREGROUND

Working forward in layers, load the round brush with a very dark mixture of Midnight Black, Dark Sienna, Van Dyke

Brown, Sap Green and Alizarin Crimson. Again, use a downward tapping motion to underpaint the basic tree and bush shapes on the right side of the stream. Use Liquid White and the same mixtures of all the Yellows, Red and Green on the round brush to highlight and create individual tree and bushes.

With Van Dyke Brown on the knife, add the land area, rocks and stones to the base of the trees and bushes. Highlights are a mixture of Dark Sienna, Titanium White and Prussian Blue. Again, use the Yellows and Green on the fan brush to "punch-in" the grassy areas along the water's edge; Liquid White, Titanium White and Prussian Blue to add the final touches of water.

LARGE TREE

Use the knife and Van Dyke Brown for the large tree trunk in the foreground. Highlight the left side of the trunk with a mixture of Titanium White, Dark Sienna and Bright Red on the knife. Use a mixture of paint thinner and Van Dyke Brown on the liner brush for the limbs and branches.

FINISHING TOUCHES

Use the point of the knife or thinned paint on the liner brush to add sticks and twigs or other small details.

Also use thinned paint on the liner brush to sign your painting and, once again, thank you for sharing with me THE JOY OF PAINTING!

Happy Accident

1. This project was designed to show you what could be done with a painting you were not happy with.

2. With a knife, scrape off all the excess paint. The color will remain in the canvas.

3. Use vertical strokes of the 2" brush . . .

4. . . . to blend the remaining color, soften and smooth.

5. With the round brush, tap in new basic tree and bush shapes.

6. Tree trunks are painted with the liner brush . . .

Happy Accident

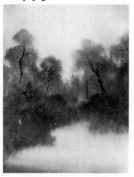

7. . . . loaded with a thin paint . . .

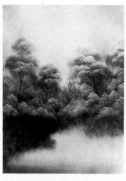

8. . . . then individual tree and bush highlights are added with the round brush.

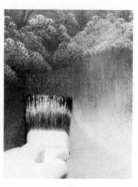

9. Decide where water will be, pull straight down . . .

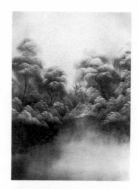

10. . . . then across to create reflections under the background foliage.

11. Land areas, rocks and stones are added with the knife . . .

12. . . . then highlighted in the same manner.

13. Pull a touch of the rock color down to create reflections.

14. Push upward with the fan brush . . .

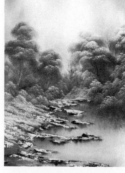

15. . . . to paint soft, grassy areas around the land areas.

16. Use the fan brush, loaded with a thin paint . . .

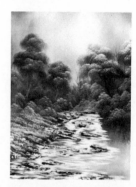

17. . . . to paint foam, ripples, swirls, etc. in the stream.

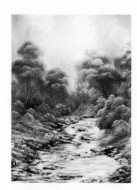

18. When the stream is completed, add foliage to the right side of the painting.

19. The knife is used to paint the tree trunk . . .

20. . . . and add highlights.

21. Use the liner brush and a thin paint to add individual limbs.

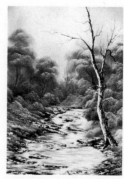

22. Add your finishing touches and your "Happy Accident" is now a beautiful painting.

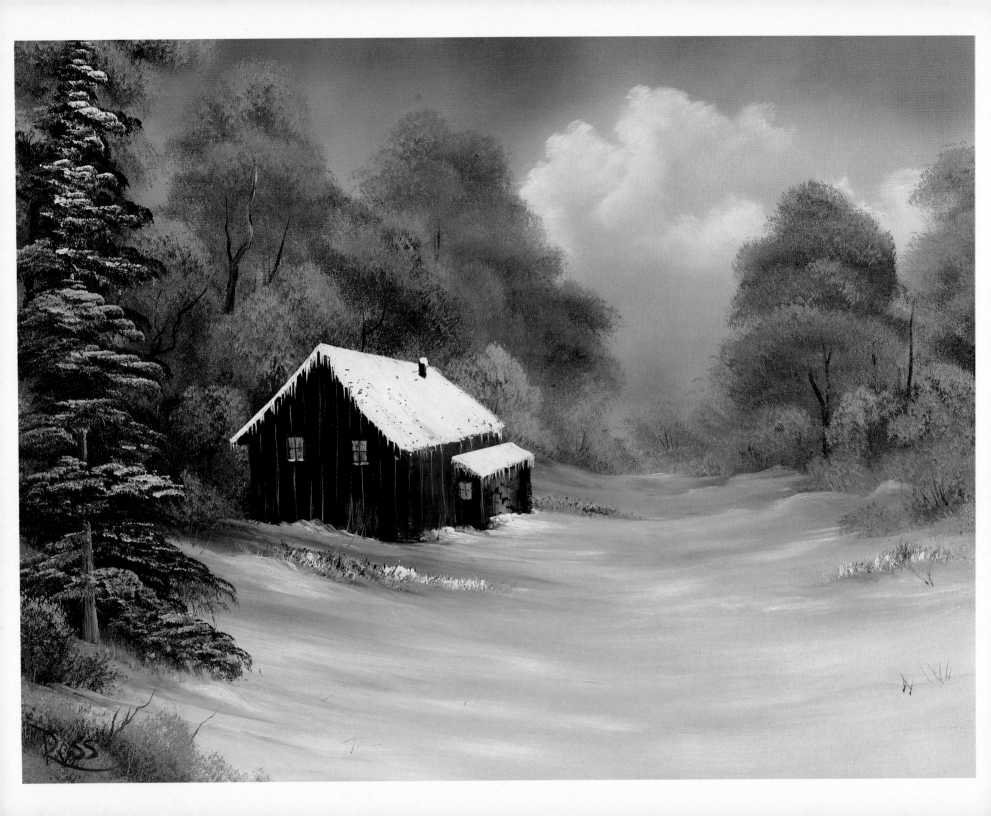

MATERIALS

2" Brush	Midnight Black
1" Round Brush	Dark Sienna
#6 Fan Brush	Van Dyke Brown
#2 Script Liner Brush	Alizarin Crimson
Large Knife	Cadmium Yellow
Liquid White	Yellow Ochre
Liquid Black	Indian Yellow
Titanium White	Bright Red
Phthalo Blue	

Start by covering the entire canvas with a thin, even coat of Liquid White, using the 2" brush. Use long horizontal and vertical strokes, working back and forth to ensure an even distribution of paint on the canvas. Do not allow the Liquid White to dry before you begin. Now, clean and dry your 2" brush.

SKY

Load the 2" brush with a little Bright Red, tapping the bristles firmly against the palette. To create the glow in the sky, make criss-cross strokes just above the horizon. Also, reflect a little of this Red color onto the ground area, using horizontal strokes. Without cleaning the brush, add a little Indian Yellow above the Red in the sky, still using criss-cross strokes. Again, add this color to the ground area. Still not cleaning the brush, pick up a mixture of Phthalo Blue and Midnight Black and cover the remainder of the sky, using criss-cross strokes. Clean and dry your brush, and blend the entire sky, especially where the colors merge. To make the clouds, load the fan brush with Titanium White, then use just one corner and small circular strokes to form the cloud shapes. Hold a clean, dry 2" brush vertically, and use just the top corner to blend the bottoms of the clouds out. Then, very gently lift upward. Again, blend the entire sky.

BACKGROUND

Load the 1" round brush by tapping the bristles firmly into Van Dyke Brown and Dark Sienna. The trees in the background are made by just tapping in the basic shapes, starting at the base of the tree, allowing the color to get lighter as you near the top of the tree and the Liquid White begins mixing with the dark base color. The tree trunks are made with a mixture of Van Dyke Brown and paint thinner, using the liner brush. Twist the brush to give your trunks a gnarled appearance. Use both warm and cool colors to highlight these trees in the background. Load the 1" round brush with a mixture of Phthalo Blue and Titanium White for the cool color. Using just the top corner of the brush and very little pressure, begin forming individual tree and bush shapes, working in layers and being very careful not to "kill" all your dark base color. As you near the sunny glow in the sky, change to the warm colors, using various mixtures of all the Yellows and Bright Red on your brush.

Use Phthalo Blue and Titanium White on the round brush to add shadow colors to the ground area. Add snow over this base color with Titanium White and the fan brush creating contours, concentrating on the lay-of-the-land.

CABIN

Load the 2" brush to a chiseled edge by pulling it through both Van Dyke Brown and Dark Sienna. Touch the edge of the brush to the canvas and pull in the back eave of the roof. Adding more paint to the brush, pull in the front of the cabin, then the side. Add Titanium White and Phthalo Blue to the same brush to lighten the side of the cabin, where the light would strike. Touch and "wiggle" the brush as you pull in the highlight color, creating a weathered-wood impression. Repeat on the front of the building, using a much darker highlight color adding less Titanium White to the Browns already on the brush. Use Titanium White on the long edge of the knife to pull in the snow-covered roof. Also add a little snow to the back eave of the roof. Cut in board shapes with Van Dyke Brown on the knife. You can also "build" a little shed next to the cabin, using the knife. The windows are

Cadmium Yellow, outlined with Liquid Black on the liner brush. Use Titanium White on the fan brush to add snow to the base of the cabin.

FOREGROUND

With a mixture of Midnight Black, Van Dyke Brown, Alizarin Crimson and Phthalo Blue, load the 2″ brush to a chisel edge to make the large evergreen in the foreground. Hold the brush vertically and just touch the canvas to create a center line, then turn the brush horizontally, using just one corner of the brush, begin tapping in the branches. Use more pressure as you near the base of the tree, causing the branches to become larger. Add snow to the tree using a mixture of Titanium White and Phthalo Blue on the 2″ brush. With the fan brush and Titanium White, continue adding snow to the ground area; pull in some little patches of grass by adding a little Phthalo Blue to the brush.

FINISHING TOUCHES

Add some long grasses, sticks and twigs to your painting using Liquid Black on the liner brush. Not all winter paintings have to be done with cool colors! Sign your painting, then stand back and admire.

Lonely Retreat

1. Use criss-cross strokes . . .

2. . . . to create the initial sky patterns.

3. Use the corner of the fan brush, in small circular patterns, to paint the basic cloud shape.

4. The top corner of the 2″ brush . . .

5. . . . is used to blend the bottom of each individual cloud.

6. Tap downward with the round brush . . .

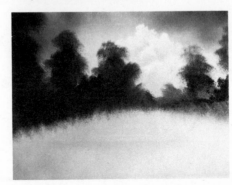

7. . . . to paint the basic tree and bush shapes.

8. Use the liner brush, with a thin paint, to make tree trunks . . .

Lonely Retreat

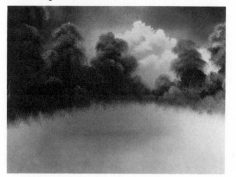

9. . . . then highlight with a round brush.

10. Pull a small amount of the tree color out . . .

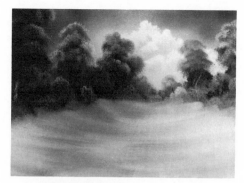

11. . . . to begin creating the general lay-of-the-land. This color will become shadows later in the painting.

12. Add snow with the fan brush.

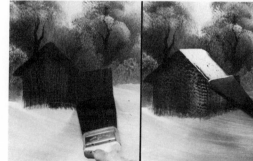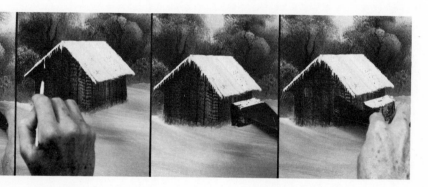

13. Progressional steps used to paint the cabin.

14. Use the fan brush . . .

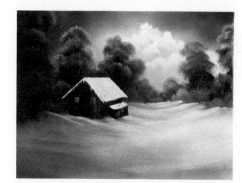

15. . . . to paint snow around the base of the cabin.

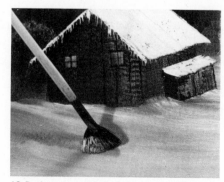

16. Push upward with the fan brush to create grassy areas.

17. The 2" brush is used to paint the large evergreen tree.

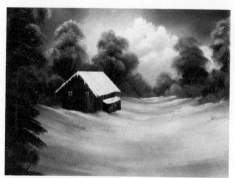

18. Add the finishing touches, sign and enjoy your finished painting.

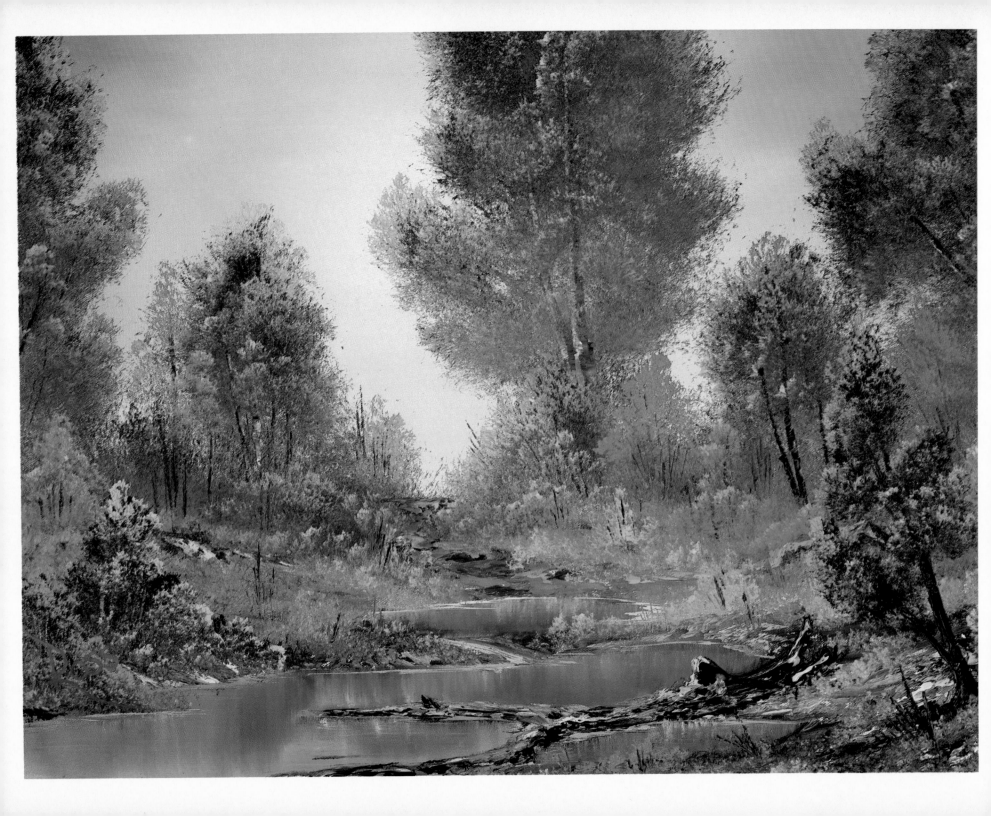

33. A WALK IN THE WOODS

MATERIALS

2″ Brush	Alizarin Crimson
1″ Brush	Phthalo Green
Large Knife	Phthalo Blue
Liquid White	Van Dyke Brown
#2 Script Liner Brush	Sap Green
Titanium White	Cadmium Yellow

Start by covering the entire canvas with a thin, even coat of Liquid White using the 2″ brush. With long, horizontal and vertical strokes, work back and forth to ensure an even distribution of paint on the canvas. Do not allow the Liquid White to dry before you begin.

SKY

The sky is made with the 2″ brush, starting with a small circle of Cadmium Yellow. Without cleaning the brush, add a small amount of Phthalo Green and paint a much larger circle around the Yellow using criss-cross strokes. Add Prussian Blue to the brush and use criss-cross strokes to cover the remainder of the sky. (Work from the outside edges of the canvas in towards the center.) With a clean brush, add Cadmium Yellow and Titanium White to the center and blend outward in circular patterns, still using the criss-cross strokes. This step may be done several times if necessary to achieve the desired effect. Very lightly blend the entire sky.

TREES AND BUSHES

Nearly all the trees in this painting are made with the 2″ brush. So often we avoid this brush because of its size, but a little experimenting will pay great dividends. Using a mixture of Alizarin Crimson with a small amount of Prussian Blue, pull the brush in one direction through the paint to round one corner. Hold the brush vertically, with the rounded corner up, and push it gently into the canvas. Force the bristles to bend slightly upward as you underpaint the trees and bushes. The grass is made by holding the brush *horizontally* and forcing the bristles to bend upward.

Tree trunks are made with Van Dyke Brown and the knife. Pull the paint out very flat on your palette and just cut across to load the long edge of the knife with a small roll of paint. Very thin trunks are made by just touching the edge of the knife to the canvas, and thicker trunks are made by pulling the knife slightly sideways.

Highlight the trunks with a mixture of Van Dyke Brown and Titanium White on the knife, using so little pressure that the paint "breaks." Always be aware of where your light source is and where light will strike each object in your painting. The highlights on the trees and bushes are a mixture of Liquid White (to thin the paint), Cadmium Yellow, Phthalo Green, and Bright Red. You should mix varying amounts of these paints right on your brush to create numerous colors and tones in your painting. Again, load the brush to round one corner. With the rounded corner up, force the bristles of the brush to bend upward as you shape each individual tree and bush. (Be very careful not to "kill" all of the dark undercolor! You need dark in order to show light and also to separate the individual shapes.)

PATH

The path is made with Van Dyke Brown on the knife, using short horizontal strokes. The highlights are Titanium White and Van Dyke Brown, again using so little pressure that the paint is allowed to "break." Now, paint a few bushes that project over the path. This will push the path down into the painting.

PUDDLES

The little rain puddles are made with the large brush using Prussian Blue. Holding the brush flat against the canvas, pull downward to create the reflections. Use several light horizontal strokes to finish your reflections. You may wish to highlight your reflections by adding a little Titanium White to the brush. Complete the puddles in stages, finishing the most distant one before moving forward. Cut in the water

lines with a small roll of Liquid White on the long edge of the knife. You don't want your water to run off the canvas, so make sure these lines are perfectly straight and parallel to the top and bottom edges of the canvas.

FINISHING TOUCHES

Finish your painting by adding small trees and bushes to the water's edge, cutting in sticks and twigs with the point of the knife, or how about an old log in the water?

Sign your painting with a very thin mixture of the color of your choice and paint thinner. Roll the liner brush as you pull the bristles through the mixture, forcing the bristles to a sharp point. Use very little pressure on the brush as you add the most important part, your name. Now, stand back and admire! Today you have truly experienced the JOY OF PAINTING!

A Walk in the Woods

1. Use criss-cross strokes . . .

2. . . . to paint the sky . . .

3. . . . then blend with the 2" brush.

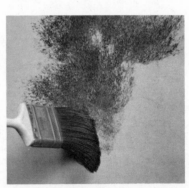

4. Use the 2" brush . . .

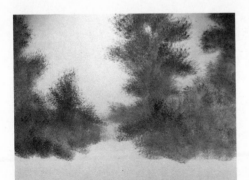

5. . . . to underpaint the trees and bushes.

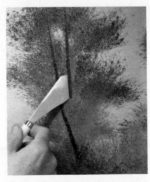

6. Use the knife to add large tree trunks . . .

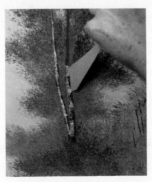

7. . . . and highlights . . .

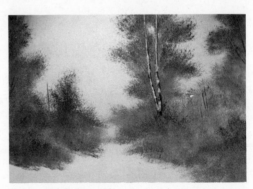

8. . . . to the background.

A Walk in the Woods

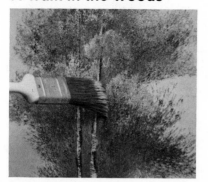

9. Push-up with the 1″ brush . . .

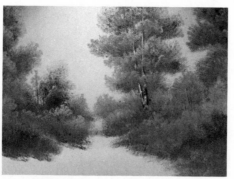

10. . . . to highlight the trees and bushes.

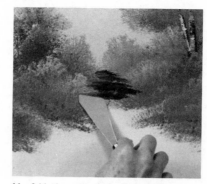

11. Add the path with short horizontal strokes . . .

12. . . . and then highlight . . .

13. . . . to complete the background.

14. Pull down with the 2″ brush to paint the water.

15. Use the knife to add the land . . .

16. . . . and the water lines . . .

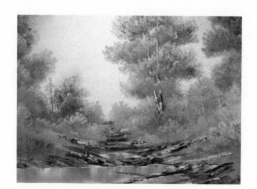

17. . . . to the water's edge.

18. Use the knife to paint the trunk . . .

19. . . . and the 1″ brush to add the foliage . . .

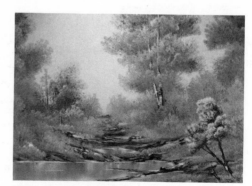

20. . . . to the foreground tree.

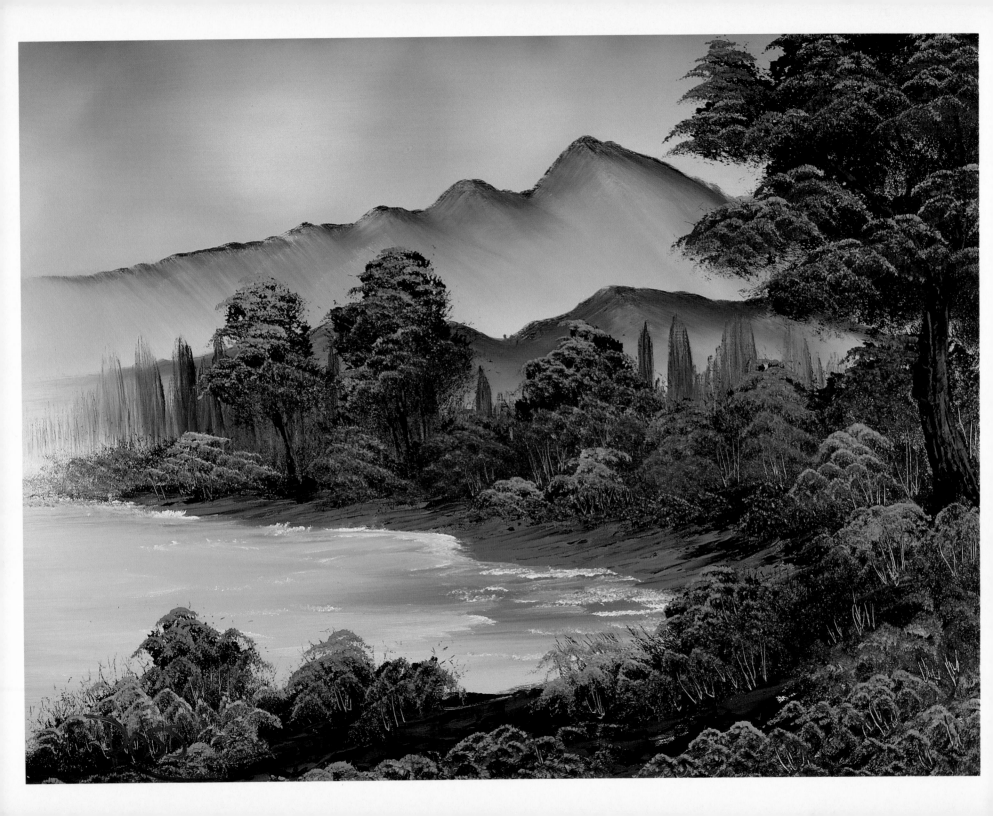

MATERIALS

2" Brush	Cadmium Yellow
1" Brush	Bright Red
1" Oval Brush	Prussian Blue
Large Knife	Phthalo Blue
Liquid White	Phthalo Green
#6 Fan Brush	Sap Green
#2 Script Liner Brush	Titanium White
Alizarin Crimson	Van Dyke Brown
Dark Sienna	Yellow Ochre

Cover the entire canvas with a thin, even coat of Liquid White using the 2" brush. Apply the Liquid White in long horizontal and vertical strokes, working it back and forth to assure an even distribution of paint on the canvas. Do not allow the Liquid White to dry before you begin.

SKY AND WATER

To make the sky, start with Phthalo Blue, evenly distributed on the 2" brush. Using criss-cross strokes, working in layers from the top down, paint in your sky. For the water, add a tiny bit of Phthalo Green to the Phthalo Blue already in your brush. To lay in the water, hold the brush flat and, with horizontal strokes, pull from the outside in. Use a clear, dry 2" brush to blend the entire canvas.

MOUNTAINS

Both ranges of mountains are made with Alizarin Crimson and Prussian Blue. The mountain that is closer should be darker. Load the color into the fan brush and use the corner of the brush to draw in a basic mountain shape. Blend downward with the 2" brush. Totally complete the back mountain before starting the second one.

TREES AND BUSHES

The most distant tree indications are made with the 1" brush, loaded to a chisel edge, with a mixture of Alizarin Crimson, Prussian Blue, Sap Green and a touch of Titanium White. Hold the brush vertically, touch the canvas and pull downward. To create mist at the bottom of the trees, use the 2" brush and lift upward in very short strokes. More distinct trees are blocked in with the 1" brush loaded with the same color. Pull the brush through the paint to round one corner, touch the canvas with the rounded corner up, and push slightly upward. With horizontal strokes of the 1" brush, pull a little of the dark tree color into the water. Before you begin highlighting the trees and bushes, lay in the land areas with the palette knife. The sand color is made from Titanium White, Van Dyke Brown, Dark Sienna and a touch of Prussian Blue. Start with a roll of paint on the knife and pull in your basic land shapes, paying close attention to the angles. The dark part of the land area is Van Dyke Brown and Dark Sienna. Use the knife to bring the light and dark areas together. Tree trunks are Van Dyke Brown, applied with the knife, and highlighted with Brown and White.

The highlights on all the trees and bushes in this painting are made with the oval brush. This brush is loaded to a chiseled edge with a very thin mixture of Cadium Yellow, Sap Green, Yellow Ochre and Bright Red, in varying amounts. Paint thinner is used to thin the paint. Hold the brush horizontally, touch the canvas and push downward, bending the bristles slightly. If you choose instead to use the standard 1" brush which is straight on the end, use just the corner of the brush to achieve this effect.

WATER

The highlights on the water are made with the fan brush loaded with a mixture of Liquid White and Titanium White. Hold the brush horizontally and use back and forth strokes to create your highlights on the water.

FINISHING TOUCHES

Sticks and twigs are cut in using the point of the knife. You are now ready to sign your creation, stand back and admire.

Quiet Inlet

1. Basic mountain shape made with the fan brush.

2. . . . then blended downward with the 2" brush . . .

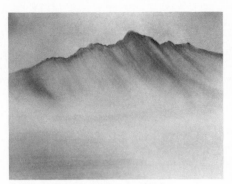

3. First range of mountains completed.

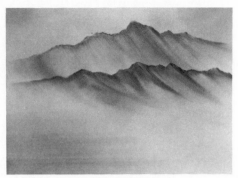

4. Second range of mountains completed.

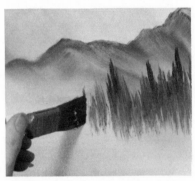

5. Distant evergreens made with the 1" brush.

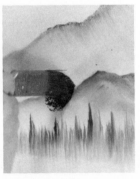

6. More distinct trees are made with the 1" brush.

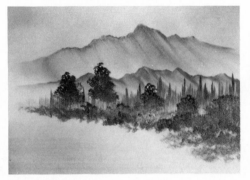

7. Basic background shapes completed.

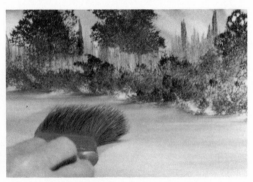

8. Pull the bottom of the tree color into the water.

9. Land areas are made with the knife.

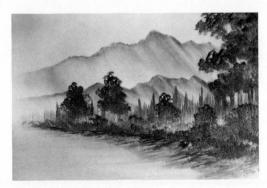

10. Ready for details and highlights.

11. Tree trunks made with the knife.

12. Large tree ready for highlighting.

13. Load the oval brush to a chiseled edge . . .

Quiet Inlet

14. . . . and lay in highlights.

15. Large tree completed.

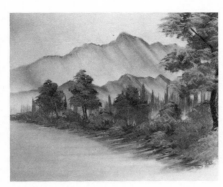

16. Background completed.

17. Pull sideways with the fan brush to create water.

18. Basic foreground shape made with the knife.

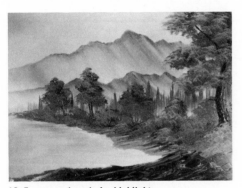

19. Foreground ready for highlights.

20. Bushes are made with the 1" brush.

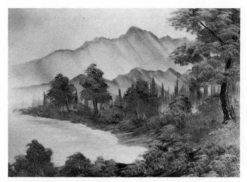

21. Foreground completed.

MATERIALS

2" Brush	Midnight Black
1" Brush	Dark Sienna
1" Round Brush	Van Dyke Brown
#6 Fan Brush	Alizarin Crimson
#2 Script Liner Brush	Sap Green
Adhesive-Backed Paper	Cadmium Yellow
Liquid White	Yellow Ochre
Liquid Black	Indian Yellow
Titanium White	Bright Red
Phthalo Blue	

Start by covering the dry canvas with an 18 x 24 piece of adhesive backed plastic (like Con-Tact Paper) from which you have removed the center. Allow the outside edges of the canvas to remain covered, creating a border around your entire painting. (I used a place mat as a pattern for removing the center of the plastic paper.)

Cover the exposed area of the canvas with a thin, even coat of Liquid White, using the 2" brush. Use long horizontal and vertical strokes, working back and forth to assure an even distribution of paint on the canvas. Do not allow the Liquid White to dry before you begin. Clean and dry your 2" brush.

SKY

Load the 2" brush with Cadmium Yellow and apply to the canvas with horizontal strokes in the sky, just above the horizon. Without cleaning the brush, pick up some Yellow Ochre and apply just above the Yellow. Still, not cleaning the brush, add a band of Bright Red. At this point, load the fan brush with Midnight Black and swirl cloud shapes into the remaining top portion of the sky. Use the top corner of a clean, dry 2" brush to blend out the bottoms of the Black clouds. Load a clean fan brush with Dark Sienna and using small, circular strokes, add this color below the Black, allowing it to blend into the Bright Red. Load a clean fan brush with a mixture of Titanium White and Bright Red, again using small circular strokes, add cloud shapes into the area where the Midnight Black and Dark Sienna merge. Use the top corner of a clean, dry 2" brush to very gently blend these clouds. Very, very lightly, blend the entire sky.

BACKGROUND

Load the 1" round brush with a mixture of Van Dyke Brown, Dark Sienna and Sap Green, tapping the bristles firmly against the palette. Push in the small basic tree and bush shapes along the horizon. Load the 2" brush with Van Dyke Brown and Dark Sienna, hold the brush horizontally and tap in the ground area at the base of the trees. This is where you begin creating the "lay-of-the-land", so carefully plan your brush strokes. Dip the liner brush into paint thinner and pull it through Van Dyke Brown to load; add the indication of a few distant tree trunks. Load the 1" round brush with various mixtures of Sap Green, all the Yellows and Bright Red to highlight the distant trees, using just the very top corner of the brush, tapping in individual tree and bush shapes. Load the 2" brush by tapping the bristles firmly into the same highlight mixtures. Hold the brush horizontally and tap in the highlights, still creating the contours of the land. If you have trouble making any of these highlight colors stick to your canvas, add a little paint thinner or Liquid White to the mixtures. Be very careful not to cover all of your dark base colors. (Remember, you need dark in order to show light.) Use a dry fan brush to smooth in a path area. Hold the brush horizontally and just use a sweeping, back and forth motion, adding a little Van Dyke Brown and Titanium White to the colors already on the ground area of the painting.

The small evergreen trees in the background are made by loading the fan brush with a mixture of Van Dyke Brown and Midnight Black. Hold the brush vertically, and tap in the trunks; turn the brush horizontally and push in the tree branches, forcing the bristles to bend upward. Highlight the larger evergreen trunks by loading the fan brush with

Titanium White, holding it vertically and just touching the right side of the trunks, where the light would strike. Add the branches to these trees with Liquid Black on the liner brush, the leaves are made again using the fan brush horizontally, forcing the bristles to bend upward. Add the highlights with Cadmium Yellow, loaded on the same dirty brush. Complete this area of the painting by using the large brush to pull in the dark evergreen tree color into the grassy area, creating shadows at the base of the trees.

FOREGROUND

At this point, you can remove the adhesive-backed plastic from the canvas, leaving an unpainted border around your painting. Load the 1″ round brush by tapping the bristles firmly into a mixture of Alizarin Crimson and a little Phthalo Blue. Tap in the large leaf tree in the left foreground. Allowing the dark base colors to extend into the unpainted borders, add the smaller leaf tree, bush and ground area using a mixture of Van Dyke Brown and Dark Sienna. Use thinned Van Dyke Brown on the liner brush to add the tree trunks and branches, the smaller tree trunk is Liquid White on the liner brush. Load the 2″ brush with a mixture of Sap Green and Cadmium Yellow, holding the brush horizontally, highlight the larger tree using just one corner of the brush to tap in leaf and branch indications. If you have trouble making your highlight colors stick to the canvas, thin the paint with either paint thinner or the Liquid White. Highlight the smaller tree and bushes by loading the 1″ round brush with

mixtures of all the Yellows, Sap Green, and Bright Red. Using just the top corner of the brush, tap in leafy effects, giving your tree and bushes shape and form. Be very careful not to cover all of the dark base color, work in layers allowing some of the highlight colors to fade into the unpainted border of the canvas.

The large evergreen tree in the foreground is made with the fan brush and a mixture of Van Dyke Brown and Midnight Black. Hold the brush vertically and tap in the tree trunk beginning at the very top of the canvas. Allow the trunk to get wider as you near the base of the tree. Highlights are added to the trunk by tapping with Titanium White on the fan brush. Use Liquid Black on the liner brush to give your tree limbs and branches, also add roots to the tree, allowing them to extend below the painting. Highlight the roots and branches, by just touching them with a little Liquid White on the liner brush. The leaves are added to the tree by using Midnight Black on the fan brush. Hold the brush horizontally, gently push it into the canvas, forcing the bristles to bend upward. Form leaf clusters, careful not to cover the entire tree trunk. Highlights are made the same way and applied over the dark base color, using Cadmium Yellow and Sap Green on the fan brush.

FINISHING TOUCHES

Use the point of the knife to scratch in small sticks and twigs. If you have decided to paint this one along with me, sign your masterpiece, stand back and admire.

Majestic Pine

1. Cut a design out of Con-tact paper and place it on the canvas prior to putting the Liquid White on.

2. With the 2″ brush, paint the background sky colors.

3. Use a "twirling" motion of the fan brush to paint the initial cloud shapes.

4. Use the top corner of the 2″ brush to blend the cloud shapes.

Majestic Pine

5. Tap downward with the round brush to paint tree and bush shapes.

6. Tap downward with the 2" brush . . .

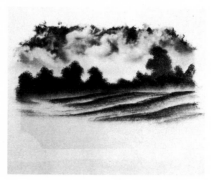

7. . . . to make the basic land shapes. Work in layers to create the illusion of distance.

8. The liner brush, loaded with a thin paint, is used to paint tree trunks.

9. Tap downward with the round brush to highlight trees and bushes.

10. The fan brush is used to paint evergreen tree trunks.

11. Push upward with the corner of the fan brush to paint leaves on the evergreens.

12. Individual limbs are painted with the liner brush loaded with a thin paint.

13. Use the fan brush to add leaves to the trees to complete the evergreens.

14. Back and forth strokes of the fan brush are used to create the path.

15. When the right side of the painting is totally completed, remove the Con-tact paper.

16. The round brush is used to tap in the basic tree and bush shapes.

17. Thin paint on the liner brush for tree trunks.

18. Tap downward with the corner of the 2" brush to highlight.

19. Tap downward to paint the trunk.

20. Roots are Liquid Black on the liner brush.

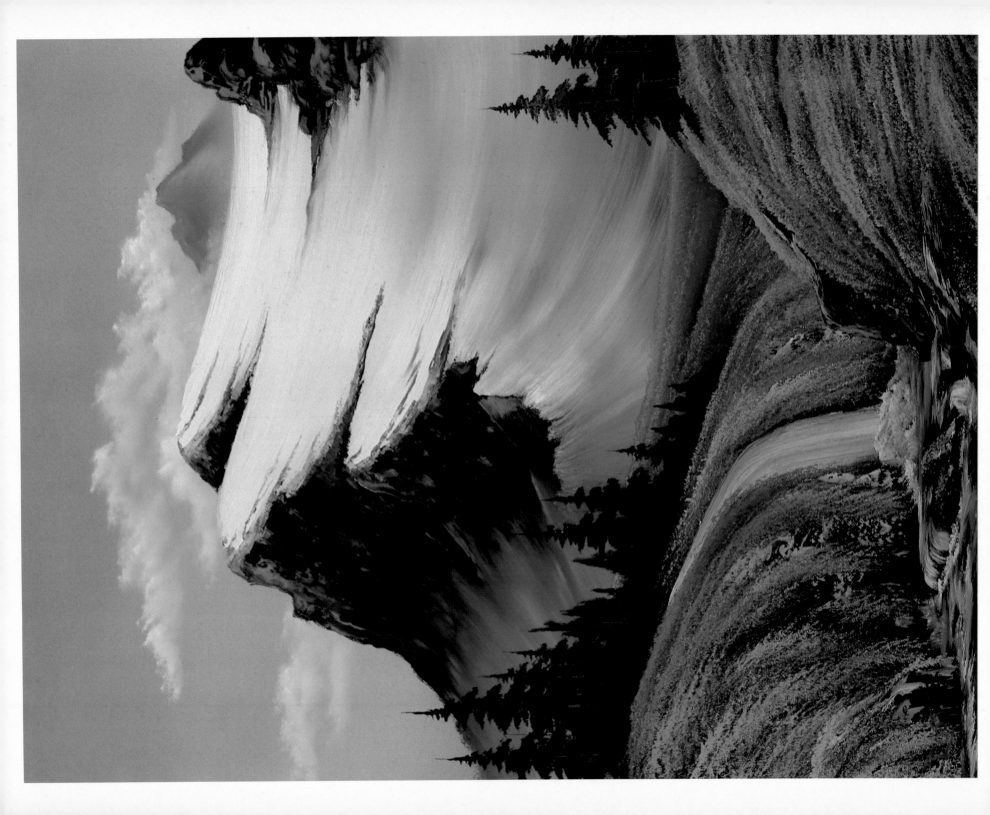

MATERIALS

2″ Brush	Prussian Blue
1″ Brush	Midnight Black
#6 Fan Brush	Dark Sienna
#2 Script Liner Brush	Van Dyke Brown
Large Knife	Alizarin Crimson
Small Knife	Sap Green
Liquid White	Cadmium Yellow
Liquid Clear	Yellow Ochre
Liquid Black	Indian Yellow
Titanium White	Bright Red

Start by covering the top half of a vertical canvas with a VERY thin, even coat of Liquid Clear using the 2″ brush. Work back and forth with long horizontal and vertical strokes to ensure an even distribution of paint on the canvas. Cover the bottom portion of the canvas with a thin coat of Liquid Black. Do NOT allow the Liquid Clear and Liquid Black to dry before you begin. Still using the 2″ brush, add a small amount of Prussian Blue to the left side of the Liquid Black on the lower portion of the canvas.

SKY

Load the 2″ brush with a very small amount of Prussian Blue, tapping the bristles firmly against the palette to ensure an even distribution of paint. Starting at the top of the canvas, use criss-cross strokes, allowing the sky to become lighter as you near the horizon.

Use just one corner of the fan brush, with Titanium White, to "swirl-in" the cloud shapes. With a clean, dry 2″ brush, blend out the bottom of the clouds and then gently lift upward to "fluff." Very carefully blend the entire sky.

MOUNTAINS

Use Prussian Blue, Midnight Black, Titanium White and Alizarin Crimson for the distant mountain. Pull the mixture out very flat on your palette and just cut across to load the long edge of the knife with a small roll of paint. With firm pressure, shape just the top of the far-away mountain. Use the knife to remove any excess paint and then the 2″ brush to pull down and blend the base of the mountain. Lightly blend the entire mountain shape.

The large glacier is formed by first loading the 2″ brush full of Titanium White. Use long horizontal, sweeping strokes to lay in the snow at the top of the large mountain, paying close attention to the lay-of-the-land (or in this case, the lay-of-the-snow). Create the shadow areas by adding Prussian Blue to the brush.

The sides of the mountain are made with the knife using a mixture of Midnight Black, Prussian Blue and Van Dyke Brown; the base of the mountain is a mixture of Prussian Blue and Titanium White. Use a lighter mixture of Titanium White and Prussian Blue on the small knife to add soft shadows to the sides of the mountain.

Following the angles, use a clean, dry 2″ brush to tap the base of the mountain and then gently lift upward.

Use the same dark mixture on the knife (Midnight Black, Prussian Blue and Van Dyke Brown) for the large rocks on the top of the mountain. The shadows are Titanium White and Prussian Blue. Use a mixture of Liquid Clear, Titanium White and Prussian Blue on the fan brush to add the snow to the base of the rocks.

BACKGROUND

Load the 2″ brush with a mixture of Sap Green and all the Yellows. Hold the brush horizontally and tap downward to add the ground area at the base of the mountain; this is where you begin creating the lay-of-the-land.

The tiny evergreens are made by loading the fan brush with the same mixture of Midnight Black, Prussian Blue and Van Dyke Brown. Hold the brush vertically and touch the canvas to create the center of each tree. Turn the brush and use one corner to add the top branches. As you work down the tree, use more pressure (forcing the bristles to bend downward) allowing the branches to become larger as you

near the base of the tree.

Some of the evergreens are just indications made by holding the brush vertically and tapping downward.

Beginning at the base of the trees, continue adding the grassy areas by tapping downward with the 2″ brush using various mixtures of all the Yellows and Sap Green. As you "build" the grassy banks, follow the same angles to add rocks and stones with Van Dyke Brown on the knife. Highlight these rocky areas with a mixture of Dark Sienna, Van Dyke Brown and Titanium White, applied so lightly that the paint "breaks."

WATERFALL

Load the fan brush with a mixture of Liquid White and Titanium White. Starting at the base of the background trees and following the angle of the land, pull in the waterfall. The White paint should automatically pick up some of the Prussian Blue already on the canvas. To create the foam action, push the fan brush straight into the canvas, forcing the bristles to bend upward and then use short horizontal strokes to "swirl-in" the water at the base of the falls.

FOREGROUND

Working on both sides of the water, continue forward in layers. Add grassy areas with the 2″ brush, the land and rock areas with the knife. Use the fan brush (loaded with the White mixture) and short horizontal strokes to add water movements to the base of the land and rocks. You can also create small falls in the water. Use the corner of the 2″ brush to add small grassy patches to the tops of the rocks and stones in the water.

FINISHING TOUCHES

Add small evergreens to the top of the land area on the right side of the painting with the fan brush and the same dark tree mixture (Midnight Black, Prussian Blue and Van Dyke Brown).

Don't forget to sign your painting using a thinned paint on the liner brush. Good job! Well done!

Towering Glacier

1. Use criss-cross strokes to paint the sky.

2. Basic cloud shapes are painted with the corner of the fan brush.

3. Use the top corner of the 2″ brush...

4. ... to blend the base of each cloud, then long horizontal strokes to blend the entire sky.

5. Distant mountain shapes are made with the knife.

6. Blend the mountain shape downward...

Towering Glacier

7. . . . to remove excess paint and add shape.

8. With the 2" brush . . .

9. . . . paint the snow areas on the mountain.

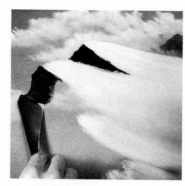

10. The knife is used . . .

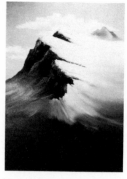

11. . . . to paint the dark areas under the glacier . . .

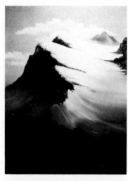

12. . . . and to create rocks and crevices. Use the fan brush to blend and soften the snow.

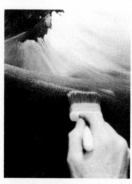

13. Tap downward with the 2" brush to paint the soft grassy areas.

14. Evergreens are made by pressing downward with the corner of the fan brush.

15. Rocks and stones are made and highlighted with the knife.

16. Pull downward with the fan brush to paint the waterfall.

17. Foam, ripples, swirls, etc . . .

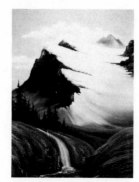

18. . . . are painted at the base of the waterfall with the fan brush.

19. Use the fan brush to add the evergreens on the right.

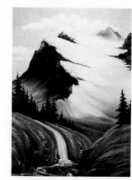

20. A few finishing touches and your masterpiece is ready for a signature.

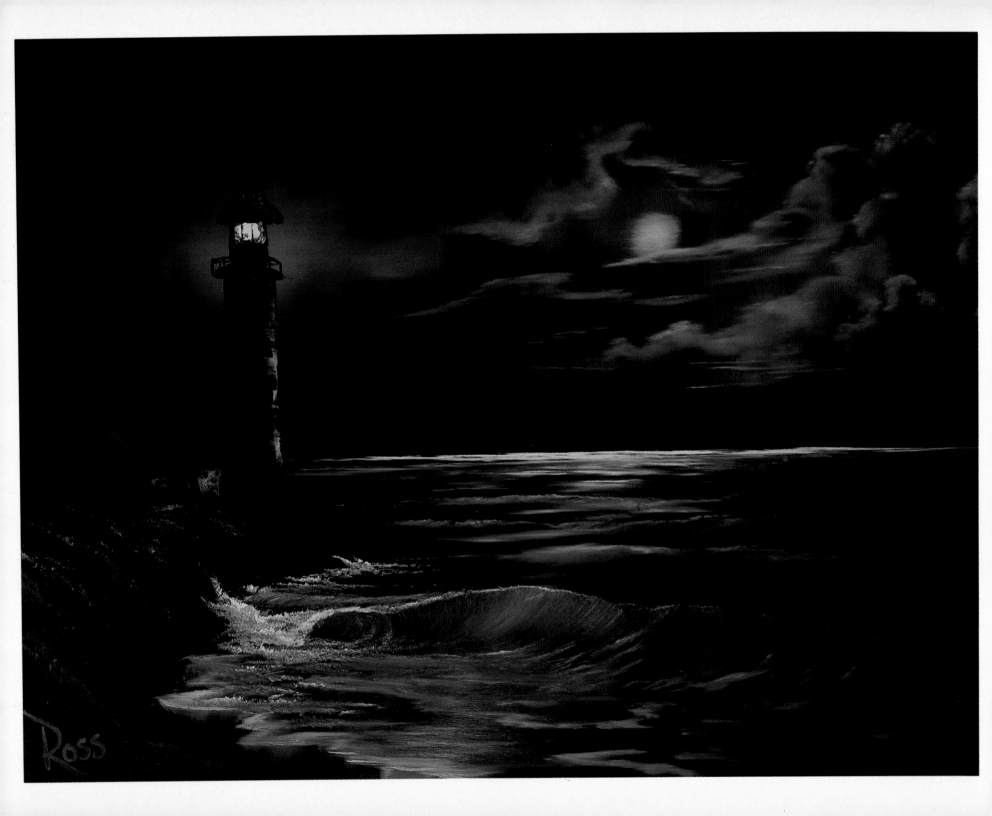

MATERIALS

2″ Brush	Dark Sienna
1″ Brush	Cadmium Yellow
Large Knife	Phthalo Green
Liquid White	Sap Green
Black Gesso	Titanium White
#6 Fan Brush	Van Dyke Brown
#2 Script Liner Brush	Yellow Ochre
Alizarin Crimson	Black Gesso Primer

Start with a canvas that has been painted with Black Gesso and allowed to dry completely. Decide where the glow from the lighthouse will be and cover that area with Alizarin Crimson (about 7″ circle). On the right side of the canvas put in a streak of Alizarin Crimson where you want the clouds to be. Cover the remaining canvas with a Grey color made from Alizarin Crimson and Phthalo Green. Blend the entire canvas with a clean, dry 2″ brush. Do not allow to dry before you begin.

SKY

Start in the area where the glow from the lighthouse will be. With the 1″ brush loaded with Cadmium Yellow, start in the center using criss-cross strokes and blend outward in a circular pattern. Make this area a little brighter than you want it to be as it will dull down as the painting dries. If you add more color, always start in the center and work outward with a clean brush loaded with Cadmium Yellow. Never take a dirty brush back into the light area. Use the 2″ brush to blend the light area, still using criss-cross strokes. Now decide where the moon will be in your painting. With a 1″ brush, using criss-cross strokes, lay in a light area in the sky using Titanium White. Use very little paint. Blend with the 2″ brush. The moon is made with your finger. With a little Titanium White on the tip of the finger, draw in a small circle for the moon. Gently blend with the large brush. Clouds are made with the corner of the fan brush loaded with Titanium White. Lay in your basic shapes and blend with the 2″ brush.

WATER

The water line under the sky is Titanium White with a touch of Cadmium Yellow. Start with a small roll of paint on the long edge of the knife and touch the canvas. Keep your water line as straight as possible. Using horizontal strokes, blend with the large brush. Waves are made with a mixture of Liquid White and Titanium White on the fan brush. Hold the brush horizontally, touch the canvas and push slightly upward. This will create the foam on top of the wave. Use the fan brush to pull a little of the color downward, paying particular attention to angles, to complete your wave. Waves in the distance should be smaller than waves that are closer. Back and forth strokes of the fan brush will create highlights in the water.

LIGHTHOUSE

Make the top of the lighthouse first using the palette knife and Van Dyke Brown. Load a roll of paint on the long edge, touch the canvas and pull sideways. This part of the lighthouse should be placed in the brightest part of the glow of yellow. The cap on the lighthouse is made with the small edge of the knife. Now, use the small edge of the knife and scrape out an area for the light. Apply Cadmium Yellow in the area you scraped out using the small edge of the knife. Complete the remainder of the lighthouse with the knife and Van Dyke Brown. The highlight is Dark Sienna first then a small amount of Cadmium Yellow and Dark Sienna over that. Use very little pressure. Details are painted in with the script liner brush and Van Dyke Brown which has been thinned. The buildings at the base of the lighthouse are made with the knife and Van Dyke Brown. Highlight the roof with a very small amount of Dark Sienna. Sides of the building are Grey and Titanium White. The windows are scraped in with the point of the knife.

LAND AREAS

The basic land shapes are laid in with Van Dyke brown on the knife. Highlights are Dark Sienna. Pay close attention to

angles. The grassy areas are made with the fan brush loaded with a thin mixture of Yellow Ochre and Sap Green. Hold the brush horizontally, touch the canvas and push upward, bending the bristles. If your paint will not stick, thin it with a small amount of paint thinner. Now, use the fan brush with Liquid White and Titanium White to complete the water. Reflections on the wet beach are made by pulling a little of the White down

with the large brush and then brushing across.

FINISHING TOUCHES

If your waves are too bright you can gently blend them with the large brush. This will reduce the color. It's now time for a signature. This is another painting that should be viewed under several different light sources.

Night Light

1. Use criss-cross strokes to create the light areas.

2. Complete the light areas with the 1" brush . . .

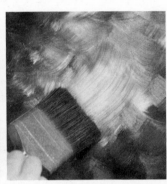

3. . . . then blend with the 2" brush.

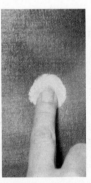

4. A finger is used to make the moon.

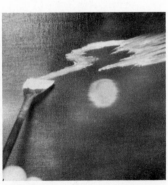

5. Clouds are made with the corner of the fan brush.

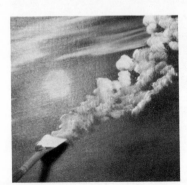

6. Fluffy clouds made with the fan brush . . .

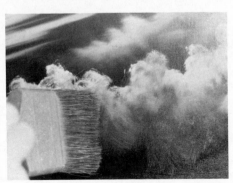

7. . . . then blended with the 2" brush.

8. The knife is used to make water lines.

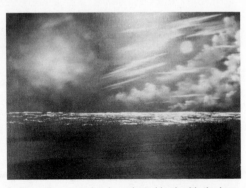

9. Water lines completed, ready to blend with the large brush.

Night Light

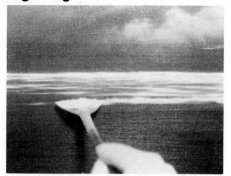

10. Make the top of the wave first . . .

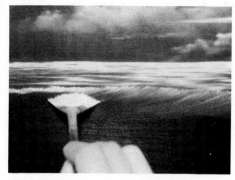

11. . . . then pull downward with the fan brush.

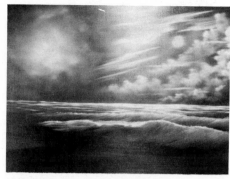

12. Complete the most distant waves first.

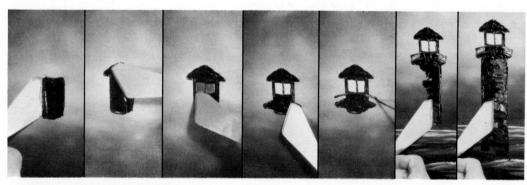

13. Steps used to complete the lighthouse.

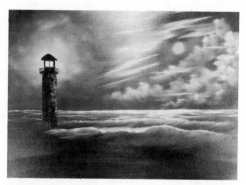

14. Lighthouse completed.

15. Lay in the land areas with the knife.

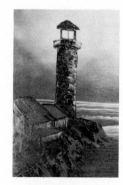

16. Lighthouse and buildings completed.

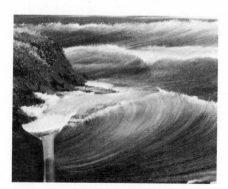

17. Pull the top of the large wave over.

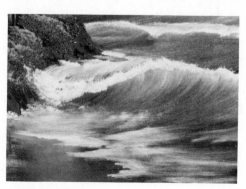

18. Wave completed.

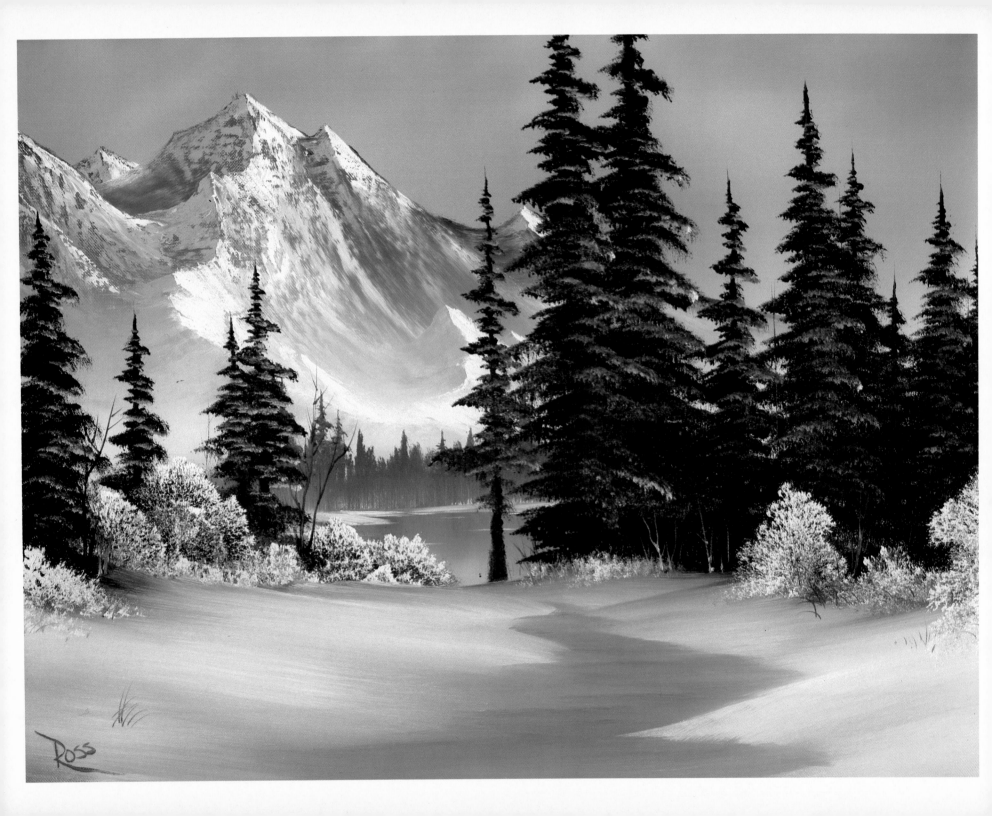

MATERIALS

2″ Brush	Phthalo Blue
1″ Brush	Prussian Blue
#6 Fan Brush	Midnight Black
#2 Script Liner Brush	Van Dyke Brown
Large Knife	Alizarin Crimson
Liquid White	Bright Red
Titanium White	

Start by covering the entire canvas with a thin, even coat of Liquid White using the 2″ brush. With long horizontal and vertical strokes, work back and forth to ensure an even distribution of paint on the canvas. Do NOT allow the Liquid White to dry before you begin.

SKY AND WATER

Load the 2″ brush with Alizarin Crimson, tapping the bristles firmly against the palette to ensure an even distribution of paint throughout the bristles. Use criss-cross strokes to paint the Pink glow in the sky. Use horizontal strokes to add Pink to the water on the lower portion of the canvas. Add Phthalo Blue to the brush and again use criss-cross strokes to "dance" in the top of the sky. With horizontal strokes, add the Phthalo Blue to the water. Use criss-cross strokes to blend the sky, long horizontal strokes to blend the water and then the entire canvas.

MOUNTAIN

Use the knife to mix Midnight Black, Prussian Blue, Van Dyke Brown and Alizarin Crimson to a marbled appearance. (Don't overmix these colors.) Pull the mixture out very flat on your palette and just cut across, loading the long edge of the knife with a small roll of paint. Use firm pressure to shape just the top edge of your mountain and then use the knife to remove any excess paint. With the 2″ brush, pull the paint from the top edge down to the base of the mountain, thereby completing the entire mountain shape.

Use Titanium White to add the snow to the mountain. Again, load the long edge of the knife with a small roll of paint.

The light in this painting is coming from the right, so holding the knife vertically, touch the top of each peak and glide the knife down the right side. Paying close attention to angles, use so little pressure on the knife that the paint "breaks."

The snow on the shadow sides of the peaks is made with the knife using a mixture of Titanium White and Prussian Blue. Again, load the long edge of the knife with a very small roll of paint and apply the mixture to the left sides of the peaks by pulling the paint in the opposing direction.

With a clean, dry 2″ brush (being careful to follow the angles) tap the base of the mountain to diffuse and then gently lift upward to create the illusion of mist.

BACKGROUND

Add Titanium White to the mountain mixture to make a Blue-Gray color. Load both sides of the fan brush and, holding the brush vertically, just tap downward to indicate the small trees at the base of the mountain. Use the corner of the brush to add branches to just a few of the tree tops. Holding the brush horizontally, touch the canvas and bend the bristles upward to add the grassy area beneath the trees. Use the 2″ brush to pull some of this dark mixture into the water and then lightly brush across to create reflections. With Titanium White on a clean fan brush, hold the brush horizontally and use small pull-up strokes to add tiny trunks to the distant trees. Load the long edge of the knife with Liquid White to cut in the water lines and ripples.

FOREGROUND

The evergreen trees are made with the 1″ brush and a mixture of Midnight Black, Prussian Blue and Alizarin Crimson. Using a lot of paint on the brush, load it to a chiseled edge by "wiggling" the bristles as you pull both sides of them through the mixture on your palette.

Holding the brush vertically, touch the canvas to create the center line of the tree. Starting at the top of the tree, use just one corner of the brush to lightly touch the canvas to

form the top branches. Working back and forth (forcing the bristles to bend downward) use more pressure as you move down the tree, allowing the branches to become larger as you near the base of the tree. Allow the larger trees to extend right off the top of the canvas.

You can use the fan brush to paint whole tree trunks (hold it vertically and tap downward) and then just the corner of the brush to add a few branches.

Use Titanium White on the 2″ brush to add the snow to the base of the trees. Hold the brush horizontally and use sweeping strokes as you begin creating the lay-of-the-land. Automatically, some of the dark tree mixture will mix with the Titanium White, creating shadows in the snow.

Use a mixture of Titanium White and Phthalo Blue on the fan brush to add the path in the center of the foreground. Use short horizontal strokes and pay close attention to perspective, the path becomes wider as it nears the bottom of the canvas. With just Titanium White on the fan brush you can add the bright snow to the edges of the path.

Load the 1″ brush by pulling it in one direction through a mixture of Liquid White and Titanium White, to round one corner. With the rounded corner UP, touch the canvas and force the bristles to spread and bend upward as you shape individual, lacy bushes at the base of the large evergreens.

Use a mixture of Liquid White, Titanium White and Phthalo Blue on the fan brush to lightly touch highlights to the branches on the right sides of the evergreens.

FINISHING TOUCHES

With the liner brush and a mixture of paint thinner and Van Dyke Brown, you can add tiny sticks and twigs and other small details to your finished painting. Also use a thinned mixture to sign. Hopefully, with this painting you have truly experienced THE JOY OF PAINTING!

Winter Mountain

1. Use the 2″ brush and criss-cross strokes to paint the sky . . .

2. . . . and horizontal strokes to paint the water.

3. Paint the basic mountain shape . . .

4. . . . then blend downward with the 2″ brush to remove excess paint and soften the base.

5. Apply highlights and shadows to the mountain with the knife.

6. With the 2″ brush, tap the base of the mountain . . .

Winter Mountain

7. . . . then lift upward to create the illusion of mist.

8. Tap downward with fan brush to create distant trees.

9. Use the 2" brush to pull down reflections . . .

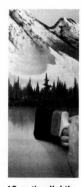

10. . . . then lightly brush across to create a watery impression.

11. Use the knife and Liquid White to cut-in water lines.

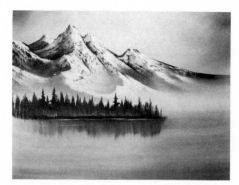

12. Background complete.

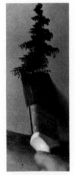

13. Use the 1" brush . . .

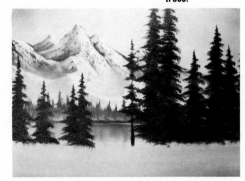

14. . . . to make the evergreen trees.

15. Use the 2" brush to lay in the snow-covered ground area.

16. Add the path using the fan brush.

17. Lacy bushes are made with the 1" brush.

18. Add tiny sticks and twigs with the liner brush.

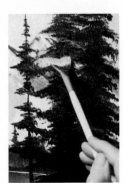

19. Highlight the evergreens with the fan brush.

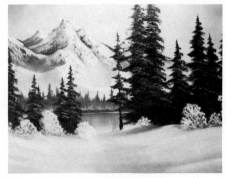

20. Your painting is ready for a signature.

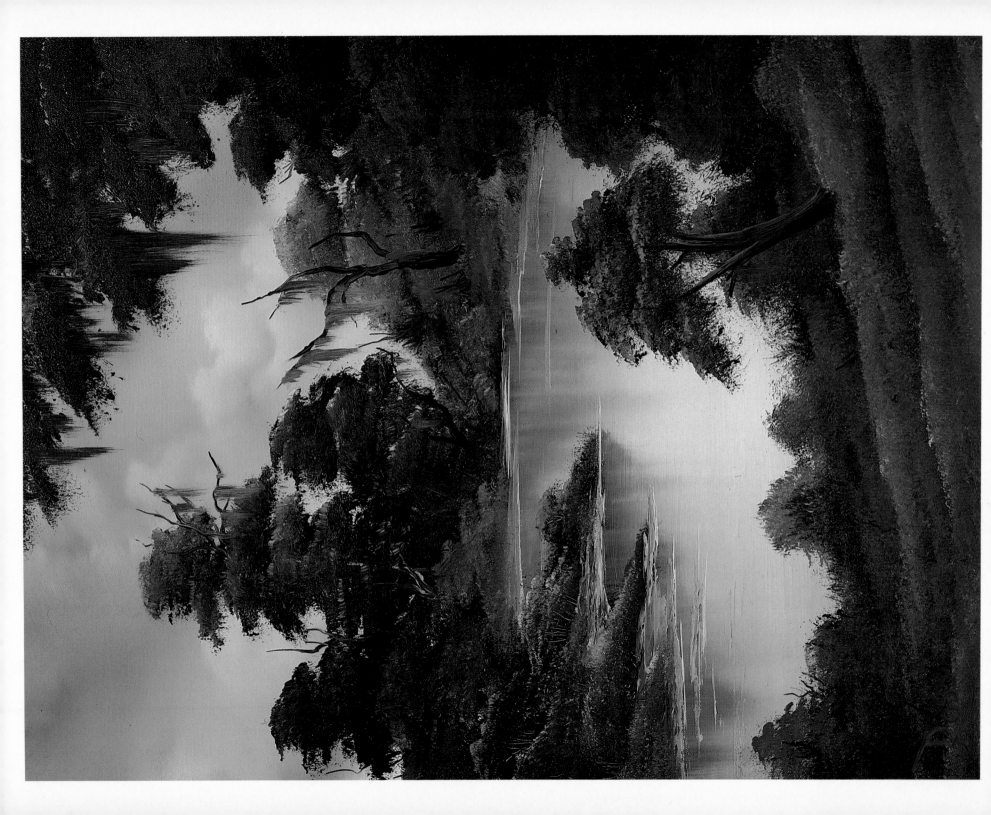

MATERIALS

2" Brush	Indian Yellow
1" Brush	Bright Red
Large Knife	Prussian Blue
Liquid White	Phthalo Blue
#6 Fan Brush	Sap Green
#2 Script Liner Brush	Titanium White
Alizarin Crimson	Van Dyke Brown
Dark Sienna	Yellow Ochre
Cadmium Yellow	

Cover the entire canvas with a thin, even coat of Liquid White using the 2" brush. Apply the Liquid White in long horizontal and vertical strokes, working it back and forth to assure an even distribution of paint on the canvas. Do not allow the Liquid White to dry before you begin.

SKY AND WATER

Load the 2" brush with a little Prussian Blue and Van Dyke Brown, evenly distributed throughout the bristles. Paint in the sky using criss-cross strokes, working across the top of the canvas and downward in layers. For the water, add a little more paint to the brush. Use horizontal strokes, with the brush held flat, working from each side in towards the center. With a clean dry 2" brush, blend the sky and water areas then blend the entire canvas.

To make the clouds, use the 1" brush loaded with Titanium White. Use just the corner of the brush in small, tight circular strokes to lay in the basic cloud shapes. Use just the top corner of the 2" brush to blend the bottom of the clouds out. Lift upward with the brush held flat, then blend.

BACKGROUND

The trees and bushes in the background are made with a very thin mixture of paint. Dip the 1" brush into paint thinner and then load it by pulling through Van Dyke Brown, Dark Sienna and Prussian Blue. The tree and bush shapes are made by gently tapping the loaded brush to the canvas. Use the 2" brush to pull some of this dark color down into the water for reflections. Gently brush across. The trees and bushes are highlighted by tapping with the 1" brush loaded with various mixtures of Cadmium Yellow, Sap Green, Bright Red, Yellow Ochre and Indian Yellow. Soften these highlights by tapping with just the corner of a clean, dry 2" brush. Add the highlight colors to the reflections in the water. Gently pull down and brush across with the large brush. The water lines are cut in with a mixture of Van Dyke Brown and Liquid White loaded on the long edge of the knife. Tree branches and dead trees are made with the liner brush and thinned Van Dyke Brown. Dip the fan brush into paint thinner and then load with Van Dyke Brown and Titanium White. Gently pull down moss hanging from some of the tree limbs and branches, using just a corner of the fan brush.

This painting must be completed in stages. Be sure the background trees and water are completed before moving forward. After the trees and bushes and the water under the small land projection are completed, use just the point of the knife to scratch in sticks and twigs. Use a small roll of Liquid White, Titanium White and Van Dyke Brown loaded on the long edge of the knife to gently lay in the land area. The water lines are cut in with Liquid White on the long edge of the knife.

FOREGROUND

Again, use a very thin mixture of Van Dyke Brown, Prussian Blue and Dark Sienna loaded on the 1" brush to form the tree and bush shapes in the foreground. Highlights are made the same way using various mixtures of Cadmium Yellow, Yellow Ochre, Indian Yellow, Sap Green and Bright Red loaded on the 1" brush. Soften the highlights by gently tapping with one corner of the 2" brush. Use the fan brush loaded with thinned Van Dyke Brown and Titanium White to "hang" moss from the trees. The grassy area is made by holding the 2" brush horizontally and gently tapping in various mixtures of Sap Green, all the Yellows and Bright Red. Pay careful attention to the lay-of-the-land.

The small tree trunk in the foreground is made by loading the fan brush with Van Dyke Brown and vertically touching the canvas and pulling downward. The highlight on the tree trunk is made the same way using Titanium White on the fan brush. The foliage is made with the 1″ brush using thinned Van Dyke Brown, Prussian Blue and Dark Sienna, gently tapping in the basic shapes. Highlight this little tree with a mixture of Phthalo Blue, Alizarin Crimson and Titanium White mixed on the 1″ brush to a soft Purple color. Again, soften with the 2″ brush.

FINISHING TOUCHES

Add more sticks and twigs using the liner brush and Van Dyke Brown which has been thinned.

1. Use the large brush to paint in sky . . .

2. . . . and water.

3. Basic shapes painted in.

4. Clouds are layed in with the 1″ brush . . .

5. . . . then blended with the 2″ brush.

6. The 1″ brush is used . . .

7. . . . to paint in basic tree shapes.

8. Pull downward to create reflections.

9. Highlights are applied with the 1″ brush . . .

10. . . . then blended with the corner of the 2″ brush.

11. Waterlines are cut in with the knife.

Wetlands

12. Tree trunks painted with the liner brush.

13. The corner of the fan brush is used . . .

14. . . . to paint moss on the trees.

15. The palette knife is used . . .

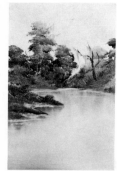

16. . . . to create the land areas.

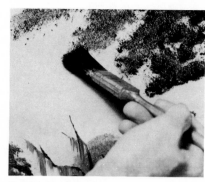

17. With the 1" brush . . .

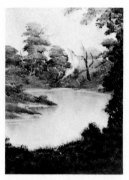

18. . . . paint in the over hanging limbs.

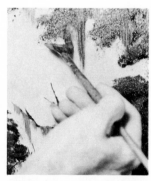

19. Moss is painted with the corner of the fan brush.

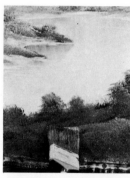

20. Grassy areas made with the 2" brush.

21. The fan brush is used . . .

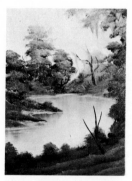

22. . . . to paint tree trunks.

23. The 1" brush is used to paint . . .

24. . . . and highlight . . .

25. . . . the foliage on the tree.

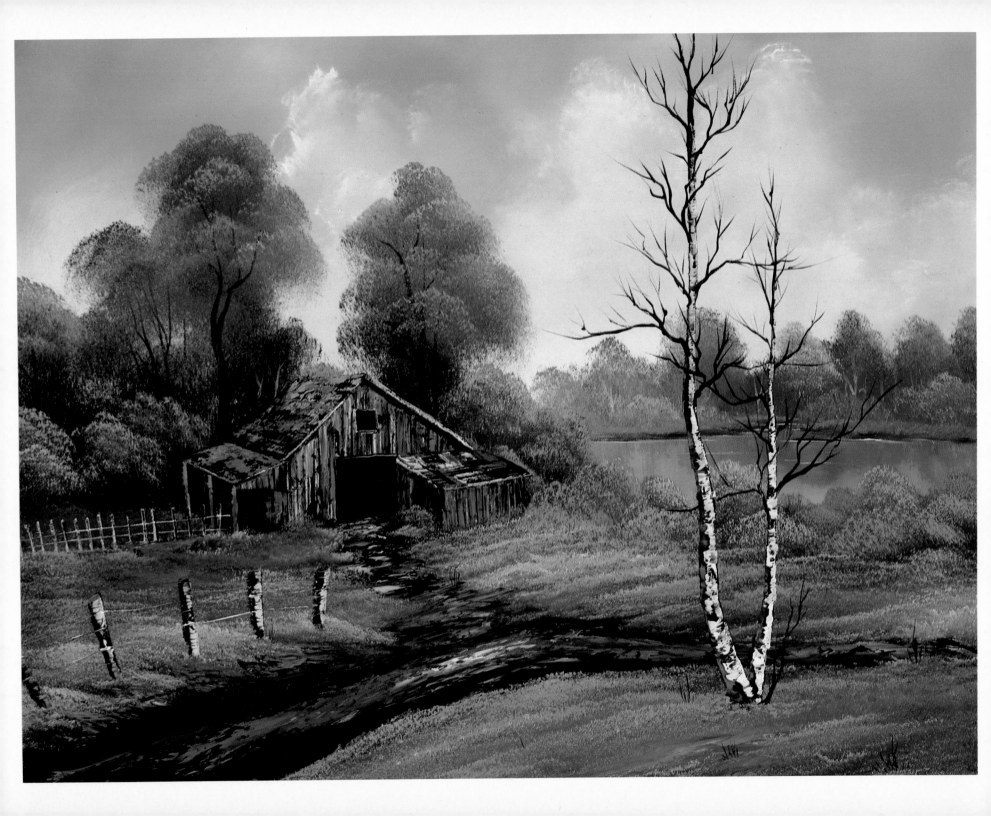

MATERIALS

2″ Brush	Midnight Black
1″ Round Brush	Dark Sienna
#6 Fan Brush	Van Dyke Brown
#2 Script Liner Brush	Alizarin Crimson
Large Knife	Sap Green
Small Knife	Cadmium Yellow
Liquid White	Yellow Ochre
Titanium White	Indian Yellow
Prussian Blue	Bright Red

Start by covering the entire canvas with a thin, even coat of Liquid White using the 2″ brush. Work back and forth with long horizontal and vertical strokes to ensure an even distribution of paint on the canvas. Do NOT allow the Liquid White to dry before you begin.

SKY

Load the 2″ brush with a mixture of Prussian Blue and a small amount of Midnight Black. Starting at the top of the canvas, begin painting the sky using criss-cross strokes. Automatically the sky will get lighter near the horizon as the color mixes with the Liquid White. Lightly brush across to blend.

With Titanium White and a small amount of Bright Red on a clean 2″ brush, use small circular strokes to add the clouds. Use a clean, dry 2″ brush to blend out the bottoms of the clouds and then gently lift to fluff.

BACKGROUND

Load the 1″ round brush with a mixture of Dark Sienna, Van Dyke Brown, Sap Green and Midnight Black. Use a tapping motion to add the small trees along the horizon. Add Yellow Ochre, Cadmium Yellow and Sap Green to the same brush to add a few highlights to the distant trees.

Use the Prussian Blue-Midnight Black mixture on the 2″ brush and horizontal strokes to add the small lake to the base of the background trees.

Tap downward to reflect the small trees into the water using the round brush and all the tree mixtures. With a clean, dry 2″ brush pull down the reflections and then gently brush across.

With a mixture of Dark Sienna and Van Dyke Brown on the long edge of the knife, add the banks along the water's edge at the base of the distant trees. Use a mixture of Van Dyke Brown and Liquid White to firmly cut-in the water lines.

Load the round brush with a mixture of Dark Sienna, Van Dyke Brown, Sap Green, Prussian Blue and Midnight Black. Add the larger trees behind the barn and the small bushes across the front of the lake.

Use a mixture of paint thinner and Van Dyke Brown to indicate a few tree trunks and branches. Highlight the trees and bushes with various mixtures of all the Yellows, Sap Green and Bright Red on the round brush. Try not to destroy all of your dark base color. When you are satisfied with your highlights, use the point of the knife to add additional sticks and twigs.

Begin forming the lay-of-the-land by using a mixture of Van Dyke Brown, Dark Sienna and Sap Green on the 2″ brush. Hold the brush horizontally and tap downward to add the grassy areas to the base of the larger trees and bushes. Add the Yellows to the same brush and again tap downward to begin highlighting the grass, still paying close attention to the lay-of-the-land.

BARN

Use a clean knife to remove excess paint from the canvas in the basic shape of the barn; pay close attention to angles.

When you are satisfied with the shape of the barn, use Van Dyke Brown on the knife to paint the front of the roof and then the back edge of the roof. Still using Van Dyke Brown, add the sides and front of the barn. Load the knife with a mixture of Dark Sienna, Bright Red and Titanium White and lightly touch a highlight to the back edge of the roof. Use Dark Sienna, Prussian Blue and Titanium White to under-

paint the highlights on the front of the roof, and then add the Dark Sienna-Bright Red-Titanium White mixture using very light pressure, causing the paint to "break." Just touch the edges of the roof with Titanium White.

With Dark Sienna and Titanium White, add highlights to the sides of the barn, then cut in slabs with Van Dyke Brown on the knife. Add the doors, the posts and the small shed with Van Dyke Brown. Use the Dark Sienna-Prussian Blue-Titanium White mixture to highlight the small roof; the Dark Sienna-Bright Red-Titanium White mixture to highlight the roof and front of the shed. Use touches of Titanium White to highlight the edges of the roof, the doors and posts.

With all the Yellows on the 2″ brush, highlight the grass at the base of the cabin. With Van Dyke Brown on the small knife, add the tiny fence in the background. Use touches of Titanium White to highlight and cut-in the fence wire.

FOREGROUND

Working forward in layers, continue highlighting the grass by tapping downward with the 2″ brush, still forming the lay-of-the-land.

Use Van Dyke Brown on the 2″ brush and a long horizontal stroke to underpaint the road. (You can extend this dark undercolor to the bottom of the canvas.) With Van Dyke Brown on the knife, use short horizontal strokes to add the path from the barn to the road. The highlights are a mixture of Dark Sienna, Van Dyke Brown and Titanium White, applied with the knife using very little pressure.

Continue highlighting the grass with the 2″ brush and all the Yellows, Bright Red and Sap Green. Use just the corner of the brush to add grass to the edges of the path and road. Extend these highlights to the bottom of the canvas.

The large fence along the edge of the road is made with Van Dyke Brown on the knife and then highlighted with a mixture of Van Dyke Brown, Dark Sienna and Titanium White. Use the heel of the knife to cut-in the wire on the fence.

LARGE TREES

Start the large tree trunks in the foreground by loading the fan brush with Van Dyke Brown. Holding the brush vertically and starting at the top of each tree, pull down. Use more pressure as you near the base of each tree allowing the trunks to become wider.

Highlight the trunks with Titanium White on the long edge of the knife. Add the limbs and branches with thinned Van Dyke Brown on the liner brush.

FINISHING TOUCHES

Use thinned paint on the liner brush or just the point of the knife to add final details (long grasses, sticks and twigs) and then sign your masterpiece!

Roadside Barn

1. Criss-cross strokes are used to paint the sky.

2. Use the 2″ brush to make . . .

3. . . . and blend the clouds. With a clean brush, use long horizontal strokes to blend the entire sky.

4. Tap downward with the round brush to make and highlight distant trees.

5. Pull straight down, then across with the 2″ brush, to create reflections.

Roadside Barn

 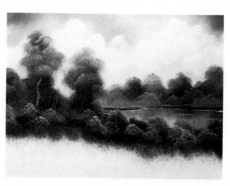

6. Land areas are layed in and highlighted with the knife.

7. Use Liquid White on the edge of the knife to cut-in water lines.

8. Larger trees are tapped in with the round brush.

9. Use a thin paint on the liner brush . . .

10. . . . to paint tree trunks, sticks and twigs. Highlights are then applied to trees and bushes with the round brush.

11. Tap downward with the 2" brush to paint the grassy areas in the foreground.

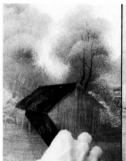 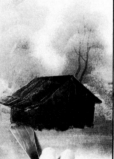 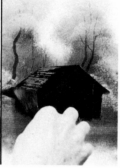 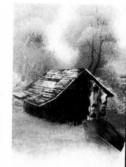 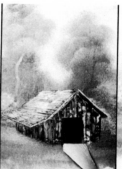 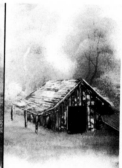

12. Progressional steps used to paint the barn.

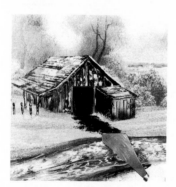 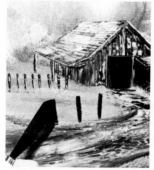 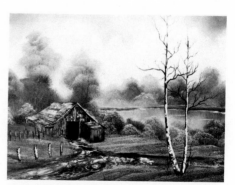

13. Use the knife to add the path and the road.

14. Large fence posts in the foreground are painted with the knife.

15. Pull down with the fan brush to make trunks . . .

16. . . . then highlight with the knife.

17. A thin paint on the liner brush . . .

18. . . . is used to paint individual tree limbs and to add sticks and twigs.

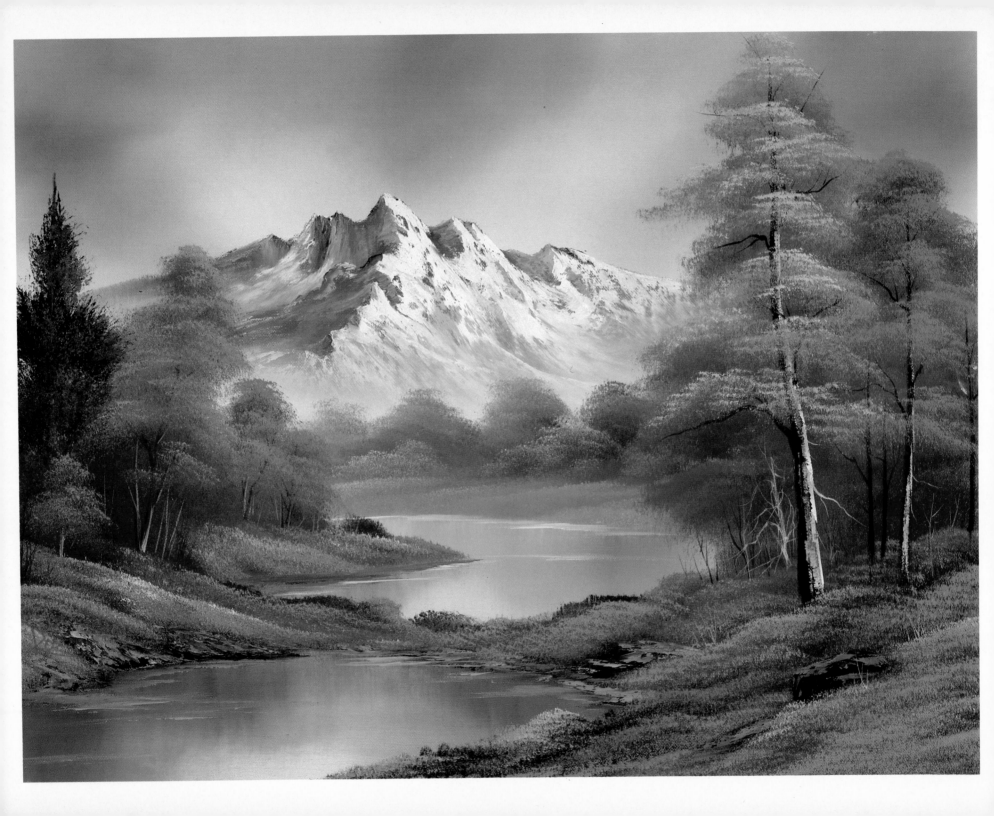

MATERIALS

2" Brush
1" Brush
#6 Fan Brush
#2 Script Liner Brush
Large Knife
Small Knife
Liquid White
Titanium White
Phthalo Blue
Prussian Blue

Midnight Black
Dark Sienna
Van Dyke Brown
Alizarin Crimson
Sap Green
Cadmium Yellow
Yellow Ochre
Indian Yellow
Bright Red

Start by covering the entire canvas with a thin, even coat of Liquid White using the 2" brush. With long horizontal and vertical strokes, work back and forth to ensure an even distribution of paint on the canvas. Do NOT allow the Liquid White to dry before you begin.

SKY AND WATER

Load the 2" brush by tapping the bristles firmly into Yellow Ochre. Use criss-cross strokes to create a bright glow in the sky near the top of the canvas. You can also add a little Cadmium Yellow to the same brush to vary the color. Clean and dry the 2" brush and then load it with a mixture of Phthalo Blue and Alizarin Crimson. Use criss-cross strokes with this mixture to complete the sky.

Add Phthalo Blue to the same brush and use long, horizontal strokes to add the water to the bottom of the canvas. With a clean, dry 2" brush, blend the entire canvas.

MOUNTAIN

Use the knife to mix Midnight Black, Prussian Blue, Van Dyke Brown and Alizarin Crimson to a marbled appearance. (Don't overmix these colors.) Pull the mixture out very flat on your palette and just cut across, loading the long edge of the knife with a small roll of paint. With firm pressure, shape just the top edge of your mountain and then use the knife to remove any excess paint. With the 2" brush, pull the paint from the top edge down to the base of the mountain, thereby completing the entire mountain shape.

Use a mixture of Titanium White with a VERY small amount of Bright Red to add the snow to the mountain. Again, load the long edge of the knife with a small roll of paint. The light in this painting is coming from the right, so holding the knife vertically, touch the top of each peak and glide the knife down the right side. Paying close attention to angles, use so little pressure on the knife that the paint "breaks." Add a mixture of Titanium White, Dark Sienna and Bright Red to the knife near the base of the mountain, where there would be less snow.

The snow on the shadow sides of the peaks is made with the small knife using a mixture of Titanium White and Prussian Blue mixed to three values (light, medium and dark). Again, load the long edge of the small knife with a very small roll of paint and apply the various mixtures to the shadow sides of the peaks by pulling the paint in the opposing direction.

With a clean, dry 2" brush (being careful to follow the angles) tap the base of the mountain to diffuse and then gently lift upward to create the illusion of mist.

BACKGROUND

Add some Sap Green to the mountain mixture of Midnight Black, Prussian Blue, Van Dyke Brown and Alizarin Crimson. Remove a small portion of the mixture and add some Titanium White, thereby creating two values of this dark mixture. Load the 2" brush by tapping the bristles firmly into the lighter mixture and use one corner of the brush to tap downward to underpaint the small, background trees at the base of the mountain. Use the darker mixture for the ground area beneath the trees and then use vertical strokes with the same brush to pull the reflection of these trees into the water.

Load the 1" brush with various mixture of all the Yellows and Midnight Black (to make Green) and tap lightly to add the soft highlights to the right sides of the small tree tops. To

form individual trees and bush shapes, be very careful not to "kill" all of the dark base color. Also highlight the ground area, but don't just hit at random; this is where you begin creating the lay-of-the-land.

Use a clean, dry 2" brush to pull a little of the highlight color into the water; pull straight down and brush across to complete the reflections. Load the long edge of the knife with a very small roll of Liquid White and cut in the water lines and ripples. Make sure these lines are parallel to the top and bottom of the canvas.

FOREGROUND

With the same dark mixture (Midnight Black, Prussian Blue, Van Dyke Brown, Alizarin Crimson and Sap Green) on the 2" brush, use just one corner of the brush to tap downward to underpaint the large trees and bushes in the foreground. Start at the bottoms of the trees and as you work upward, add various mixtures of Dark Sienna and Yellow Ochre to the brush to lighten the tree tops.

The evergreen tree on the left side of the painting is made with the 1" brush. Load the brush to a chiseled edge by wiggling the bristles as you pull them through the same dark base mixture. Hold the brush vertically and just touch the canvas to create the tree top. Still holding the brush vertically, force the bristles to bend upward to add the branches; more pressure on the brush will force larger branches.

After you have blocked in the entire foreground with the dark base color, use the large brush and vertical strokes to create the water area in the foreground; lightly brush across.

Load the fan brush with Van Dyke Brown, hold the brush vertically and pull down to add the tree trunks. Use the liner brush and a mixture of paint thinner and Van Dyke Brown to add the limbs and branches to the trees.

Use the fan brush to make the large tree trunk, but highlight it with a mixture of Titanium White and Van Dyke Brown loaded on the long edge of the knife. Hold the knife vertically, touch just the right edge of the trunk and give a little sideways pull.

Load the 1" brush with various mixtures of all of the Yellows, Midnight Black, Sap Green and Bright Red to highlight the foreground trees and bushes. (If the paint won't stick, you may need to thin it with the Liquid White or paint thinner.) Use just the corner of the brush and tap downward. Work in layers as you use the highlights to create individual tree, bush and leaf shapes.

Add the banks along the water's edge with Van Dyke Brown and the knife. Highlight the banks with a mixture of Titanium White and Van Dyke Brown on the knife and use Liquid White to cut in the water lines and ripples.

FINISHING TOUCHES

You can add small details with the point of the knife or thinned paint on the liner brush. Don't forget to sign your painting!

Soft Mountain Glow

 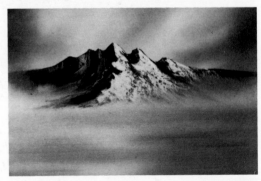

1. Use criss-cross strokes to paint the sky . . .

2. . . . and horizontal strokes for the water with the 2" brush.

3. Shape the top of the mountain with the knife . . .

4. . . . then pull the paint down with the 2" brush.

5. Add snow with the knife . . .

6. . . . to complete the mountain.

Soft Mountain Glow

7. Tap down with the 2" brush to paint background trees . . .

8. . . . then pull down to reflect them into the water.

9. Use the 1" brush to highlight background.

10. Cut in the water lines with a small roll of Liquid White.

11. Use the 2" brush to underpaint foreground trees . . .

12. . . . and the 1" brush for the evergreen.

13. The 2" brush is used to paint and reflect . . .

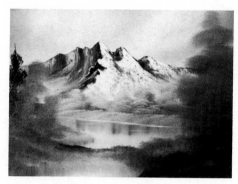

14. . . . land areas in the foreground.

15. Pull down trunks with the fan brush . . .

16. . . . add branches with the liner brush . . .

17. . . . then highlight with the knife.

18. Highlight the grassy areas with the 1" brush.

19. Use the knife to paint the land areas . . .

20. . . . and cut in water lines . . .

21. . . . to complete the painting.

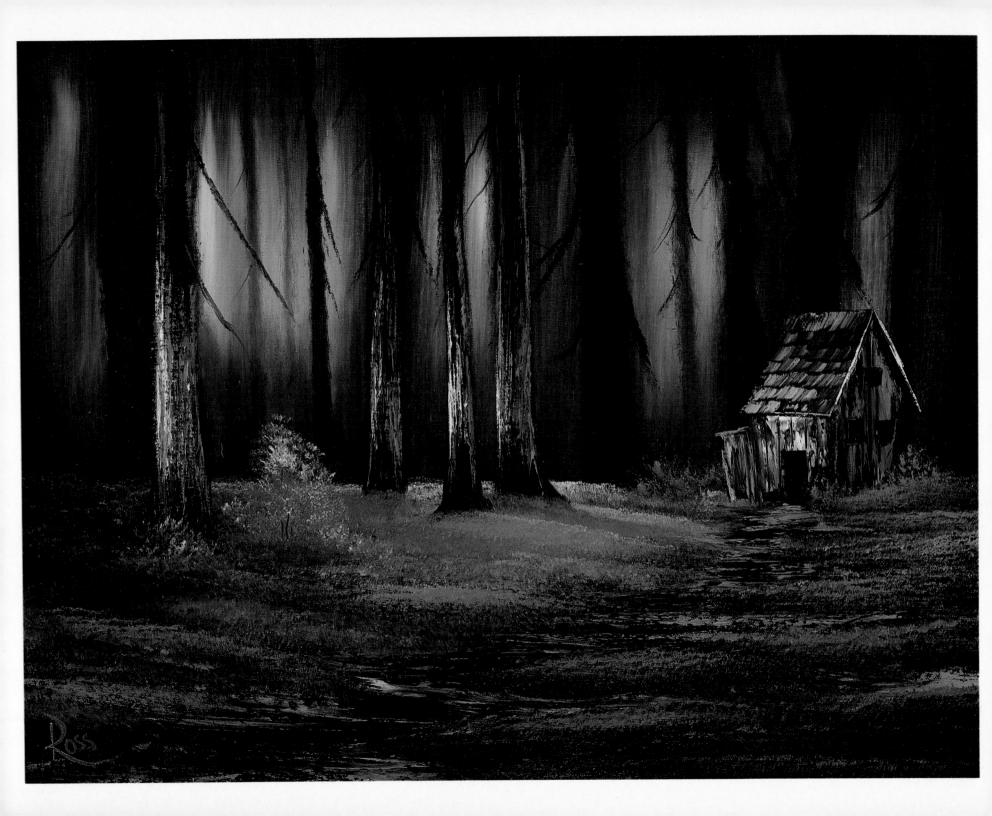

MATERIALS

2" Brush	Cadmium Yellow
1" Brush	Indian Yellow
Large Knife	Bright Red
Liquid White	Phthalo Blue
Black Gesso	Phthalo Green
#6 Fan Brush	Sap Green
#2 Script Liner Brush	Van Dyke Brown
Alizarin Crimson	Yellow Ochre
Dark Sienna	

Start with a canvas that has been painted with Black Gesso paint and allowed to dry completely. With the 2" brush, cover the entire canvas with a thin even coat of Phthalo Blue and Sap Green. These colors can just be mixed on the brush, using long horizontal and vertical strokes to blend the entire canvas. Do not allow the paint to dry before you begin.

SKY

Load the fan brush with Titanium White and apply vertical streaks at random in the sky area of the canvas. With a clean, dry 2" brush, blend these light areas with long vertical strokes.

TREES

Make a Black mixture with equal parts of Phthalo Green and Alizarin Crimson. Test the color by mixing a very small amount with a little Titanium White. Correct if necessary by adding more Phthalo Green or Alizarin Crimson.

The distant tree trunks are made by loading the fan brush with the Black paint and just tapping downward in long vertical strokes. Place the Black trees between the light areas in the sky, keeping the edges rough. Use the liner brush with the Black mixture to make the limbs and branches.

The grassy areas under the trees are made with the 2" brush using various mixtures of Cadmium Yellow, Indian Yellow, Yellow Ochre, Bright Red and Sap Green. Load the

brush with very little paint, and holding it horizontally gently tap the color onto the ground area under the trees. As you work forward, add a few closer trees by extending the base of some of the background trees down into the grassy area, again using the fan brush and Black paint. Additional trees can be added at this point using the same tapping motion and the Black mixture. Highlight a few of the nearest trees with two mixtures of Bright Red, Phthalo Blue and Titanium White. One mixture should look Pink, the other should be mixed to a Blue. Load the long edge of the knife with a very small roll of paint and gently touch the highlight color to the lower half of the tree trunks. Touch the Pink mixture to the left of the trees, where the light would strike; the Blue mixture goes on the right shadow side.

With the 2" brush, continue to tap in the grassy areas allowing the color to get darker as you near the bottom of the canvas. Tap in a little of the Black paint to create shadows at the base of the trees.

CABIN

With a small roll of Van Dyke Brown on the long edge of the knife, lay in the back overhang first. With the same color, complete the front of the roof. Using the same color, put in the front, the side and then a little shed. Pay close attention to angles. Highlight the cabin with a mixture of Titanium White, Van Dyke Brown and Dark Sienna on the knife. This mixture should be lighter on the front of the cabin and applied with so little pressure that the paint is allowed to "break". Add a touch of Phthalo Blue to the shed and the windows. The door is made with Van Dyke Brown; roof shingles are a mixture of Van Dyke Brown and Bright Red laid on with the short edge of the knife.

PATH

The path is made with horizontal strokes of Van Dyke Brown and Dark Sienna loaded on the long edge of the knife. Allow the path to get wider as it comes closer, near the bottom of the canvas. Highlights are a mixture of Van Dyke

Brown, Titanium White and Phthalo Blue, applied with so little pressure that the paint is allowed to "break."

FINISHING TOUCHES

Using the 2″ brush and various mixtures of Cadmium Yellow, Yellow Ochre, Indian Yellow, Bright Red, and Sap Green, paint the grassy areas to extend just over the edges of the path. This will "set" the path down into the painting.

The bushes in the background are quite dark, made with a mixture of Sap Green and Cadmium Yellow. Load the 1″ brush by pulling it through the paint in one direction to round one corner. With the rounded corner up, touch the canvas and gently force the bristles to bend upward.

Cabin In The Woods

1. Color is applied to the canvas with a fan brush.

2. The 2″ brush . . .

3. . . . is used to blend the background.

4. Use the fan brush to make tree trunks.

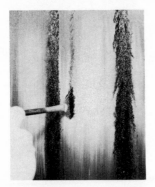

5. Very little paint is used to paint distant trees.

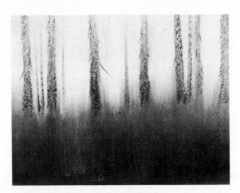

6. Background tree trunks completed.

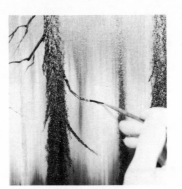

7. The liner brush is used . . .

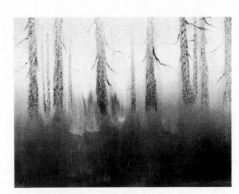

8. . . . to paint limbs on the trees.

Cabin In The Woods

9. The 2" brush is used . . .

10. . . . to paint the grassy areas.

11. Bushes made with the 1" brush.

12. Use the fan brush to make the foreground trees.

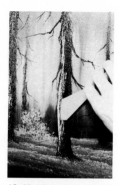

13. Highlights are applied with the knife.

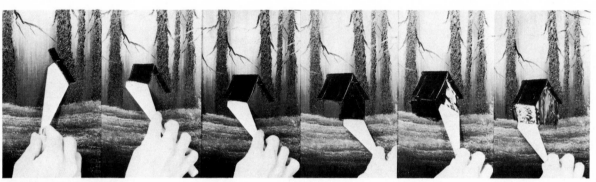

14. Steps used to paint the cabin.

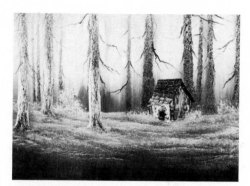

15. Cabin completed.

16. Use the knife . . .

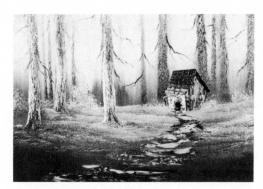

17. . . . to paint and highlight the path.

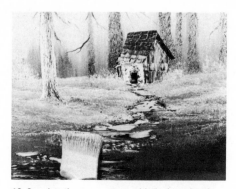

18. Complete the grassy areas with the large brush.

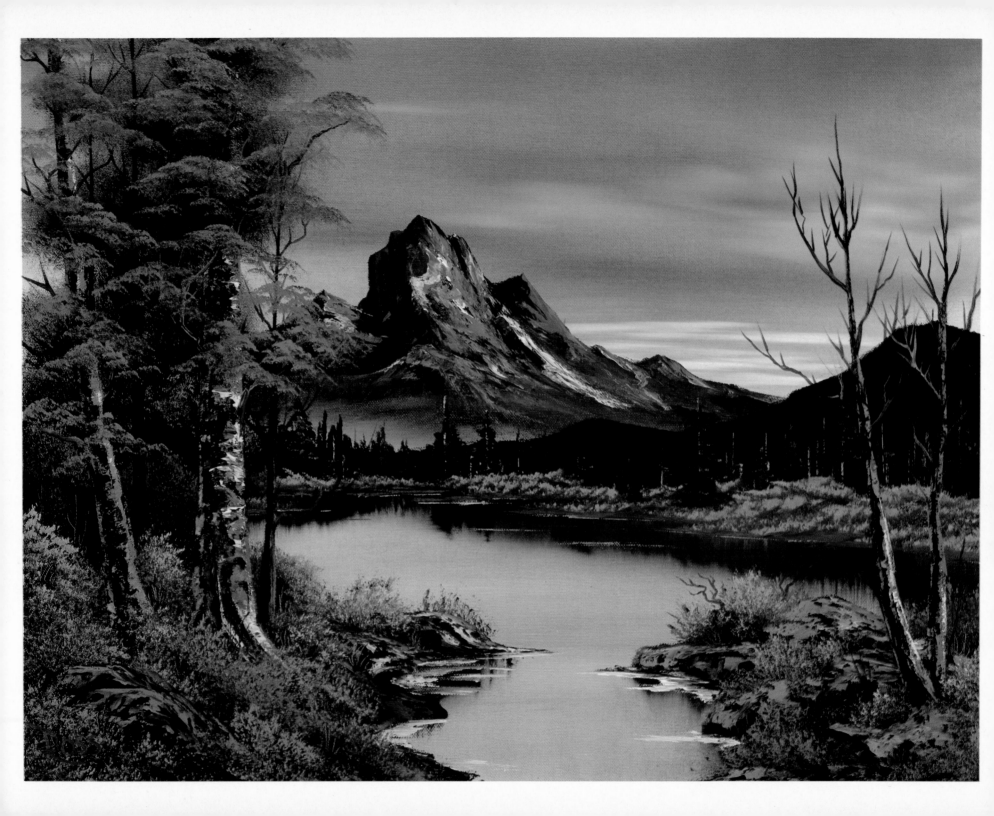

MATERIALS

2" Brush	Prussian Blue
1" Brush	Midnight Black
#6 Fan Brush	Dark Sienna
#3 Fan Brush	Van Dyke Brown
#2 Script Liner Brush	Alizarin Crimson
Large Knife	Sap Green
Small Knife	Cadmium Yellow
Liquid White	Yellow Ochre
Liquid Black	Indian Yellow
Titanium White	Bright Red
Phthalo Blue	

Start by covering the entire canvas with a VERY THIN even coat of Liquid Clear, using the 2" brush. With long horizontal and vertical strokes, work back and forth to ensure an even distribution of paint on the canvas. Do NOT allow the Liquid Clear to dry before you begin.

SKY

Load the 2" brush with Indian Yellow, tapping the bristles firmly against the palette to ensure an even distribution of paint throughout the bristles. Use horizontal strokes to add the Yellow to the area just above the horizon and then continue using horizontal strokes to add some of the same color to the center of the water, just below the horizon. Without cleaning the brush, pick up a little Alizarin Crimson and still using horizontal strokes, add it above the Indian Yellow in the sky and below the Indian Yellow in the water. Add Phthalo Blue to the Alizarin Crimson already in the brush and use criss-cross strokes to cover the entire area to the top of the canvas; use horizontal strokes to add the color to the water.

With a clean, dry 2" brush, use criss-cross strokes to blend the colors together in the sky and then long, horizontal strokes to blend the entire canvas.

Use the knife and Titanium White for the clouds. Pull the paint out very flat on your palette and just cut across to load the long edge of the knife with a small roll of paint. Use diagonal, sweeping motions with the knife to add the clouds; horizontal strokes with the 2" brush to blend the knife clouds. You can also use the 2" brush and Titanium White with sweeping strokes to indicate additional clouds. Again, lightly blend the entire sky.

MOUNTAIN

Use a mixture of Dark Sienna, Bright Red, Titanium White and Yellow Ochre to highlight the mountain. (Do not over-mix these colors.) Again, load the long edge of the knife with a small roll of the mixture. Notice that the light is coming from the right. Paying close attention to angles, hold the knife vertically, touch the top of each peak and use so little pressure that the paint "breaks," as you glide the knife down the right sides of all the peaks.

Use a mixture of Dark Sienna, Bright Red, Titanium White and Yellow Ochre to highlight the mountain. (Do not over-mix these colors.) Again, load the long edge of the knife with a small roll of the mixture. Notice that the light is coming from the right. Paying close attention to angles, hold the knife vertically, touch the top of each peak and use so little pressure that the paint "breaks", as you glide the knife down the right sides of all the peaks.

On the shadow (left) sides of the peaks, use the small knife with a mixture of Titanium White, Prussian Blue and Dark Sienna. Again, load the long edge of the knife with a small roll of paint and apply it by pulling the knife in the opposing direction.

With a clean, dry 2" brush (being careful to follow the angles) tap the base of the mountain to diffuse and then gently lift upward to create the illusion of mist.

BACKGROUND

The dark hill at the base of the mountain is made with the knife, still using the mountain mixture of Midnight Black, Prussian Blue and Van Dyke Brown. (The mixture should look Black.) You should again concern yourself with only the top

shape of the hill, but use the 2″ brush to pull the paint down to the base, thereby completing the entire shape of the hill.

Use a dark mixture of Prussian Blue, Midnight Black and Titanium White on the knife to add just a few shadows for details to the hill.

Holding the 2″ brush flat against the canvas, pull some of the dark-hill color straight down into the water to create a reflection, and then lightly brush across to give your reflection a watery appearance.

To add the ground at the base of the hill, use a mixture of Sap Green with a small amount of Cadmium Yellow on the larger fan brush. Hold the brush horizontally and force the bristles to bend upward as you shape the indication of tiny trees in the distance. Add a little more of the Yellows to the brush for highlights.

Use a small roll of Van Dyke Brown on the knife to add the bank along the water's edge, in the background. The water lines and ripples are cut in with a small roll of Liquid White loaded on the long edge of the knife. These lines should be perfectly straight and parallel to the top and bottom of the canvas: you don't want your water to run off the canvas.

Load the small fan brush with a light mixture of Sap Green and all the Yellows. Hold the brush vertically and tap downward to indicate just the tops of some very small evergreen trees in this background area.

FOREGROUND

Load the 2″ brush with a mixture of Van Dyke Brown, Alizarin Crimson, Dark Sienna and Sap Green. Begin by underpainting the large trees and bushes in the foreground, using just one corner of the brush to tap downward quite firmly. If you start at the base of each tree and work upward, the color will automatically get lighter as you near the tree tops. Add Yellow Ochre to the brush as you near the tree tops.

Continue using the dark mixture to tap in the entire ground area, creating small bushes and undergrowth at the foot of the large trees. Use vertical strokes with the brush to reflect this dark base color into the water. Lightly brush across horizontally to give these reflections a watery appearance.

Load the large fan brush with Van Dyke Brown. Hold the brush vertically and, starting at the top of the canvas, pull down to add the tree trunks. Use more pressure on the brush as you near the bottoms of the trunks, allowing them to become larger at the base.

Highlight the bushes at the base of the trees by loading the 2″ brush with various mixtures of all the Yellows, Sap Green and Bright Red. Use one corner of the brush and just tap downward. You can also use the 1″ brush for the highlights. Load the brush by pulling it in one direction (to round one corner) through a mixture of Liquid White, all the Yellows, Sap Green and Bright Red. With the rounded corner up, touch the canvas and force the bristles to bend upward as you form the individual bushes and small trees. Be very careful not to "kill" your dark base color. Use the dark to separate individual shapes and remember, you need dark in order to show light.

Use Van Dyke Brown on the knife to add the rocks and stones, and then highlight with the mountain highlight mixture of Dark Sienna, Bright Red, Titanium White and Yellow Ochre. You can even add a little Blue to the shadow sides of the rocks.

Working in layers, continue making the rocks and stones, using the 1″ brush to add the grassy areas to the base of the stones. Use Liquid White on the knife to cut in the water lines and ripples.

LARGE TREES

Highlight the large tree trunks with a mixture of Dark Sienna and Titanium White on the knife. Hold the knife vertically, touch the right sides of the trunks and give the knife a little sideways pull. Use Liquid Black on the liner brush to add the limbs and branches to the tree trunks.

Load the 2″ brush with various mixtures of all the Yellows and Bright Red. With just the corner of the brush, add the leaf clusters to the large, foreground trees.

FINISHING TOUCHES

Add small sticks and twigs with Liquid Black on the liner brush and you are ready to sign your masterpiece. Today, you have truly experienced THE JOY OF PAINTING!

Mountain At Sunset

1. Paint the sky with the 2" brush and horizontal strokes.

2. Paint the clouds with the knife . . .

3. . . . then blend with the 2" brush.

4. Add cloud indications with the 2" brush.

5. Shape the mountain with the knife . . .

6. . . . then pull down with the 2" brush.

7. Apply the highlights with the knife . . .

8. . . . then tap to mist with the 2" brush.

9. Add the second mountain top with the knife . . .

10. . . . then complete the shape with the 2" brush.

11. Use the 2" brush to pull down reflections.

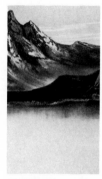

12. Use push-up strokes to add grass with the fan brush.

13. Cut in the water lines with the knife.

14. Fan brush evergreens complete the background.

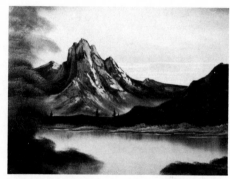

15. Tap down with the 2" brush to underpaint trees and bushes.

16. Pull down tree trunks . . .

17. . . . limbs and branches are added.

18. Tap down to paint small bushes with the 2" brush.

19. Paint and highlight rocks and stones with the knife.

20. Add bushes. . .

21. . . . then cut in water lines with the knife.

22. Highlight large trunks . . .

23. . . . and leaves.

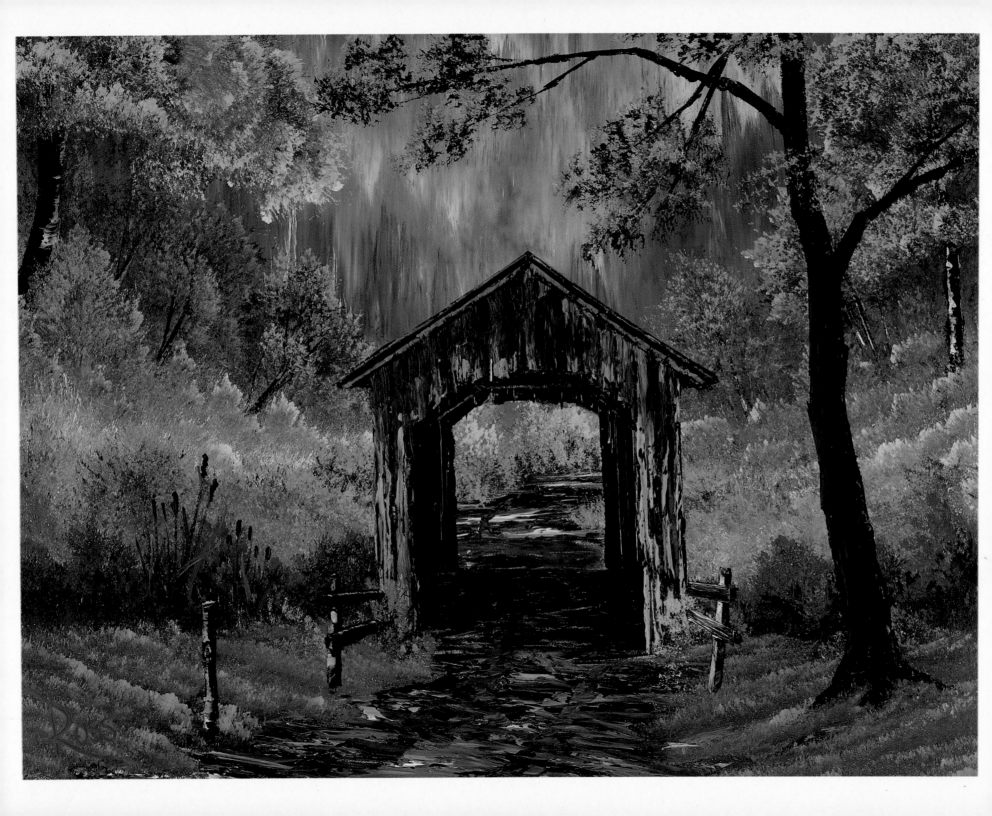

MATERIALS

2″ Brush	Cadmium Yellow
1″ Brush	Bright Red
Large Knife	Prussian Blue
Liquid White	Sap Green
#6 Fan Brush	Titanium White
#2 Script Liner Brush	Van Dyke Brown
Alizarin Crimson	Yellow Ochre
Dark Sienna	

Cover the entire canvas with a thin, even coat of Liquid White using the 2″ brush. Apply the Liquid White in long horizontal and vertical strokes, working it back and forth to assure an even distribution of paint on the canvas. Do not allow the Liquid White to dry before you begin.

BACKGROUND

Load the large brush with a mixture of Alizarin Crimson and Prussian Blue. Using criss-cross strokes lay in a basic color for your background. Distant tree indications are made with the 1″ brush loaded to a chiseled edge. Load the brush by pulling it flat through varying mixtures of Cadmium Yellow, Sap Green, Yellow Ochre and very small amounts of Bright Red. Hold the brush vertically and tap downward. Vary the colors so individual shapes are visible. With the 2″ brush, blend the entire background using long, upward vertical strokes.

TREES AND BUSHES

The basic shapes for trees and bushes are laid in with the 2″ brush loaded with Sap Green, Alizarin Crimson and Van Dyke Brown. Load the brush to round one corner and, with the rounded corner up, push in your basic shapes. Push hard enough to bend the bristles. Turn your brush to make individual shapes. Tree trunks in background trees are made with the knife loaded with Van Dyke Brown and Dark Sienna. Use a small roll of paint, hold the knife vertically, touch the canvas and pull slightly to the side. Highlights on the tree

are applied the same way using a mixture of Van Dyke Brown, Dark Sienna and Titanium White. Highlight the trees and bushes with the 1″ brush loaded with varying amounts of Liquid White, Cadmium Yellow, Sap Green and Yellow Ochre. Complete the entire background before starting the covered bridge. With the large brush loaded with Sap Green, Van Dyke Brown and Prussian Blue, lay in a band of dark color under the area where your bridge will be. This area should remain dark to give the impression of a recessed area where the water is.

ROAD

The road is made with the knife loaded with Van Dyke Brown. Hold the knife horizontally and use back and forth horizontal strokes to lay in the basic shape. Allow the road to get larger as it gets closer to you. Highlights on the road are applied the same way using a mixture of Van Dyke Brown, Titanium White, and a touch of Prussian Blue.

COVERED BRIDGE

Using the knife, scrape out a basic shape for your bridge. With Van Dyke Brown, completely fill in your basic shape. Complete the back of the bridge first by highlighting the inside of the structure with a very dark mixture of Van Dyke Brown and Titanium White. The boards on the front of the bridge are made with Van Dyke Brown, Dark Sienna and Titanium White. Load a small roll of paint on the short edge of the knife, touch the canvas, and pull downward, using very little pressure. Use the point of the knife to cut in lines between the boards.

FOREGROUND

The grassy areas in front of the bridge are made with the fan brush loaded with a thinned mixture of Cadmium Yellow, Sap Green and Yellow Ochre. Hold the brush horizontally, touch the canvas and push upward, forcing the bristles to bend. Work in layers, completing the most distant layers

first. Allow some of the grassy areas to come over the road. This will help push the road down into the painting and make it look more realistic. The large tree on the right is made with Van Dyke Brown loaded on the edge of the knife. Hold the knife vertically, touch the canvas and pull to the side. Limbs on the tree are made the same way, only smaller. The highlights are applied with the knife loaded with Van Dyke Brown, Bright Red and White. Apply the brightest highlight on the side of the tree light would strike. Leaves are made with the 2″ brush loaded with Sap Green and Van Dyke Brown. Pull the brush through the paint in one direction to round one corner. With the rounded corner up, push in your

basic leaf shapes. Highlights on the leaves are Cadmium Yellow and Sap Green applied with the 1″ brush in the same manner.

FINISHING TOUCHES

Sticks and twigs may be cut in with the point of the knife. The cattails are made with the liner brush using a dark color which has been thinned with paint thinner. The small fence at the front of the bridge is made with the palette knife loaded with Van Dyke Brown. Highlights are Brown and White. Your signature will complete the painting.

Covered Bridge

1. Distant trees are made and highlighted with the 1″ brush.

2. Blend upward with the 2″ brush to soften.

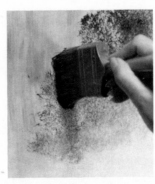

3. Basic tree shapes made with the 2″ brush.

4. Basic background shapes completed.

5. Tree trunk made with the knife.

6. Highlight bushes and trees with the 1″ brush.

7. The 1″ brush used sideways to create soft grassy areas.

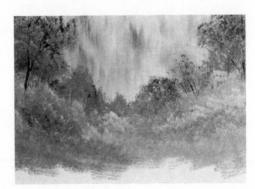

8. Background highlighted.

9. The road is laid in with the knife.

Covered Bridge

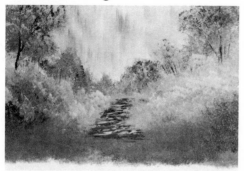

10. Background completed.

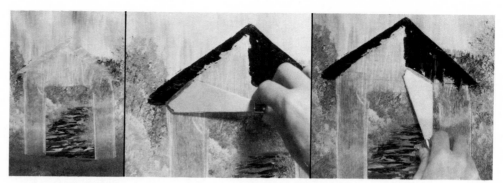

11. Steps used to complete the covered bridge.

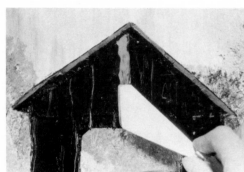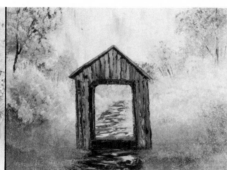

12. Grassy areas are made with the fan brush.

13. The knife is used to paint in the tree trunk.

14. Trunk completed.

15. Base leaf shapes are applied with the 2" brush . . .

16. . . . and highlighted with the 1" brush.

17. The knife is used to make the fence.

18. Cattails made with the liner brush.

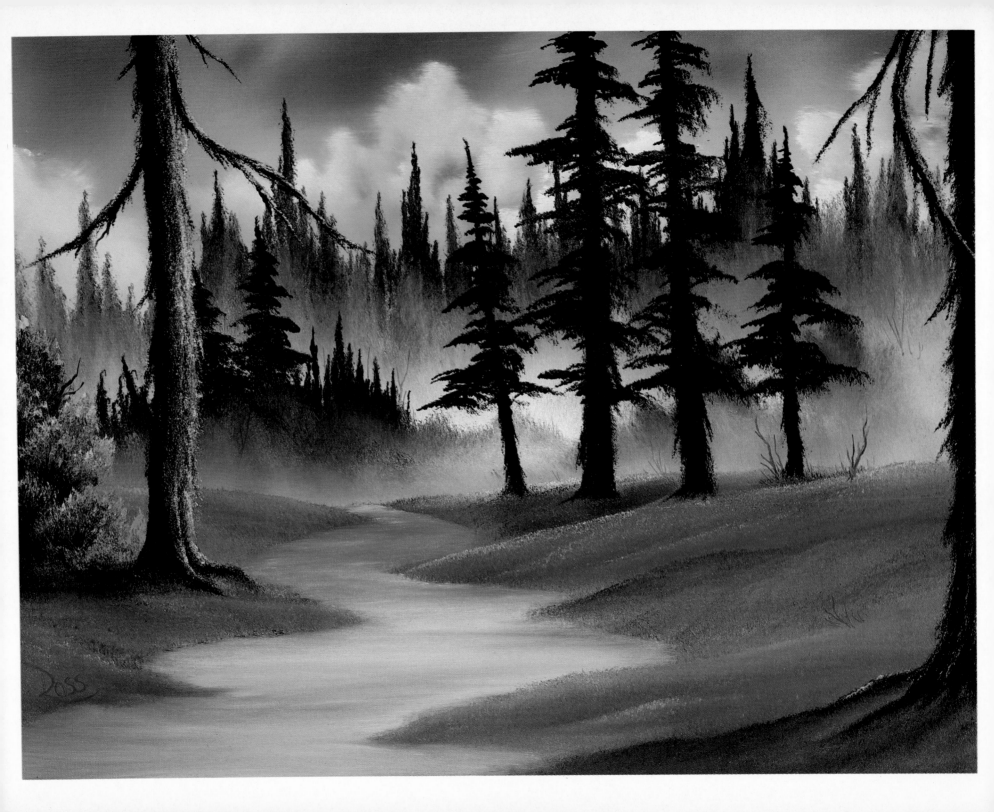

MATERIALS

2" Brush	Indian Yellow
1" Brush	Bright Red
Large Knife	Phthalo Blue
Liquid White	Phthalo Green
#6 Fan Brush	Sap Green
#2 Script Liner Brush	Titanium White
Alizarin Crimson	Van Dyke Brown
Dark Sienna	Yellow Ochre
Cadmium Yellow	

Cover the entire canvas with a thin, even coat of Liquid White using the 2" brush. Apply the Liquid White in long horizontal and vertical strokes, working it back and forth to assure an even distribution of paint on the canvas. Do not allow the Liquid White to dry before you begin.

SKY

Use the 2" brush, loaded with Phthalo Blue and Van Dyke Brown, to make the sky. Start at the top of the canvas, working all the way across using criss-cross strokes and working downward in layers. The clouds are made with the 1" brush filled with Titanium White and a touch of Bright Red. Hold the brush vertically, touch the canvas and paint in basic cloud shapes, using very tight circular strokes. Hold the 2" brush vertically and use just the top corner of the brush to blend out the bottom of each cloud with small, circular strokes. Lift upward with the 2" brush held flat to fluff the cloud, then blend using long horizontal strokes.

BACKGROUND

The distant tree indications are made with a mixture of Phthalo Blue, Alizarin Crimson and Titanium White. Load the fan brush full of paint, touch the canvas vertically and gently tap downward. Use the 2" brush vertically and tap just the bottom of these trees to create mist. With the brush flat, lift upward to blend and soften. Add another row of trees and bushes using the same paint mixture which has been darkened with a little Van Dyke Brown and Dark Sienna. Again,

mist the base of these trees with the 2" brush.

Still using the 2" brush and various mixtures of Sap Green, Alizarin Crimson and Cadmium Yellow, hold the brush horizontally and begin tapping in the land mass. As you move forward in the painting, these grassy areas can be highlighted with Cadmium Yellow, Indian Yellow and Sap Green.

TREES AND BUSHES

Mix a little Black paint using equal amounts of Alizarin Crimson and Phthalo Green. Load the fan brush with this mixture. Hold the brush vertically, touch the canvas and, pulling downward with short strokes, paint in the evergreen tree trunks. Keep the edges of the trunks rough and uneven, giving the impression of pine bark. With Black, paint the branches of the evergreen trees. Hold the fan brush horizontally and begin by touching just the corner of the brush to the tree trunk. Working down the tree, use more pressure, causing the bristles to bend downward and the branches to get wider. The two large evergreen trees in the foreground have branches that are just tapped in using the fan brush or the liner brush. These trees are highlighted with a mixture of Titanium White and Dark Sienna applied by tapping with the fan brush.

The bushes are made using the Black paint and just tapped in using the fan brush or the 1" brush. Highlight the bushes using just one corner of the 2" brush and various mixtures of Sap Green, Cadmium Yellow, Yellow Ochre and Indian Yellow.

PATH

The path is made with the fan brush and Titanium White. Use sweeping, horizontal strokes to lay in the path allowing the paint to pick up the colors used in the grassy areas. Be sure the path becomes wider as it moves forward. Use the 2" brush to go back and tap in some grass over the edges of the path to "set" it in.

FINISHING TOUCHES

Add sticks and twigs to the completed painting using the liner brush and thinned Van Dyke Brown.

Quiet Woods

1. The sky is made with criss-cross strokes.

2. Lay in the sky and ground areas . . .

3. . . . then blend with the large brush.

4. Clouds are applied with the 1" brush . . .

5. . . . then blended with the corner of the large brush.

6. Clouds completed.

7. Distant evergreens made with the fan brush.

8. Tapping with the top corner of the large brush . . .

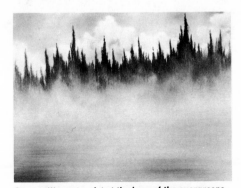

9. . . . will create mist at the base of the evergreens.

10. Evergreen tree made with the fan brush.

11. Mist is created . . .

12. . . . with the large brush . . .

Quiet Woods

13. at the base of each group of trees.

14. Use the large brush . . .

15. . . . to create soft, grassy areas.

16. The fan brush is used . . .

17. . . . to make trunks and leaves . . .

18. . . . on the four evergreen trees . . .

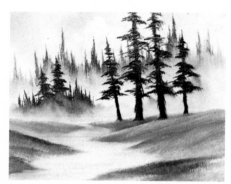

19. . . . in the background.

20. Use horizontal strokes to make the path.

21. With the fan brush . . .

22. . . . paint in large bushes.

23. Use the fan brush vertically to make large trees.

24. The fan brush is used . . .

25. . . . to paint branches on the trees.

Steve's appearances on Bob's programs have become a very popular addition to THE JOY OF PAINTING Series. Not only does he display an extraordinary ability to paint (having trained at the knee of the master) but his good looks, charm and wit have made him a favorite among students across the country. Having mastered this technique of painting at a very early age, it is no wonder that Steve has become one of the most popular Bob Ross Instructors.

Steve Ross

MATERIALS

2" Brush
1" Brush
#6 Fan Brush
#2 Script Liner Brush
Large Knife
Liquid White
Adhesive-Backed Plastic
Titanium White
Phthalo Blue
Prussian Blue

Midnight Black
Dark Sienna
Van Dyke Brown
Alizarin Crimson
Sap Green
Cadmium Yellow
Yellow Ochre
Indian Yellow
Bright Red

Start by covering the entire canvas with adhesive-backed plastic (such as Con-Tact Paper) from which you have removed a 14 x 20 center oval.

Cover the exposed area of the canvas with a thin, even coat of Liquid White using the 2" brush. Use long horizontal and vertical strokes, working back and forth to ensure an even distribution of paint on the canvas. Do not allow the Liquid White to dry before you begin.

SKY

Load the 2" brush by tapping the bristles firmly into some Alizarin Crimson. Make horizontal criss-cross strokes in the sky just above where the horizon will be on the vertical canvas. Reflect some of this Pink color into the water by using horizontal strokes in the center of the canvas below the horizon. Reload the brush with a mixture of Alizarin Crimson, Phthalo Blue and Midnight Black. Still using criss-cross strokes, cover the remainder of the sky. Add Phthalo Blue to the same brush and use horizontal strokes to complete the water, pulling from the outside edges of the canvas in, allowing the center to remain quite light. With a clean, dry 2" brush, blend the entire canvas.

Use Titanium White with a touch of Alizarin Crimson on the fan brush to make the clouds. With just one corner of the brush using tiny circular strokes, form cloud shapes that are mostly flat on the bottom and fluffy on top. Blend the clouds with just the top corner of a clean, dry 2" brush. Again, use small circular strokes, being very careful not to touch the top edges of the clouds. Gently lift upward to fluff.

MOUNTAIN

The mountain is made with a mixture of Alizarin Crimson, Phthalo Blue and Midnight Black. Load the long edge of the knife with a small roll of paint by pulling the mixture out flat on your palette and just "cutting" across. Use firm pressure to push the paint into the canvas, shaping just the top edge of the mountain.

Use a clean, dry 2" brush to grab the paint from the top of the mountain and pull down to complete the entire shape. The color will automatically mix with the Liquid White and become lighter near the base, creating the illusion of mist.

Highlight the mountain with a mixture of Titanium White and a touch of Alizarin Crimson. Again, pull the paint out very flat on your palette and just "cut" across to load the long edge of the knife with a small roll of paint. Since the light is

coming from the right, very gently touch the loaded knife to the right side of the top of the peaks. As you glide the knife down the sides of the peaks, use so little pressure that the paint is allowed to "break."

The shadows are applied to the left sides of the peaks using various mixtures of Titanium White with Phthalo Blue, Prussian Blue, Alizarin Crimson, Dark Sienna and Midnight Black.

To complete your mountain, use a clean, dry 2" brush to tap and diffuse the base (following the angles) and then gently lift upward to mist.

FOOTHILLS

Load the 2" brush by tapping the bristles into a mixture of Sap Green, Phthalo Blue and Midnight Black. Holding the brush horizontally, just tap in the basic foothill shapes. With a clean, dry 1" brush, grab just the top edges of the hills and make quarter-inch upward strokes. This will give the impression of tiny trees in the distance. Use the same brush to tap and diffuse the base of the hills, creating a misty appearance. Add a closer range of hills, a little darker in color, using the same technique.

The land at the base of the foothills is made with a mixture of Van Dyke Brown and Midnight Black using the knife. Paying close attention to angles, highlight with a mixture of Van Dyke Brown, Midnight Black and Titanium White. Again, use the knife with so little pressure that the paint "breaks." You can add some small bushes to the banks using the dark foothill mixture on the 1" brush, touching the canvas and bending the bristles upward. Highlights are made by adding Cadmium Yellow over the dark base color. Use the point of the knife to scratch in small sticks and twigs.

Use the 2" brush to grab just the very bottom of the dark land color and pull down, creating reflections in the water. Gently brush across to give the reflections a watery appearance.

With Liquid White and a touch of Midnight Black loaded on the long edge of the knife, "cut-in" the water lines and ripples.

The small evergreens in the background are made with a mixture of Phthalo Blue, Midnight Black, Van Dyke Brown and Sap Green loaded on the fan brush. Hold the brush vertically and just touch the canvas to create the center line of the tree. Turn the brush horizontally and begin adding the small branches at the top of the tree by using just one corner of the brush. Working from side to side and forcing the bristles to bend downward, use more pressure as you near the base of the tree allowing the branches to become larger. Use the point of the knife to scratch in trunk indications. Add Cadmium Yellow to the same brush and just touch some highlights to the right side of the branches.

FOREGROUND

At this point you can remove the Con-Tact Paper from the canvas. Already, you have a very effective painting, or you can add the large trees in the foreground.

To make the birch trees, load the long edge of the knife with a small roll of Van Dyke Brown. Holding the knife vertically, start at the top of the canvas to form the trunk shapes. Be sure to allow the trunks to become wider as you near the base. Use a mixture of Van Dyke Brown, Phthalo Blue and Titanium White on the knife to just touch and pull the highlights to the right side of the trunks. Limbs and branches are added with thinned Van Dyke Brown on the liner brush.

The land area at the base of the tree is made using the 2" brush and a mixture of Prussian Blue, Van Dyke Brown and Sap Green. Touch the canvas and bend the bristles upward as you block in the bushes at the base of the tree. Allow this land area to extend outside your oval. Highlight the bushes by pulling the 1" brush or the 2" brush through various mixtures of all the Yellows and Bright Red. Touch the canvas and force the bristles to bend upward as you shape each individual bush. Be careful not to "kill" all of your dark base color.

FINISHING TOUCHES

Use the point of the knife or the liner brush to add additional small sticks and twigs. Don't forget to sign your painting!

Mountain Oval

1. Cover the canvas with Contact paper which has an oval cut out of the center.

2. Use horizontal criss-cross strokes to paint the sky.

3. The corner of the fan brush is used to paint clouds.

4. Use the knife to make the initial mountain shape, . . .

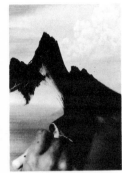

5. . . . then blend downward with the 2" brush.

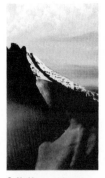

6. Knife used for highlights and shadows. Angles are important.

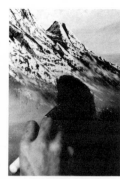

7. With the 2" brush, tap the base of the mountain.

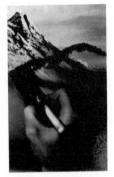

8. The 1" brush is used to paint the foothills.

9. Land areas are made and highlighted with the knife.

10. Pull straight down, then across, to make reflections.

11. Push upward with the 1" brush to create grassy areas.

12. Use the knife, loaded with Liquid White, . . .

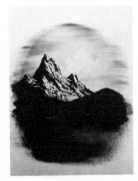

13. . . . to "cut-in" water lines where reflections and land meet.

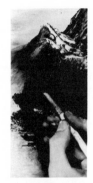

14. Push down with corner of fan brush to paint evergreens.

15. When the background is totally finished, . . .

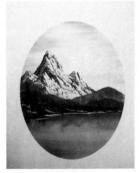

16. . . . carefully remove the Con-tact paper to expose your oval painting.

17. Tree trunks are made and highlighted with the knife.

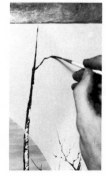

18. Individual tree limbs are made with the liner brush loaded with a thin paint.

19. Push upward with the 2" brush to paint bushes in the foreground.

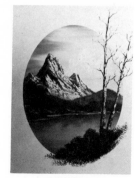

20. You are now ready to sign your unique painting. Experiment with various other shapes.

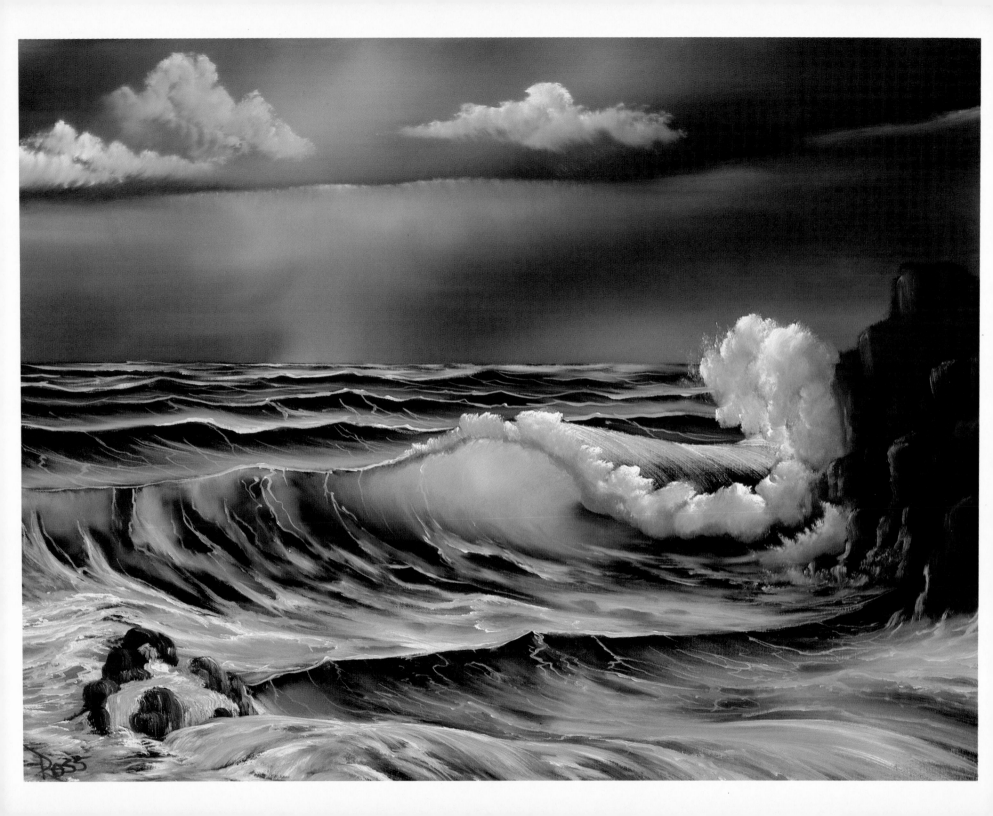

MATERIALS

2″ Brush	Phthalo Green
#6 Fan Brush	Phthalo Blue
#6 Filbert Brush	Midnight Black
#2 Script Liner Brush	Dark Sienna
Masking Tape	Van Dyke Brown
Black Gesso	Cadmium Yellow
Titanium White	Bright Red

Cover the entire canvas with a thin, even coat of Black Gesso and allow to dry completely before you begin. When the canvas is dry, mark the horizon by placing a piece of masking tape eight inches down from the top of the horizontal canvas.

With the 2″ brush, cover the entire dry canvas with a mixture of Midnight Black and a small amount of Phthalo Blue. Add Phthalo Green to the same brush to underpaint the large wave in the center of the bottom portion of the canvas. Do not allow your canvas to dry before you begin the painting.

SKY

Use Titanium White on the 2″ brush to place a diagonal White area across the center of the sky, then use Titanium White and criss-cross strokes to add the light areas to the sky. Hold the brush flat against the canvas to pull light rays down towards the horizon.

The clouds are formed with the fan brush and Titanium White, using just one corner of the brush to make tight, circular, strokes. With just the top corner of a clean, dry 2″ brush, gently blend (to diffuse) the bottoms of the cloud shapes and lightly lift upward to "fluff."

BACKGROUND WATER

Before beginning to paint the background water, remove the masking tape from the canvas and then use the 2″ brush with the Midnight Black-Phthalo Blue mixture to underpaint the dry area (left by the tape) along the horizon.

Use Titanium White on the filbert brush to loosely sketch the large wave in the foreground.

With the fan brush and Titanium White, use short, horizontal strokes to lighten the water along the horizon.

Make long, horizontal strokes with Titanium White on the fan brush, to outline the tops of the small swells behind the large wave. Use short, horizontal, sweeping strokes to pull back and blend the tops of these White lines.

LARGE WAVE

The transparency, or "eye" of the wave is made with a mixture of Titanium White and a small amount of Cadmium Yellow loaded on the filbert brush. Use small circular motions to "scrub" the paint into the light, egg-shaped area of the wave. Continue using circular strokes to carry the light out across the top of the wave, allowing it to fade to dark as you near the edge of the canvas.

Blend the "eye" of the wave with one corner of a clean, dry 2″ brush, using circular movements. Shape and blend the remainder of the wave by holding the brush flat against the top of the wave and pulling downward. Pay close attention to the angle of the water here.

Pull the highlights over the top of the crashing breaker using the fan brush and Titanium White. Again, watch the angle of the water as you hold the brush horizontally and use single downward strokes to pull the White over the top of the breaker.

Underpaint the foam with a mixture of Phthalo Blue, Bright Red and Titanium White on the filbert brush. Use circular strokes to scrub-in this base color. Highlight the edges of the foam with a mixture of Titanium White and Cadmium Yellow on the filbert brush, using circular, push-up strokes. Use just the corner of a clean, dry 2″ brush and circular strokes to very lightly blend the foam highlights.

FOREGROUND

Continue using Titanium White and the fan brush to extend the water movements to the bottom of the canvas.

Following the angle of the water, use the fan brush to add the foam actions to the large wave.

Use a mixture of paint thinner and Titanium White on the liner brush to highlight the top edges of the swells and waves.

The rocks are shaped and contoured with the fan brush and a mixture of Van Dyke Brown and Dark Sienna. Use Bright Red on the corner of the fan brush to apply the highlights. With a mixture of Titanium White and Phthalo Blue, use the fan brush to "swirl" water around the base of the rocks.

FINISHING TOUCHES

Use various mixtures of paint thinner, Titanium White and Phthalo Blue on the liner brush to add the final details of water movement to the painting. Sign your name with pride!

Black Seascape

1. Use the 2" brush to paint the light area . . .

2. . . . pull down light rays . . .

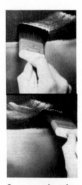
3. . . . and make criss-cross strokes to paint the sky.

4. Make the clouds with the fan brush . . .

5. . . . and then blend with the 2" brush.

6. Remove the masking tape to create the horizon.

7. Loosely sketch the large wave with the filbert brush.

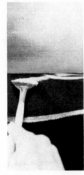
8. Use the fan brush to add highlights . . .

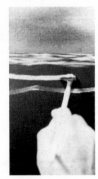
9. . . . paint the swells . . .

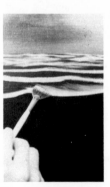
10. . . . and pull back to blend the swells . . .

Black Seascape

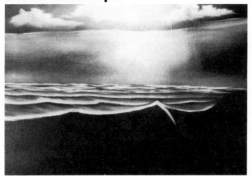

11. . . . to complete the background water.

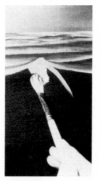

12. Scrub in the "eye" of the wave with the filbert brush . . .

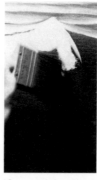

13. . . . and then blend with one corner of the 2" brush.

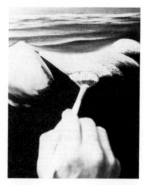

14. Single downward strokes with the fan brush highlight the breaker.

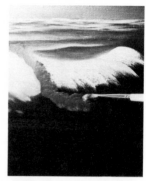

15. Use circular strokes with filbert brush to underpaint the foam . . .

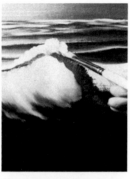

16. . . . circular push-up strokes to highlight the foam . . .

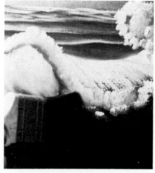

17. . . . and one corner of the 2" brush to blend the foam . . .

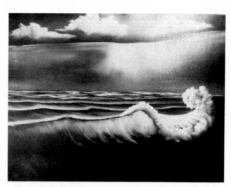

18. . . . to complete the breaker.

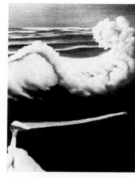

19. Add the swell in the foreground . . .

20. . . . and then pull back to blend . . .

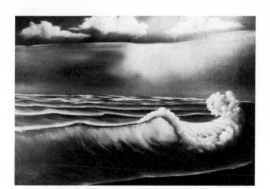

21. . . . using the fan brush.

22. Continue using the fan brush to add water movement . . .

23. . . . and foam patterns to the wave.

24. Add small details and highlights with the liner brush.

25. Add rocks and stones with the fan brush.

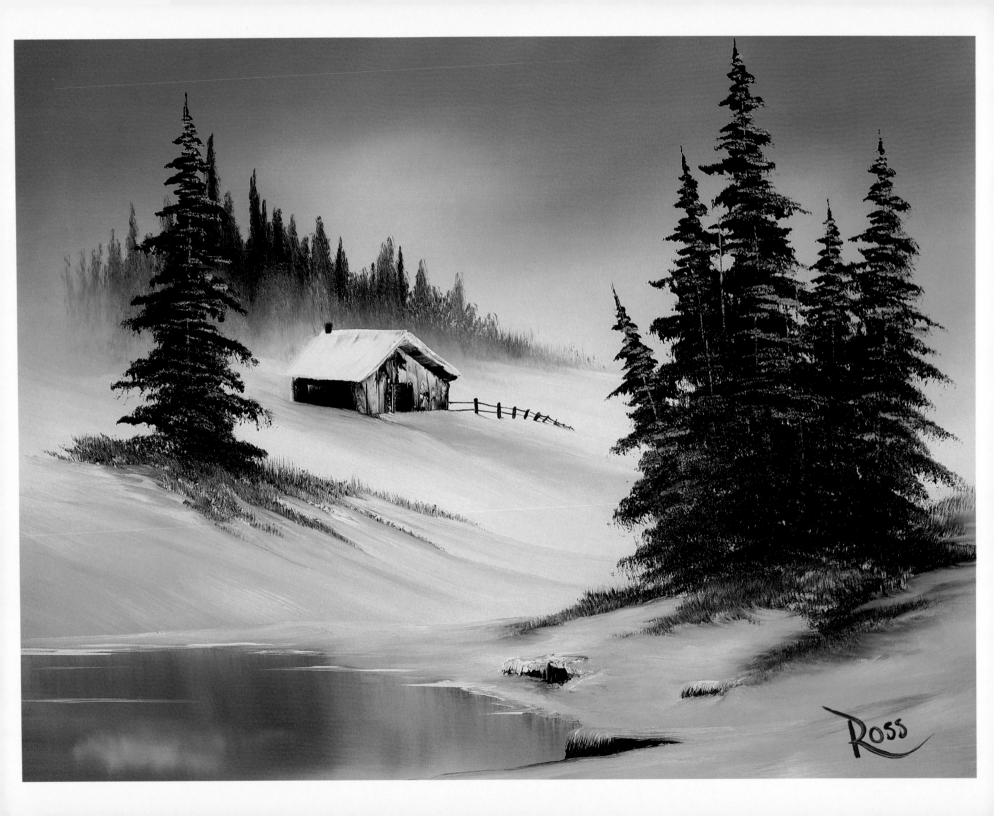

MATERIALS

2" Brush	Alizarin Crimson
1" Brush	Phthalo Blue
Large Knife	Titanium White
Liquid White	Van Dyke Brown
#6 Fan Brush	Bright Red
#2 Script Liner Brush	

Cover the entire canvas with a thin even coat of Liquid White using the 2" brush. Apply the Liquid White in long vertical and horizontal strokes, working it back and forth to assure an even distribution of paint on the canvas. Do not allow the Liquid White to dry before you begin.

SKY AND WATER

Mix a large batch of dark Purple by blending a small amount of Phthalo Blue into some Alizarin Crimson. This mixture will look Black, but you can test the color by adding a very small amount to a little Titanium White. If necessary, adjust the color by adding more Alizarin Crimson or Phthalo Blue. To make the sky, load a small amount of the dark mixture into the 2" brush. Tap the bristles firmly against the palette to insure an even distribution of paint. Start at the top of the canvas, working across using small criss-cross strokes, moving downward in layers. The brush will pick up the Liquid White on the canvas and automatically your sky will get lighter toward the horizon. Using more of the same color on the 2" brush, lay in the water. Use long horizontal strokes, pulling from the edge of the canvas in toward the center. Gently blend the sky and water with a clean, dry 2" brush.

BACKGROUND

The distant tree indications are made using the dark Purple mixture and the fan brush. Load the brush full of paint. Holding it vertically, touch the canvas and tap downward. Use the 2" brush vertically to tap just the bottom of the trees, creating a misty area. With the brush held flat, gently lift upward to blend and soften. Using the fan brush with Titanium White, and Phthalo Blue for shadows, put in the snow under the trees paying close attention to the lay-of-the-land.

CABIN AND FENCE

Using the Large Knife and a small roll of Titanium White, lay in the front roof of the cabin, then add the back overhang. The front and side are put in using the knife and a roll of Van Dyke Brown. Angles are very important to give your cabin the right appearance. Highlight the front of the cabin with Van Dyke Brown and Titanium White. Using Van Dyke Brown, make the cabin door and cut in slab indications. Use the fan brush with Titanium White and Phthalo Blue to lay in snow and shadows around the cabin. The fence and chimney are made with the script liner brush and Van Dyke Brown which has been thinned with a little oil. Add a touch of Bright Red to the chimney.

EVERGREEN TREES

The large evergreen trees are made with the fan brush loaded with the same dark mixture. Start by holding the brush vertically and touching the canvas to make a center line. Turn the brush horizontally and use just the corner to start your tree. Barely touch the brush to the center line to make the first top branches. Use the same corner of the brush to paint the entire tree. As you work down the tree, use more pressure forcing the bristles to bend downward, moving the brush from side to side of the tree. The evergreens are highlighted with a mixture of Titanium White and Phthalo Blue. Highlights are applied in the same way the tree was made, applying more color to the side of the tree where the light would strike. Be careful not to cover all the dark areas of the tree. Finish the background by laying in the snow covered ground area with the fan brush using Titanium White and Phthalo Blue. Load the fan brush with the same dark Purple paint to make the grassy areas by just touching the canvas horizontally and gently lifting upward. Be sure to complete the background tree and ground area before beginning the stand of trees in the foreground.

WATER

With a little of the dark Purple mixture, hold the 2″ brush flat as you touch the canvas and pull straight downward to make the pond in the foreground. Gently brush across in horizontal strokes to create a watery appearance. Cut in the water lines with a little Liquid White on the long edge of the knife. These lines should be perfectly straight and parallel to the bottom edge of the canvas. The rocks and stones are made with the dark paint using the fan brush and then highlighted with Titanium White and Phthalo Blue.

FINISHING TOUCHES

Sign your masterpiece; stand back and admire.

Purple Splendor

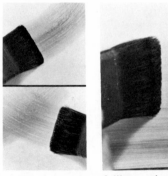

1. Use criss-cross strokes to make the sky.

2. Water made with horizontal strokes.

3. Distant evergreens made with the fan brush.

4. Tap the bottom of the evergreens to create mist.

5. Snow is layed in with the fan brush.

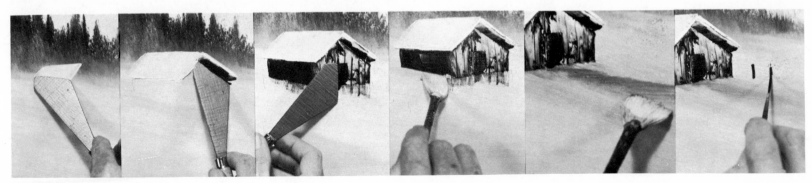

6. Steps used to make the cabin and fence.

Purple Splendor

7. Evergreen tree made with the fan brush.

8. Grassy areas made with the fan brush.

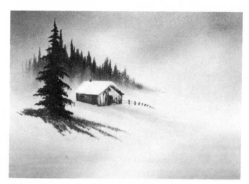

9. Complete the most distant areas first . . .

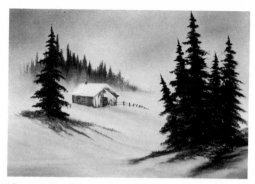

10. . . . and work forward.

11. Blending snow into the grassy areas.

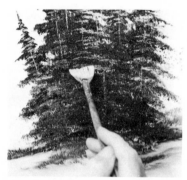

12. Painting highlights on evergreen trees.

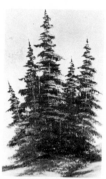

13. Stand of evergreens completed.

14. Pull down with the large brush . . .

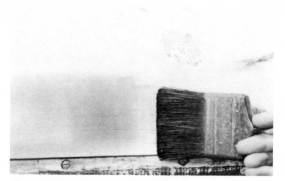

15. . . . then go across to create reflections.

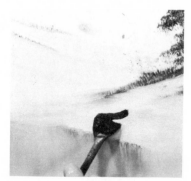

16. Stones are made and highlighted with the fan brush.

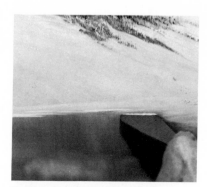

17. Water lines cut in with the knife.

18. Painting completed and ready for a signature.

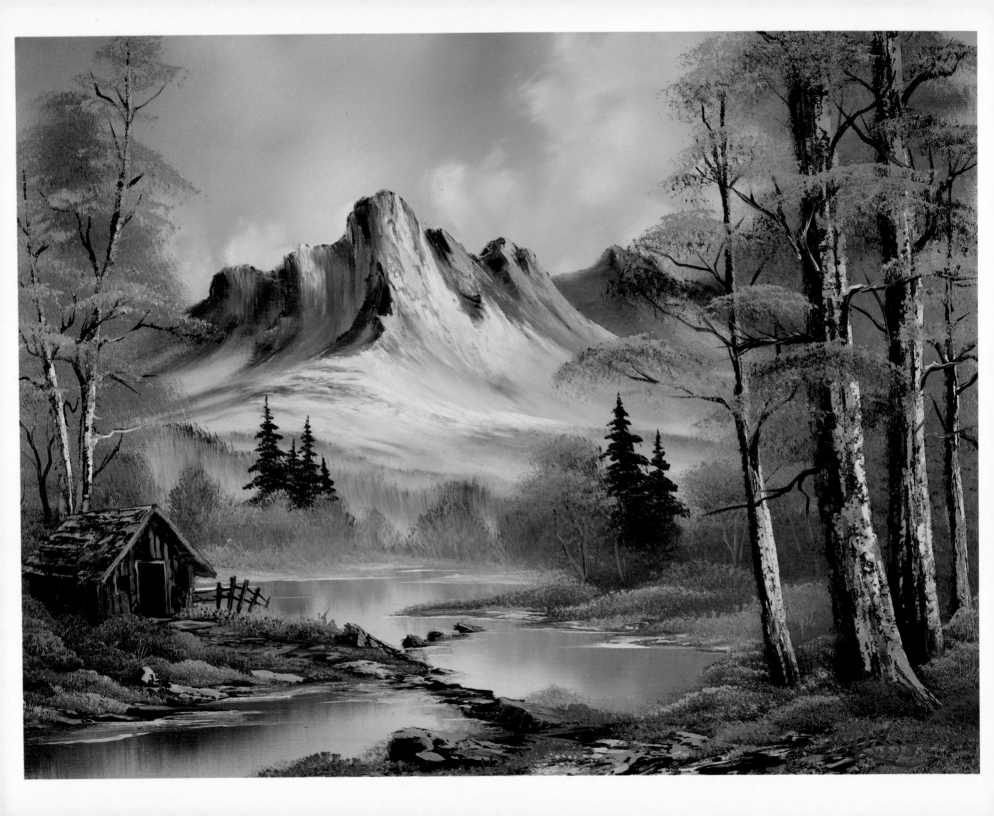

MATERIALS

2″ Brush	Phthalo Blue
1″ Brush	Midnight Black
1″ Round Brush	Dark Sienna
#6 Fan Brush	Van Dyke Brown
#2 Script Liner Brush	Alizarin Crimson
Large Knife	Sap Green
Small Knife	Cadmium Yellow
Liquid White	Yellow Ochre
Liquid Black	Indian Yellow
Titanium White	Bright Red
Phthalo Green	

Start by covering the entire canvas with a thin, even coat of Liquid White, using the 2″ brush. Use long horizontal and vertical strokes, working back and forth to ensure an even distribution of paint on the canvas. Do not allow the Liquid White to dry before you begin.

SKY

With the 2″ brush, and a mixture of Midnight Black and Phthalo Blue, make criss-cross strokes in the sky allowing some of the White areas of the canvas to remain.

Without cleaning the brush, pick up a little Phthalo Green and pull in the water using long horizontal strokes.

With a clean, dry 2″ brush, blend the entire canvas.

The clouds are made by loading the 2″ brush with Titanium White and just a touch of Bright Red. Use very small circular shapes. Use just the top corner of a clean 2″ brush to blend out the bottoms of the shapes, then very gently pull upward to fluff the clouds. Lightly blend the entire sky.

MOUNTAINS

With a mixture of Phthalo Blue, Midnight Black and Titanium White, load a roll of paint on the long edge of the knife. Firmly press the knife into the canvas forming a very small distant mountain shape. Use the 2″ brush to pull down and diffuse the base of the small mountain and then gently blend.

The large mountain is made with a mixture of Phthalo Blue, Midnight Black and Van Dyke Brown. Load a small roll of paint on the long edge of the knife, using firm pressure to apply the mountain shape to the canvas. Use the large brush, held vertically, to pull the color down and remove excess paint.

Highlights are various mixtures of Van Dyke Brown, Dark Sienna, Yellow Ochre, Titanium White and a touch of Bright Red. Again, load a small roll of paint on the long edge of the knife and begin laying these colors on the right side of the mountain peaks. Use very little pressure, allowing the paint to "break."

The shadow colors are mixtures of Titanium White, Phthalo Blue, Midnight Black and Van Dyke Brown applied to the left sides of the peaks.

Using the 2″ brush, tap the base of the most distant peak before completing the forward areas of the mountain.

Tap the bristles of the large brush into Cadmium Yellow and some Sap Green. Begin tapping in little grassy areas at the base and up the side of the mountain, closely following the angles.

BACKGROUND

The most distant tree indications are made by loading the fan brush with Midnight Black, Phthalo Blue, Van Dyke Brown and Titanium White. Hold the brush vertically and just tap downward. Diffuse the base of these trees by tapping firmly with the 2″ brush and gently lifting upward to create the illusion of mist.

Load the round brush with Midnight Black, Sap Green and Van Dyke Brown. Tap in some basic tree and bush shapes, reflecting some of this dark mixture into the water area of the painting.

Add Cadmium Yellow and Yellow Ochre to the round brush and gently tap a few highlights onto these trees.

With the 2″ brush, pull down the reflections and brush across to create the water. Water lines are made with a

mixture of Liquid White and Phthalo Blue loaded on the long edge of the knife.

Still using the dark mixture and the round brush, move forward in the painting and tap in larger tree and bush shapes. Extend this dark color into the water area.

Tree trunks are made by loading the fan brush with Van Dyke Brown, touching the canvas and just pulling down.

To highlight the tree and bush shapes, dip the 1″ brush into Liquid White and then through various mixtures of Sap Green, the Yellows and Bright Red. Pull the brush through the paint in one direction, to round one corner. With the rounded corner up, gently touch the canvas forcing the bristles to bend upward, creating tree and bush shapes. Reversing this procedure will create reflections.

With a clean, dry 2″ brush, pull down the reflections and gently brush across to create the water.

The stones and shoreline are made with the knife and Van Dyke Brown. The highlights are a mixture of Van Dyke Brown and Titanium White, applied with so little pressure that the paint is allowed to break.

CABIN

The cabin is made by loading the long edge of the knife with Van Dyke Brown. Lay in the front roof and then add the back overhang. Paying close attention to angles, lay in the front and side of the cabin. Highlight the front with a mixture of Van Dyke Brown and Titanium White. Use Van Dyke Brown for the door. The roof is finished by just laying on some Bright Red mixed with a little Van Dyke Brown.

FOREGROUND

The large tree trunks are made with the fan brush, loaded with Van Dyke Brown and Dark Sienna. Hold the brush vertically, touch the top of the canvas and just pull down, allowing the tree to get wider near the base. Use thinned Liquid Black on the liner brush to indicate a few limbs and branches. These can be highlighted with Liquid White on your brush. Highlight the right side of the trunks by loading the long edge of the knife with a mixture of Van Dyke Brown and Titanium White. Holding the knife vertically, gently touch and pull. The leaves are made with the 2″ brush and various mixtures of Yellow, Bright Red and Sap Green. Tap the color onto the canvas forming leaf patterns.

FINISHING TOUCHES

Use the 1″ brush to add a few grassy areas at the base of the large trees. Scratch in sticks and twigs using the point of the knife.

Sign and admire!

Mountain Cabin

1. Use criss-cross strokes to make the sky.

2. Basic cloud shapes are painted in with the 2″ brush.

3. Use the top corner of a clean, dry 2″ brush to blend the clouds.

4. With the knife, lay in the initial mountain shapes . . .

5. . . . then pull downward with the 2″ brush.

6. Paying close attention to angles, use the knife to paint highlights and shadows on the mountains.

Mountain Cabin

7. Tap downward with fan brush to make distant hills.

8. Tap the base with the large brush to create mist.

9. The round brush is used to make the next layer of trees.

10. Pull downward with the 2" brush to create reflections.

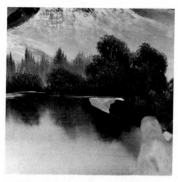

11. With Liquid White on the knife, use a firm pressure to "cut-in" water lines.

12. Use the round brush to tap in large background tree shapes.

13. Fan brush pulled downward to make tree trunks. 14. Push upward with the 1" brush to highlight individual bushes.

15. The knife is used to make land areas.

16. Push upward with the large brush to lay in the foreground shapes.

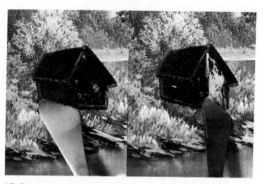

17. Progressional steps used to paint the cabin.

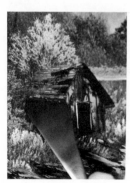

18. Push upward with the 1" brush held horizontally to create grassy areas.

19. Large trees are painted in with the fan brush . . .

20. . . . then highlighted with the knife.

21. Tree branches made with the liner brush and a thin paint.

22. Leaves are tapped on using the 2" brush.

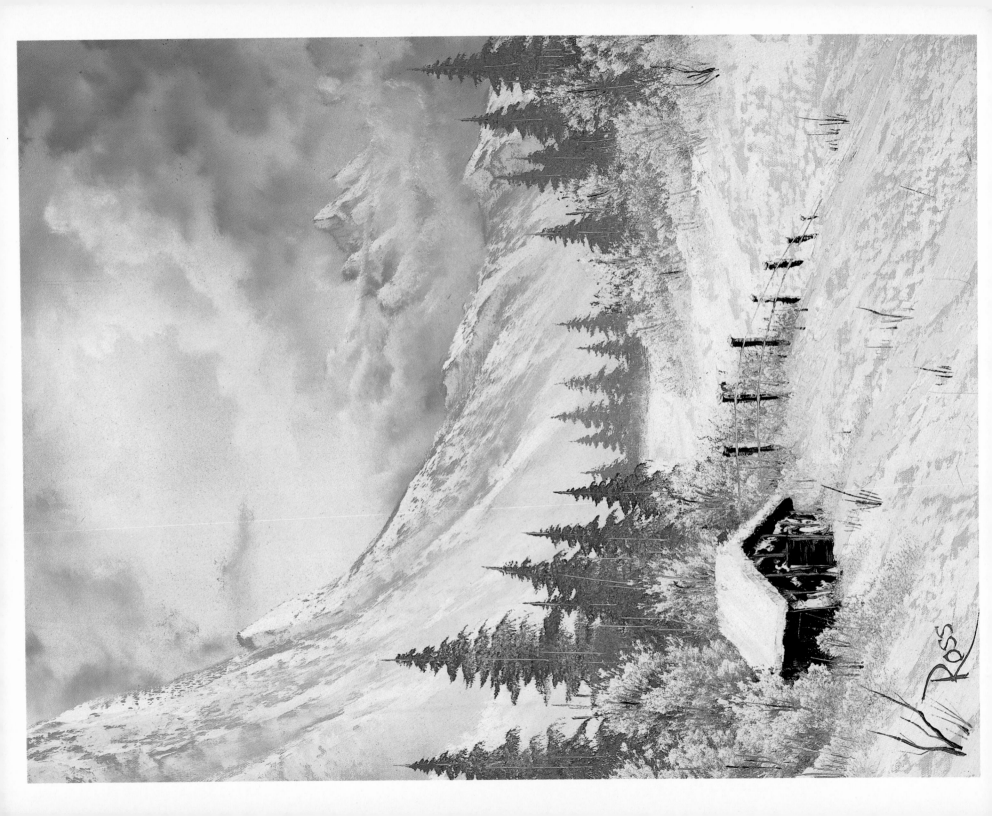

MATERIALS

2″ Brush	Liquid White
1″ Brush	Titanium White
#6 Fan Brush	Bright Red
#2 Script Liner Brush	Prussian Blue
Large Knife	Van Dyke Brown

Start by covering the entire canvas with a thin, even coat of Liquid White using the 2″ brush. With long, horizontal and vertical strokes, work back and forth to ensure an even distribution of paint on the canvas. Do not allow the Liquid White to dry before you begin.

SKY

We start this painting with a Gray mixture made by combining Titanium White, Van Dyke Brown, and a small amount of Prussian Blue. Use circular strokes with the 2″ brush to create very basic cloud shapes. Starting with the most distant clouds, highlight the outside edges with the fan brush and a mixture of Titanium White and a very small amount Bright Red. Use the 2″ brush, in very tight circular strokes, to blend the highlights into the clouds. Complete each cloud before moving to the next closer one. As you work forward, use less of the Pinkish highlight color and graduate to pure Titanium White. Blend the entire sky with a clean, dry 2″ brush.

MOUNTAINS

Shape the small mountains in the clouds using the knife and a mixture of Van Dyke Brown and Titanium White and then lightly highlight the mountain with a small amount of Titanium White on the knife. The shadows are Prussian Blue and Titanium White. These mountains are very soft, nearly the same color as the sky; you can soften them even further by gently tapping them with the 2″ brush. "Float" additional clouds around the base of the small mountains using Titanium White on the fan brush and circular strokes.

The large mountains are a mixture of Van Dyke Brown, Prussian Blue and Titanium White applied with the knife. Use firm pressure to shape just the top edge of the mountain and then use the 2″ brush to pull the paint down to the base of the mountain to complete the entire shape. To highlight the mountain, load the long edge of the knife with a small roll of Titanium White. As you glide the knife down the right sides of the peaks, use so little pressure that the paint "breaks." The shadows are a mixture of Titanium White and Prussian Blue applied to the left sides of the peaks. Use a clean, dry 2″ brush to tap the base of the mountain and then lift upward to create the illusion of mist.

EVERGREENS

The tiny evergreens at the base of the mountain are made with the fan brush and a mixture of Van Dyke Brown, Prussian Blue and Titanium White. Hold the brush vertically and just touch the canvas to create the center of the tree. With one corner of the brush begin adding the top branches. As you work down the tree, apply more pressure on the brush (forcing the bristles to bend downward) and automatically the branches will become larger. To create the mist at the base of the trees, tap with the 2″ brush, then lift gently upward. Working forward in the painting, reduce the amount of Titanium White in the mixture as your trees get larger and darker.

BUSHES

Underpaint the small trees and bushes with the 1″ brush and a mixture of Van Dyke Brown, Prussian Blue and Titanium White. To add snowy highlights, dip the 1″ brush into Liquid White and then pull the brush in one direction (to round one corner) through Titanium White. Hold the brush vertically (with the rounded corner up) and using very little pressure, force the bristles to bend upward as you shape each individual bush. Be very careful not to completely cover the dark underpaint.

SNOW

Add the snow to the base of the trees and bushes with Titanium White on the knife. Use very little pressure, allowing the paint to "break" and pay close attention to angles. This is where you begin creating the lay-of-the-land.

CABIN

Use the knife to remove paint from the canvas in the basic shape of the cabin. Use Van Dyke Brown to paint the back of the roof (or overhang), the front of the roof is Titanium White. Again, pay close attention to angles. The front and side are Van Dyke Brown. Small amounts of Titanium White may be added for highlights and to create an aged appearance. Add the door using Van Dyke Brown, highlighting the edges with a small amount of Titanium White. Boards in the cabin may be made by cutting in lines with the point of a clean knife.

FENCE

The fence is made with the knife and Van Dyke Brown, highlighted with Titanium White. Watch your perspective here, the posts get larger as you move forward in the painting. Add fence wire by cutting through the paint with the heel of the knife.

FINISHING TOUCHES

Add final details (small sticks and twigs) using thinned Van Dyke Brown on the liner brush. Now you are ready to sign your painting; stand back and admire.

Winter Mist

1. Use circular strokes . . .

2. . . . to underpaint the cloud shapes.

3. Highlight the clouds with one corner of the fan brush . . .

4. . . . and then blend with the 2" brush . . .

5. . . . to complete the sky.

6. Use the knife to shape . . .

7. . . . and highlight . . .

8. . . . the small distant mountain.

9. Shape the large mountain with the knife . . .

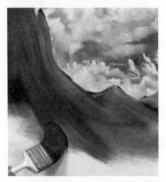

10. . . . then pull the paint down with the 2" brush.

Winter Mist

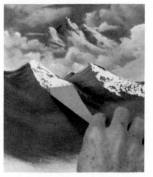

11. Add highlights with the knife...

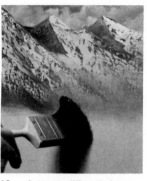

12....then tap to diffuse the base...

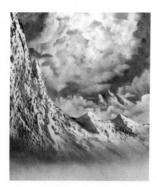

13.... creating the illusion of mist.

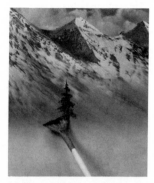

14. The evergreens are made with the fan brush...

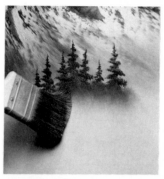

15.... then tapped with the 2" brush...

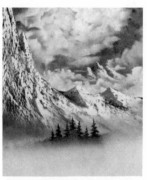

16.... to create the illusion of mist.

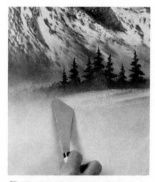

17. Working in layers, add snow to the base of the small trees...

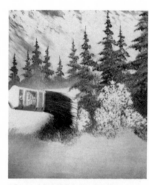

18.... highlight the bushes...

19.... then add more snow...

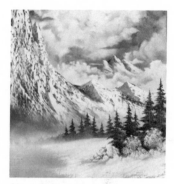

20.... in the foreground.

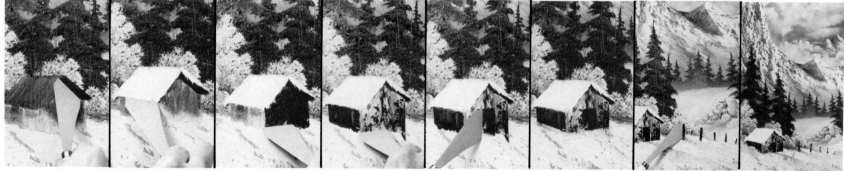

21. Progressional steps used to paint the cabin.

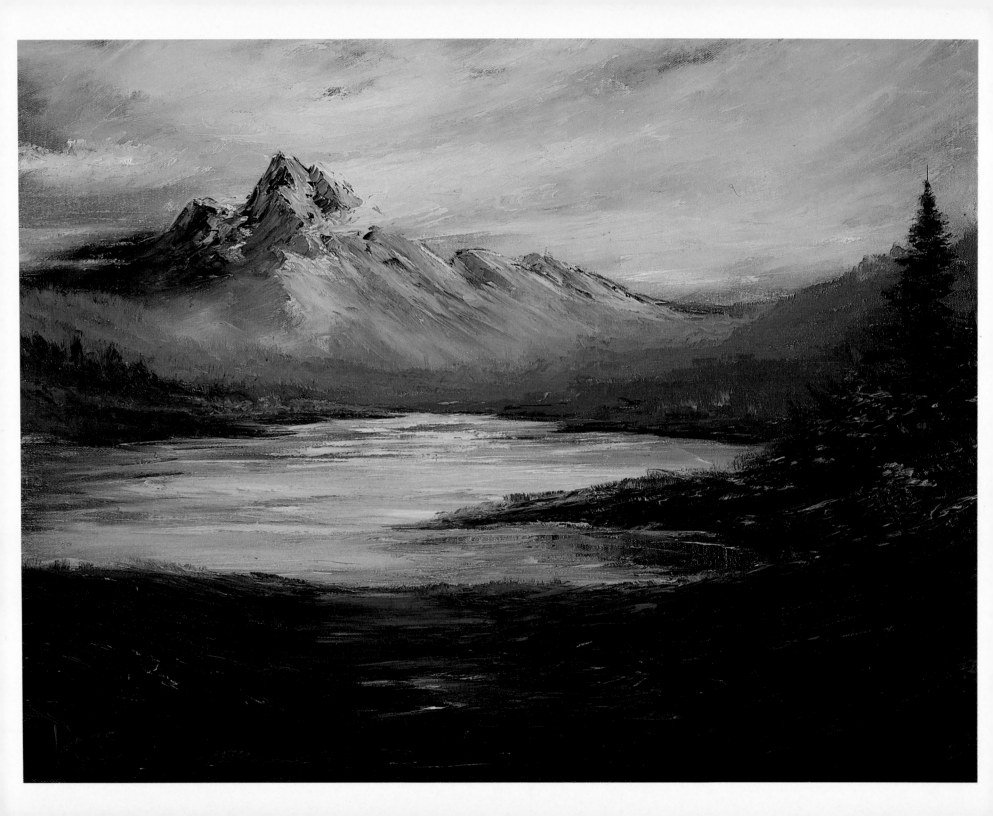

MATERIALS

2" Brush
Large Knife
Alizarin Crimson
Dark Sienna
Cadmium Yellow
Indian Yellow
Prussian Blue

Phthalo Blue
Phthalo Green
Sap Green
Titanium White
Van Dyke Brown
Yellow Ochre

This painting is done completely with the knife and uses no Liquid White. But the canvas is covered with a thin wash. Use the 2" brush dipped in paint thinner to apply very little Dark Sienna to the center area of the dry canvas. This paint should be so thin that it has very little covering power. Without cleaning the brush, repeat with Phthalo Blue making diagonal streaks in the sky and horizontal streaks across the bottom of the canvas. Allow the wash to dry just to the point where it is no longer "dripping" on the canvas.

SKY

The clouds are made by loading the long edge of the knife with a roll of Titanium White. Pull the paint across the sky area in long diagonal strokes.

MOUNTAIN

The mountain is made with a mixture of Prussian Blue, Van Dyke Brown, Alizarin Crimson, and Titanium White. Load the long edge of the knife and lay in the mountain shape. Pull the paint down applying additional pressure to cause the mountain color to become lighter as it nears the base. The highlights are Titanium White with just a touch of Alizarin Crimson. Loaded on the long edge of the knife, this paint is applied with little pressure; allowing it to "break". The shadows on the mountain are made the same way using a mixture of Titanium White with a little Prussian Blue, but pulled in the opposite direction. The application of the highlight and shadow paints should become very thin near the base of the mountain and blended into the canvas to create mist.

FOOTHILLS

The first range of foothills is made with a mixture of Van Dyke Brown, Sap Green, Titanium White and Phthalo Blue, applied with the knife. Using very little paint near the base of the hill and rubbing it into the canvas in tight little circles will create the illusion of mist. To make the second range of hills appear a little darker, add Phthalo Blue to the mixture. Shape these hills by pushing in a few tree indications with the knife. Rub a little Titanium White into the base of the hills, holding the knife flat against the canvas, to create a misty area. A little Cadmium Yellow can be used to highlight the top of the hill. Repeat with the third and fourth ranges of hills, adding Van Dyke Brown and Phthalo Blue as each gets darker and shows a little more detail. The tree indications are highlighted with various mixtures of Cadmium Yellow and Yellow Ochre and Phthalo Blue. A little mist at the base of each hill rubbed in with Titanium White will "separate" the ranges.

WATER

A mixture of Prussian Blue, Van Dyke Brown, Titanium White and Sap Green is rubbed into the canvas to create the reflections under the foothills. Add Titanium White with a touch of Alizarin Crimson into the water area using a firm pressure. Horizontal strokes made with a mixture of Titanium White and Phthalo Blue applied very lightly will create a watery appearance. With a small roll of Titanium White on the long edge of the knife, lay in highlights across the water holding the knife horizontally and using very little pressure. The land area around the water is made with a mixture of Van Dyke Brown and Dark Sienna. At this point a projection of land can be extended into the lake by using a mixture of Phthalo Blue, Sap Green and Van Dyke Brown loaded on the knife. Reflect a little of this dark color into the water. Rub across the reflections with a mixture of Titanium White and

Phthalo Blue to create a watery appearance. Water lines are cut in with the knife using a small roll of Titanium White loaded on the long edge of the knife.

TREES AND BUSHES

The evergreen tree is made with a mixture of all the dark colors; Van Dyke Brown, Sap Green, Alizarin Crimson and Prussian Blue. Pull the long edge of the knife through the paint and touch the canvas, with the knife held vertically, to make the center of the tree. Load a small amount of paint on the very point of the knife; holding the knife flat, touch the canvas and move the blade from side to side to create branches. Highlight the tree by adding a little Yellow paint to the dark mixture.

Use the same colors to make leaf trees and bushes by just laying in the basic shapes with the knife.

FOREGROUND

The large land area in the foreground is made with a mixture of Sap Green, Alizarin Crimson, Van Dyke Brown and Prussian Blue. Highlights in this area are made with the various mixtures on the palette, but it is important that they be kept quite dark.

FINISHING TOUCHES

Sticks and twigs can be made by loading dark paint on the long edge of the knife and gently touching the canvas.

This is a good painting to use the leftover paint on your palette. Color is not important, and by varying the mixtures used you can create some exciting effects.

Mountain Challenge

1. A thin wash is applied to the canvas with the 2" brush.

2. The knife is used to create clouds in the sky.

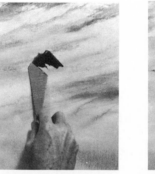

3. With the knife held flat . . .

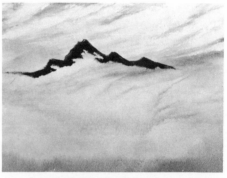

4. . . . lay in the basic mountain shape.

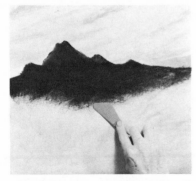

5. Blend downward to complete the base of the mountain.

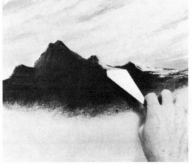

6. Use the knife . . .

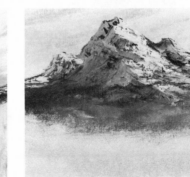

7. . . . to lay in highlights and shadows.

8. Foothills are made with short up and down strokes.

Mountain Challenge

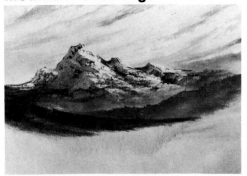

9. Complete the most distant foothill first before moving forward.

10. Use the knife . . .

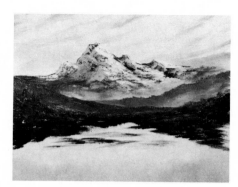

11. . . . to lay in dark color for reflections.

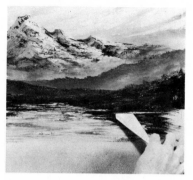

12. A small amount of light color is applied over the dark reflections to create a watery appearance.

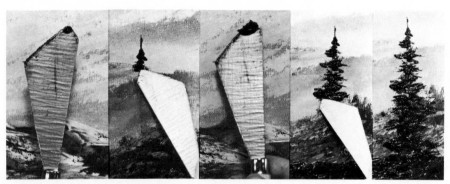

13. Steps used to paint an evergreen tree with the palette knife.

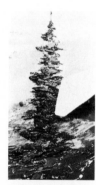

14. Highlights applied to the evergreen tree.

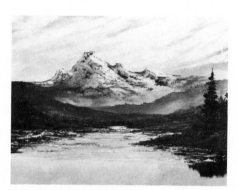

15. Background completed.

16. Use the knife . . .

17. . . . to lay in foreground areas.

18. The path is created with a lighter color.

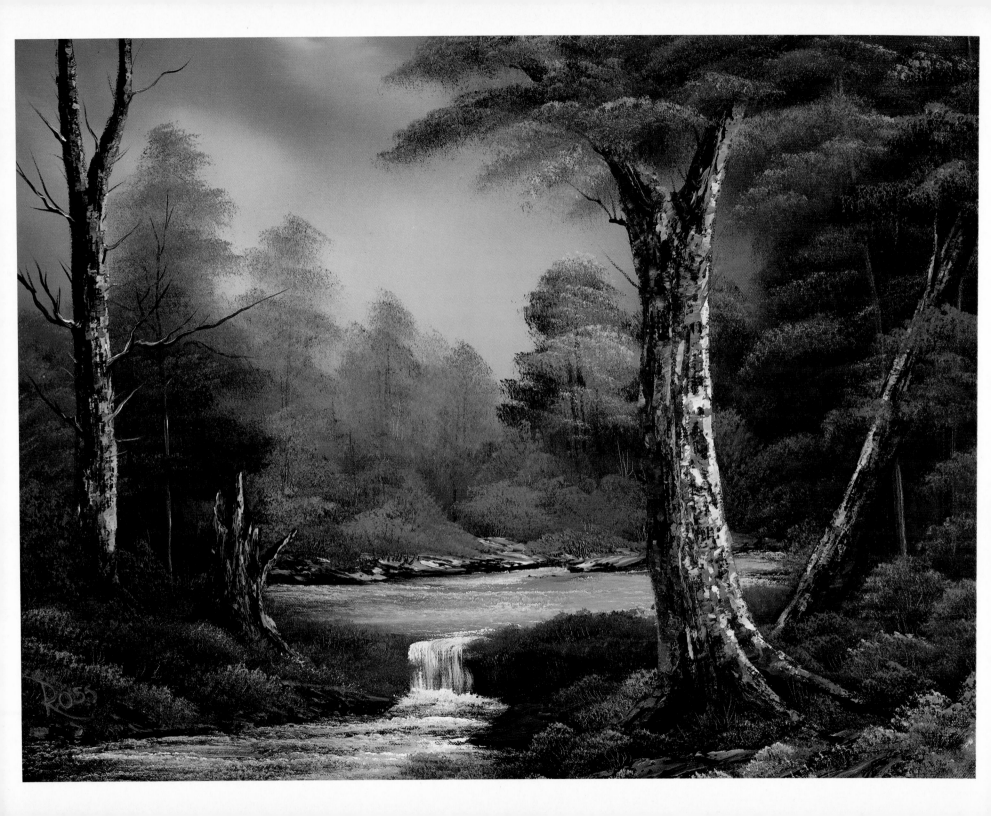

MATERIALS

2" Brush	Phthalo Blue
1" Brush	Dark Sienna
1" Round Brush	Van Dyke Brown
#2 Script Liner Brush	Alizarin Crimson
Large Knife	Sap Green
Small Knife	Cadmium Yellow
Liquid White	Yellow Ochre
Liquid Black	Indian Yellow
Titanium White	Bright Red

Cover the bottom 1/3 of the canvas with a thin, even coat of Liquid Black. Allow the Liquid Black to extend half-way up the left side of the canvas, and all the way to the top on the right side.

Fill in the remainder of the canvas with a thin, even coat of Liquid White. Brush-blend where the Black and White merge.

Do not allow the canvas to dry before you begin.

SKY

Tap a little Indian Yellow into the bristles of the 2" brush. Using criss-cross strokes, add a little color into the bottom of the sky area. Without cleaning the brush, pick up some Alizarin Crimson and add a little color above the Yellow. Still not cleaning the brush, pick up a mixture of Van Dyke Brown and Phthalo Blue and extend this color to the edge of the canvas in the sky area. With a clean, dry 2" brush, blend the entire sky.

BACKGROUND

Load the round brush with a mixture of Alizarin Crimson and Phthalo Blue. Tap in basic background tree shapes, starting at the bottom of the trees, allowing the color to get lighter as you near the top.

Tree trunks are made with Van Dyke Brown on the knife. Load the round brush with various mixtures of Phthalo Blue, Alizarin Crimson and Titanium White. Highlight the trees by tapping in leaf shapes to give your trees form.

Load the long edge of the knife with a small roll of Van Dyke Brown. Carefully lay in the land areas under the background trees. Highlight by applying a mixture of Phthalo Blue, Alizarin Crimson, Sap Green and Titanium White, allowing the paint to "break." Load the fan brush with these same colors and push in some little grassy areas along the banks.

WATER

Using the 2" brush and a mixture of Phthalo Blue and Van Dyke Brown, just lay some dark color into the water area. With a clean 2" brush, pick up a mixture of Titanium White with just a touch of Phthalo Blue. Holding the brush horizontally, tap in the background water movements over the dark base color.

FOREGROUND

Foreground trees and bushes are made using a mixture of Van Dyke Brown, Dark Sienna, Bright Red and Titanium White. Load the 2" brush by pulling through the paint in one direction, to round one corner. With the rounded corner up, begin pushing in some general tree and bush shapes. Extend this dark color into the center of the painting to act as a base for your waterfall. Tree trunks are pulled in using the fan brush with Van Dyke Brown, and highlighted with Van Dyke Brown and Titanium White on the knife. Load the round brush with Yellow Ochre, Bright Red and Titanium White and gently tap in the leaves on the trees. Highlight small trees and bushes with a mixture of Yellows, Sap Green and Bright Red on the 1" brush.

WATERFALL

Load your fan brush with a mixture of Liquid White and Titanium White. Hold the brush horizontally and go straight into the canvas. Make a short horizontal stroke and then pull straight down to create the falling water. The foam and bubbling action at the base is made by touching the canvas and forcing the bristles to bend upward. Continue the water action

as before using the 2" brush with Titanium White and Phthalo Blue. Extend the water to the bottom of the canvas. To contain this waterfall, load the knife with Van Dyke Brown and "build" rock and land masses on either side of the fall and along the water's edge. Highlights are applied with the small knife using a mixture of Van Dyke Brown and Titanium White. Bring some little grassy areas over the edge of the land masses by holding the 1" brush horizontally and pushing upward.

LARGE TREES

The large trees in the foreground are made by loading the fan brush with Van Dyke Brown. Starting at the top of the canvas, holding the brush vertically and just pull down,

allowing the trunks to become wider at the base by using more pressure. Highlight the right side of the tree trunks with a mixture of Van Dyke Brown, Titanium White and Dark Sienna. Load a small roll of paint on the long edge of the knife and gently touch to the canvas, give a little pull. Use Phthalo Blue on the left side of the trunks. Make tree limbs and branches using Liquid Black on the liner brush. Put leaves on the trees by tapping with the 2" brush using mixtures of Sap Green and Yellow.

FINISHING TOUCHES

Scratch in sticks and twigs, then sign your painting. You have once again truly experienced "The Joy of Painting."

Dark Waterfall

1. Start with a canvas that has both Liquid White and Liquid Black on it.

2. Use criss-cross strokes to paint the sky.

3. The round brush is used to make the basic shapes for background trees.

4. A small roll of paint on the knife is used to make tree trunks.

5. Tap with the round brush to highlight background trees and bushes.

6. The knife is used to make and highlight land areas.

7. Push upward with the brush to create grassy areas.

8. Use the 2" brush to create the illusion of running water.

9. Tap with the 2" brush . . .

. . . to make the basic shapes for the large trees.

11. Pull downward with the fan brush to make the waterfall.

Dark Waterfall

12. Splashes at the base of the waterfall are made by bending the brush upward.

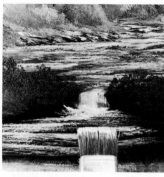

13. With the 2" brush finish painting the water area.

14. Tree trunks made by pulling downward with the fan brush.

15. Tap with the round brush to highlight the tree.

16. Push upward with the 1" brush to highlight individual bushes.

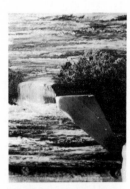

17. Rocks and stones are made . . .

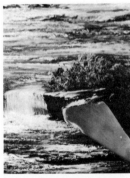

18. . . . and highlighted with the knife.

19. Use the knife to lay in land areas.

20. With the point of the knife, scratch in twigs and sticks.

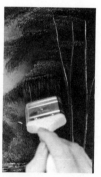

21. Use the 2" brush to tap in a few background leaves.

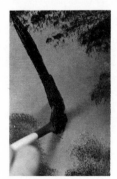

22. Pull downward with the fan brush . . .

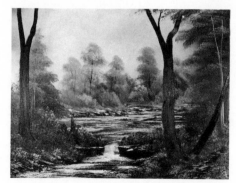

23. . . . to make the basic shapes for the large trees.

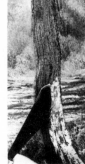

24. Trees and stumps highlighted with the knife.

25. Limbs are painted with Liquid Black/White.

26. Tap in a few leaves on the large foreground tree using the 2" brush.

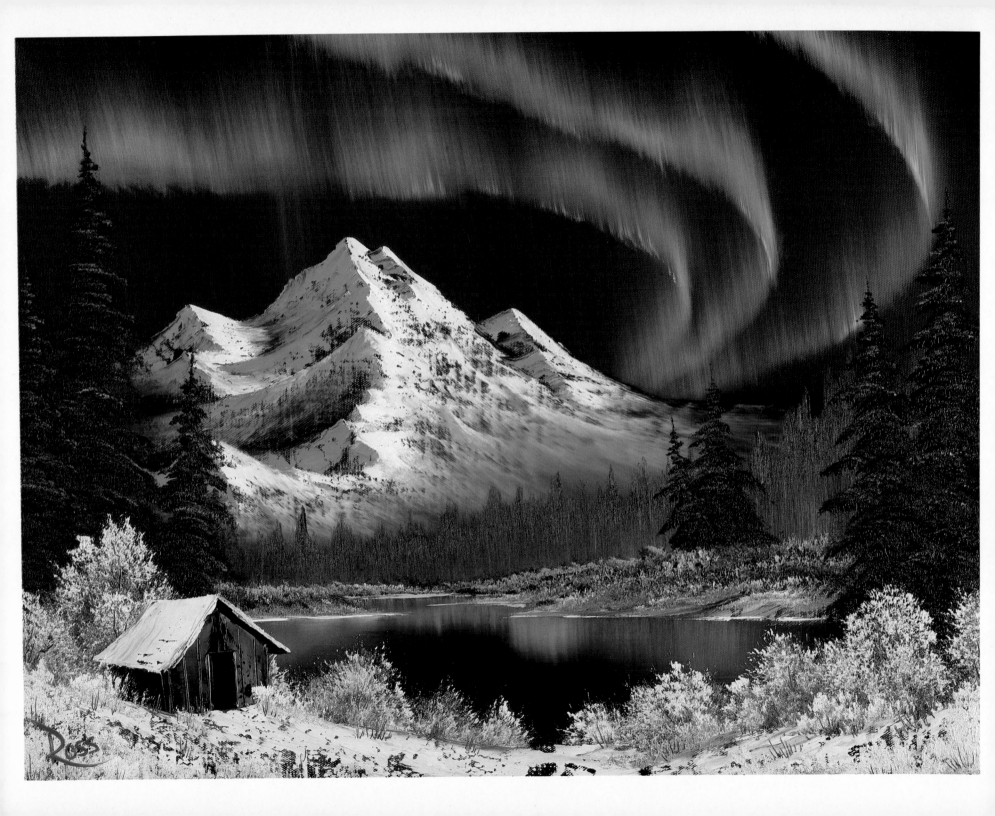

MATERIALS

2" Brush
1" Brush
#6 Fan Brush
#2 Script Liner Brush
Large Knife
Black Gesso
Liquid White
Titanium White
Phthalo Green
Phthalo Blue
Midnight Black
Dark Sienna
Van Dyke Brown
Alizarin Crimson
Bright Red

Cover the entire canvas with a coat of Black Gesso and allow to dry. When the canvas is dry, use a clean, dry 2" brush to apply Alizarin Crimson in the left portion of the sky, Phthalo Green on the right, and a mixture of Phthalo Green and Phthalo Blue over the remainder of the canvas. Make sure the entire canvas is covered with a thin, even coat of paint and do not allow these colors to dry before you begin.

SKY

Use a clean, dry fan brush to just outline the curtains of light in the sky. Load the brush with Titanium White and use just the ends of the bristles to tap in the top edges of the lights, following your outline. With a clean, dry 1" brush, grab the top edges of the lights and lift upward in short strokes allowing your base colors to mix with the Titanium White. Use a clean, dry 2" brush and make gentle, upward strokes through the entire sky.

MOUNTAIN

The mountain is made with a mixture of Midnight Black, Phthalo Blue and Van Dyke Brown. Use the knife and firm pressure to form just the top edge of the mountain, using very little paint. Now, with the 2" brush, pull this paint down to complete the entire mountain shape. The snow is a mixture of Titanium White and a little Phthalo Blue on the long edge of the knife. Touch the paint to the right side of the peaks and gently pull down, using so little pressure that the paint is allowed to "break." The shadow sides of the peaks are made

with a darker mixture, using more Phthalo Blue with the Titanium White; pulling in the opposite direction. With a clean, dry, 2" brush, gently tap the base of the mountain, following the angles. Then lift upward, to diffuse and create the illusion of mist.

BACKGROUND

The trees at the base of the mountain are made by loading the fan brush with a mixture of Midnight Black, Phthalo Blue and Van Dyke Brown. Hold the brush vertically and just tap downward. With a mixture of Phthalo Blue and Titanium White on the fan brush, hold the brush horizontally at the base of the small trees and pull upward with short strokes to make the tiny tree trunks.

With the dark tree mixture (Van Dyke Brown, Midnight Black and Phthalo Blue) on the fan brush, add small bushes to the base of the trees. Push in the grassy area at the base of the bushes with Titanium White using the fan brush. With the 2" brush, pull a little Titanium White into the water area with long vertical strokes and then gently brush across, to create reflections. Add snow to the base of the grassy area with a mixture of Liquid White and Titanium White on the knife. Use a small roll of just Liquid White on the long edge of the knife, to cut in the water lines. Use the fan brush to add larger, more distinct evergreen trees in the background.

FOREGROUND

The large evergreen trees are made by loading the fan brush with a mixture of Midnight Black and Phthalo Blue. Hold the brush vertically and just touch the canvas to create a center line. Use just one corner to touch the canvas and begin forming the small branches at the top of the tree. Force the bristles to bend downward, allowing your tree to become wider near the base. Highlights are made with a mixture of Phthalo Blue and Titanium White on the fan brush. To make the leaf trees and bushes, load the 1" brush with a mixture of Midnight Black, Phthalo Blue and a little

Titanium White. Form the trees and bushes forcing the bristles to bend upward. Highlights are made by dipping your clean 1″ brush into Liquid White and then pulling the brush through Titanium White and Phthalo Blue. Form individual tree and bush shapes, using very little pressure.

CABIN

Use the knife with no paint to just scrape in the basic shape of the cabin. Then, load the long edge of the knife with a small roll of Van Dyke Brown and Dark Sienna. Pull in the back eave shape and the front of the cabin and then the side adding more paint to the knife as necessary. Add a little Van Dyke Brown and Titanium White to the front for highlight,

then just Van Dyke Brown for the door. The snow covered roof is Titanium White on the knife, Bright Red for the chimney, a touch of White for the snow on the chimney.

FINISHING TOUCHES

Add a few snow-covered bushes and grasses to the base of the cabin. The snow on the ground is pulled in with Titanium White on the knife, careful of angles, creating the lay-of-the-land. Use the point of the knife to scratch in small sticks and twigs. For all of my friends, especially the ones in Alaska, I dedicate this painting. Sign yours, stand back and admire.

Northern Lights

1. With a fan brush, tap in the basic shapes.

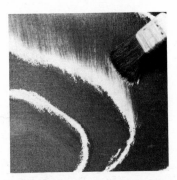
2. Lift upward with the 1″ brush . . .

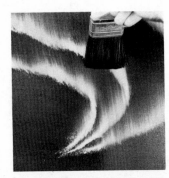
3. . . . then blend the entire sky with long upward strokes of the 2″ brush.

4. Completely finish the Northern Lights before starting the next step.

5. Use the knife to paint the basic mountain shape.

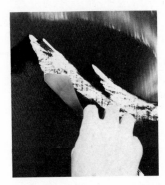
6. Apply the highlights and shadows with a very light pressure.

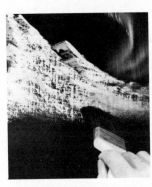
7. Tap the base of mountain with the 2″ brush . . .

8. Tap downward with the fan brush to paint distant evergreen trees.

9. Lift upward with a light color on the fan brush . . .

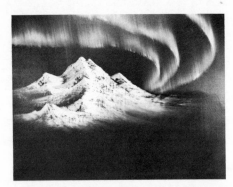
10. . . . to create the indication of tree trunks in the distant trees.

Northern Lights

11. Push upward with the fan brush to highlight grassy areas.

12. Pull straight down, then across, to create reflections in the water.

13. Use the knife to lay in snow areas . . .

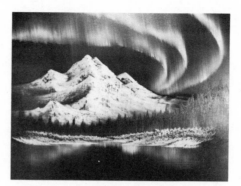

14. . . . and to "cut-in" distant water lines.

15. Push downward with the corner of the fan brush to make . . .

16. . . . and highlight evergreen trees.

17. Push upward with the 1" brush . . .

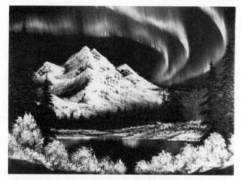

18. . . . to make and highlight individual bushes in the foreground.

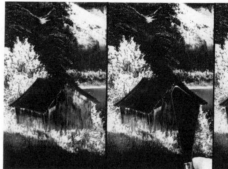
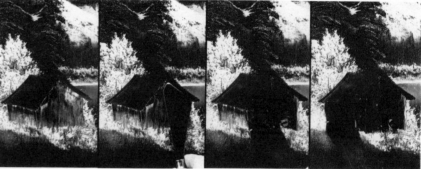

19. Progressional steps used to paint the cabin.

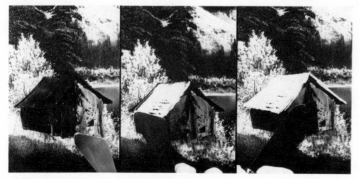

19. Progressional steps used to paint the cabin.

20. Use the knife to lay in snow . . .

21. . . . paying particular attention to angles. View this painting under several different light sources.

MATERIALS

2″ Brush
1″ Round Brush
#6 Fan Brush
#2 Script Liner Brush
Large Knife
Small Knife
Liquid White

Titanium White
Prussian Blue
Dark Sienna
Van Dyke Brown
Yellow Ochre
Bright Red

Start by covering the entire canvas with a thin, even coat of Liquid White, using the 2″ brush. Use long horizontal and vertical strokes, working back and forth to ensure an even distribution of paint on the canvas. Do not allow the Liquid White to dry before you begin.

SKY

Load a clean, dry 2″ brush with Van Dyke Brown. Start by making criss-cross strokes in the sky. As you near the horizon, without cleaning the brush, add a little Dark Sienna to the brush and continue making x-patterns.

Again, without cleaning the brush, add Yellow Ochre to the Browns already on the brush and pull in a little shadow color across the bottom of the canvas using long horizontal strokes.

Gently blend the entire canvas and clean the brush.

The clouds are made by loading the 1″ round brush with Titanium White. Begin by making small, circular movements in the sky. When you are satisfied with your cloud placement, use a clean, dry 2″ brush to blend out just the bottoms of the shapes. Use very gentle upward strokes to "fluff" the clouds.

BACKGROUND TREES

Load the 1″ round brush by tapping the bristles firmly into Van Dyke Brown and Dark Sienna. Form basic tree shapes along the horizon by tapping the paint onto the canvas. Start at the base of the trees and work upward.

Small tree trunks are made with a mixture of thinner and Van Dyke Brown on the liner brush.

The large tree trunk is made by loading the fan brush with Van Dyke Brown. Vertically, push and pull down, adding more pressure, allowing the trunk to get wider near the bottom of the tree. Highlights are made by loading the large knife with a mixture of Yellow Ochre, Dark Sienna and Titanium White. With a small roll of paint on the long edge of the knife, gently touch the right side of the tree trunk and pull. Then, repeat with just Titanium White on the very edge of the tree trunk.

Load the liner brush with Liquid Black to add branches to the tree. Liquid White can be used to highlight and add snow to the branches and limbs.

Using the 1″ round brush, add a little Yellow Ochre to some Titanium White paint and gently tap highlights onto the large tree in the background.

With the same colors still on the round brush, begin laying in the snow-covered ground area under the background trees.

Add Van Dyke Brown to the brush and push in some bush shapes at the base of the trees.

Begin forming the lay-of-the-land by using the fan brush to pull a little of the dark color into the snow, creating shadow areas.

CABIN

To "build" the cabin, load the long edge of the knife with a small roll of Van Dyke Brown.

Pull in the back roof overhang, then the front and side of the cabin.

With a mixture of Titanium White, Dark Sienna and a touch of Prussian Blue, highlight the sides of the cabin. Use a little Van Dyke Brown on the knife and cut in boards on the front and side of the cabin.

Load the knife with a small roll of Titanium White and gently pull in the snow-covered roof.

Using the small knife and Van Dyke Brown, add a door and windows. Touch the windows with just a little Prussian

Blue to give the indication of glass.

Finish your cabin by adding a chimney. Use the small edge of the small knife and Bright Red. With Titanium White, add just a touch of snow to the chimney top.

Use the fan brush to grab the dark paint at the base of the cabin and pull in some shadow areas.

FOREGROUND

Load the round brush with Van Dyke Brown paint and push in the grassy areas in the foreground.

With a small roll of Van Dyke Brown on the long edge of the knife, gently lay in the fence posts. Barely touch the right side of each post with a mixture of Titanium White, Van Dyke Brown and Prussian Blue to create highlights. With Titanium White paint on the small edge of the knife, touch a little snow to the top of each fence post. Use Liquid White and the heel of the knife to cut in the wire on the fence.

Use the fan brush and Van Dyke Brown to add weeds and grasses to the base of the fence.

Finish your painting by using the liner brush and thinned Van Dyke Brown paint to pull up some long grasses.

Sign and admire.

Winter Cabin

1. The sky is made using criss-cross strokes.

2. Add water with long horizontal strokes.

3. Basic cloud shapes are made with the round brush, . . .

4. . . . then blended with the top corner of the large brush.

5. Blend the entire sky with the 2" brush to soften and smooth.

6. The round brush is used to tap in the initial background tree shapes.

7. The liner brush, and a thin paint, are used to paint small branches.

8. Large trunks are painted with the fan brush.

9. Highlights are applied to the trunk with the knife.

10. Limbs are painted on the larger trees with the liner brush.

11. Highlights are applied by tapping with the round brush.

12. Use the round brush to lay in snow covered areas.

13. The round brush pushed upward to create grassy areas.

Winter Cabin

 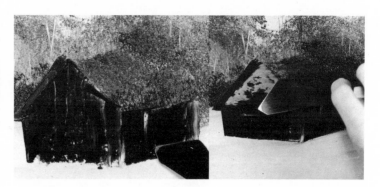

14. With the fan brush, pull in shadows, following the lay of the land.

15. This helps create the illusion of distance in your painting.

16. Progressional steps used to paint the cabin.

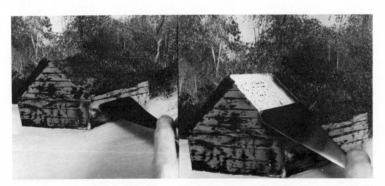 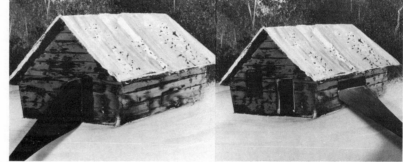

17. Push upward with the round brush to make bushes in the foreground.

18. Fence post painted with the knife.

19. With the "heel" of the knife "cut-in" wire on the fence.

20. Individual blades of grass made with the liner brush and a thin paint.

21. Large fence posts are made . . .

22. . . . and highlighted with the knife.

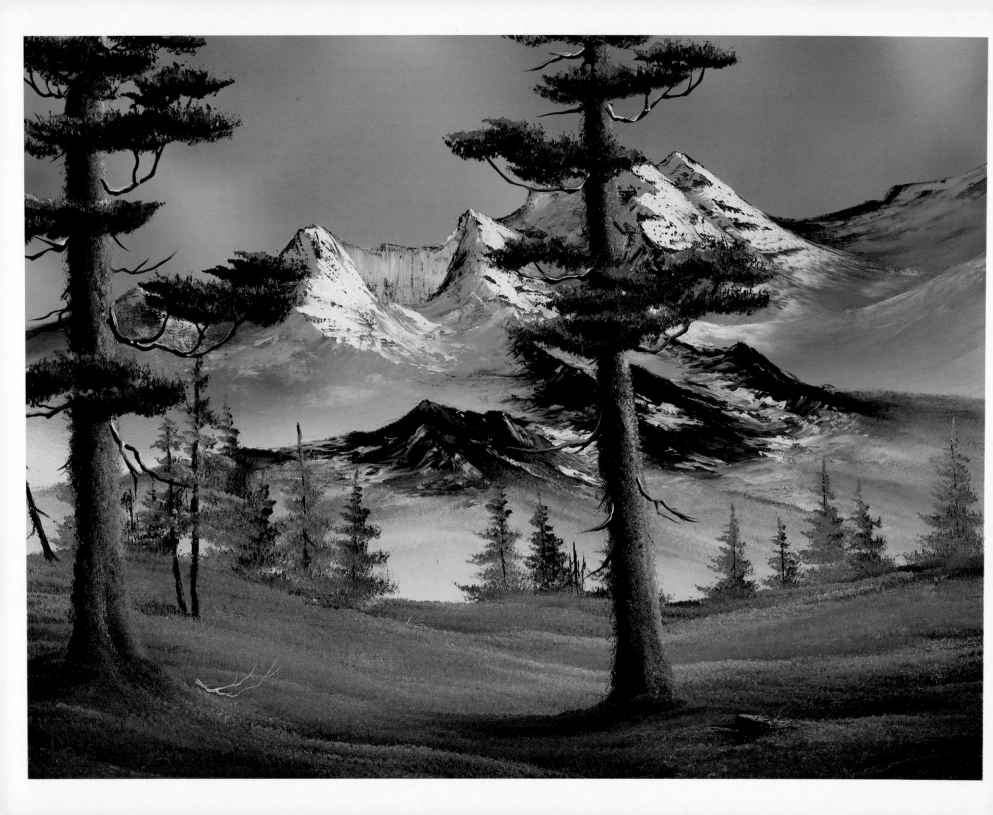

MATERIALS

2″ Brush	Prussian Blue
#3 Fan Brush	Midnight Black
#2 Script Liner Brush	Dark Sienna
Large Knife	Van Dyke Brown
Small Knife	Sap Green
Liquid White	Cadmium Yellow
Liquid Black	Yellow Ochre
Titanium White	Indian Yellow
Phthalo Blue	Bright Red

Start by covering the entire canvas with a thin, even coat of Liquid White, using the 2″ brush. Use long horizontal and vertical strokes, working back and forth to ensure an even distribution of paint on the canvas. Do not allow the Liquid White to dry before you begin.

SKY

Load the 2″ brush with Phthalo Blue, tapping the brush briskly against the palette to ensure an even distribution of paint throughout the bristles. Starting at the top of the canvas, make criss-cross strokes in the sky area, leaving holes, allowing the White canvas to show through. Blend the entire sky.

MOUNTAIN

The first range of mountains is made with a mixture of Midnight Black and Prussian Blue. With a small roll of paint on the edge of the knife, outline the top of the mountain using very firm pressure. Use the knife to remove any excess paint. With a 2″ brush, grab the paint and begin pulling it down toward the base of the mountain blending it into the Liquid White.

Highlight the right side of the peaks by loading the knife with a small roll of Titanium White. Very gently touch the paint to the top of the peak and pull down. Use very little pressure—causing the paint to break. The shadows are applied to the left sides of the peaks using a mixture of Prussian Blue and Titanium White—pulled in the opposite direction. Use the small knife to apply the paint to small, hard-to-reach areas of the mountain. Use a clean, dry 2″ brush and gently tap and diffuse the base of the mountain, paying very close attention to angles. Lift upward to create a misty appearance.

The second range of mountains is made with a mixture of Van Dyke Brown and Midnight Black. Load a small roll of paint on the long edge of the knife and begin shaping these peaks in front of the larger mountains. With a mixture of Van Dyke Brown, Dark Sienna and Titanium White, begin laying highlights on these peaks, using the knife and very little pressure. The shadow side is Brown. You can use Titanium White to add a little snow to these mountains—allowing the paint to "break." The snow on the shadow side is made with a mixture of Blue and Titanium White.

Load the 2″ brush with mixtures of Yellow, Sap Green and Van Dyke Brown and begin tapping grassy areas at the base and up the sides of this dark mountain. Be sure to follow the already established angles of the mountain.

BACKGROUND

The rolling hills at the foot of the mountains are made by loading the 2″ brush with a mixture of Midnight Black and Sap Green. Holding the brush horizontally, create hill shapes by just tapping downward. Extend this dark, base color to the bottom of the canvas.

Highlight the ground area with mixtures of Yellow Ochre, Yellow and Sap Green on the 2″ brush. Again, hold the brush horizontally and begin creating the lay-of-the-land by tapping downward with this lighter color. Be careful not to "kill" all of your dark base color.

The small evergreen trees are made by loading the fan brush with a mixture of Yellow Ochre, Yellow and Sap Green. Hold the brush vertically, touch the canvas to make a center line, and then turn the brush horizontally. Use just one corner of the brush, forcing the bristles to bend upward.

As you work down the tree, more pressure on the brush will cause the branches to become larger near the base. Use a little Van Dyke Brown on the knife and just touch the center of each tree for trunk indications.

Larger tree trunks are made by loading the knife with a very small roll of Van Dyke Brown and just touching the canvas. Again, use the fan brush and the Yellow-Green mixture to add foliage to these trees.

FOREGROUND

The large trees in the foreground are made by loading the fan brush with Van Dyke Brown. Holding the brush vertically, tap in the trunks. A series of short, downward taps will give the bark a rough, fuzzy appearance. Highlights are applied in the same way, using Titanium White on the brush and tapping the right side of each trunk. Limbs and branches are added with thinned Liquid Black on the liner brush. You can add some highlights using Liquid White.

The leaves on the large trees are made with Sap Green and Midnight Black using the fan brush. Just touch, push and bend upward to apply the color. Highlight by adding a little Yellow to your brush.

FINISHING TOUCHES

Add sticks, twigs and long grasses using Liquid Black and White on the liner brush.

Mountain Glory

1. With criss-cross strokes . . .

2. . . . lay in the basic sky pattern . . .

3. . . . then blend with a clean 2″ brush.

4. With a firm pressure . . .

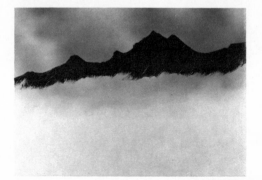
5. . . . lay in a basic mountain shape. Remove excess paint . . .

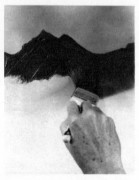
6. . . . then blend downward with the 2″ brush . . .

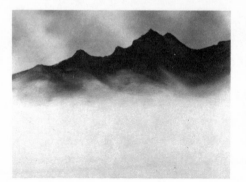
7. . . . to create a misty effect at the base.

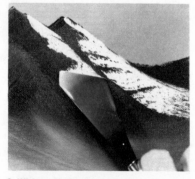
8. With a roll of paint on the knife, lay in the highlights and shadows.

Mountain Glory

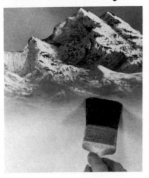

9. Tap the base gently with the 2" brush . . .

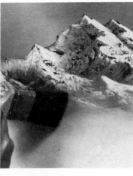

10. . . . then lift upward to create a soft, misty look.

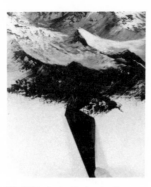

11. With the knife, lay in the next layer of mountains . . .

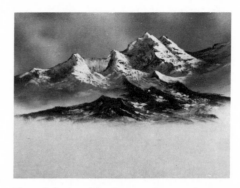

12. . . . being careful to leave a misty area between each layer.

13. With the 2" brush, tap in grassy areas, following the angles in the mountains.

14. With the 2" brush, tap in a dark base color . . .

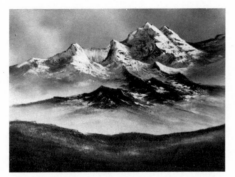

15. . . . for the foreground area.

16. Push upward with the fan brush for distant evergreens.

17. Working in layers, tap downward with the 2" brush . . .

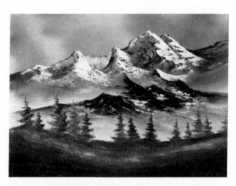

18. . . . to make soft grassy areas.

19. Use the knife, pulled sideways to paint tree trunks.

20. Tap downward firmly to paint . . .

21. . . . the two large evergreen trees.

22. Use the liner brush . . .

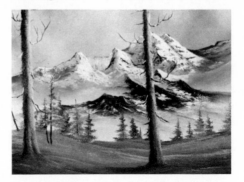

23. . . . to make the highlight branches on the large trees.

24. Push upward with the fan brush . . .

25. . . . to paint leaves on the large trees.

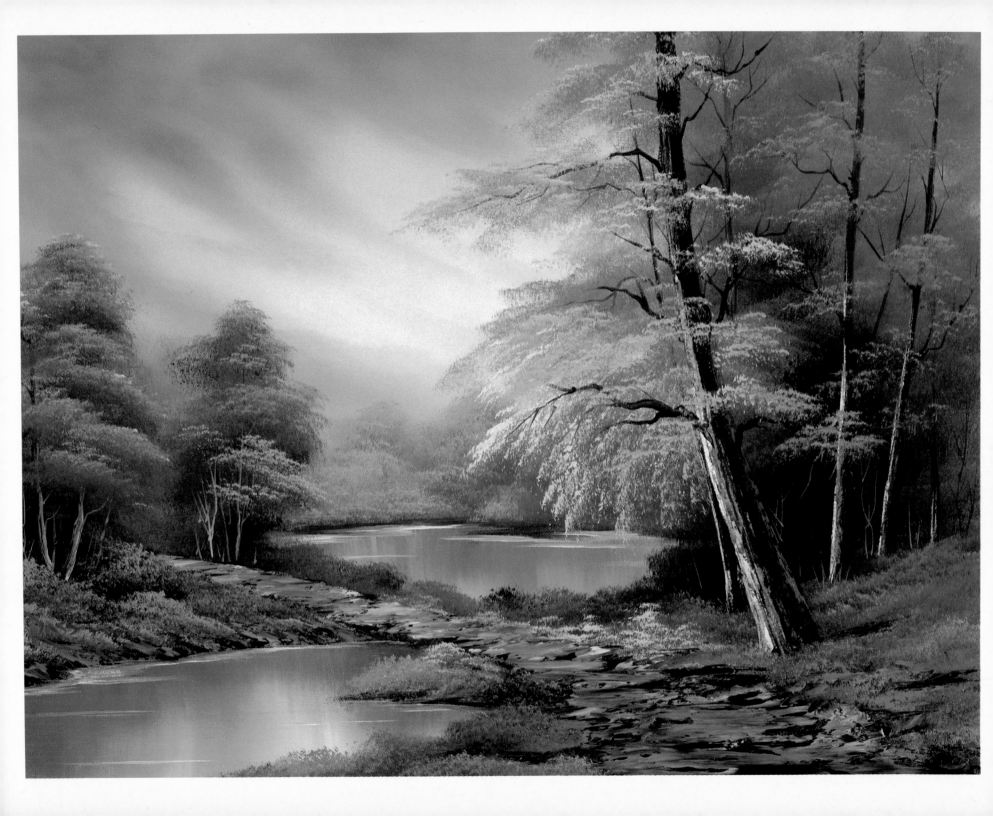

MATERIALS

2" Brush	Midnight Black
#6 Fan Brush	Dark Sienna
#2 Script Liner Brush	Van Dyke Brown
Large Knife	Alizarin Crimson
Liquid White	Sap Green
Liquid Black	Cadmium Yellow
Titanium White	Yellow Ochre
Phthalo Blue	Indian Yellow
Prussian Blue	Bright Red

Before beginning this painting, mix equal amounts of Liquid White and Liquid Black in a small container and stir well.

Using the 2" brush, cover the center of the canvas with a thin, even coat of Liquid White. Apply a thin coat of the Liquid White/Liquid Black mixture to the outside edges of the canvas. So as not to have a distinct line between the Liquid White and the Liquid White/Black mixture, use criss-cross strokes to blend where the two come together and then with long horizontal and vertical strokes, work back and forth to ensure an even distribution of paint on the canvas. Do NOT allow the Liquid White/Black to dry before you begin.

SKY

Load the 2" brush with Yellow Ochre. Starting in the center of the sky, begin by making diagonal, sweeping, strokes. Add Midnight Black and a small amount of Phthalo Blue to the brush and use criss-cross strokes to extend the sky to the top and sides of the canvas. Add Alizarin Crimson to the same brush and use criss-cross strokes to add Pink areas to the sky. With the same brush, tap to indicate cloud shapes in the light area of the sky and then blend with a clean, dry 2" brush, using criss-cross strokes.

BACKGROUND

Load the 2" brush with a mixture of Midnight Black, Dark Sienna, Van Dyke Brown and Prussian Blue. Use just one corner of the brush and tap downward to form the small background trees. Use long, horizontal strokes with Phthalo Blue on the brush to add the water to the base of the trees. Using the same tree mixture on the brush, just tap to add the reflections to the water, pull straight down and then gently brush across to give the reflections a watery appearance.

Add Phthalo Blue, Alizarin Crimson, Titanium White and a little Liquid White to the same brush for the highlight colors on the trees, still using just one corner of the brush to tap.

Load the long edge of the knife with a small roll of Van Dyke Brown. With very little pressure on the knife, add the banks to the water's edge. Load the knife with a small roll of Liquid White to cut in the water lines and ripples.

FOREGROUND

Moving forward in the painting, underpaint the large trees and bushes with a mixture of Van Dyke Brown, Dark Sienna, Midnight Black and Sap Green on the 2" brush. Starting at the base of the trees and bushes, again just tap downward with the corner of the brush. As you work up towards the tree tops, add various mixtures of Dark Sienna, Yellow Ochre and Alizarin Crimson to the brush.

To create the reflections in the foreground water, hold the large brush flat against the canvas and pull straight down. Use light horizontal strokes to give the reflections the appearance of water.

Load the fan brush with Van Dyke Brown and Dark Sienna. Hold the brush vertically and starting at the top of each tree, pull down to add the trunks.

Mix paint thinner with Van Dyke Brown to the consistency of water. Turn the liner brush as you pull it through the mixture, bringing the bristles to a sharp point. Use very little pressure on the brush to add limbs and branches to the trunks.

Load the 2" brush with various mixtures of all the Yellows, Dark Sienna, Titanium White and Bright Red. Use just one corner of the brush to highlight the leaf clusters. The very pale leaf highlights are made with a mixture of Cadmium

Yellow and Liquid White.

Highlight the small bushes at the base of the trees by adding a little Midnight Black to the Yellows to make Green. Still using the 2″ brush to tap downward, form individual bush shapes being very careful not to "kill" all of the dark base color.

Use horizontal strokes with Van Dyke Brown on the knife to add the path that extends across the foreground, the banks, rocks and stones along the water's edge. Use a mixture of Titanium White and Dark Sienna on the knife for the highlights, using so little pressure that the paint "breaks."

The water lines and ripples are cut in with Liquid White on the knife.

Use the fan brush to add the large tree trunk in the foreground and then highlight with a mixture of Titanium White and Van Dyke Brown on the knife. Again, use the liner brush to add the limbs and branches and the 2″ brush to tap on the leaf colors, using the same highlight mixtures.

FINISHING TOUCHES

Add tiny sticks and twigs using the thinned mixture of Van Dyke Brown on the liner brush and then load the liner brush with a thinned color to add the most important detail, your name.

Bright Autumn Trees

1. Cover the canvas with the Liquid White/Black mixtures.

2. Use the 2″ brush for criss-cross strokes . . .

3. . . . and tapping cloud shapes . . .

4. . . . to complete the sky.

5. Use the 2″ brush to tap downward for the background trees . . .

6. . . . and to pull down for reflections.

7. With the knife, add the banks . . .

8. . . . and the water lines . . .

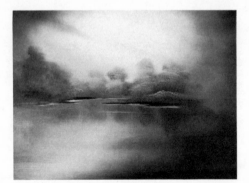

9. . . . to complete the background.

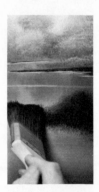

10. Tap downward with the 2″ brush . . .

Bright Autumn Trees

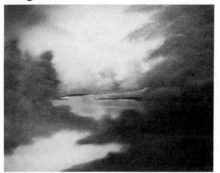

11. . . . to underpaint the foreground.

12. Pull down to paint trunks with the fan brush . . .

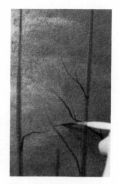

13. . . . then add branches with the liner brush.

14. Pull down with the 2" brush to make reflections.

15. Tap downward with the 2" brush to add leaves to the trees . . .

16. . . . and to paint bushes.

17. Use the knife to make . . .

18. . . . and highlight . . .

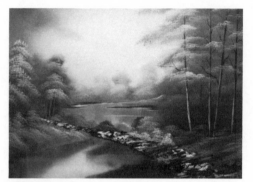

19. . . . the path.

20. Use the knife to cut in water lines . . .

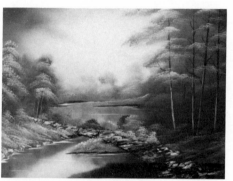

21. . . . under all the land projections.

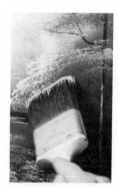

22. Tap down with the 2" brush to highlight leaves.

23. Pull down with the fan brush to make the large tree trunk . . .

24. . . . and then highlight with the knife . . .

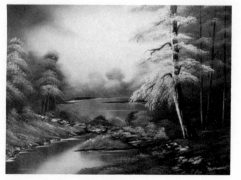

25. . . . to complete the painting.

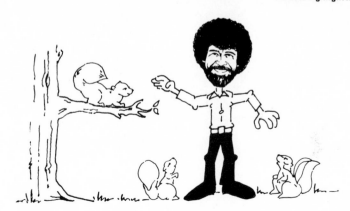

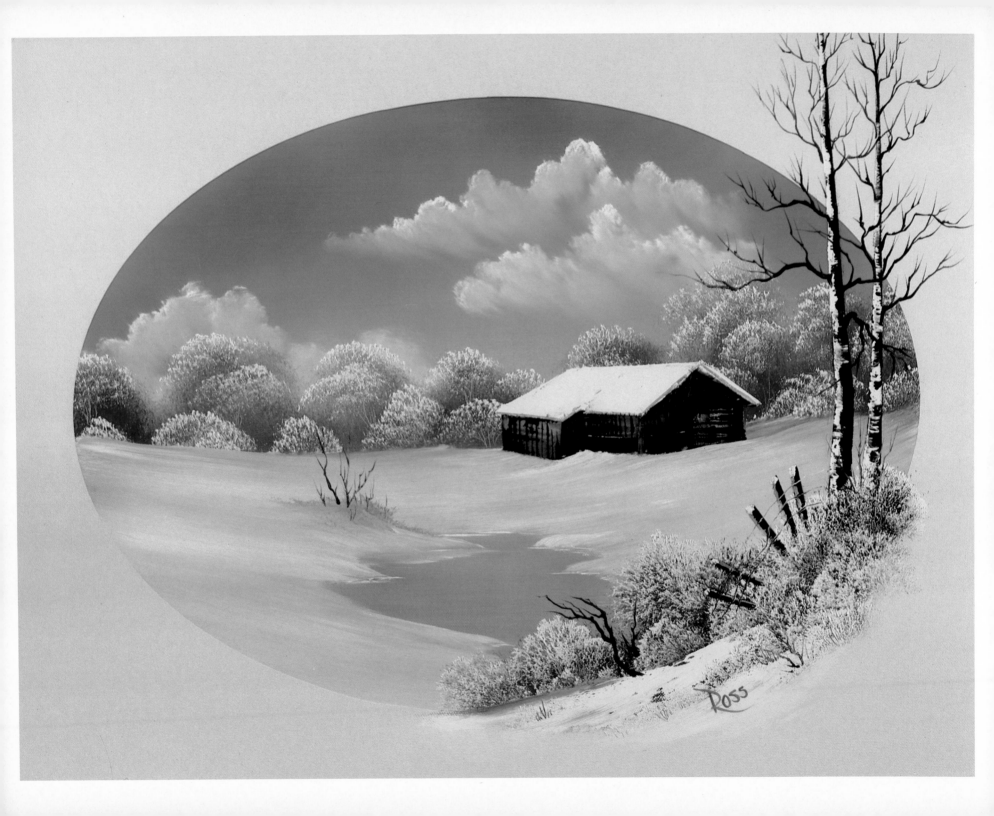

MATERIALS

2″ Brush	Liquid White
1″ Brush	Liquid Clear
1″ Round Brush	Titanium White
#6 Fan Brush	Prussian Blue
#2 Script Liner Brush	Midnight Black
Large Knife	Dark Sienna
Small Knife	Van Dyke Brown
Adhesive-Backed Plastic	Bright Red

Start by covering the entire canvas with adhesive-backed plastic (such as Con-Tact Paper) from which you have removed a 14 x 20 center oval.

Cover the exposed area of the canvas with a thin, even coat of Liquid White using the 2″ brush. Do NOT allow the Liquid White to dry before you begin.

SKY

Load the 2″ brush with a small amount of Prussian Blue and Midnight Black. Use criss-cross strokes to apply the color to the sky, starting at the top of the canvas, allowing the color to become lighter as you work down towards the horizon. Use long horizontal strokes to add the water to the lower portion of the painting. With a clean, dry brush, blend the entire canvas.

The clouds are made by loading the 1″ brush with Titanium White and a touch of Bright Red. Use small circular strokes to add the clouds, working in layers. Use the top corner of a clean, dry 2″ brush to blend just the bottoms of the cloud layers, then gently lift upward to "fluff." Very lightly blend the entire sky.

BACKGROUND

Tap in the background tree shapes, along the horizon, using a mixture of Midnight Black, Prussian Blue and Van Dyke Brown on the 1″ round brush. Mist the base of the trees by tapping with a clean, dry 2″ brush and then lightly lift upward.

Add snow to the trees with Titanium White on the round brush. Use the point of the knife to scratch in small trunk indications.

With Titanium White on the 2″ brush, begin adding the snow-covered ground to the base of the trees. Use long horizontal strokes and pay close attention to the lay-of-the-land.

BARN

Use the knife to remove the paint from the canvas in the basic shape of the barn. With a small roll of Titanium White on the knife, lay in the front of the roof and then the back edge of the roof. Underpaint the roof edge with Van Dyke Brown and then use a mixture of Van Dyke Brown and Dark Sienna on the knife to underpaint the front and then the sides of the barn.

Highlight the front of the barn with a mixture of Dark Sienna, Bright Red and Titanium White. Load the small knife with a very small roll of paint by pulling the mixture out flat on the palette and just cutting across. Hold the knife vertically and just lightly touch to create the vertical slats. Use Van Dyke Brown to add the doors and a darker mixture of Dark Sienna, Bright Red and Titanium White for the vertical and horizontal slats on the sides of the barn.

Use a mixture of Liquid Clear and Titanium White on the fan brush to add the snow to the base of the barn.

WATER

With Midnight Black and Prussian Blue on the 2″ brush, use downward strokes to add the pond. Lightly brush across to create the appearance of water. Add the snow-covered edges to the pond with the Titanium White-Liquid Clear mixture on the fan brush. Add the Midnight Black-Prussian Blue mixture to the fan brush and just "pop-in" some little grassy areas by bending the fan brush bristles upward.

Use a small roll of Liquid White on the edge of the knife to cut-in the water lines around the edges of the pond.

Use a mixture of paint thinner and Van Dyke Brown on the liner brush to add the small leafless trees to the edges of the pond.

FOREGROUND

At this point, you should remove the adhesive-backed plastic from your painting. Extend the foreground outside the oval by loading the fan brush with Van Dyke Brown. Holding the brush vertically, start at the top of the canvas and pull down to add the tree trunks to the right side of the painting. Use a mixture of Van Dyke Brown and Titanium White on the knife and just touch highlights to the right sides of the trunks. With thinned Van Dyke Brown on the liner brush, add the limbs and branches.

Load the 1″ brush with the Prussian Blue-Midnight Black mixture to add small bushes to the base of the tree trunks. Use a mixture of Liquid White, Titanium White and a touch of Bright Red on the 1″ brush to add the snowy highlights.

Add the snow-covered ground area using the knife and Titanium White. The fence is Van Dyke Brown, highlighted with Titanium White, using the small knife.

FINISHING TOUCHES

You can use the point of the knife to scratch in final details or a thinned paint on the liner brush to add small sticks and twigs.

To sign your painting, dip the liner brush into paint thinner and then turn the brush as you pull the bristles through the paint, forcing them to a sharp point. Use very little pressure as you add the most important part of your painting, your signature!

Oval Barn

1. Start with a canvas covered with Con-Tact Paper which has an oval cut out of the center.

2. Use criss-cross strokes to paint the sky.

3. Make the initial cloud shapes with a 1″ brush.

4. Use the top corner of the 2″ brush to blend the base of the clouds . . .

5. . . . then use long horizontal strokes to blend the entire canvas.

 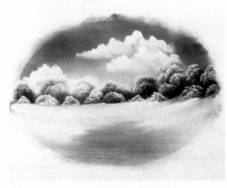

6. Tap downward to paint the bushes.

7. Tap the base of the trees to create mist.

8. Use the 2″ brush . . .

9. . . . to paint snow under the distant trees.

Oval Barn

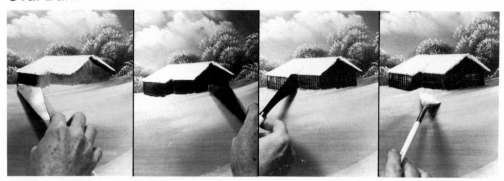

10. Progressional steps used to paint the barn.

11. Use the fan brush to paint details in the snow.

12. Water lines are "cut-in" with the edge of the knife.

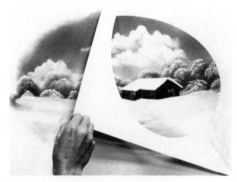

13. Carefully remove the Con-Tact Paper.

14. Tree trunks are painted with the fan brush . . .

15. . . . then high-lighted with the knife.

16. Use the liner brush, loaded with a thin paint, . . .

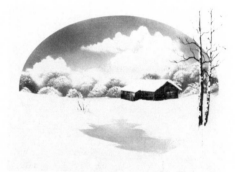

17. . . . to paint individual tree limbs.

18. Foreground bushes are made and highlighted with a 1" brush.

19. Use the knife to lay snow in the foreground.

20. Fence posts are painted with the edge of the knife.

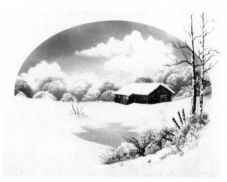

21. Add a few finishing touches, sign, then stand back and admire.

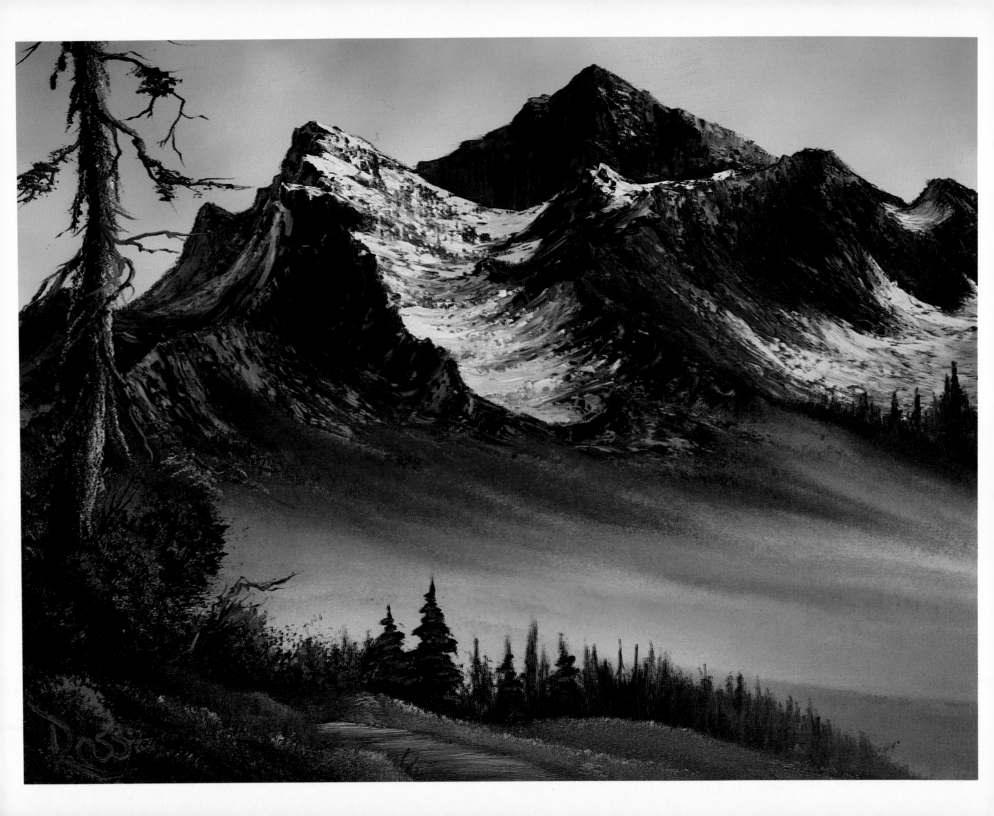

MATERIALS

2" Brush	Indian Yellow
1" Brush	Bright Red
Large Knife	Prussian Blue
Liquid White	Phthalo Blue
#6 Fan Brush	Phthalo Green
#2 Script Liner Brush	Sap Green
Alizarin Crimson	Titanium White
Dark Sienna	Van Dyke Brown
Cadmium Yellow	Yellow Ochre

Cover the entire canvas with a thin, even coat of Liquid White using the 2" brush. Apply the Liquid White in long horizontal and vertical strokes, working it back and forth to assure an even distribution of paint on the canvas. Do not allow the Liquid White to dry before you begin.

SKY

Load the 2" brush with Phthalo Blue. Start with a very small amount of paint on the brush, evenly distributed throughout the bristles. Apply the Blue paint randomly throughout the sky area of the canvas, leaving light spots here and there. Without cleaning the brush, pick up a little Dark Sienna and apply to the light areas of the sky. With a clean, dry 2" brush, blend the entire sky.

MOUNTAINS

Mix a Black color using equal parts of Alizarin Crimson and Phthalo Green. This color can be tested by adding a very small amount to some Titanium White; it should look Grey. If the color is too Red, add more Phthalo Green. If it is too Green, add more Alizarin Crimson. Lay in the basic mountain shape with a small roll of the black mixture on the long edge of the knife. Push the paint into the canvas with a firm pressure. Blend the basic mountain shape downward with the 2" brush. To highlight the mountain, use the Large Knife and various mixtures of the Black paint, Titanium White, Dark Sienna and Van Dyke Brown. Use a small roll of paint on the long edge of the knife and apply to the mountain using almost no pressure. The paint should "break", allowing some of the base color to show through. Pay careful attention to angles and also where the light would strike the mountain. The shadow sides of the mountain are made in the same way but by adding Prussian Blue and Phthalo Blue to the highlight colors and pulling the paint in the opposite direction.

TREES AND BUSHES

The indication of distant evergreens at the base of the mountain is made with the fan brush and the Black mixture. Load the brush full of paint, hold it vertically, touch the canvas and tap downward. Using the 2" brush tap in the grassy areas at the base of the mountain using mixtures of Sap Green, Prussian Blue and Van Dyke Brown. Tap in the highlights with the 2" brush using the various Yellows and Titanium White paying close attention to the lay-of-the-land. Use Prussian Blue, Van Dyke Brown and Sap Green on the 2" brush to make the trees and bushes in the foreground. Pull the brush through the paint in one direction to round one corner. Touch the canvas with the rounded corner up and gently bend the bristles upward. The ground area can be made by turning the brush horizontally and bending the bristles upward. The small evergreens in the foreground are made with the same Prussian Blue, Van Dyke Brown and Sap Green mixture. Load the fan brush full of paint and just tap in tree indications. The larger, more distinct evergreens are made by holding the brush vertically and touching the canvas to make a center line. Turn the brush horizontally and use just the corner to start the tree. Barely touch the brush to the center line to make the top branches. Use the same corner to paint the entire tree. As you work down the tree, move the brush from side to side applying more pressure forcing the bristles to bend downward. The leaf trees and bushes are highlighted with various mixtures of Sap Green, Cadmium Yellow and Bright Red. If the paint is too

thick it can be thinned with a little thinner. Pull the 1" brush through the paint in one direction, to round one corner. Touch the canvas with the rounded corner up and push in the highlights with a slight upward motion. The large evergreen tree is made with the fan brush and Van Dyke Brown. To make the tree trunk, load the brush with paint and lay in the trunk by tapping downward. The edges of the trunk should be left quite rough and uneven. Highlight the tree trunk in the same way, using Titanium White and Dark Sienna. The limbs and branches are made with the liner brush using Van Dyke Brown which has been thinned with a light oil. Gently tap some leaves onto the branches using the 1" brush and Sap Green and Cadmium Yellow.

FOREGROUND

The path is made with Van Dyke Brown and Titanium White. Load the fan brush and pull the paint from side to side, allowing the path to get wider as it comes closer. The grassy areas in the foreground are made with the fan brush using Sap Green and Cadmium Yellow. Hold the brush horizontally, touch the canvas and bend the bristles slightly upward. Working in layers, pay close attention to the "lay-of-the-land." If your fan brush makes "smiley-faces", try using just one corner of the brush.

FINISHING TOUCHES

Sticks and twigs may be made using the liner brush and Van Dyke Brown thinned with a light oil. You are now ready to sign your painting with a color thinned to water consistency.

Majestic Mountains

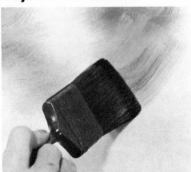
1. The sky is painted with the 2" brush.

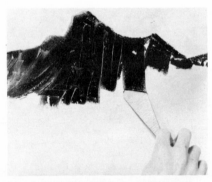
2. Lay in the basic mountain shape with the knife...

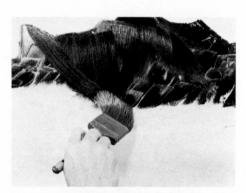
3. ... then blend downward with the 2" brush.

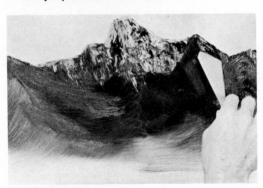
4. The knife is used to highlight rocks ...

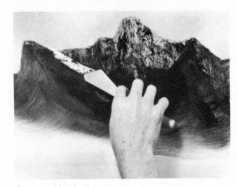
5. ... and lay in the snow.

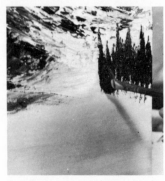
6. Distant evergreens made with the fan brush.

Majestic Mountains

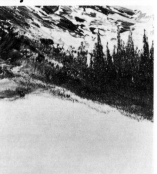

7. Evergreens should follow the angles in the mountains.

8. The large brush is used to create grassy areas . . .

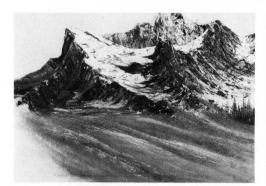

9. . . . and apply highlights.

10. The large brush is used to create basic tree and bush shapes.

11. Evergreen made with the fan brush.

12. Highlights applied with the 1" brush.

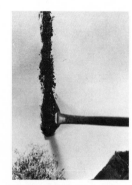

13. The fan brush is used to make the large tree.

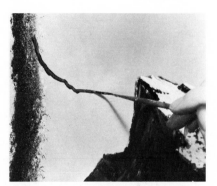

14. Limbs are painted with the liner brush.

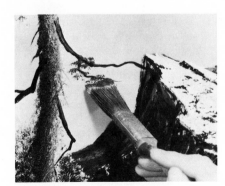

15. Leaves are made with the corner of the 1" brush.

16. Lay in the path with a fan brush.

17. Grassy areas made with the fan brush. Don't forget to sign!

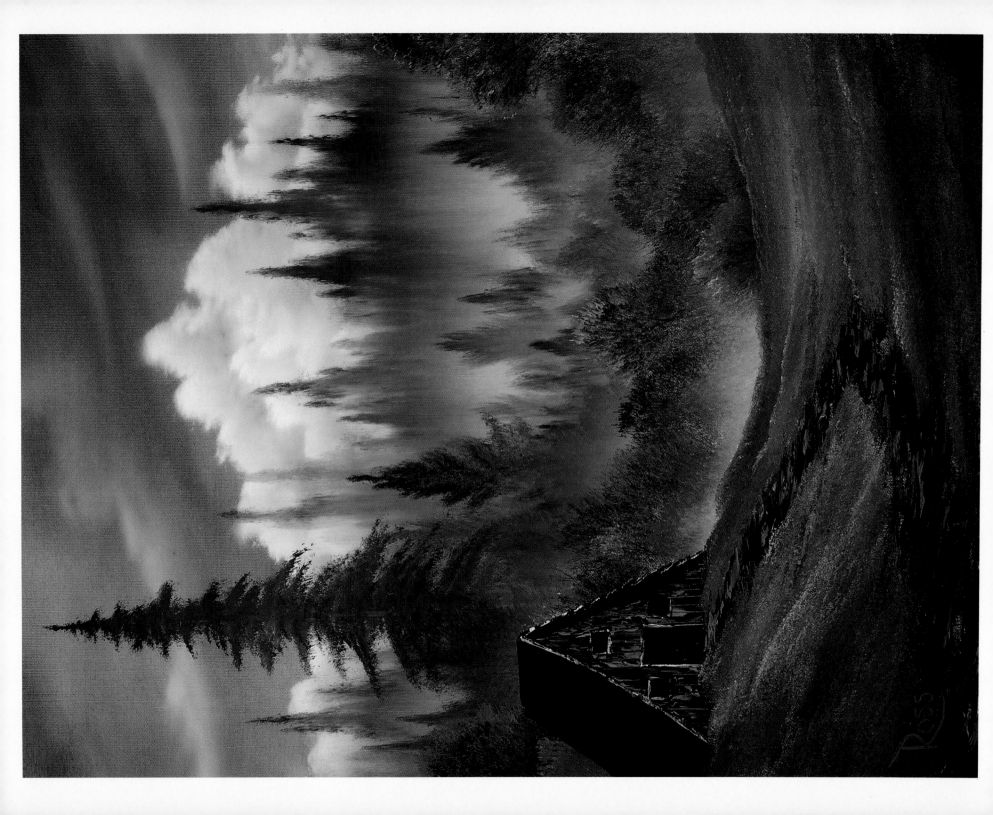

MATERIALS

2″ Brush	Indian Yellow
1″ Brush	Bright Red
Large Knife	Phthalo Blue
Liquid White	Phthalo Green
#6 Fan Brush	Sap Green
#2 Script Liner Brush	Titanium White
Alizarin Crimson	Van Dyke Brown
Dark Sienna	Yellow Ochre
Cadmium Yellow	

Start with a canvas that is completely dry. Load a small amount of Dark Sienna into the 2″ brush. With a very firm pressure, scrub the color onto the top part of the canvas. Without cleaning the brush, add a small amount of Phthalo Blue and cover the remainder of the sky. With a clean, dry 2″ brush, blend the sky colors to your satisfaction.

Clouds are made with the fan brush loaded with Titanium White. Use the corner of the brush, in tight circular strokes to lay in the basic cloud shapes. With the top corner of the 2″ brush held vertically, blend the bottom of the clouds using the same small circular strokes. Hold the brush flat and lift upward in large circular strokes to fluff the cloud, then blend. When your sky is completed, cover the entire bottom part of the canvas with a thin, even coat of Liquid White.

BACKGROUND

The background trees are made with the fan brush loaded with a Purple color made from Phthalo Blue and Alizarin Crimson. This color is thinned with a small amount of paint thinner, then applied with the brush held vertically and tapped downward. Mist at the bottom of these trees is created by firmly tapping with the top corner of the 2″ brush held vertically. The tapping will cause your tree colors to blend with the Liquid White on the canvas and beautiful, soft effects will occur. Lift upward with the large brush to blend and remove tap marks. Apply as little pressure as possible.

The next layer of trees is made the same way using a mixture of Alizarin Crimson and Phthalo Green.

TREES AND BUSHES

The large evergeen tree in the background is made with the fan brush, fully loaded with a Black color made from Alizarin Crimson and Phthalo Green. Start by holding the brush vertically and touching the canvas to make a center line. Turn the brush horizontally and use just the corner to make the branches. As you work down the tree, apply more pressure, force the bristles to bend downward and work back and forth.

Indications of distant trees and bushes are made with the 1″ brush loaded with varying mixtures of Cadmium Yellow, Sap Green, Yellow Ochre and Indian Yellow. Load a small amount of paint on the brush, touch the canvas with the brush held vertically and tap downward. Turn your brush to create the different shapes. Tap the bottom of these bushes with the 2″ brush held vertically to create a misty effect.

More distinct trees and bushes are made with Van Dyke Brown, Alizarin Crimson and Dark Sienna on the 2″ brush. Hold the brush vertically and tap downward. The highlights are painted with the top corner of the 2″ brush. Pull the brush vertically through varying mixtures of Cadmium Yellow, Sap Green, Yellow Ochre, Indian Yellow and Bright Red to load layers of color in the bristles. Apply very little pressure to your brush when painting highlights. If the highlight colors do not want to stick to the canvas, add a small amount of paint thinner. Use a clean, dry 2″ brush to tap the bottom of the bushes and trees to create a misty area.

The soft grassy areas are painted with the 2″ brush. Cover the entire bottom portion of the canvas with a mixture of Van Dyke Brown, Alizarin Crimson and Phthalo Green. Hold the brush horizontally and tap downward, creating the general lay-of-the-land. The highlights are then applied in the same manner with the highlight colors used for the trees. Work in

layers, completing the most distant layers first. Angles are very important and will determine the lay-of-the-land.

BUILDING

With the knife, scrape out a general shape for your building. This gives you a basic guide to follow as well as removing excess paint from the canvas. Use Van Dyke Brown to lay out the entire building using the knife. Shingles are painted on the roof using Van Dyke Brown and Bright Red on the short edge of the knife. Load a small roll of paint on the knife, touch the canvas and pull downward, completing the bottom row of shingles first. Work upward in layers, so each new row overlaps the previous row. Highlights on the front

of the house are Van Dyke Brown and Titanium White, laid on with the knife using no pressure. Doors and windows are made with Van Dyke Brown.

FINISHING TOUCHES

A path may be painted in using the knife and Van Dyke Brown. With a small roll of paint, hold the knife horizontally and use short, back and forth strokes to lay in the basic path. Allow the path to get wider as it gets closer to you. Highlights are Van Dyke Brown and Titanium White, applied the same way. Sticks and twigs may be scratched in with the point of the knife. A little thin paint on the liner brush is all you need to sign this beauty.

High Chateau

1. With the 2" brush, scrub the color into the sky area . . .

2. . . . then blend to your satisfaction.

3. Use the corner of the fan brush to lay in basic cloud shapes . . .

4. . . . then use the top corner of the large brush . . .

5. . . . to blend out just the bottoms of the clouds.

6. To make the distant tree indications, tap downward with the fan brush . . .

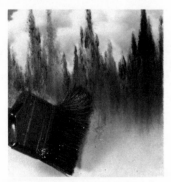

7. . . . diffuse the base of the trees . . .

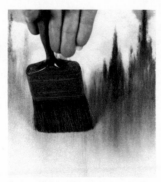

8. . . . and then lift upward to create a misty effect.

9. Continue working forward . . .

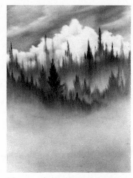

10. . . . allowing the misty areas to separate the layers of trees.

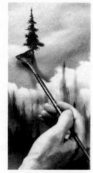

11. Use the corner of the fan brush . . .

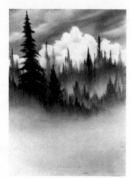

12. . . . to paint the large evergreen tree in the background.

High Chateau

13. More distant trees and bushes are made using the 1" brush . . .

14. . . . and the 2" brush . . .

15. . . . continuing to work in layers.

16. The 2" brush is used . . .

17. . . . to highlight the trees and bushes . . .

18. . . . and to create a misty area at the base of the trees.

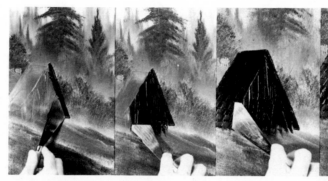

19. The soft grassy areas are painted with the 2" brush . . .

20. . . . creating the lay of the land.

21. Progressional steps used to paint the chalet. . .

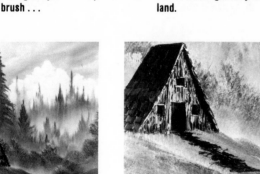
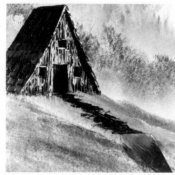
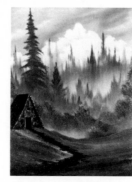

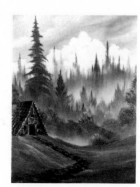

22. . . . and the chalet is complete.

23. Use a small roll of paint on the knife . . .

24. . . . to lay in the path.

25. With the 2" brush, tap a little grass over the edges of the path.

26. Cut in sticks and twigs with the point of the knife and sign.

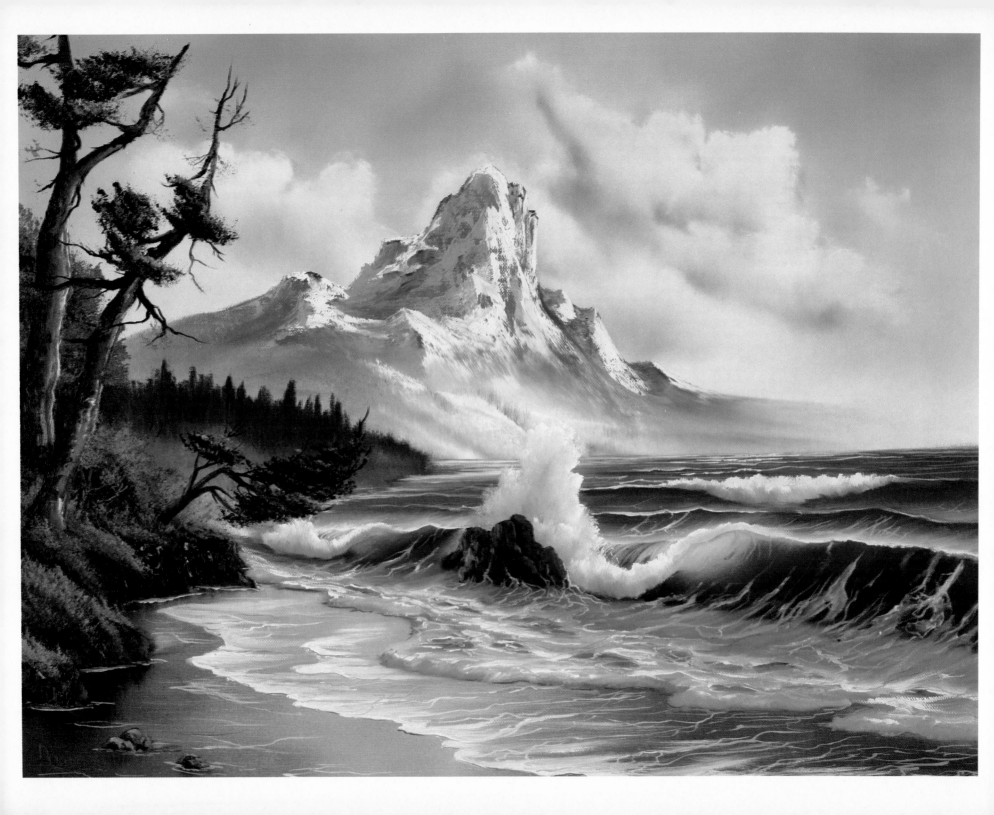

MATERIALS

2″ Brush	Phthalo Blue
1″ Brush	Prussian Blue
#6 Fan Brush	Midnight Black
#6 Filbert Brush	Dark Sienna
#2 Script Liner Brush	Van Dyke Brown
Large Knife	Alizarin Crimson
Liquid White	Sap Green
Liquid Black	Cadmium Yellow
Liquid Clear	Yellow Ochre
Titanium White	Bright Red
Phthalo Green	

Start by covering the top half of the canvas with a thin, even coat of Liquid White using the 2″ brush. Cover the bottom half of the canvas with Liquid Clear. Do not allow the Liquid White and Liquid Clear to dry before you begin.

SKY

With a mixture of Prussian Blue and Midnight Black on the 2″ brush, use small criss-cross strokes to add color to the sky. Leave the basic cloud shapes unpainted. With Midnight Black and Bright Red on the same brush, use small circular strokes to add the dark underside of the clouds to the unpainted areas in the sky. Highlight the clouds by pulling the 1″ brush through Titanium White with a touch of Bright Red. Again using circular strokes, add this light color to the tops of the clouds. With a clean, dry 2″ brush lightly blend the light into the dark then upward strokes to "fluff." Very, very lightly blend the entire sky.

MOUNTAIN

The mountain is made with the knife and a mixture of Prussian Blue and Midnight Black.

This mountain lives right up in the clouds. With firm pressure and using very little paint, shape just the top edge of the mountain. Use the 2″ brush to pull the paint down to the base of the mountain to complete the shape.

To highlight the mountain, load the long edge of the knife with a small roll of Titanium White. Pull the paint down the right side of each peak using so little pressure that the paint is allowed to "break." The shadows are a mixture of Titanium White, Phthalo Blue and Midnight Black applied to the left side of each peak. Use a clean, dry 2″ brush to tap and diffuse the base of the mountain, carefully following the angles you have created.

WATER

Use some Prussian Blue on the filbert brush to lightly sketch in the large wave in the foreground.

The horizon in this painting is about eight inches down from the top of the canvas. Underpaint the area between the horizon and the top of the major wave with a mixture of Prussian Blue and Alizarin Crimson using the 2″ brush. Add Phthalo Green to the same brush to underpaint the wave and also the dark water at the base of the wave. Be very careful to leave the two transparencies of the wave UNPAINTED!

Add the tops of the swells behind the wave with long horizontal lines using Titanium White on the fan brush. Follow the angles of the water. Also add Titanium White to the top edge of the large wave. Remove the excess paint from the fan brush, "grab" the top edge of the swell lines and use small sweeping strokes to pull the paint back. Diffusing the top edges of the swells, be very careful not to "kill" all of your dark base color. Repeat this procedure with the White along the top of the large wave.

Load the filbert brush with a mixture of Titanium White and a touch of Cadmium Yellow. Scrub this color into the "eye" or transparency of the wave allowing the paint to extend out and across the top of the wave. Repeat this procedure with the smaller transparency in the wave. Use the corner of a clean, dry 2″ brush to lightly blend the two transparencies; then blend the entire wave by pulling from the top to the base using the brush strokes to create the angle of the water.

Load the fan brush with a dark mixture of Phthalo Green and

Prussian Blue to underpaint the breakers (the water crashing over the tops of the transparencies). Pay close attention to angles as you curve the strokes from the top of the breakers to the base. Highlight the breakers by gently pulling Titanium White over the dark base color using the fan brush. Also add a light edge to the top of the wave with the Yellow-White mixture.

Underpaint the foam created by the two breakers with a mixture of Titanium White, Phthalo Blue and Alizarin Crimson. Scrub the paint in with small circular strokes using the filbert brush. Use the Titanium White and Cadmium Yellow mixture on the filbert brush to push in the highlights along the top edges of the foam. Blend this light color into the darker base color using small circular strokes with a clean, dry filbert brush. Complete the blending with just the top corner of a clean, dry 2″ brush.

The foam patterns in the wave are made with Titanium White and the fan brush. Use sweeping strokes to create the angles of the water.

Use the knife with a mixture of Van Dyke Brown and Dark Sienna to add the stone to the water, very much as you made the mountain. Highlight the right side of the stone with a mixture of Dark Sienna, Yellow Ochre and Bright Red. Use the fan brush and Titanium White to swirl water around the base of the stone.

With Dark Sienna, Van Dyke Brown and Alizarin Crimson on the 2″ brush, use long horizontal strokes to add the sandy beach area to the left corner of the painting. Bring the sand right up to the edge of the water.

Use the liner brush to add small details to the water; Titanium White and Cadmium Yellow (thinned with paint thinner) to "sparkle" the water along the horizon; Titanium White and Phthalo Blue to highlight the tops of the swells and to make small foam patterns in the background water. With Prussian Blue and paint thinner, add a thin dark line right under the water on the beach. Gently blend the entire beach area with the 2″ brush.

FOREGROUND

Load the fan brush with a mixture of Sap Green, Midnight Black and Van Dyke Brown. Hold the brush vertically to tap in the small background trees along the horizon. With Dark Sienna and Van Dyke Brown on the 2″ brush, tap in the ground area under the trees and the cliffs along the water's edge. Use the knife to form the edges of this land projection. Use the large brush to pull some of this dark color onto the beach and brush across to create reflections.

With a mixture of Yellow Ochre and Dark Sienna on the 2″ brush, highlight the ground area under the distant trees by just tapping. As you work forward, add grassy areas to the ground with the fan brush using a mixture of Sap Green, Cadmium Yellow and Yellow Ochre.

Add small trees and bushes with a mixture of Van Dyke Brown and Sap Green on the 1″ brush.

Highlight the small trees and bushes by pulling the 1″ brush in one direction through various mixtures of Sap Green and all the Yellows, to round one corner. With the rounded corner up, gently touch the canvas, forcing the bristles to bend upward. Create individual bushes and trees by shaping them one at a time and being very careful not to "kill" all the dark base color.

The large tree is made with the filbert brush and Van Dyke Brown. Starting at the top of the canvas pull in the trunk using more pressure as you near the base of the tree allowing the trunk to become wider. Small limbs and branches are made with a mixture of Liquid Black and paint thinner on the liner brush. Add the indication of leaves with a mixture of Sap Green and Van Dyke Brown on the fan brush.

FINISHING TOUCHES

Use Titanium White on the fan brush to "clean up" the edges of the water at the base of the land projection in the background.

With a mixture of Phthalo Blue, Titanium White and paint thinner on the liner brush, you can add the water lines to the base of the cliffs in the foreground. Also use this mixture for the ripples on the beach and to make the trickling water over the stone.

Don't forget to scratch in small sticks and twigs with the point of the knife.

This painting is a challenge but well worth the effort. Sign your masterpiece and be proud!

Mountain-By-The-Sea

1. Criss-cross strokes are used to paint the sky.

2. Corner of the 2" brush used for shadow areas of the clouds.

3. Clouds are highlighted with a 1" brush.

4. Blend with small, circular strokes, using the top corner of the 2" brush.

5. Basic mountain shapes made with the knife . . .

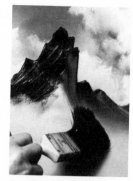

6. . . . then blended downward with a 2" brush.

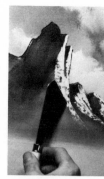

7. Highlight using very little pressure.

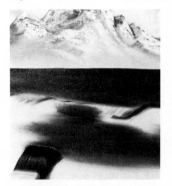

8. The 2" brush is used to paint the dark areas.

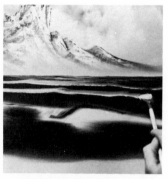

9. Individual large waves are outlined with the fan brush.

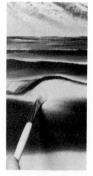

10. Paint in the eye of the wave with the filbert brush.

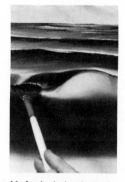

11. Apply dark color to the top of the wave with the fan brush . . .

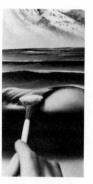

12. . . . then add a light color for highlights.

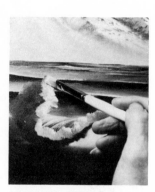

13. Foam is painted on the wave with the filbert brush.

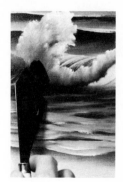

14. Rocks are made and highlighted with the painting knife.

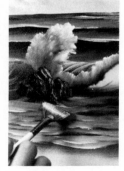

15. The fan brush is used to paint water around the base of the rocks.

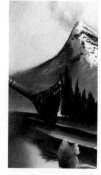

16. Tap downward with the fan brush for evergreens.

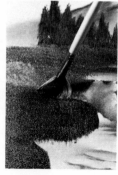

17. Push upward with the fan brush to paint the grassy areas.

18. Water lines are painted with a thin paint on the liner brush.

19. Push upward with the 1" brush to make and highlight trees and bushes.

20. Individual limbs are painted with the liner brush and a thin paint.

OTHER BOB ROSS PUBLICATIONS

"The Joy of Painting" Book, Volume 1

"The Joy of Painting" Book, Volume 2

"The Joy of Painting" Book, Volume 3

"The Joy of Painting" Book, Volume 4

"The Joy of Painting" Book, Volume 5

"The Joy of Painting" Book, Volume 6

"The Joy of Painting" Book, Volume 7

"The Joy of Painting" Book, Volume 8

"The Joy of Painting" Book, Volume 9

"The Joy of Painting" Book, Volume 10

"The Joy of Painting" Book, Volume 11

"The Joy of Painting" Book, Volume 12

"The Joy of Painting" Book, Volume 13

"The Joy of Painting" Book, Volume 14

"The Joy of Painting" Book, Volume 15

ALL INQUIRIES REGARDING

THE AUTHOR AND THIS PAINTING TECHNIQUE

SHOULD BE ADDRESSED TO:

BOB ROSS

P.O. Box 946

Sterling, Virginia 22170

Telephone: **1-800-BOB ROSS** (1-800-262-7677)

THE ARTIST

After a few short years of teaching his methods, Bob Ross has become the talk of the art world. He has brought the thrill of oil painting to thousands of people who have never before painted. His use of this quick-study, wet-on-wet technique with unconventional brushes and palette knives, has revolutionized the art of oil painting.

Bob Ross first encountered the "wet-on-wet" method of painting in the mid-1970's. "I had always wanted to paint freely and quickly," Bob recalls. He had been practicing art for 20 years, but had always been frustrated with traditional painting and art schools. This style made painting simple and fun.

Bob Ross is living proof that "wet-on-wet" methods allow for individual freedoms of style and expression. The distinguishing colors and details in Bob's paintings add a new dimension to this unique art form. Bob Ross has quickly became an accomplished artist in his own fashion.

As a traveling art instructor, Bob has generated great excitement over this unusual technique. "The Joy of Painting" surfaced the unknown talents of many never-before painters.

Painting demonstrations by Bob in civic centers, art leagues, churches, and shopping centers were met with enthusiasm and awe. Crowds of people from all walks of life watched in amazement as Bob, with the stroke of a knife or the sweep of a brush, formed snowcapped mountains, bubbling waterfalls, and trees reflecting in a pond. His classes and seminars were filled as quickly as they were scheduled.

Bob's soft-spoken charm and apparent zest for life have captured the hearts of many. He teaches his students to see the world for the first time. "You are only limited by imagination," he tells them.

Spend one minute with Bob and it is easy to see that his painting is more than a hobby. It is a means of expression, encompassing a philosophy of life. Other professional artists have never been able to express themselves so freely through conventional practices. Following his retirement from the military, and after only one year of teaching throughout the United States, Bob Ross was asked to produce an instructional public television series. This first endeavor, which was aired on 50 stations nationwide, has

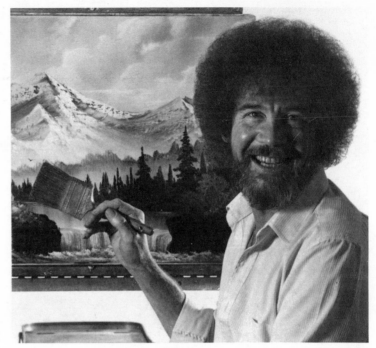

Photography by: Ron Markum, Muncie, Indiana

since been parlayed into 16 highly-rated PBS series. Now, nearly 300 stations are committed to carry "The Joy of Painting" series.

The Bob Ross magic comes through on the screen. "Just let it happen," he tells his viewers. "This is your world."

The Bob Ross story is truly an American success story. Born in 1942 and raised in Orlando, Florida, Bob gives credit to his mother for instilling in him the love of nature. He inherited his tradesmanship qualities from his father, a carpenter who took great pride in his work. For eleven of the twenty years Bob spent in the military, he was stationed in Alaska. The breathtaking allure of this untouched land kindled Bob's enthusiasm for the art of oil painting.

But the secret to his success Bob attributes to "dedicated practice" and continual innovation of his techniques and tools. "My reward," says Bob, "is that I am able to share all of this with others."

Joyce Moscato
Media Associate